₩₩₩₩₩₩₩₩₩₩₩₩₩ </2 W9-ANH-883

THE CLASSIC ERA OF AMERICAN COMICS

NICKY WRIGHT collected comics all his life and wrote for American comics magazines. He was principally known as an award-winning writer and photographer of books on American cars. He lived for most of the last fifteen years in Michigan, America but died in 2000 in England, where he was born.

JOE KUBERT started working in the comics business aged eleven and for the next sixty years produced stories for Hawkman, Tarzan and Batman, and many other great comics. He was an editor for DC Comics for 25 years and founded the only school for comic artists. He is the recipient of many honours including the 1998 Will Eisner Hall of Fame award. He lives in New Jersey.

NICKY WRIGHT

Foreword by Joe Kubert

CONTEMPORARY BOOKS

Library of Congress Cataloging-in-Publication Data

Wright, Nicky.

The classic era of American comics / Nicky Wright ; foreword by Joe Kubert. p. cm.

Includes bibliographical references and index.

ISBN 0-8092-9966-6 1. Comic books, strips, etc.—United States—History and criticism. I. Title.

PN6725.W75 2000 741.5'0973—dc21

00-31405

Jacket image credits: Front cover – Top right: *Superman* © 1945 D.C. Comics, Inc. Bottom right: *Detective Comics* © 1949 D.C. Comics, Inc. Top left: *Jumbo Comics* © 1949 Fiction House Magazines. Bottom left: *Astonishing* © 1954 Marvel Comics Group.

Back cover – Top left: *Captain Marvel Adventures* © 1949 Fawcett Publications. Bottom left: *Tales from the Crypt* © 1953 W.M. Gaines. Top right: *Journey into Mystery* © 1959 Marvel Comics Group. Bottom right: *Jungle Comics* © 1946 Fiction House Magazines.

All images courtesy of Nicky Wright.

Thanks to Peter Haining and to Geoff West and Ken Harman at The Book Palace for their kind help and assistance.

All D.C. Comics, Marvel Comics, and other comic book material, illustrations, titles, characters, related logos, and other distinguishing marks remain the trademark and copyright of their respective copyright holders and are reproduced here for purpose of historical study.

Designed by Ivan Dodd Designers Design © Prion Books Ltd. Cover designed by Jon Gray

This edition of *The Classic Era of American Comics* is published under license from Prion Books Limited, London.

This edition first published in 2000 in the United States by Contemporary Books A division of NTC/Contemporary Publishing Group, Inc. 4255 West Touhy Avenue, Lincolnwood (Chicago), Illinois 60712-1975 U.S.A. Copyright © 2000 by Nicky Wright Foreword copyright © 2000 by Joe Kubert All rights reserved. No part of this book may be reproduced, stored in a retrieval system, or transmitted in any form or by any means, electronic, mechanical, photocopying, recording, or otherwise, without the prior written permission of NTC/Contemporary Publishing Group, Inc. Printed in Singapore by Imago International Standard Book Number: 0-8092-9966-6 00 01 02 03 04 05 19 18 17 16 15 14 13 12 11 10 9 8 7 6 5 4 3 2 1

CONTENTS

	Foreword by Joe Kubert	vii
	Introduction	1
1	Come on the Clowns	8
2	Up, Up and Away!	32
3	A Superhero Frenzy	48
4	The Comics Go to War	68
5	Let's Go Girls	90
6	Animal Crackers	104
7	Give Me a Home Where the Buffalo Roam	128
8	Horror and Crime at a Dime a Time	138
9	More Good Girls, A Bit of Romance and War Too	158
10	Horror We, How's Bayou?	174
11	It's All Over Now	202
	Bibliography	218
	Index	

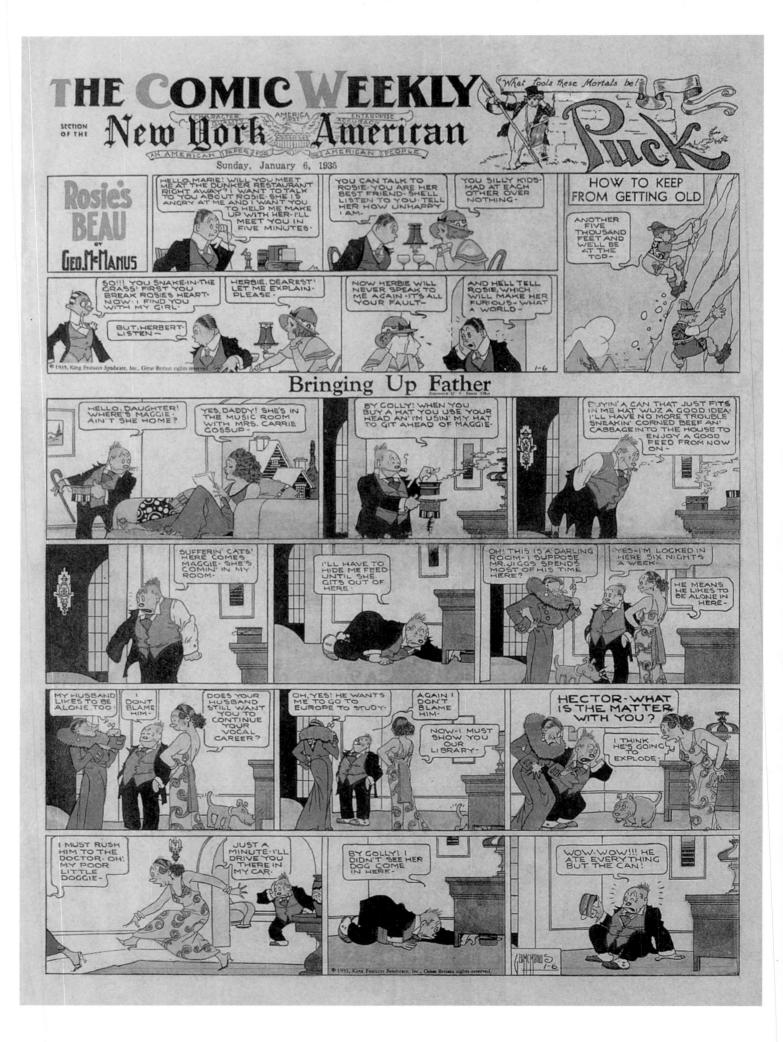

FOREWORD

Left The Comic Weekly in the *New York American* from January 6, 1935 featured classic strips like Bringing Up Father. It seems to me that my early life and career are reflected in the words contained between the covers of this book. They bring back vivid memories for me. Of the people I've met: the editors, the artists, the publishers. And the friends.

I've always loved cartoons, cartooning and cartoonists. I remember the comics in the *New York American*: Flash Gordon, Bringing Up Father, Jungle Jim, The Katzenjammer Kids. And the *New York Mirror* with Joe Palooka, Tarzan, Li'l Abner. The *New York News*' Dick Tracey, The Gumps, Terry and the Pirates. That was my world. One that inspired me to become a cartoonist.

I was ten years old in 1936 when I became fully aware of comic books. Most of my friends in the neighbourhood were reading them and we traded with each other, so with one magazine I was able to read a dozen others. *Tip Top Comics* contained six or seven Tarzan Sunday pages. For me, that was like finding a treasure trove.

I'd been drawing since I could hold a pencil and learned which end made the mark. My fascination with newspaper comics made me want to draw them. Handsomely muscled heroes and dangerously menacing villains. So, it was in the nature of things that I wanted to be a cartoonist.

I remember reading the first Superman story in *Action Comics*. Great story. But I could draw better than that. Ah, the naiveté of youth! And all my school chums encouraged me. One boy in particular, who happened to be related to a comic book publisher, MLJ Publishing, the forerunner of Archie Comics. "Joe, you can draw as good as those guys," Melvin told me. "Go on up and show 'em your stuff. They'll pay you for it."

I travelled from Brooklyn, where I lived in East

New York, to Manhattan. The subway ride was only a nickel. M.L.J. Publishing was on Canal Street. I wore my knickers that had the least holes in and carried my drawings in a folded newspaper. I entered the office and entered a new world. I still remember the intoxicating smell of paper, ink and erasures. And I met the kindest people in the world. Mort Meskin, sitting by a window, crouched over his drawing board, stuttered a warm 'hello'. Big Charlie Biro patted my shoulder as he looked at my work. Bob Montana winked at me, "You're okay, kid", he drawled. Harry Shorten asked me where I lived and raised a heavy eyebrow when I told him, Brooklyn. "Be careful onna subway", he said. VII

Then they all proceeded to help me by suggesting how I could improve my drawing. They were all so kind. The advice came with a huge helping of encouragement. And I was invited to come back anytime, which I did, again and again.

I got my first job at the same time as I entered my first year of high school. A five page strip called Volton, for five dollars a page. High school was The High School of Music and Art, at 135th Street and Convent Avenue in Manhattan. I soon made a habit of visiting every publisher between Manhattan and Brooklyn.

Harry "A" Chesler had a shop on 14th Street. He supplied me with unused scripts and allowed me to work in the shop from 3:00 pm (after school) until quitting time. He gave me five dollars a week for expenses. He told the other artists to help me, show me how to improve my drawing. People like Charles Sultan, Rube Moreira, Raphael Astarita, George Tuska. They were great.

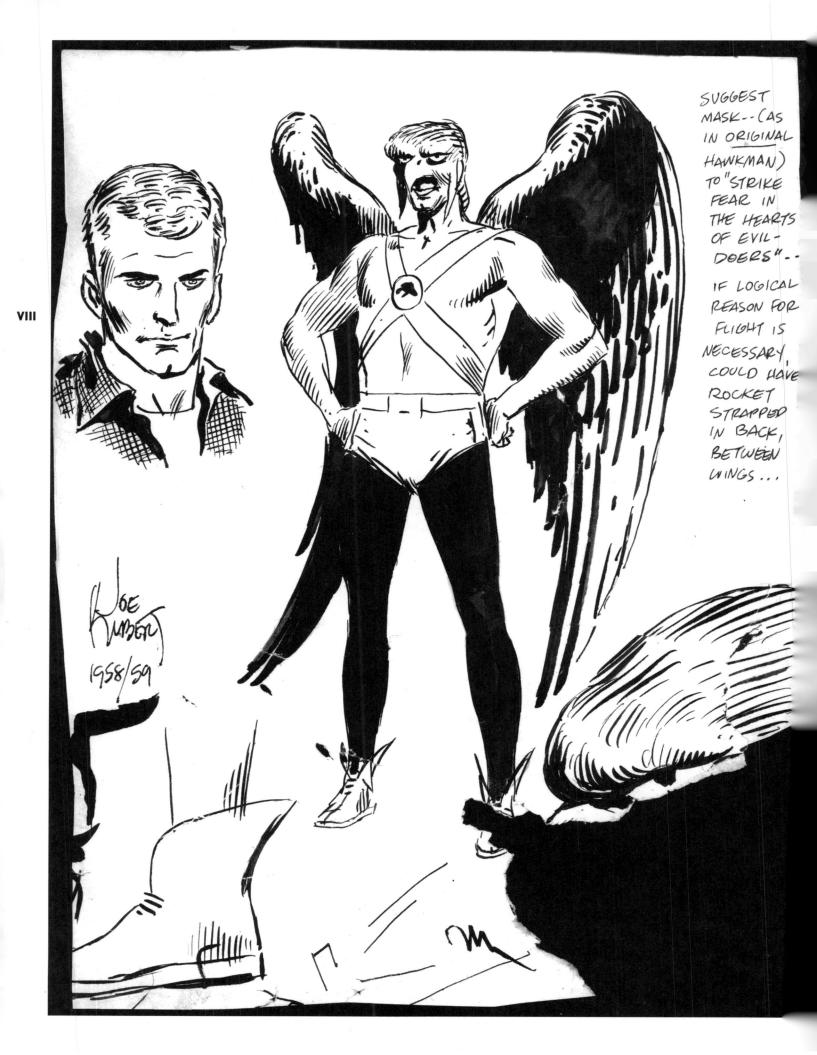

Left Original Joe Kubert drawing-board artwork for his Hawkman character circa 1958/59.

> The summer before my second year in high school, I was hired by Will Eisner. My job? Sweep out the place, erase the artists' work and do general clean-up. This was in Tudor City, an apartment cum studio on the east side of Manhattan where I met Chuck (Blackhawk) Cuidera, Bob (Mr Mystic) Powell, Nick (Lady Luck) Cardy, and Tex Blaisdell. I never dreamed I'd be inking The Spirit over Lou Fine's pencils during the summer before my senior year in high school.

> About this time, I'd worked for Jerry Iger, just prior to my job with Will Eisner. Bob Lubbers was unstinting in his help and advice. I did all-nighters with Charlie Biro and Bob Wood, (editors/artist/ writer of *Crime Buster* and *Daredevil*) with my high school buddy, Norman Maurer.

This was now the start of my Senior year in High School. I'd gone up to All American Comics, located at 225 Lafayette Street in Manhattan. I met the editor, a tall, rangy guy who wore thick glasses. A really nice guy who told me he was also a cartoonist. Name? Sheldon Mayer. Miracle of miracles, he wanted me to draw a monthly strip called Hawkman. And to do the covers, as well. I don't think my feet touched the ground once as I made my way home to Brooklyn to tell my Mom and Dad about my new job.

It was at All American Comics that I met some of my life-long friends and associates. I said hello to M.C. Grimes once or twice, but only fleetingly. Shelly Mayer was my mentor. He had the patience of three saints. He was the one who explained the cartoonists' credo to me. "We are STORY-TELLERS", he'd say. "Communicators. We don't just draw pretty pictures. They gotta say something to people." I've repeated that lesson to many young, aspiring cartoonists. It was there that I met Carmine Infantino, Frank Giacoia, Lee Elias, Irwin Hasen, Sol Harrison, Eddie Eisenberg, Jack Adler, Julie Schwartz, Bob Kanigher and other perhaps too vaguely remembered.

When All American merged with D.C. Comics, we moved uptown to 480 Lexington Avenue. There I met the Donenfelds, Harry and later, his son Irwin. My discussions, however; were more with people like Bill Finer (who wrote some Hawkman scripts) than the bigwigs. To me, the "suits" were still another world and miles apart from my interests.

I must admit to having been completely unaware of the "inside info", the "business" end of the business, during those early years. My focus was always on drawing. Refining. Trying to put on paper the visuals that churned in my mind's eye. To create in my drawings the kind of excitement, wonder and awe that artists like Hal Foster, Alex Raymond and Milt Caniff communicated in their work. Who did what to who and why were of no interest to me. At that time.

This book, authored by Nicky Wright, has filled a lot of the gaps in my early education and experience. And, I'm still willing to learn.

Joe Kubert www.joekubert.com

INTRODUCTION

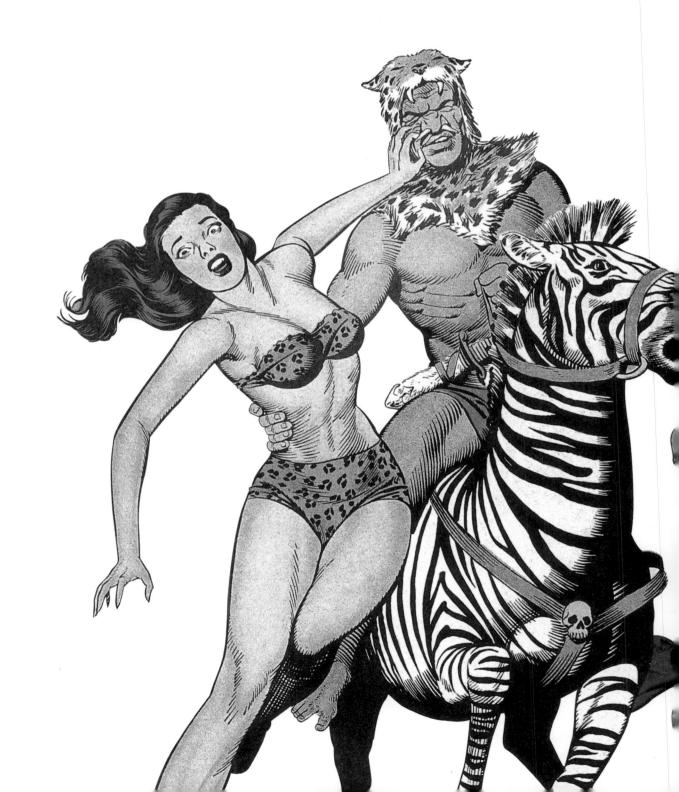

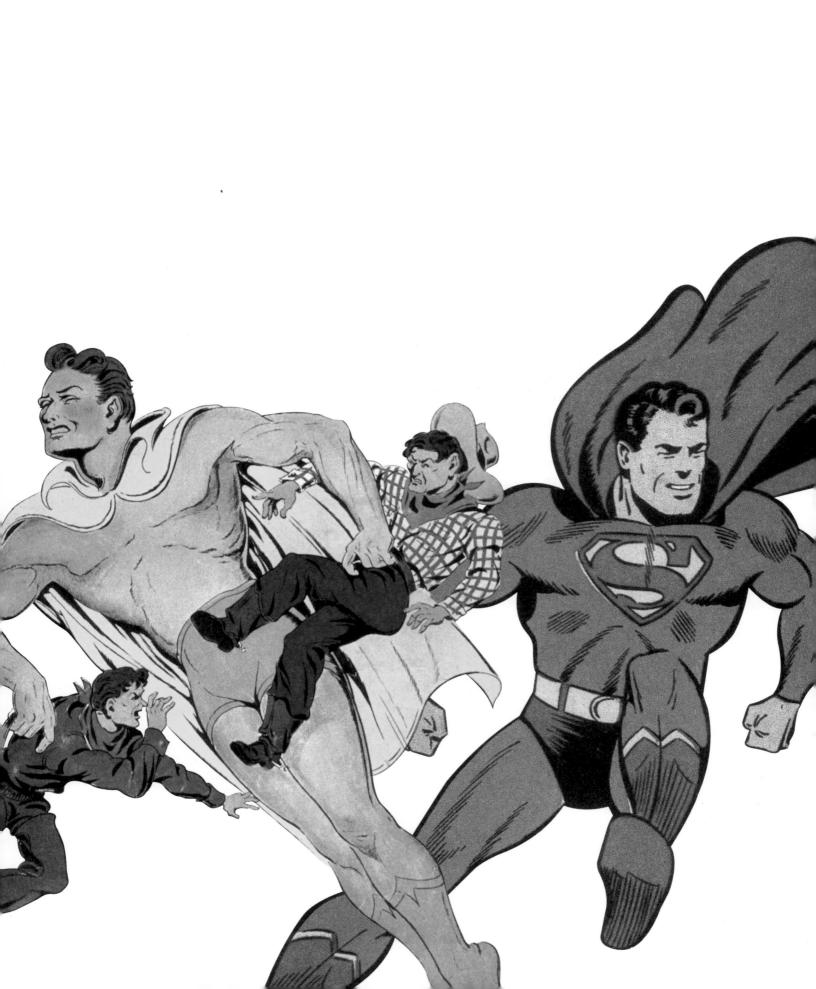

IT WAS THE DIRECT RESULT OF A DEEPLY WORRIED psychiatrist named Dr. Fredric Wertham. His best-selling book, *Seduction of the Innocent*, brought about the end of my first comic book collection. Having read this horrific tome on the evils of the American comic book, my parents ordered the gardener to burn my precious treasures. Mr. Finch dutifully obliged and I watched tearfully as *Captain Marvel*, *Superman*, *Justice Traps the Guilty*, and *Ringo Kid* were cast into the bonfire's hungry flames. The colorful pages distorted and burned, and blackened ash floated and sailed in the breeze. Had I been old enough I would have admonished my parents for committing the same heresy as Hitler's henchmen – the book-burning bonfires of the thirties. As I watched Mr. Finch rake the burning embers the irony of this nightmarish situation became all too apparent...it was Finch's son Peter who had originally introduced me to the fascination that is the American comic. It was that incurable fascination that led me to become a true blue collector of the genre loved by so many.

Comic books were a mere 21 years old when Wertham's damning book came out. They had begun in Depression-weary 1933, the year Hitler came to power and Europe was facing turmoil. People desperately needed to laugh, to forget the gray realities of their day-to-day existence, trying to put food on the family table and picking up whatever work they could find – if they were

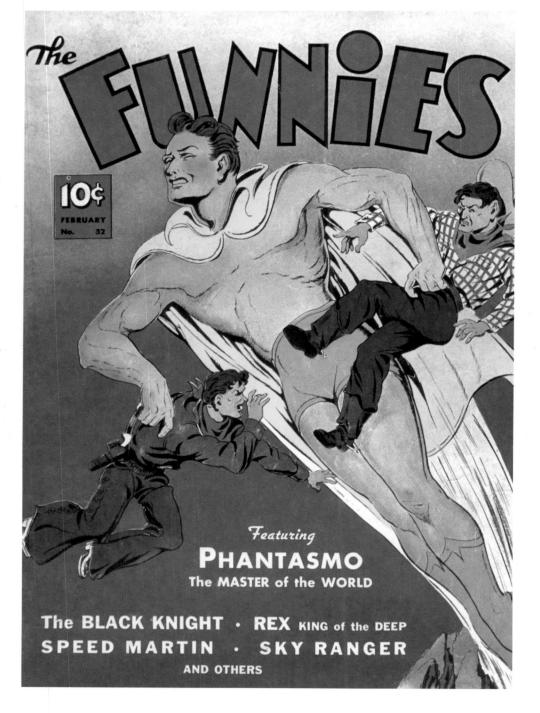

Left The very first comics were reprints of "the funnies" – amusing cartoon strips taken from the Sunday newspapers. *The Funnies* © 1941 Dell Publishing Co.

lucky enough. At least after supper the family could chuckle over *Funnies on Parade*.

Funnies on Parade was an 8 by 11-inch full-color comic that reprinted Sunday newspaper comic strips such as *Joe Palooka* and *Mutt & Jeff*. The book's 36-page format was sold to Proctor & Gamble who purchased 10,000 copies to be given away as premiums to customers. Following this initial success Eastern Color Printing's ace salesman Maxwell C. Gaines approached other companies to take comics. He was rewarded with an even bigger print run for the same type of comic but this time it was called *Famous Funnies: A Carnival of Comics*. The sponsors bought 100,000 copies. Gaines could see that he and his partners at Eastern Color were on to a good thing and decided to stick a ten-cent sticker on a few dozen comics and gave them to newsstands to sell. Two days later the newsstands were back demanding more: all copies had sold within two days! The comic book was off and running.

By the mid-thirties other publishers were turning to comics and original material began to appear within the by now standard format of 68 pages of mostly primary colors. Superman, perhaps the most famous comic book hero of them all, turned up in 1938, Batman in 1939, and Captain Marvel in 1940. It was during the war that some of the most imaginative and great art appeared in the comic books. To be a comic book artist in those days was

Below Superman, the original superhero and possibly the best-known comic book character ever, first appeared in 1938. *Superman* © 1945 D.C. Comics, Inc.

NOW I'M SURE YOU'RE NOT SUPERMAN! AS I'VE SOMETIMES SUSPECTED! THE CROOKS STOLE THE ONLY TWO EXISTING SAMPLES OF THE ONLY ELEMENT THAT CAN OVERCOME HIM ... KRYPTONITE!

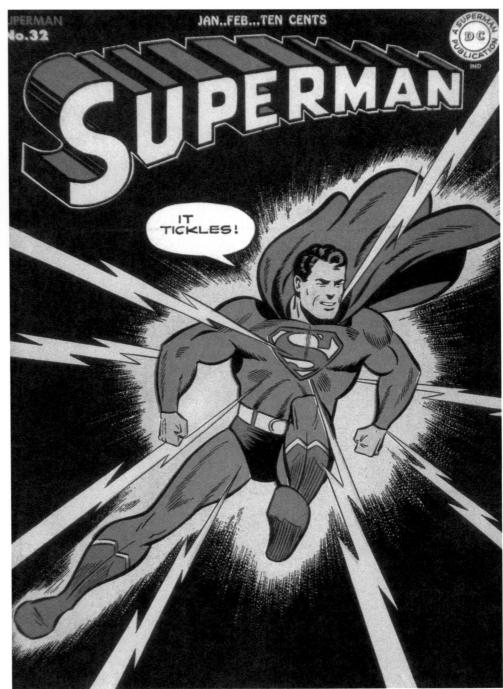

a dirty word; illustrating for those dime-a-time comics was akin to being a low-life, the bottom of the heap. The result was that many artists were embarrassed to own up to what they did. They needn't have worried. Recognition originally came from Europe, and those artists have finally come in from the cold to become the founding heroes of a unique art form.

After World War II there were at least 45 publishers in the business of producing comics. Small companies came and went but the total number remained more or less the same until 1955, when the hue and cry begun by the media and Dr. Wertham led to the formation of the Comics Code to regulate comic book contents. Until the end of the war comics usually featured funny animals, or superheroes bashing the Nazis and Japanese. One publisher sneaked in a few jungle comics featuring skimpily clad females doing their bit for "our boys over there," but by and large, though impossibly violent, nobody could say much against them. After the war all this changed; superheroes were out, crime, horror, and sleazy jungle girls were in. Jungle comics from Fox, crime comics from Gleason and others, and horror from several companies (a publisher by the name of Entertaining Comics produced far and away the best horror comics ever to be seen...and also the most controversial) grabbed the attention of Wertham, local government agencies, and media such as *Newsweek*,

Below and near right In the post-war era comics became increasingly salacious and violent: skimpily-clad jungle girls vied with crime and horror for supremacy with teenage readers. Jungle Comics and Jumbo Comics © 1948 and 1942 Fiction House Magazines. Fight Against Crime © 1954 Story Comics.

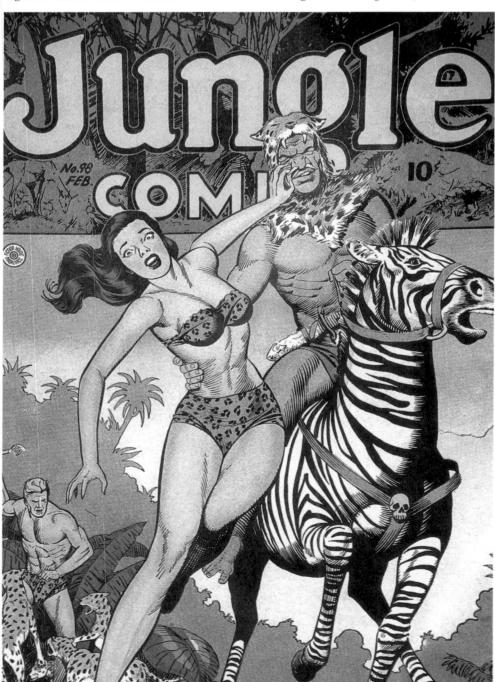

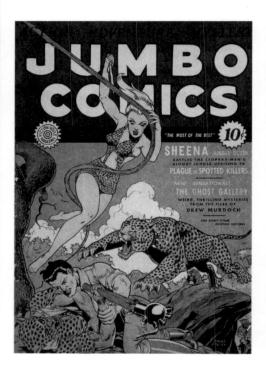

Ladies Home Journal and the Catholic press. Concerned parents rushed to their congressmen and the hysteria that gave birth to McCarthyism turned its panic-stricken attention on the lowly comic. Wertham led the way and satisfaction was finally guaranteed after a Senate Sub-committee told the comics industry to regulate itself...or be regulated.

White-washed and sanitized the new, squeakyclean comics were unutterably boring. Then in 1961 under the inventive spirit of one Stan Lee, the once colossal Marvel/Timely/Atlas comic publishers came up with the highly original superhero team, The Fantastic Four. More, such as the Incredible Hulk and Iron Man, followed and in 1962 Lee, aided by artist Steve Ditko, invented The Amazing

Spiderman. This character was as fresh as Superman was in 1938 and soon became a household word. The comics industry was alive and well, the renaissance had begun.

The first 30 years of the comics industry were as important to American culture as jazz, John Steinbeck, Citizen Kane, and the art of the American automobile. The American comic slowly achieved recognition as an art form by virtue of its influence around the world. Tutsi tribesmen in Rwanda have heard of Superman and the reprints in different languages, including Russian, have brought untold pleasure to millions. Classics Illustrated, those marvelous Gilberton publications that presented classical literature in comic book

Right After the panic- stricken

censorship of the mid-fifties,

clean and ostensibly killed the

of the early sixties with a new

generation of characters like

that made comics squeaky-

art form off, came the Stan

Lee inspired renaissance

The Fantastic Four.

The Fantastic Four © Marvel Comics Group.

form, were so popular that they sold more issues in various languages than any other American magazine. Thanks to the French and the British who were the first to appreciate comic book artwork, the American comic is finally regarded in a serious light on its home turf.

Here then is the full story of this unique medium's first 32 years, the successes, the failures, the trials and tribulations, Senate hearings, court cases, and even the burnings. Read the story of E.C., of Major Malcolm Wheeler-Nicholson, Simon and Kirby, Carl Barks the "duck man," Dr. Wertham, and Victor Fox. These are some of the personalities that have made the American comic book an imaginative force in the twentieth century. Of course there were badly drawn comics just as there are bad singers, bad painters, and bad actors. But the good comics were, and are, art; artists like Joe Kubert, Jack Cole, Al Williamson, and C.C. Beck are the genre's Degas, Van Gogh, Manet, and Dali. Al Williamson's soft, sensitive work compares favorably with the sensuous romanticism of Manet, Degas, and Monet, while Jack Cole's disturbing images share much with Van Gogh on the one hand and Salvador Dali on the other. There were, and still are, great and imaginative artists in this truly twentieth-century medium.

A huge collector base has grown up around the comic book. Some have even sold for six-figure sums at auction. There are comic stores in almost every Below Spiderman and the Incredible Hulk (in a British edition) – two more Stan Lee creations that fueled the sixties comics renaissance. Spiderman ©, The Incredible Hulk © Marvel Comics Group.

town and there's a list of the better dealers later in this book. They sell many older comics at affordable prices.

Illustrated with many examples of comics and some of the personalities who wrote, drew, and edited them, this book will enlighten newcomers and give veteran collectors many hours of pleasure. It does not, however, pretend to be a complete history: rather the book is a celebration of a great popular art form, retelling the main events in its history and illustrating its fascinating evolution.

Below The comic book had a huge influence across the globe. *Classics Illustrated* was published in many languages and sold more copies throughout the world than any other American magazine of that era. *Classics Illustrated* © 1941 (below) and 1943 (right) Gilberton Co.

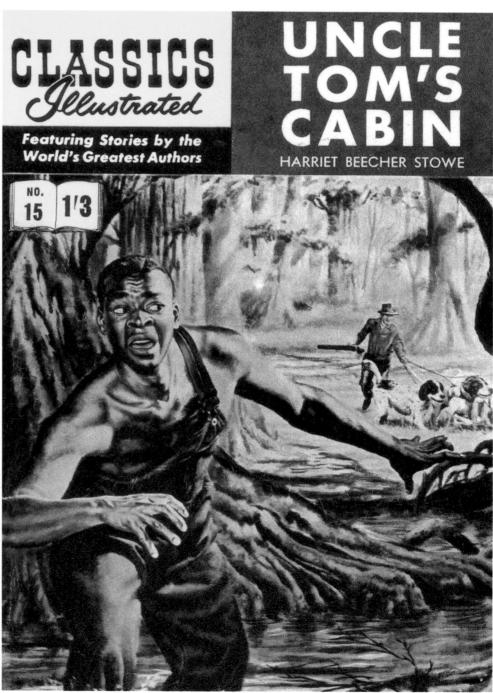

Chapter One

COME ON The clowns

LATE SPRING IN 1933 AND A WARM BREEZE PLAYFULLY danced along New York's dusty streets, whirling the city's debris into eddies that blew into the nooks and crannies of Times Square, Fifth Avenue, and Broadway. Along one quiet street, the breeze lifted a little magazine full of comics and color into the air. As the magazine fell back to the gray, worn pavement its pages opened to reveal the bright, warm colors that contrasted with the somber street.

A man, whose clothes had seen better days, shuffled out of the crowded main thoroughfare. There was whiskery growth upon his chin and he carried a pathetic bundle under his arm, a bundle that was all that was left to his name. At least he could take comfort in the fact he was one of many millions, walking in his flappy shoes to nowhere in particular in the vain hope there might be a job along the way. Even though four years had passed since the Wall Street Crash had leveled America, the Depression that resulted was far from over. And newspaper headlines were telling of sinister events in Europe, of a man called Adolf Hitler....

He spotted the colorful pages on the ground, put down his bundle and picked them up. Turning the pages the man recognized characters from newspaper Sunday comic strips. Sitting on a sidewalk step he read one of the strips and began to laugh. Flipping over a couple of pages he laughed some more. Looking at the cover the man stood up, stuffed *Funnies on Parade* into his pocket and walked on....

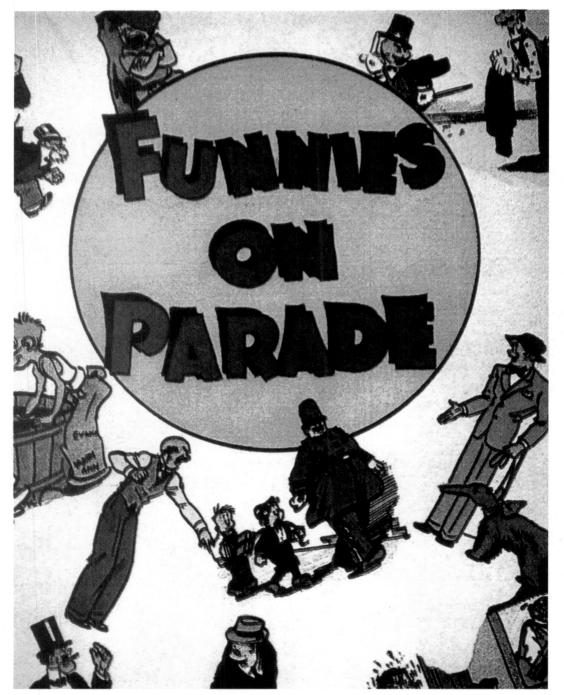

Left In 1933 Funnies on Parade became the first real comic book ever published: popular cartoons, including the likes of The Gumps and Mutt & Jeff, reprinted from the Sunday newspapers. It was aimed at the millions who needed a little comic respite during the dark days of the Great Depression. Funnies On Parade © 1933 Eastern Color Printing Co.

11

Although the events described above didn't actually happen, they could have. There was a Depression and millions were out of work. Europe and the rest of the world had been badly affected and dark days lay ahead. Millions of people in a similar predicament found that *Funnies on Parade* brought a few minutes of escape. The result of the collaborative efforts of sales entrepreneurs Maxwell Charles Gaines, Harry Wildenberg, and George Janosik, all involved with Eastern Color Printing of Waterbury, Connecticut, *Funnies on Parade* was the first true comic book to be published.

Maxwell Gaines found himself laughing at the Sunday funnies one day when he found a bunch of old newspapers in his mother's attic. He was working as a salesman for Eastern Color Printing, a successful company that used all the latest equipment to print many copies of the Sunday comics for newspapers across America. The more he read the comics the more Maxwell Gaines realized other people might like a good laugh as well. So why not reprint them in a handy format not unlike the pulp magazines of the day?

Harry Wildenberg was very keen on the idea of producing comic strip reprints as big company promotions. He discovered he could give more for the advertisers' buck by folding a standard Sunday newspaper comic in two, thus doubling the pages. He went to Gulf Oil who bought the comic to give away as an advertising premium at its gas stations.

Below Famous Funnies issues no. 3 and 13. First published in 1933, it was the first comic to be sold through newsstands as an item in itself rather than as a promotional tool.

Famous Funnies © 1934 (left) and 1935 (right) Eastern Color Printing Co.

ENTS

)стов

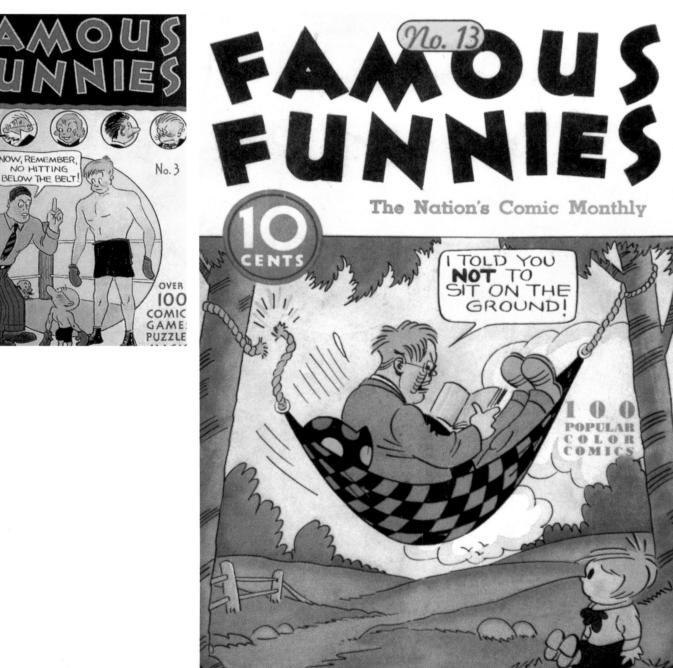

Naturally it was a successful promotion, but Wildenberg, Gaines, and Janosik thought they could do better by reducing the comics' size even further. Wildenberg found that by folding the tabloid comic in two he quadrupled the pages of the original newspaper Sunday funnies. This size, with some minor alterations, evolved to become the standard comic book that would shortly take America by storm. With 64 pages (68 counting the covers) full of different newspaper Sunday comics in color, Eastern Color had a very marketable commodity on its hands. Gaines soon sold other advertisers the idea of using comics as premiums, and clients ranged from Proctor & Gamble to Kinney Shoes. While newspaper reprint comics did well as advertising premiums, the companies involved seldom made regular orders. They might order a print run of a 100,000 or so, some going to one million copies, but once the promotion was over, the advertisers moved on to something new, something different, to keep the customers' interest in the product. Realizing this, Gaines suggested selling the comics to newsstands. With Gaines's ten-cent price on the comics, Wildenberg approached the American News Company and managed to persuade the doubtful distributor to try hawking the comics to newsstands across the nation. Wildenberg called the comic *Famous Funnies*...and history was made that day in 1933.

Below More Famous Funnies. On the cover of its sixth issue it adopted the strap line "The Nation's Comic Monthly" – by this time they were selling 350,000 copies each issue. Alongside the humorous favorites, Buck Rogers and his space adventures soon became the comic's most popular strip. Famous Funnies © 1936 (left) and 1940 (right) Eastern Color Printing Co.

Below Jiggs, the despair of his aspirational wife and daughter in George McManus's classic strip *Bringing Up Father*. It was one of a host of popular newspaper strips reprinted between cardboard covers starting in 1916 with the Cupples and Leon publishing house. Comic strips already had a considerable history. They actually began with Richard F. Outcault's classic and revered creation, The Yellow Kid, in 1896. First appearing in Joseph Pulitzer's *New York World*, then shortly after in William Randolph Hearst's *The New York Journal*, the Yellow Kid's main claim to fame was his bright yellow nightshirt, which the newspapers gleefully printed in yellow. This was a leap forward in newspaper printing techniques; they were able to print in four colors for the first time. *The Yellow Kid* was street-wise and decidedly irreverent; gossipy, muckraking scandals and sensational crime stories were soon described as "Yellow Journalism."

In the early years of the twentieth century, several

characters that eventually became household names made their appearance in the country's newspapers. Rudolph Dirks's Katzenjammer Kids, Bud Fisher's Mutt & Jeff, Windsor McKay's famous Little Nemo and George McManus's lovable Bringing Up Father became so popular that they ran for decades. Little Nemo, now regarded by historians as perhaps the best of the early strips, didn't last as long as the others but was reprinted in book form in 1909.

Perhaps the most famous precursor to proper comic books was a publisher called Cupples and Leon. Victor Cupples and Arthur Leon founded their publishing house in 1902. The partners saw there was money to be made from reprinting newspaper comics and were responsible for Little Nemo

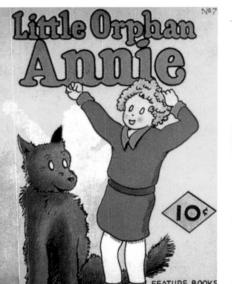

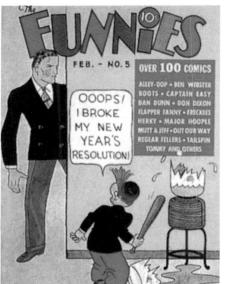

books and another popular character, Buster Brown.

In 1916 Cupples and Leon embarked on a series of black-and-white reprint books starting with *Mutt* & Jeff. Later, Bringing Up Father and The Gumps were added to Cupples and Leon's list. The books generally had black and red colored cardboard covers, measured 9^{1/2} inches square, were 48 pages long, and cost 25 cents each. A later series of hardcover books, reprinting the adventures of Little Orphan Annie and other popular newspaper strips, had full color covers and dust jackets, was a smaller format (7^{1/4} inches wide and 8^{1/2} inches long) and longer (92 pages). This series cost 60 cents each and continued until 1934 when Cupples and Leon quit the comics to concentrate on their growing line of children's books.

Eastern Color pioneered the type of comic book that came to be known from 1933 onward. Their Famous Funnies set a precedent others were soon to follow. Sales were around 350,000 an issue, good enough to make any publisher happy. By 1935 Famous Funnies found it had major competition in the form of Popular Comics, The Comics and The Funnies. All three titles followed the same format as Famous Funnies and came from Dell Publishing, who already had the license to publish all Walt Disney characters including Mickey Mouse and Donald Duck. Among Popular Comics' reprint strips were Don Winslow, Terry & the Pirates, Ripley's Believe it or Not, and Little Orphan Annie. Although the three comics were Dell publications, the comics they were packaged at McClure Syndicate's offices by none other than Maxwell Gaines.

Surely he was over at Eastern Color? Not any more! After the success of *Famous Funnies*, Eastern inexplicably fired Gaines, without even a thank you.

15

Gaines was unceremoniously dumped to join the millions still out of work in mid-thirties America. But he did not remain out of work for very long. He was offered a position with the McClure Syndicate where he utilized its printing presses to produce *Popular Comics, The Funnies,* and *The Comics.* With a heavy workload, Gaines needed an editor for *Popular Comics,* so he hired a teenager named Sheldon Mayer. Initially the young Sheldon did paste-up work in the McClure studios before becoming editor of *Popular Comics.* Editing one comic book was work enough, but soon Sheldon Mayer was editing all three of the comics around was using original stories and art. Reprint material was

Below Sheldon Mayer (centre), with colleagues William Moulton and Harry G. Peter, presents a cover rough to the great Maxwell Gaines (far right). very popular and, at only five dollars a page, reprint rights were relatively cheap. Mayer, like his rivals, used two-page written fillers for which he did the one or two little illustrations that the fillers required. This brand new medium was barely two years old and nobody had thought about commissioning original strips, except for one newcomer to the scene. Enter the dapper 45-year-old Major Malcolm Wheeler-Nicholson, a former cavalry officer, adventurer, traveler, writer of fiction, and entrepeneur.

With a name that evoked an upper-class British officer playing tennis and sipping gin slings in colonial India, Wheeler-Nicholson might have encouraged that opinion with his very military bearing and neat dress. "I was born in the South and

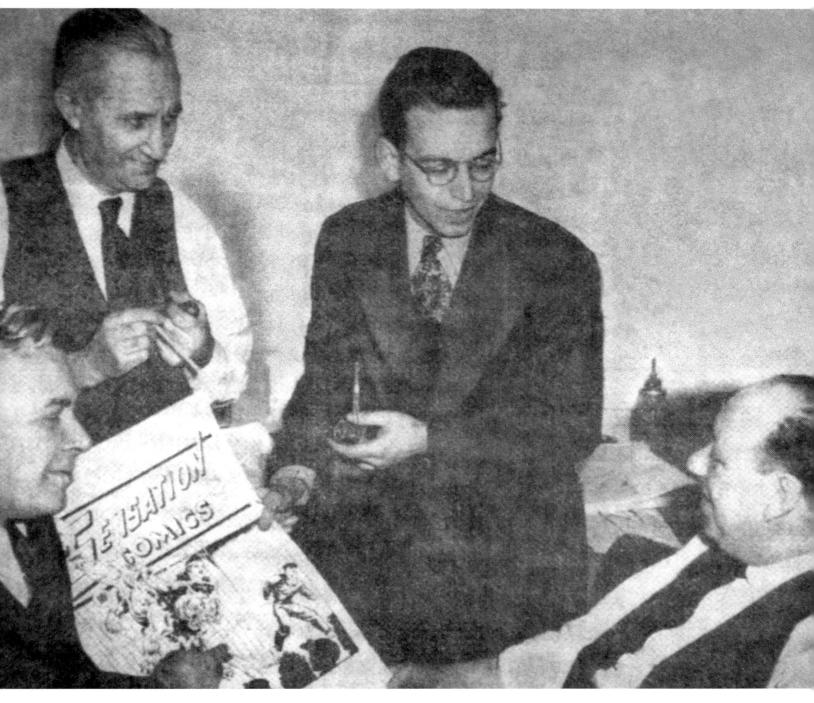

raised on a Western ranch," he once said. After a stint as a cub newspaper reporter, Wheeler-Nicholson joined the U.S. cavalry as a second-lieutenant, rising to the rank of major by the time he left the army. He fought Mexican bandits on the border, commanded an infantry battalion fighting the Bolsheviks in Siberia, helped the French re-organize their army after World War I, and was commanding officer at cavalry headquarters on the Rhine. Nicholson blotted his copybook when he accused senior military officers of Prussianism and complained to President Harding about the matter. He had violated the Articles of War, and was court-martialed and dismissed from the army in 1922. It was to take a further two years of court battles before the issue was finally resolved.

Already a dab hand at banging out articles on military matters, Nicholson turned to writing fiction for the phenomenally successful pulp magazine market. Street & Smith publishing company hired him to ghost adventure stories for famous air hero Bill Barnes, but after writing six novels about Barnes's derring-do, Nicholson was fired by the editors for not doing the job to their satisfaction. Down but by no means out, Nicholson was back a few months later running his own publishing company called National Allied Magazines.

By the time Wheeler-Nicholson came on the scene and tried to acquire rights to reprint newspaper comic strips, he found that everybody else had Left *Popular Comics*, edited by Sheldon Mayer, featured Little Orphan Annie, Dick Tracy, The Gumps and Terry and the Pirates. *Popular Comics* © 1937 Dell Publishing Co.

Below Enigmatic comic book entrepreneur Major Malcolm Wheeler-Nicholson.

17

already jumped on the bandwagon. It was at this point Wheeler-Nicholson made history. He produced a comic appropriately titled *New Fun – The Big Comic Magazine*, so-called because it was larger than the other comics, measuring 10 by 15 inches. Only the cover of this 32-page comic was in color; the rest of *New Fun* was black and white. Not only was the size different, so were the strips. They were all original, featuring all new characters specially drawn for *New Fun*. There was Sandra of the Secret Service, Buckskin Jim, and Barry O' Neill, a pipesmoking detective pitted against a sinister oriental named Fang Gow. These were just some of the onepage stories *New Fun* featured in its early issues.

Below Wheeler-Nicholson pioneered the idea of all new, specially drawn comic strips. His ground-breaking *New Fun Comics* was renamed *More Fun Comics by issue No.7. More Fun Comics* © 1938 D.C. Comics, Inc.

Besides original strips, New Fun was the first

comic to carry advertising. Two of the early advertisers were Charles Atlas and Gem Razor, and Charles Atlas was to become a steady provider in many comic books from 1935 to 1955. *New Fun* also offered text stories, plans for building model planes and boats, and a classic, well-drawn strip by one Charles Flanders. All in all, *New Fun* was a well-rounded comic that followed the pattern of British weeklies, albeit on a larger scale.

The first half-dozen issues of *New Fun* comics suffered from the disadvantage of being tabloid size and in black and white. Sales might have been better had distributors shown more inclination to put *New Fun* and the other comics on the newsstands. Even if the comics made it to the newsstands the owners

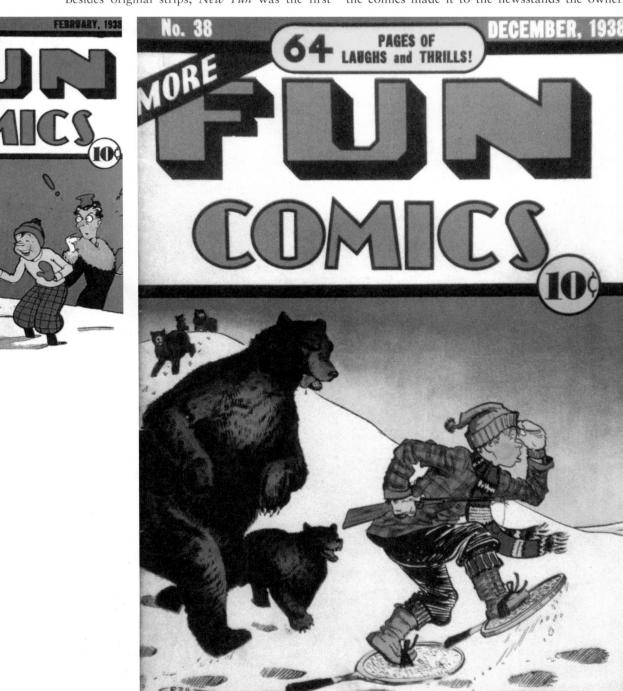

rarely put them in a noticeable position...those precious spaces were commandeered by the top magazines of the day. Often the comics were returned unopened to their publishers. Nicholson was losing money, was unable to pay his artists, and owed his printers. But he persevered and continued to publish *New Fun*, paying when he was able.

By the time it was in its second year, the struggling comic had changed its name to *More Fun Comics*, shrunk in size and acquired color pages. Nicholson's editors were Whitney Ellsworth and Vincent Sullivan, both of whom would become famous in their own right. Ellsworth and Sullivan heavily promoted the new look comic by saying everything in *More Fun* was "Brand New, never before published," and making a virtue out of *More Fun's* larger print size by claiming that "type and lettering are clear and legible...no eyestrain!" Several new artists were taken on including Jerry Siegel and Joe Shuster, two young men barely out of their teens, from Cleveland, Ohio. They wrote and drew a strip called Doctor Occult, a ghost detective who fought supernatural evil in the world. Later, Siegel and Shuster created a second musketeering strip called Henri Duval. Both strips ran together in *More Fun*. As we shall see later, Siegel and Shuster created a legend that has since become an American institution and a part of New World culture.

Even with the array of talented artists and writers working for *More Fun* and a second title, *New* Below A rare 1930s Dick Tracy newspaper comic strip that shows the eponymous hero without his trademark hat on. Tracy, drawn by Chester Gould, was a mainstay of several early comics including Dell's *Popular Comics.*

19

Right A panel from Bud Fisher's Mutt & Jeff syndicated newspaper strip, (1926). Mutt is the original shark-on-themake, while the diminutive Jeff plays his idiot, innocent foil. They were soon regularly syndicated in *The Funnies* too and had their own comic published by D.C. in 1939 which ran for decades.

Comics, the major was sinking further into a financial hole. Still he persisted, and with the help of his imaginative editors, brought in new innovations such as extending stories from the accepted single page to four, six, even eight pages, thus allowing complete stories in every issue. *New Comics* was a unique blend of text, movie, radio, and book review columns with comic strips ranging from adventure (Federal Men, by Siegel & Shuster), to humor (J. Worthington Blimp Esq.). The first issue of *New Comics* was given 80 pages and was printed mostly in color, though to save money several pages were black and white. The new comic's size was much closer to the standard format than *More Comics*, which had remained tabloid size.

Financial worries notwithstanding, the debonair major soldiered on, determined to make a success of his comics. Artists and writers were seldom paid for their work but continued delivering the stories and artwork. Most found it quite easy to forgive the major because of his huge charm. He even managed to charm his printers into letting him have additional credit because he believed everything would eventually work out in his favor.

By the end of 1936 there were ten different comic books put out by seven publishers. George Delacorte of Dell Publishing Company, under the guidance of Maxwell Gaines, published *The Funnies*, the first issue coming out in October of that year. In February 1936 Dell had launched *Popular Comics* and both titles featured reprinted strips from the Sunday newspapers. Gaines managed to obtain the best strips, such as Terry and the Pirates, Alley Oop, Moon Mullins, Dick Tracy, Little Orphan Annie, and Mutt & Jeff. Dell would eventually become the world's biggest comic book publisher.

David McKay, owner of the small McKay publishing house, worked an extremely good deal with the Hearst syndicate to reprint King Features Syndicate's strips in a title called *King Comics*, which had Flash Gordon and Popeye, two of the most popular strips ever conceived. *King Comics* first appeared in April 1936 and was edited by Ruth Plumly Thompson. This lady was L. Frank Baum's successor as the writer of the Oz books he had begun with the classic *Wizard of Oz*.

In the same month, King Features' biggest rival, United Features Syndicate, launched *Tip Top Comics*, which had Tarzan and Al Capp's Li'l Abner for starters. Lev Gleason edited *Tip Top Comics* and eventually started his own comic publishing company. Then along came the Comic Magazine Company Inc. who issued *The Comics Magazine* in May 1936. By the second issue *The Comics Magazine* had changed to *The Comic Magazine Funny Pages*, then in November 1936 to just *The Funny Pages*. At the same time this publisher also brought out the first anthology comic, called *Detective Picture Stories*, featuring nothing but detectives, and also a horror comic called *Funny Picture Stories*.

More new comic book publishers, with the funds to print, publish, and pay their way, appeared in 1937. Poor Wheeler-Nicholson, with good ideas but little business sense, was virtually bankrupt. By now he had lost Siegel and Shuster to The Comic Magazine Company, whose comics, unsurprisingly, were a Left Comics on Parade and Tip Top Comics were both United Features comics and featured firm newspaper favorites such as Tarzan, Captain and the Kids and Li'l Abner. Comics On Parade © 1939 and Tip Top Comics © 1939 United Features Syndicate.

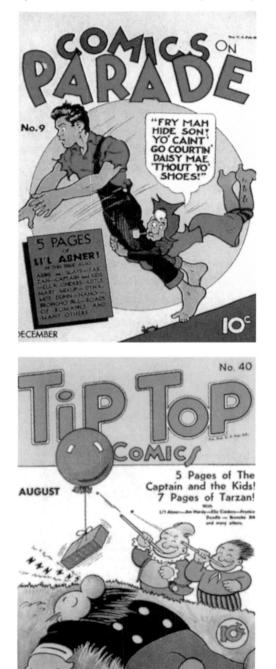

copycat version of Wheeler-Nicholson's. The company was founded by John Mahon and William Cook, who were business manager and managing editor of Nicholson's comics before they defected, taking many of his artists with them. At least the artists were paid...

Siegel and Shuster renamed their Dr. Occult character Dr. Mystic for *The Comics Magazine* and gave him super-powers along the way. Dr. Mystic became the first superhero in comics but he was nothing compared to what was blowing in the wind. There were only a few months more to go before the hero to end all heroes hit the newsstands.

Though Nicholson was getting desperate – he was penniless and living in one of his artist's homes – his debonair personality was undiminished. He carried a cane, used a cigarette holder, and bowed when he shook hands, according to one of his artists, Craig Flessel, who became famous as a comic book illustrator. Another famous artist, the late Bob Kane, who was to become known the world over for his Batman creation, remembered Nicholson well enough to know that the work he did for him was never paid for. "At one point Nicholson had the jump on me for seven months worth of art. When I finally lost my cool, I threatened him with a lawsuit for the approximately \$1200 he owed me. He capitulated and promised to have the check the following day." In an interview published in *Comic Book Marketplace*, Kane said he got up early next morning, excited in

Below A Katzenjammer Kids strip taken from the *Los Angeles Examiner* circa 1919. The Kids, created by Rudolph Dirks in 1897 and still being published is America's longestrunning comic strip.

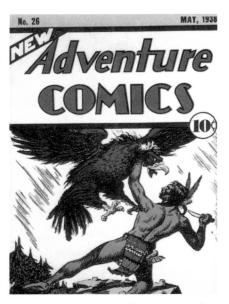

Left The May 1938 issue of Wheeler-Nicolson's *New Adventure Comics*. In addition to the high adventure stories, the comic featured early superheroes such as The Sandman and The Hour-Man. *New Adventure Comics* © 1938 D.C. Comics, Inc.

anticipation of finally being paid. He arrived at Nicholson's office and there was nobody, least of all, Nicholson, there.

Enter now a principal character who would shortly be playing a major role in the comic kingdom. This was Harry Donenfeld, who owned a printing company. Donenfeld printed the covers for Nicholson's More Fun Comics and New Comics (the latter had a name change to New Adventure Comics with issue 12, January 1937). Consequently Nicholson owed him a large sum of money. Never anything but an optimist, the suave major had decided to launch yet another comic. Featuring a racial stereotype Chinese villain on the cover of the first issue, Detective Comics was dated March 1937. The first issue was very striking, with title lettering printed in yellow against a very red background. When the cash-strapped major, who still owed Donenfeld a lot of money, went to him, cap in hand, Donenfeld became actively involved as a partner to Nicholson. Donenfeld knew a good thing when he saw one and Detective Comics was right on line.

Harry Donenfeld's publishing background went back possibly to 1926. Pulp fiction magazines dealing in science fiction, detective, horror...and sex...were all the rage in the twenties, many selling a million copies per issue. *Black Mask*, which first appeared in 1920 and showcased the detective tales of Raymond Chandler and Dashiell Hammett, was a big seller. So were *Amazing Stories* (sci-fi) and *Weird Tales*, a horror title that helped launch Ray Bradbury on his way to fame and fortune. In a way, the pulp fiction magazines were the precursors of the comic books, albeit aimed at an older audience. During the pulp boom of the late twenties, a somewhat complicated, and sleazy, record of Donenfeld's affairs emerged. On 10 August 1929 Harry, his wife Gussie, and close associate, Jack Liebowitz, began the Merwil Publishing Company Inc. Liebowitz was Donenfeld's friend, business manager, and accountant. Donenfeld had a printing company called Donny Press that printed the sexy covers for girlie magazines. Harry's brother Irving was also in the publishing business. His Irwin Publishing Company produced girlie titles like La Paree and Hot Stories. Irving's publishing house was at the same address as brother Harry's: 143 W. 20th Street, New York. Merwil's and Irwin's editor was one and the same, a Mrs. Merle W. Hersey. To make things truly muddled, a company called Elmo Press was publishing a sleaze magazine called, appropriately, Juicy Tales. It was published from the same address.

Donenfeld eventually became associated with Frank Armer, who ran a publishing house called Ramer Reviews which published nude photographs under the title *Artists and Models Magazine*, socalled because it gave the air of being artistic rather than sexy...which it was! When Amer's line of western, sci-fi, and adventure pulps suddenly collapsed Ramer Reviews introduced *Spicy Stories*, complete with lurid covers of girls clad in stockings and underwear generally at the mercy of orientals, hooded villains, and so on. Naturally it sold enough to encourage Ramer to launch *Broadway Nights*, *Frolics, Ginger Stories*, and *Wow* magazines.

In 1929, the Stock Market Crash, caused by lack of regulation and human greed, brought about the virtual end of the pulp publishing market...25 cents was far better used on food for the table than frivolities. Magazines with huge circulations died, the publishing houses going with them to the bankruptcy graveyard. Two companies that were Right Issue one of *Detective Comics*, March 1937, the highly influential violent, all-action collaboration between Wheeler-Nicholson and Harry Donenfeld. *Detective Comics* © 1937 D.C. Comics, Inc.

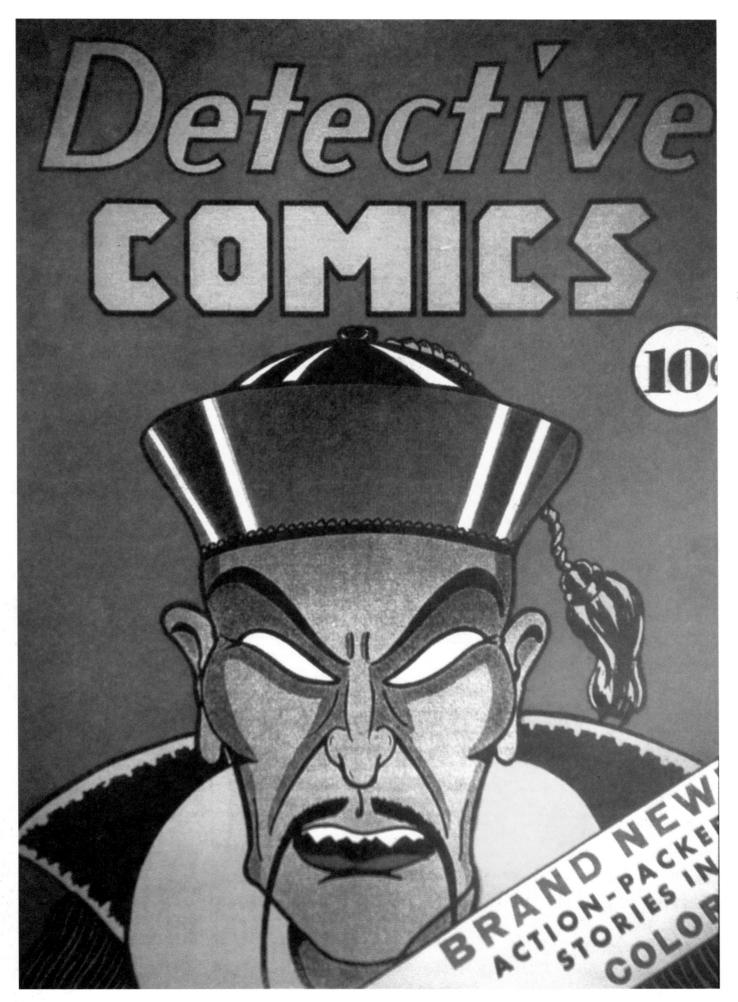

part of Ramer's publishing empire, Marvel and Follywood, went bust, leaving Donenfeld to pick up *Spicy Stories* and another title, *Pep*, from Ramer. Donenfeld probably took the titles in lieu of payment for printing covers for Ramer Reviews; this was common practice because so few had any money in those wretched days.

Donenfeld, always with an eye to main chance, built himself a thriving little empire when many others were going to the wall. Soon he obtained *La Paree*, *Broadway Follies*, *Bedtime Stories*, and *Artists and Models*, the latter published under the mischievous banner, Culture Publications.

Late in 1933 Harry and Irving Donenfeld began yet another publishing company, called Super Maga-

zines Inc. It published two pulp titles in 1934, Super Detective Stories and, later in the year, Super Love Stories, the latter not lasting more than four or five issues. Frank Armer was employed by the Donenfelds to run the company. In July 1935 Detective Stories came to a temporary end, probably because Armer and Donenfeld guessed that the way to big bucks was to include lashings of sex in adventure magazines. Yet another publisher, this time Modern Magazines, became the banner for Spicy Detective Stories (the hyphen was added so that the publishers of the clean-living "Adventure" magazine wouldn't sue them).

The *Spicy* titles were red hot. They sold quicker

Below Detective Dan, 1933, an early comic book take on the popular crime genre.

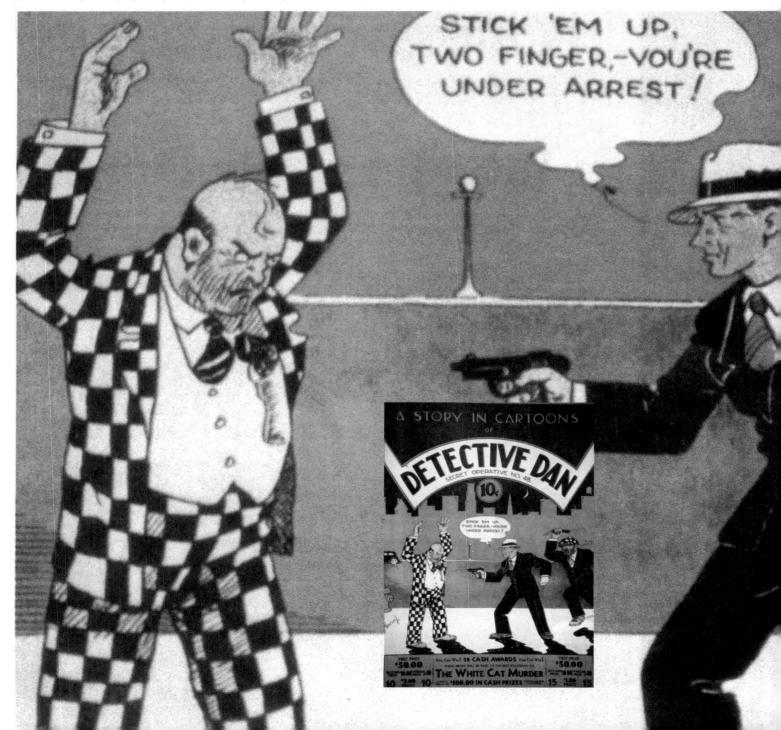

25

York Society for the Suppression of Vice was causing problems. The New York Licensing Commission had already banned the sale of Donenfeld's *Gay Parisienne, Pep*, and *La Paree* on the streets of New York. Not that Donenfeld worried too much; his more erotic magazines were selling like hot cakes everywhere else. But this wasn't good enough for the New York Society for the Suppression of Vice. It charged that the above magazines were obscene, following the discovery of an issue of *Pep* featuring full frontal nude photographs of a woman. Donenfeld persuaded *Pep's* editor, Herbert M. Seigel, to take the rap. He went to prison, but was rewarded with a

than the newsstands could get them. But an

organization which went under the name of the New

Right Detective Story Magazine and Amazing Detective Cases, two of the huge array of pulp magazines. Precursors of the comic book, they had initially flourished in the 1920s before being largely superceded by the comic book format. job for life once he came out after a few months.

Donenfeld was more careful after that. He gave his various publications, the ones with risqué material anyway, a Wilmington, Delaware address which was really a postal box. But his *Spicy* magazines revolutionized the pulp industry which once had frowned upon them. Now they were all following Donenfeld and Armer's lead. Even top class pulps began to introduce scantily-clad women in some of their stories. For a while sex and sadism were popular, with near-nude females being whipped, strangled, or beheaded. The fad did not last too long, probably due to public complaints and more conscientious editors.

Donenfeld added yet another string to his ever-

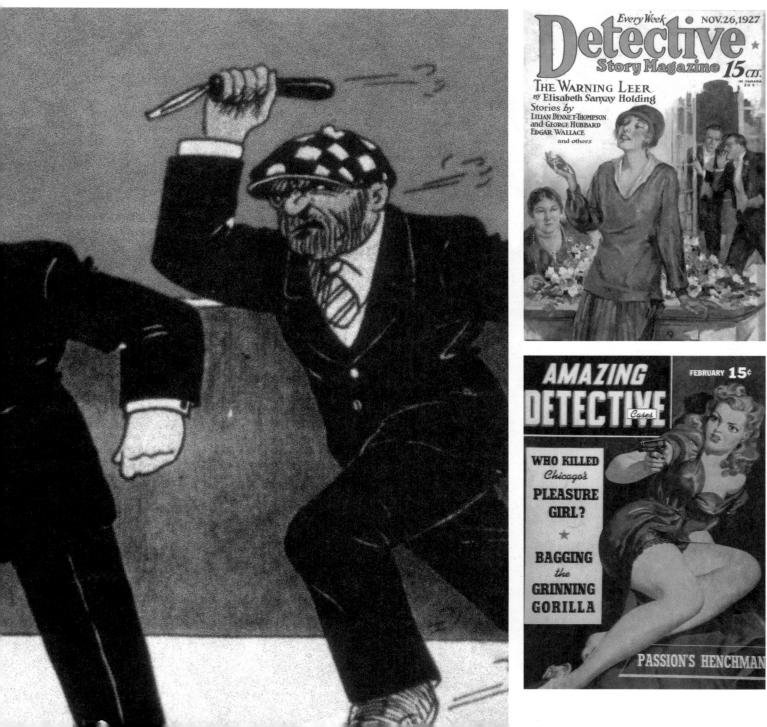

expanding bow: a distribution company. The Independent News Company came about after Eastern Distributors, run by Paul Sampliner and Charles Dreyfus, threw in the towel. The Donenfeld brothers relied on Eastern for their distribution; when it disappeared in 1934 they found themselves in debt to the tune of over \$27,000. So Donenfeld, his trusty accountant Jack Liebowitz, and Paul Sampliner joined together to form Independent. Nicholson also owed Independent money from advances given him by Donenfeld. Nicholson went to Donenfeld and offered him a partnership in his comics line and Donenfeld accepted immediately. Though later than Wheeler-Nicholson originally intended, *Detective* was launched, cover-dated March 1937. Yet another new company, Detective Comics Inc., was started to publish *Detective Comics*. Vincent Sullivan, who had been with Wheeler-Nicholson's shaky publishing house from almost the start, was the editor, and he is said to have drawn the oriental villain on *Detective Comics*' first issue. Sullivan eventually left what was to become the famous D.C. line of comics and began his own comic publishing company called Magazine Enterprises.

Detective Comics was just that...a detective comic. In the pages of the first few issues was Speed Saunders, a plain-clothes policeman drawn by Craig Flessel, then Fred Guardineer, and scripted by Gardner Fox. All three would become legends for their comic book work. Major Malcolm Wheeler-

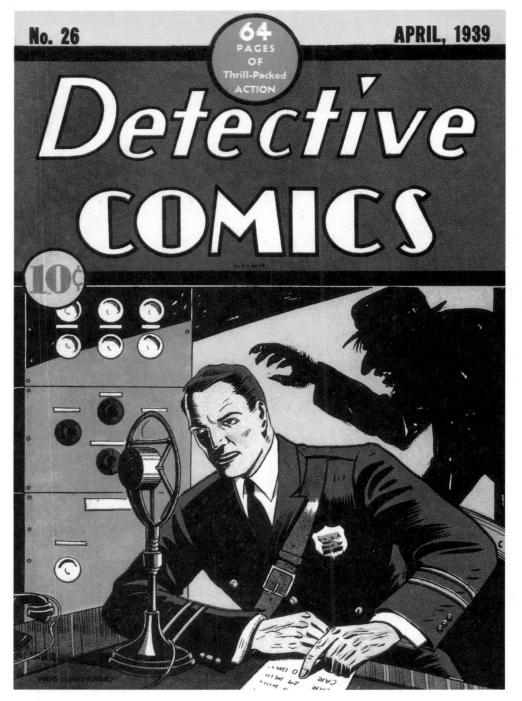

Left Issue no.26 of *Detective Comics.* Initially, it following the crime-fighting ground covered by so many pulp magazines and also favored their taste for sinister Oriental villains, including Sax Rohmer's Fu Manchu in issue no. 18.

26

27

Nicholson, whose initial claim to fame was his undoubted talent as a pulp writer, scripted private detective Brad Nelson, well drawn by Tom Hickey, who modeled himself after Alex Raymond and Milton Caniff. Brad Nelson was extremely violent, as were most of the stories in *Detective Comics*. Other detective types were Cosmo, the Phantom of Disguise, western detective Buck Marshall, and one who would stay around for a considerable time, Slam Bradley. The early issues of *Detective* were notable for their ceaseless action and large helpings of violence.

Although much has been written about Wheeler-Nicholson's ending with comics, most of it has been supposition, and there is little information about what actually happened to him in 1938. Apparently, Donenfeld and Nicholson saw less and less to complement each other on, until a day in 1938 when Nicholson left, probably at Donenfeld's and his accountant, J. Liebowitz's behest. Donenfeld bought Nicholson out. He knew Nicholson's weakness: he had debts and he needed money. Still, nothing can detract from Nicholson's importance to the comics industry. He was the man who created the true comic book with original stories and art.

With Nicholson gone, Donenfeld had what he always wanted: a complete publishing empire doing pulps, sexy magazines, and comics. The latter were beginning to show fruit and would eventually take over. Vincent Sullivan, comic book editor for

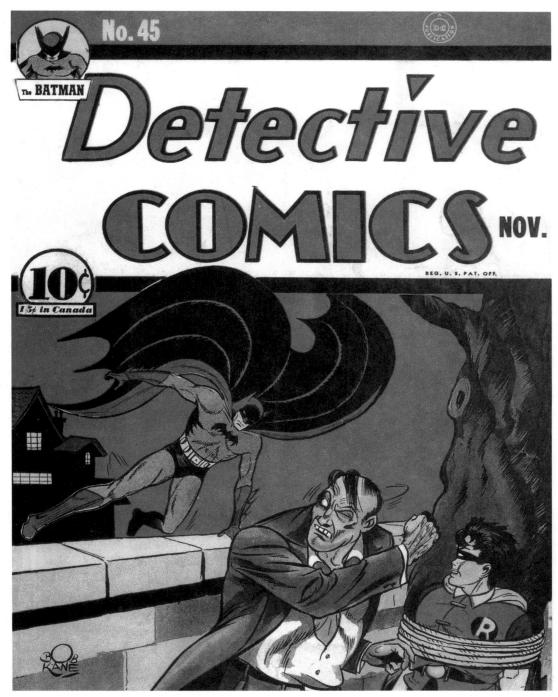

Right Detective Comics' most famous son, billed as "the amazing and unique" Batman, first appeared in issue no.27. He was joined 11 issues later by Robin, the Boy Wonder.

Donenfeld, had been working together with Nicholson to put the finishing touches to *Action Comics*, an adventure comic to complement *Detective Comics*, which was beginning to do quite well. With Nicholson gone and the deadline fast-approaching, Sullivan was desperate to find a lead story.

It was 1938 and Jerry Siegel and Joe Shuster were down in the dumps. In 1933 they had invented a character called Superman. The duo went from publisher to publisher, syndicate to syndicate and nobody wanted Superman. "Ridiculous nonsense," the publishers cried. How wrong they were. Superman was born on the planet Krypton which was about to blow up. The tot's father, Jo-El, put him into a rocket ship and pointed it toward Earth. When the space ship landed the baby was discovered by Mr. and Mrs. Kent, who adopted him. Soon they discovered he had extraordinary powers and did things no earthling could ever do. Christened Clark by the Kents, he was told by his adopted parents to keep his powers a secret and use them only when he had to. When he grew up, Clark bade his parents goodbye and set off for Metropolis (read New York), where he got a job as a reporter on the *Daily Planet*. Being a reporter allowed him access to what was going on in the world and the chance, as Superman, to prevent crimes or calamities.

It goes without saying that Superman had dual identities. Clark portrayed himself as mildmannered, a bit bumbling, and delicate, while his Bottom left Jerry Siegel and Joe Shuster had invented and drawn Superman in an embryonic comic book form (at first he had no costume) as early as 1933, but it was notuntil 1938 that Action Comics had the confidence to try something so different. Top left Action Comics issue no.1, the first apperance of Superman. Action Comics © 1938 D.C. Comics, Inc.

Below Superman from the cover of *Superman* issue no.6. *Superman* © 1940 D.C. Comics, Inc.

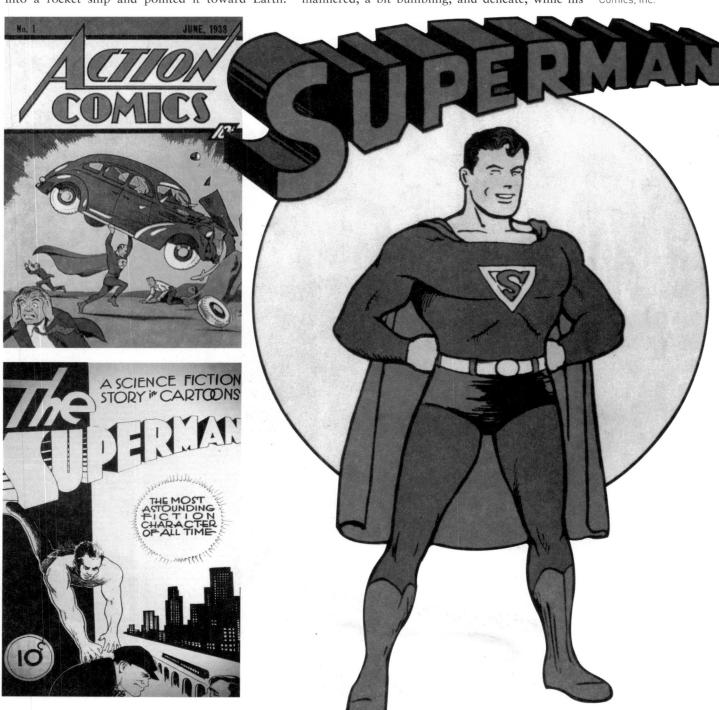

29

alter-ego Superman was the opposite. He was a sensitive intellectual with a physical prowess nobody could master. As Clark he befriended ace reporter, the attractive brunette, Lois Lane, who had little time for his perceived weakness yet adored Superman. And you know the rest....

Downhearted at the years of failure trying to get Superman accepted, Jerry and Joe tried one last avenue. This was the McClure Syndicate, and working there was young Sheldon Mayer who had previously edited *Popular Comics* at Dell. Sheldon Mayer made an appointment to see Siegel and Shuster, whom he remembered from their days drawing Dr. Occult for Wheeler-Nicholson. Inviting them into his office, he looked over the Superman strip and was struck by what he saw. Much later, Mayer explained how he felt about Superman. "I went nuts over the thing," he enthused. "It struck me that it had all the elements that were popular in the movies, all the elements popular in the novels, and all the elements that I loved."

Mayer took the strip to show the powers-that-be at McClure, who looked at it and said no. He tried Maxwell Gaines who wasn't impressed. Once again it looked as though Jerry and Joe were to be disappointed, but Mayer told them to leave it with him for as long as it took for him to find a buyer. "The thing that fascinated me about Superman, the thing that really sold Superman in the first place, is the alterego of the hero as contrasted to the crime fighter

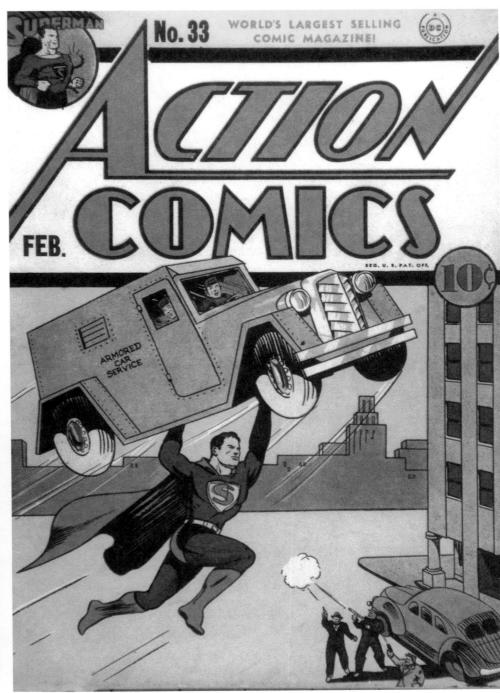

Below Superman struts his stuff in Action Comics. Action Comics © 1941 (right) and 1953 (left) D.C. Comics, Inc.

himself." The persistent Mayer told McClure officials that he knew the Superman character would work. Although he was turned down again and again, he kept bringing it up to Gaines. Eventually Gaines had a long hard look at Superman and realized his assistant was right. The character had much more going for it than he had originally supposed. But he knew Superman was not a newspaper strip and Mayer and he agreed that it should be shown to Vincent Sullivan.

To be at a place at the right time sometimes means the difference between success or failure. Gaines walked into Vince Sullivan's office at precisely the right time. Sullivan was tearing his hair out, desperate for a lead story to meet the fast-approaching deadline for sending the new *Action Comics* to the printer. Pulling the strips from his portfolio, Gaines showed Sullivan Superman. That was it. Vincent liked the character as much as Mayer and he wanted to buy Superman for the first issue.

Siegel and Shuster were immediately contacted and told to come over right away. Sullivan said he wanted the strip altered to fit the comic book format. There was no time to draw it again. "The only solution Jerry and I could come up with was to cut the strips into panels and paste the panels on a sheet the size of a page," remembered Joe Shuster. "If some panels were too long, we would shorten them...cut them off...if they were too short we would extend them."

Below Joe Shuster at work on Superman circa 1938 and more all-action displays of Superman's awesome powers in Action Comics. Action Comics © 1943 (left) and 1953 (below) D.C. Comics, Inc.

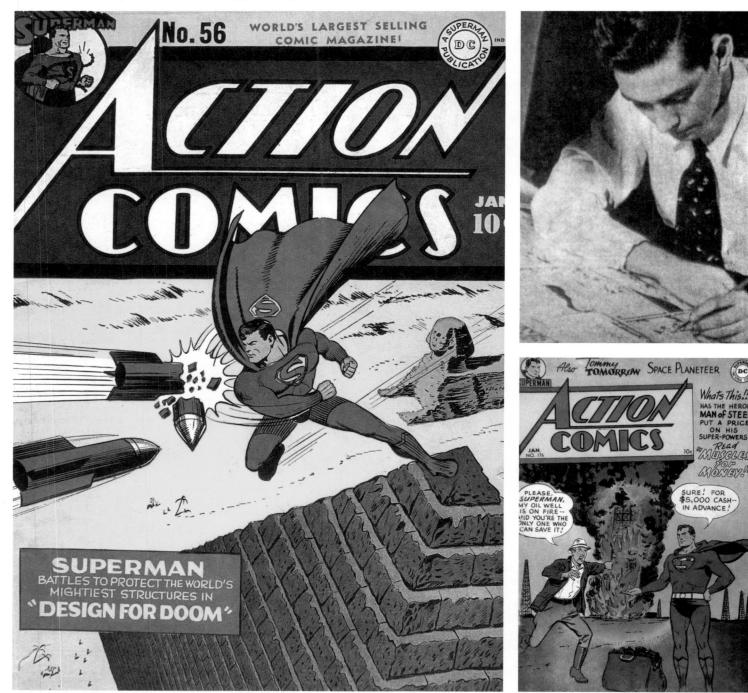

30

The hastily finished, 13-page story was rushed back to Sullivan, along with a cover adapted from one of the panels in the story. It showed Superman clad in blue tights and red cape holding aloft a car and smashing it against a large rock, while a couple of bad guys run for their lives. With a mix of primary colors and an eye-catching red title, there was little doubt that *Action Comics*' cover, dated June 1938, was very striking. When Donenfeld saw it he became alarmed. "He really got worried," Sheldon Mayer said. "He felt nobody would believe it; that it was ridiculous...crazy." How wrong Donenfeld was; by the fourth issue children were clamoring for more. Here was a man after their own hearts, a hero who could destroy Adolf Hitler and his evil henchmen.

Below Superman was the first all-American superhero. His appearance opened the floodgates to dozens of imitators. Superman © 1942 (inset) and Action Comics issue no.1 © 1938 D.C.Comics, Inc. Soon Superman would become an American institution, a definitive force in popular culture. From the day of his first appearance Superman espoused Truth, Justice, and the American Way and marched into history. The Golden Age of comic books had begun....

IAMP DE

Chapter Two

UP, UP, AND AWAY!

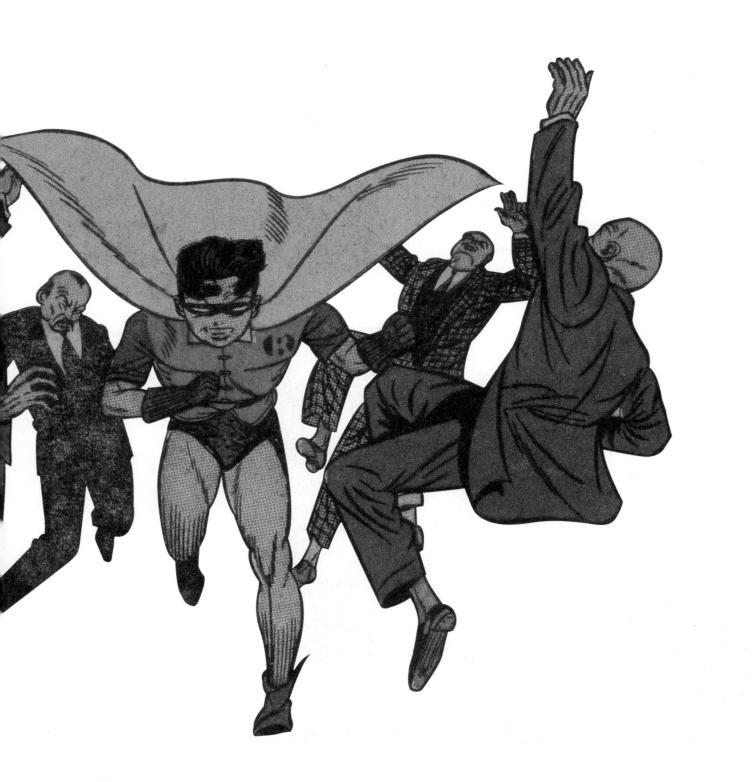

34

By 1937 THE NUMBER OF COMIC BOOK PUBLISHERS HAD increased and between them they issued 20 different titles. The two major publishers were National Comics and its subsidiary publishers such as Detective Comics, and Centaur Publications Inc. Centaur began as the Comics Magazine Company, founded by John Mahon and William Cook, who had defected from the Wheeler-Nicholson camp in 1935. By 1937 Cook and Mahon sold their interests to Ultem Publications; they in turn sold out to a Joseph Hardie, who used Cook and Mahon's three original titles to form Centaur Publications. Soon Centaur was publishing a range of comics, adding seven titles to the three originals in 1938. These were *Amazing Mystery Funnies, Keen Detective Funnies, Little* Giant Detective Funnies, Cowboy Comics, Little Giant Movie Comics, Little Giant Comics, and Star Ranger Funnies. The original artwork for all these titles came from the first comic art shop run by Harry "A" Chesler. (The "A" in Harry "A" Chesler was actually his middle name – Chesler liked the "A" because he thought it looked classy.) He employed artists as cheaply as he could, and packaged stories and art for companies like Centaur.

In fact, Chesler even went into publishing his own comic books. There were two titles: *Star Ranger*, which was the world's first western comic, and *Star Comics*, which was a mix of adventure and humor. Artists included Craig Flessel, Fred Schwab and Henry C. Kiefer. Kiefer eventually drew Wambi the

Left In 1938 *Amazing Mystery Funnies* became one of the new titles in the expanding portfolio of Centaur comics.

Amazing Mystery Funnies © 1938 Centaur Publications. Jungle Boy for Fiction House in its Jungle Comics title, but found fame illustrating many of the Classics Illustrated comics that would do colossal business in the forties and fifties. Ken Fitch wrote many of the stories, staying with comics for many years.

Chesler sold off his two comics after publishing a half-dozen issues of each title. It was Centaur who picked them up and Chesler's art shop continued to supply packaged stories and art. Centaur was benefitting from some excellent new artists such as Jack Cole and Charles Biro, both of whom would eventually make history in the comics. As for *Star Ranger* and *Star Comics*, both lasted for a couple of years before folding at the end of 1939. While America flourished under President Roosevelt's New Deal Administration, which created the Hoover Dam, built roads, and nationalized the Post Office, the situation in Europe and Asia was growing steadily worse. The Japanese were fighting and gaining in China, and Hitler was saber-rattling with a vengeance. Britain, under the premiership of Neville Chamberlain, capitulated to Hitler's every demand. His armies marched and nobody stopped them. Nobody wanted another killing field like World War I so they mistakenly thought appeasement was the right way to handle Hitler. And nobody cared about the thousands being slaughtered in Stalin's Russia. In America, faraway America, an insignificant event occurred: in the May

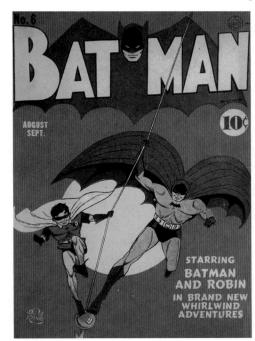

Early issues of Batman's very own comic. Batman had appeared for the first time in the May 1939 issue of *Detective Comics. Batman* © 1941 D.C. Comics, Inc.

Left The Joker, one of Batman's many surreal adversaries.

Below Batman's creator Bob Kane (left) and fellow Batman artist Dick Sprang (right) circa 1941, along with classic examples of their art. Dectective Comics © 1940, Batman © 1944 D.C. Comics, Inc.

1939 issue (No. 27) of *Detective Comics*, Batman appeared for the first time....

Batman was the brainchild of Bob Kane, a young freelance cartoonist from the Bronx in New York, who began as a professional artist drawing Hiram Hick for a short-lived comic entitled *Wow What a Magazine* put out by Henle Publishing. It could be said that Batman was an idea Kane had as far back as 1934. He drew sketches of a gliding man dressed in a bat-winged costume, probably taking inspiration from Leonardo da Vinci's flying machines. Obviously Kane retained the idea of a bat-man in his subconscious until it was awakened by events a few years later.

In 1937 Kane joined Eisner-Iger comic shop, another studio that packaged comic strips, founded by freelance writers and illustrators, Will Eisner and Jerry Iger (see Chapter 3). Here, he drew Peter Pupp, a funny adventure strip for Fiction House's Jumbo Comics. In 1938 he was working for Donenfeld's Adventure Comics doing an adventure strip called Rusty and his Pals. Kane did the artwork while the scripts were written by a Bronx neighbor, Bill Finger, whom Kane had met at a party. Finger suggested that Kane's creation should acquire a cowl with pointed bat ears and mysterious eye slits. Kane remembered being fascinated by a 1926 movie called The Bat in which the villain wore a bat-type costume. Batman saw his parents mugged and killed when he was a little boy, and Kane and Finger felt he should be a dark, vengeful figure of the night, striking terror into hoodlums and gangsters.

Bob Kane said he originally wanted Batman to be cartoony rather than serious, his drawings to emulate Chester Gould's Dick Tracy strip, which he admired. This can be seen in some of the wonder-

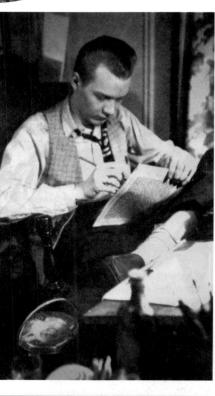

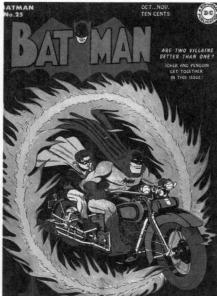

Right Purrfection itself – Catwoman still alive and kicking in a 1990's D.C. comics offering. *Catwoman* © 1993 D.C. Comics, Inc.

Below Batman and Robin do their bit for the war effort on the cover of their June/July 1943 issue. Batman © 1943 D.C. Comics, Inc. fully imaginative villains Kane created for the stories. Like Dick Tracy, Batman's bad guys were the memorable, surreal characters that nighmares are made of. Each character's name fitted his or her personality. Two Face, for instance, had been a handsome, successful lawyer who accidentally fell in a vat of acid. One side of his face was horribly scarred, the other side remained handsome. His personality took on two forms: good and bad. Catwoman purred and was sexy, while the Penguin was short and fat, had a beak-like nose and dressed in a black morning coat, with a top hat and monocle. Both he and the Joker, Batman's other deadly foe, turned crime into an artform using elaborate practical jokes to execute their fiendish plots.

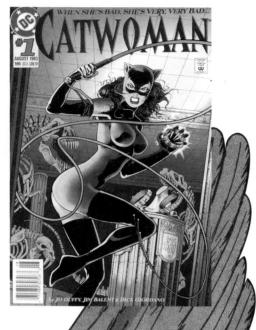

KEEP THE AMERICAN EAGLE FLYING ! BUY WAR BONDS

AND STAMPS !

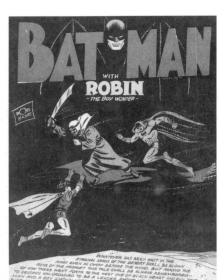

S THE GROUP

SMALL COMPAC

FRAME PLOWS

A HUMAN

BATTERING RAM

ROBIN

THE BOY

WONDER:

Left and below After eleven issues in *Detective Comics*, Batman was given a young sidekick – Robin, the Boy Wonder – who adopted the daring spirit of Robin Hood. © D.C. Comics, Inc.

JUST LIKE IN

AKING YOU OUT!

FOOTBALL!

SO THE BATMAN

THROUGH!

CAN GO

Batman was dark and foreboding in the beginning. He worked by night on his own, searching for the killers of his parents. The Caped Crusader policed Gotham City, helping police chief Commissioner Gordon. By day Batman was wealthy socialite Bruce Wayne who employed an English butler called Alfred who knew Wayne's secret identity. Then, after working for ten issues of Detective Comics on his own. Batman got an assistant: "An exciting new figure whose incredible gymnastic and athletic feats will astound you," the introduction shouted. "A laughing, fighting young daredevil who scoffs at danger like the legendary Robin Hood whose name and spirit he has adopted...Robin the Boy Wonder." This was Dick Grayson, who became a ward of Bruce Wayne's, donned a green, red, and yellow costume and became Batman's loyal companion. Batman and Robin's relationship would cause controversy later on and will be discussed in a later chapter.

With the original Batman concept cleverly drawn, Bob Kane visited *Detective Comics* editor Vincent Sullivan who looked at Kane's strip and said it was "great." Associate publisher Jack Liebowitz thought Batman too sinister for children, too creepy. On the contrary, Batman took off and sales increased greatly when Robin was introduced ten months later. "In my subconscious mind I longed to be like Robin when I was his age." Bob Kane once said. "I figured Robin would appeal to all children of his age group as an identifiable person for their inner fantasies."

Donenfeld had changed the name of his comics publishing company from National Allied to Detective Comics Inc. Nobody at Detective Comics Inc., with the possible exception of Vincent Sullivan, had

39

bargained for the enormous success of Batman and Superman. Every other comic publisher was rushing to the drawing boards to create their own superhero.

In 1938 Centaur Publications was given a sciencefiction costumed hero created by Bill Everett who then worked for Lloyd Jacquet's Funnies Incorporated. Appearing in *Amazing Mystery Funnies*, Skyrocket Steele owed more to Buck Rogers than he did Superman. A month later the Arrow, clothed in a completely concealing red costume that showed no face, debuted in *Funny Pages*. By 1939, Centaur was busily pumping out yet more costumed heroes. Paul Gustavson, also from the Funnies Inc. art shop, had been the man behind the Arrow and created the Fantom of the Fair, complete with a skin-tight black outfit, yellow belt, and red cape. Another hero without a face, it was the job of this clever scientist to protect the 1939 World's Fair from evildoers.

The Masked Marvel appeared in the July 1939 issue of Centaur's *Keen Detective Funnies*. Another Bill Everett creation, this time with help from Centaur editor Lloyd Jacquet, was Amazing Man. Amazing Man appeared in his own comic book entitled *Amazing Man Comics*. Eschewing skin-tight costumes, he wore a plain old double-breasted suit. The Iron Skull, an android who was invulnerable to harm, also appeared in *Amazing Man Comics*. Two others, 12-foot-tall Mighty Man and the tiny 8-inchhigh Minimidget, also slammed and socked their way through *Amazing Man Comics*.

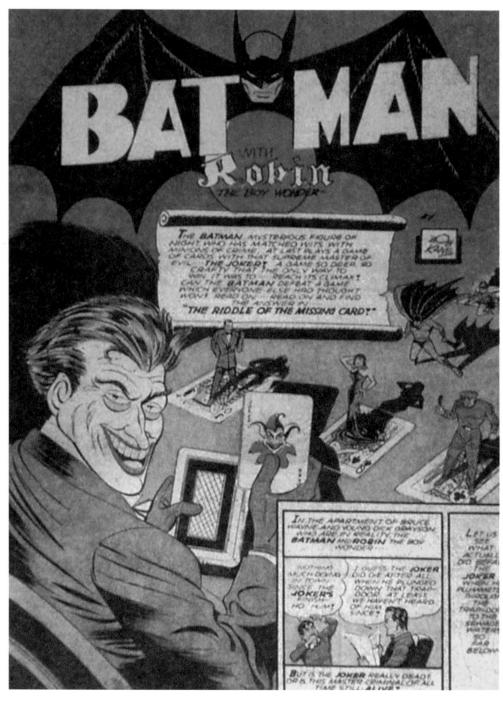

Right Batman and Robin enmeshed within the Joker's warped criminal world in the "Riddle of the Missing Card". © D.C. Comics, Inc.

Former Centaur editor, Lloyd Jacquet, had broken away to form his own comic book publishing company with John Mahon, one-time publisher of the Comics Magazine Company. Jacquet pirated a number of Centaur's talented artists and writers such as Paul Gustavson, Bill Everett, Carl Burgos, Ray Gill, and John Compton, to work for his new publishing company. Unfortunately, finances weren't forthcoming so Funnies Incorporated, became an art packaging studio instead competing with Chesler and Eisner's shops.

This wasn't going to be the easiest job in the world because Chesler and Eisner already supplied four publishers. Fortunately Funnies Incorporated also had an excellent salesman, Frank Torpey, as one of the partners, and he sold the idea of comic books to pulp magazine publisher Martin Goodman. Goodman had begun with pulps in 1932 and followed the trend to science fiction with *Marvel Science Stories* in 1938. Always with an eye on the main chance, Goodman looked at samples of comic books presented to him by Torpey, learned very quickly the economics of publishing comic books, and listened long enough to him to be sold on the idea of publishing comic books, with Torpey's company providing the artists and writers to package them.

Goodman decided to try one to begin with. He asked Funnies Incorporated to package a series of stories for a comic to be called *Marvel Comics*. This

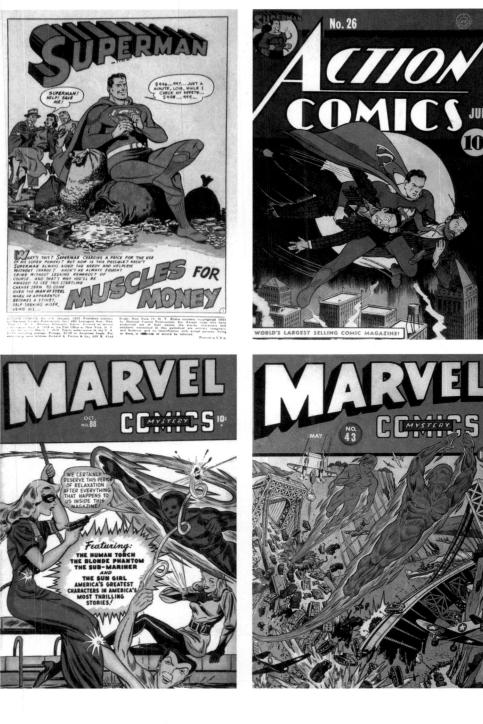

Top Superman was such a success for Action Comics that he was given his own title in the Summer of 1939. Superman © 1953, Action Comics © 1940 D.C. Comics, Inc.

Bottom Martin Goodman had published science fiction pulp magazines and made the leap into comics with *Marvel Comics* – the humble beginning of a vast comic book empire. *Marvel Comics* © 1947 (left) and 1943 (right) Marvel Comics Group.

would be the beginning of a vast and prolific comic book publishing empire that would become Donenfeld's D.C.'s greatest rival. With a contract under his arm, Torpey galloped back to Funnies Inc.'s tworoom offices on New York's West 45th Street where Lloyd Jacquet turned to his three superhero artists and asked them to create new superheroes for *Marvel Comics*. The result was Bill Everett's legendary comic superhero Sub-Mariner, a mystery man from beneath the sea, while Carl Burgos came up with the idea of an artificial being called the Human Torch and Paul Gustavson gave birth to the lesser known Angel.

Meanwhile Superman was going great guns. His popularity in *Action Comics* encouraged D.C. to

publish Superman in his own title as a quarterly comic. Launched for Summer 1939, *Superman* came out just in time to capture the attention of the millions of schoolchildren starting their long summer vacations. Superman had become the hero of the moment, and his creators Siegel and Shuster saw their character become a newspaper strip syndicated by the McClure Syndicate. Ironically, it was McClure who had rejected Superman time and again when Sheldon Mayer pleaded for the strip to be taken on.

Victor Fox came from England. He was an accountant at D.C. Comics and possessed first-hand information about the financial status of the company. By 1939 it was very profitable and Fox

Right A sinister death cult for Victor Fox's new superhero the Flame to deal with. The Flame © Fox Features Syndicate.

WESTCHESTER PUBLIC LIBRARY CHESTERTON, IN

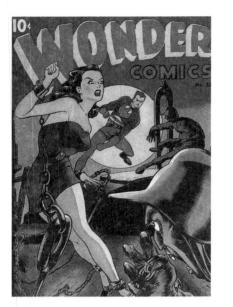

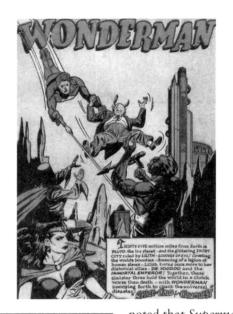

Victor Fox's Wonder Comics, Mystery Men Comics and his superheroes Wonderman and the Flame all tried to muscle in on the territory D.C. had staked out with Superman. Wonder Comics © 1946, Mystery Men Comics © 1940 and The Flame © 1941 Fox Features Syndicate.

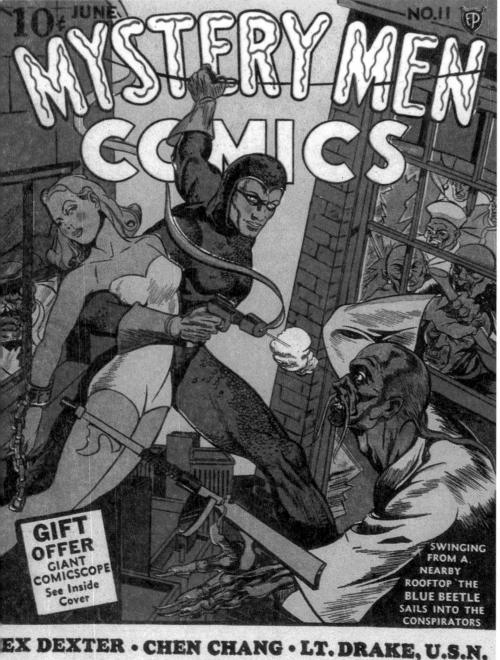

noted that *Superman* was the most profitable of all. He decided that he wanted a piece of this superhero action and the only way to get it would be to become a comic book publisher himself. Legend has it that Fox said to Jerry Iger of the Iger-Eisner studio "Look. I want another Superman." No sooner was it was said than the deed was done. Eisner created Wonder Man, complete with a skin-tight red suit, cape and a big "W" on his chest.

Fox's Wonder Comics, published in the same building as Superman and Batman, went on sale with a cover dated May 1939. Donenfeld, whose company owned Superman outright, was enraged. He called D.C.'s lawyers and sued Victor Fox and his new publishing company, Fox Features Syndicate, for infringement of copyright and plagiarism of the Superman character. Fox saw he didn't have a leg to stand on and dropped a very short-lived Wonder Man, even though he continued fighting the lawsuit, probably just to be a nuisance. It is said that Fox grew to hate D.C. and every time he passed its doors he issued expletives and gave the company the onefingered salute.

But Victor Fox would not be put down. Returning to Iger and Eisner he asked for more superheroes (although not so similar to Superman as the ill-fated Wonder Man) for another comic, to be called *Mystery Men Comics*. Wonder Comics became Wonderworld Comics with issue No. 3 (July 1939) and featured a new superhero, the Flame, devised by Eisner and artist Lou Fine. Clad in red mask, cape, boots, and a yellow costume, the Flame would ignite, burn through buildings, and embroil miscreants in fiery mayhem. Beautifully drawn by Fine, the Flame remained with Wonderworld Comics until its end in early 1942.

Of all Fox's superheroes, only one lasted any length of time. This was the Blue Beetle. He was born alongside the Green Mask, both characters appearing in Mystery Men Comics. In the beginning Green Mask had a distinctive costume but no superpowers. One day, according to a Green Mask story, "Michael Selby was placed in a vita-ray machine, discovers that the supercharged shocks have made him a miracle man. He can zoom through the air and perform super-human feats." As for the Blue Beetle, he had super-powers from the beginning, all obtained through dieting. His energy was acquired through vitamins called 2X that were only available to Blue Beetle. He also wore a little black mask and a chain mail suit that made him almost impervious to harm.

THE YANK

THE REBEL

40

FLAM

Blue Beetle realized Victor Fox's ambition to have a popular superhero, and at least one that he couldn't be taken to court over. By winter 1939, the Blue Beetle was popular enough to warrant his own comic, a newspaper strip drawn by Jack Kirby, albeit short-lived, and a radio show. He also became one of the longest-running superheroes of the Golden Age, lasting into the sixties.

Everett M. Arnold (nicknamed "Busy" in school because he wouldn't stop talking) became a very successful comic book publisher, claiming some of the very best characters ever to grace a comic page. Quality Comics' more memorable creations included Plastic Man, Doll Man, Blackhawk, and Torchy. They were drawn by talented artists such as Lou Fine, Reed Crandall, the surreal Jack Cole, and pin-up artist, Bill Ward.

Arnold began his career selling color printing presses to newspaper syndicates who needed them to print their Sunday funnies. This led to him becoming

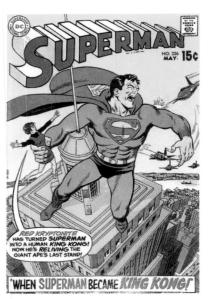

vice-president of the Greater Buffalo Press, who printed many of the Sunday comic sections for newspapers across America. By 1936 Arnold was printing Mahon and Cook's Comic Magazine Company comic books. Noticing how well comics like *Famous Funnies* were doing, "Busy" began Comic Favorites Inc. and published *Feature Funnies*. It was another comic filled with newspaper reprint material such as Joe Palooka and Dixie Dugan. The comic also featured some original strips like Eisner's Hawks of the Sea, while George Brenner provided a masked detective titled The Clock.

When the Eisner-Iger art shop was formed, Arnold was there, negotiating for artists to draw his comics. His second comic, *Smash Comics*, came out in August 1939 and *Feature Funnies* was retitled *Feature Comics* (June 1939). Both comics had original stories and art done by some of the best in the field. Lou Fine was drawing Will Eisner's creation, the diminutive Doll Man for *Feature Comics* and later The Ray for *Smash Comics* (from the fourteenth issue onward). Not for nothing did Arnold call his publishing company the Quality Comics Group. And true to the company title, his comics got progressively better.

Superman hadn't been called in yet to help fight the war that started in Europe in September 1939; instead he was being introduced to British readers through the pages of *New Triumph*, a weekly comic magazine 24 pages long and measuring 9 by 12 inches. Although the stories were reprints of the originals, the covers of *New Triumph*, showing Superman repeating many of the same feats of strength Shuster drew for *Action Comics*, were rendered by famous British cartoonist John McCail. McCail's interpretation of Superman was actually

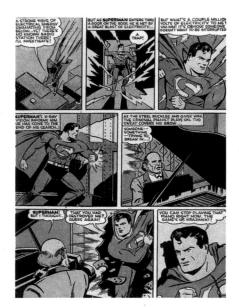

quite good, though sometimes the Shuster splash panels beginning the stories were replaced by a rather crude British drawing. Why, nobody really knows.

At home Superman had become the biggest phenomenon in comics history. Siegel and Shuster's years of persistence had paid off - though not necessarily for them. Detective Comics Inc. paid them \$130 for their first Superman story and they were told it was "normal" to sell all their rights in the character to the publisher...who was Donenfeld, of course. Still, the young men had more work than they could handle as Superman's popularity zoomed into the stratosphere, and soon they had to hire in other artists, among them Wayne Boring. Boring, who became the quintessential Superman artist later on, recalled once how small Siegel and Shuster's studio was. He was working on Superman when some reporters and photographers from Saturday Evening Post came to interview Siegel and Shuster. Seeing the crowded conditions, one of the reporters came over and asked Boring to leave the studio because they needed the room!

Two brothers, Leon and Alfred Harvey, began Harvey Comics in 1939 with *Speed Comics* and *Champion Comics*. M.L.J. Magazines joined the fray before the end of 1939; the initials stand for the first names of Morris Coyne, Louis Silberkleit, and John Goldwater, the founders of the company. Their first two titles were *Top-Notch Comics* and *Blue Ribbon Comics*. M.L.J.'s adventure, and eventually superhero, comics were full of violence and color, contributing a couple of superheroes who stood out from the crowd. But the publisher's main claim to fame was a freckle-faced teenager called Archie, about whom there will be more later on. Left Superman foils pianist master criminal Krazinski. Far Left Red Kryptonite turns Superman into King Kong. Superman became so popular D.C. had to hire in other artists to assist Siegel and Shuster, including Wayne Boring, who would eventually be the quintessential Superman artist. Superman © D.C. Comics, Inc.

Right Smash Comics, first issued in August 1939, was drawn by the Eisner-Iger studio and featured such superheroes as the Ray and Midnight. Smash Comics © 1948 (top) and 1941 (bottom) Quality Comics Group.

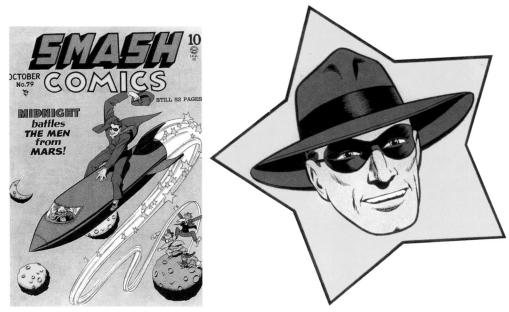

No.26 SEPTEMBER BOZO DORO REAT ction THE RAY ESPIONAGE MIDNIGHT

INGS WENDALL

One of America's best known pulp publishers was Fiction House. The company began in 1921 as the brainchild of two clever young businessmen, Jack Kelly and Jack Glenister, who saw a future in publishing action and adventure stories in a thick magazine format. Pulps had become big business after World War I, stimulated by the demands of returning American troops who had been swayed by European culture and morals. Down home, corn-fed men could no longer be satisfied with the Bible and the local paper; they wanted action and adventure stories and the pulps supplied their needs with gusto.

Kelly and Glenister provided some of the best pulp magazines in those early years with titles like Air Stories, Wings, Black Aces, and others. Later they added Planet Stories and Fight Stories. Eventually Fiction House would turn to comic books, but not until the original company went to the wall in 1932. It was taken over by Fiction House company secretary, T.T. Scott, who revived the pulps and was persuaded to go into the comic book business by the Eisner-Iger studio. The first comic was Jumbo Comics, which appeared in September 1938. In 1939 Fiction House made history with the introduction of Sheena, Queen of the Jungle, in Jumbo Comics. Drawn originally as a British newspaper strip, Sheena was beautiful, buxom, and blonde, wore little and fought an array of African natives, white men, and animals with her trusty knife (see Chapter 5). Sheena was the dream of pubescent youth who gawked at her carefully drawn and generous anatomy...her breasts probably became the first to be nicknamed "headlights" by shyly fascinated and giggling twelve-year-olds.

Meanwhile, in the last couple of months of 1938, Maxwell Gaines, who had virtually invented the comic book, had entered into an agreement with Harry Donenfeld to start his own line of comic books under the title of All-American Comics. Gaines's titles would be published and distributed alongside D.C.'s *Action*, *Detective*, and *Adventure* comics. Faithful to the last, Gaines made the very youthful Sheldon Mayer his editor and the first title, *All American Comics*, had an April 1939 cover date. The book consisted of mostly reprinted newspaper strips, though this would soon be changed. His next title was *Mutt & Jeff*, a reprint comic devoted to the popular strip. Mutt & Jeff were so popular that they occasionally even outsold *Superman*.

New York City held a big trade fair with stands

and entertainment directed at all-comers. Called the New York World Fair, it attracted thousands upon thousands of visitors to the various exhibitions. D.C. editor Vincent Sullivan produced a very thick comic called *New York World's Fair Comic*, which featured Superman, Sandman, and many of D.C.'s costumed characters. Eventually the comic became *World's Best Comics* and lasted just one issue before becoming the long-running *World's Finest Comics* in 1941. Besides Superman, Batman and Robin were given generous space in this 15-cent larger than life comic.

A troubled decade drew to a close. There were no air raid warnings over New York and America, guided by the mistaken notion that distance and Left Planet Stories, an early pulp magazine from Fiction House, which went on to produce Jumbo Comics. Planet Stories © Fiction House.

Below Sheena, Queen of the Jungle, the name that made Jumbo Comics, was originally the star of a British newspaper strip. Jumbo Comics © 1946 Fiction House.

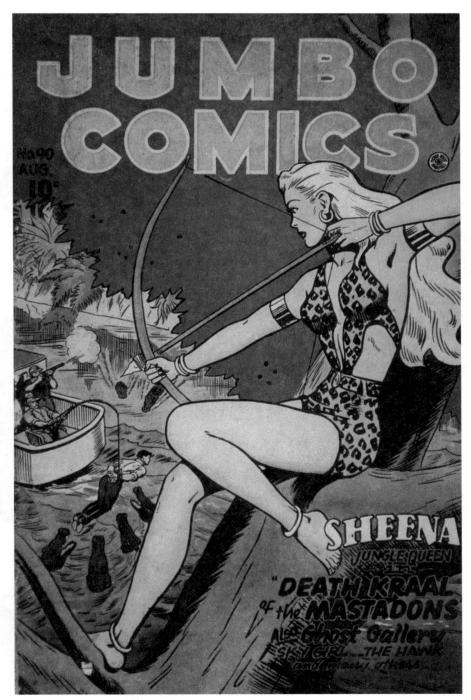

isolationism would keep it secure from the war situation in Europe and Asia, was beginning to breathe easier as the effects of the Depression eased. On the growing comic book front, two new publishers entered the field. One was Arthur Bernhard and his partner, Leverett M. Gleason, the other Ned L. Pines. Bernhard's first venture was *Silver Streak Comics* (December 1939), which introduced America to arch-villain, the Claw, who many regard as the first super-crook.

Ned Pines attempted a new type of comic. Calling his company Better Publications, Pines tried a larger format book called *Best Comics*, that appeared in November 1939. Oddly, the comic was printed sideways, an experiment which failed dismally. When Pines reentered the fray the following year, his comics appeared in the regular size and format.

Superman led the field, followed by several superhero imitators, all carefully avoiding the mistake Victor Fox had made with Wonder Man. They were dissimilar enough not to bother the ever-watchful Donenfeld. But 1940 would introduce Donenfeld's nemesis, a costumed superhero that would put Superman to flight in the popularity stakes. This cartoony superhero had a cheery air, wore a red costume and yellow boots and completely captured children's hearts. "Shazam!" cried Billy Batson. And Captain Marvel was born. Chapter Three

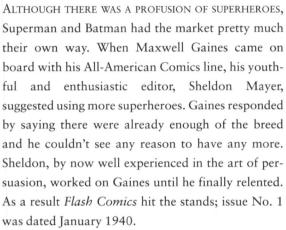

Flash Comics No. 1 was what collectors refer to as a "key issue." Mayer wanted the comic to have superhero characters so he hired ex-lawyer turned comic book writer, Gardner Fox, to come up with some ideas. Fox, already experienced in writing superhero stories (he wrote many Sandman adventures for Adventure Comics), created the Flash and Hawkman for the new title. The Flash's claim to fame was his speed, gained through an accident in a science laboratory. Taking the Greek god Mercury as his role model, the Flash donned a winged helmet, winged boots, a skin-tight red top adorned with a yellow flash, and blue tights also emblazoned with a few flashes. It goes without saying that the Flash was referred to as "The Fastest Man Alive!". The Hawkman was a resurrected Egyptian prince, who wore a hawk mask and possessed huge wings. Part of Hawkman's stock-in-trade was his collection of antique weapons which were used to good effect against evil enemies. Famed comic book artist Shelly Moldoff drew the first Flash Comics cover.

Flash Comics proved very successful so Gaines, encouraged by the sales of the new comic, asked Mayer to come up with another superhero title to

cash in on the obvious superhero boom. Mayer put together All Star Comics and introduced the famed Justice Society of America in the winter 1940 issue. The J.S.A. included superheroes from both the D.C. and All American camps. All these popular superheroes together in one comic was bound to sell...and it did. At the very first J.S.A. meeting was the Atom, Dr. Fate, Flash, Green Lantern, Hawkman, Hourman, and Sandman. The Hourman first appeared in D.C.'s Adventure Comics in March 1940, and only possessed super-powers for an hour at a time. The diminutive Atom first appeared in the October 1940 issue of All American Comics, but the arrival of the Green Lantern, who appeared in the summer, was more significant. Green Lantern, who was created by artist Mart Nodell, eventually got his own comic and became one of the most enduring superheroes in the D.C. stable. Sandman made his debut in the 1939 World's Fair Comics before moving over to Adventure Comics. As for Dr. Fate, he came into being in the pages of More Fun.

America in 1940 had an insatiable appetite for costumed superheroes who were able to put the world to rights with a flashing left hook and words of simple wisdom children could understand. They were fairytales in tights, escapees from the grim reality of the real world, viewed with a flashlight under the blankets at night. For the youngsters who suffered appalling discomforts during the Depression, the superheroes came too late to save Daddy's farm from repossession by the evil banks, but at least they could derive comfort in the knowledge that Superman wouldn't let the bad men do it again.

The last chapter ended with reference to a superhero called Captain Marvel. His popularity was so great that for a time he outsold Superman. He was Right Whiz Comics first appeared in February 1940 and gave us Captain Marvel – a more approachable kind of superhero with a sense of humor who often outsold Superman. Whiz Comics © 1950 (top left), 1946 (top centre), 1947 (top right) and 1940 (bottom) Fawcett Publications.

Above The Green Lantern, created by Mart Nodell, first appeared in July 1940 in *All American Comics* as part of the post-Superman superhero stampede and was eventually given his own comic. The Flash, created by Gardner Fox, was billed as the "Fastest Man Alive!". *The Green Lantern* © 1947, *Flash Comics* © 1940 D.C. Comics, Inc.

CAPTAIN MARVEL and the WONDERFUL MAGIC CARPET

the brainchild of artist Charles Clarence Beck and writer Bill Parker. A family-owned company called Fawcett Publications Inc. was the publisher. Fawcett, along with D.C., Dell and Marvel, became one of the most influential and important publishers in the business of producing comics.

"Another character sensation in the comic field" proclaimed the promotional pamphlet sent out by Roscoe Fawcett to distributors across the country late in 1939. The leaflet announced Whiz Comics and its hero Captain Marvel to the world. Whiz was dated February 1940 and when it hit the newsstands, the comic was a near sell-out. After three issues of Whiz, Fawcett knew Captain Marvel was a hot commodity who should be rewarded with a comic devoted to himself. Subsequently, Captain Marvel appeared in Special Edition Comics, the number two issue of which was changed to Captain Marvel Adventures. Captain Marvel was an instant hit with children, who found they could identify with him better than they could with Superman. Superman was mild-mannered Daily Planet reporter Clark Kent who rushed into phone booths, to speedily change into his costume (actually he wore it all the time under his clothes), but Captain Marvel was star broadcaster Billy Batson, a young lad who shouted "Shazam!" to change instantly amidst a blinding flash of lightning into his superhero self.

Before continuing with Captain Marvel, what of the publisher itself? As noted earlier, Fawcett was a family-owned business that began life several years earlier in Robbinsdale, Minnesota. The company, which published mostly lightweight, somewhat risqué joke and cartoon magazines, was founded by Wilford H. Fawcett. Magazines like *Ballyhoo*, or *Smokehouse Monthly*, proved popular in barber shops and places where men tended to congregate. But it was *Captain Billy's Whiz-Bang* that really hit pay dirt with sales of over 500,000 copies a month. "Whiz-Bang", by the way, was a slang expression for a World War I artillery shell. Captain Billy was W.H. Fawcett, and he really had been a captain in the army. He dedicated the humor magazine to the armed forces as a way of thanking them for all the amusing anecdotes they had provided. Later Fawcett would launch *Mechanix Illustrated* and *True*, both of which proved enormously successful. There was a men's magazine called *Cavalier* and film fans feasted on *Motion Picture Magazine*. Tales of love and heartbreak found a home in *True Confessions*.

By 1939 William H. Fawcett Jr. was running the

show. Roger Fawcett was vice-president, Gordon Fawcett treasurer, and Roscoe K. Fawcett was circulation director. There were other Fawcetts on the board of directors. In other words, they were a big, happy family who had no intention of losing control of their very profitable company. The hard-working Fawcetts were quick to spot trends in publishing. By the late thirties they noted how well *Superman* and similar comics were doing. Meetings were held to discuss this new phenomenon and Ralph Daigh, executive editor at Fawcett, was given the job of finding someone to head a new line of "picture-story magazines." Or to be more precise, comic books.

Daigh didn't have to look far. The man he wanted had been working with Fawcett for the past couple

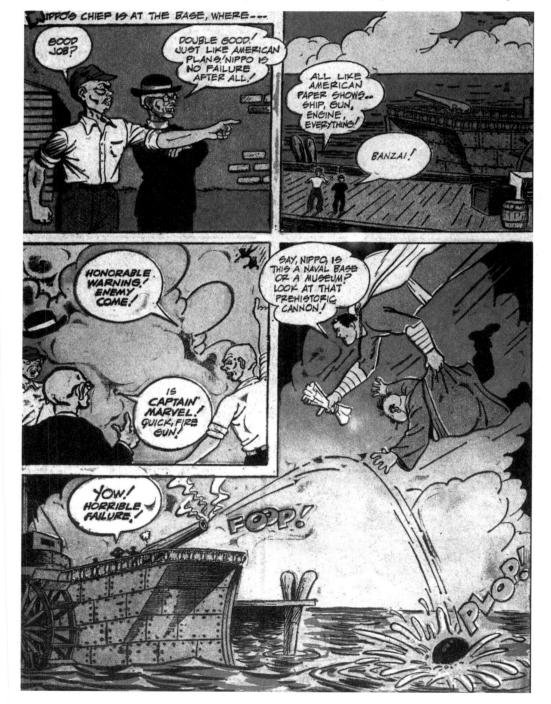

Left The Japanese feeble military equipment proves no match for Captain Marvel. *Captain Marvel Adventures* © Fawcett Publications.

Right Captain Marvel and his occasional companion Mr. Tawney the talking tiger. Captain Marvel's huge success meant that by spring 1941 he had been given his own comic. *Captain Marvel Adventures* © 1948 (left) and 1950 (right) Fawcett Publications.

of years as a supervising editor on movie and detective magazines. A classical student and college graduate, young Bill Parker could also write. Parker was more than happy to take on the job because part of the assignment was to write the stories and create the heroes for what would become Fawcett's first comic book.

Creating a line of superheroes and adventurers for a comic magazine, then writing the stories about them, takes some doing, as Parker was to discover. Still, he came up with several ideas for what was to be an anthology comic initially titled *Flash Comics*. There would be a magician, an aviator, a cowboy, and a sea-going adventurer. For the lead Parker suggested a team of heroes, each having the power of a mythological god (Mercury for speed; Hercules for strength and so on). The team would work together and would be led by Captain Thunder.

While the magician, cowboy, seafarer, and aviator were passed, Daigh and the Fawcetts knocked the Captain Thunder team on the head. Too clumsy, they said, and readers can't identify with a group. What they wanted was a similar character to Superman: a single superhero.

At about this time (September 1939), Parker discovered his artist. He had worked with him on the movie magazines. Charles Clarence Beck was his man. When approached, Beck wasn't sure about it. "At the time," explained Beck in an interview with *The Comics Journal* magazine, "I felt that most comic books on the market were the cheapest, trashiest sort of pulp fiction, written and illustrated by underpaid hacks who, if they had any original ideas, were not allowed to express them by their illiterate, money-grubbing publishers."

C.C. Beck was born on 8 June 1910 in the small

town of Zumbrota, Minnesota. His father was a Lutheran minister, his mother a school teacher. Quiet and retiring, Beck developed an early interest in writing, music, and art. He took a correspondence course in drawing and learned to play several musical instruments. After graduating from West Bend High School, Minnesota, Beck's parents sent him to the Chicago Academy of Fine Arts with the proviso that he should take a job in a restaurant to avoid becoming a "starving artist."

After a year at the Academy, Beck started drawing comic strip characters on lampshades. Soon he quit working in restaurants because he was making much more money as a cartoonist. Then came the stock market crash which caused his lampshade job to fold. He returned to his parents, who were now living in Minneapolis, enrolled in the University of Minneapolis and studied art. Soon he was drawing cartoons for the university humor magazine. Four years were to pass before C.C. Beck finally found employment. It was 1933 when Fawcett Publications hired him to replace two artists. He was paid \$55 every two weeks for drawing cartoons for Fawcett's various humor magazines, including the famous Captain Billy's Whiz-Bang. Beck was a great admirer of three newspaper strips, Chester Gould's Dick Tracy, Harold Gray's Little Orphan Annie, and Billy Debeck's Barney Google. He liked their simple, yet expressive style and developed it in his own drawing. He once said: "Never put a single line in that isn't necessary. Don't try to show off."

Once Beck knew he would be working with Parker, his doubts began to dissipate. He had enjoyed working with the writer on the movie magazines and knew Parker's work was good. Beck and Parker worked for long hours developing and honing the various characters Parker had created, especially Captain Thunder, who now possessed all the super-powers from the team he originally would have led. "We spent weeks working out the characters for our stories," Beck told the *Comics Journal*. "Bill typed descriptions of various characters on yellow copy paper for me to draw. I drew whatever he specified. Many, many characters were born and died during those weeks. We always worked from a simple desire to write and draw a comic book story that would appeal to ten-year-old children...of course, I have always felt that children are much more intelligent and discriminating than publishers give them credit for," he added knowingly.

As the characters evolved, changes had to be

made along the way. Daigh had to drop *Flash* as the comic's title because D.C., now renamed National Comics Publications, had recently introduced a *Flash Comics* under Maxwell Gaines's "All American" banner. One of the characters in *Flash* was Johnny Thunder, so Captain Thunder was still-born. In his place came...Captain Marvel. There was another false start with the name *Thrill Comics* (it had been discovered that Better Publications were about to release *Thrilling Comics*) so in honor of Fawcett Publications' founder, the comic would be called *Whiz Comics* after *Captain Billy's Whiz-Bang* magazine. As for the other characters, Ibis was the reincarnated Egyptian magician, Lance O' Casey the seaman, the bow-and-arrow-wielding cowboy was

Below Captain Marvel – modeled on movie-star Fred MacMurray – was a man with an expressive face and a soft heart who could also be strong when the need arose. *Captain Marvel Adventures* © 1950 Fawcett Publications.

Golden Arrow, the airman became Spy Smasher and two lesser heroes were Scoop Smith, a reporter, and Dan Dare the daredevil.

Launched as issue No. 2, *Whiz Comics* was coverdated February 1940. Why issue 2? Probably because an "ash-can" copy was released first. A halfdozen ash-can issues, all in black and white, including the cover, were printed and distributed around the offices, shown to the directors, and taken to the post office to register the title for second-class mailing privileges.

Whiz was an immediate hit. The cover was cheekily similar to Action Comics' first issue and showed Captain Marvel hurling a gangster car against a brick wall. Perhaps Daigh and Captain Marvel's creators thought National wouldn't notice. But the kids loved him. C.C. Beck had steered away from the more serious Superman look and created a more cartoon-like character whose looks resembled movie star Fred MacMurray. This was intentional; Ralph Daigh wanted Captain Marvel to look like the popular film actor who had an expressive face and a soft heart, but could also be strong when the need arose. By looking like a familiar person, children would identify more with the "World's Mightiest Mortal." Beck said Captain Marvel was 6 feet 2 inches in height, weighed 190 pounds, and was well built without looking like a chesty muscle man. He wore a red costume endowed with a yellow sash, yellow cuffs and boots and a yellow trimmed cape.

Below The amenable Captain Marvel was equally at home having fun with his fan club as he was seeing off the Yellow Peril in the line of duty. *Captain Marvel Adventures* © 1950 (right and top left, an ice cream giveaway comic) and 1942 (bottom left) Fawcett Publications.

There was a yellow lightning flash emblazoned upon his chest.

Unlike Superman and the rest of the ever-growing legion of superheroes, all of whom were vengeful or deadly serious, C.C. Beck's Captain Marvel had a sense of humor. A homeless orphan called Billy Batson, he was endowed with the superhero attributes of wisdom, strength, stamina, power, courage, and speed in order to battle the forces of evil. By speaking the name of "Shazam!", the wizard who had bequeathed him his magic powers, he becomes the strongest and mightiest man in the world...Captain Marvel. Dr. Sivana, the ingenious scientist, became a much-loved villain who stayed to harass Captain Marvel right to the bitter end. He would later be joined by another genius, this time in the shape of a tiny caterpillar. This was Mr. Mind, who desired, like Sivana, to take over the world. Sterling Morris, who owned first a radio, then a TV station, appeared in almost every issue of Captain Marvel. His relationship to Billy was that of employer, but more than that: he looked after Billy in a kindly paternal way, inviting him to stay for weekends at his home, or go on holidays with him. One other enduring personality was Mr. Talky Tawny, the talking tiger, who traveled to America and became a fully-clothed lecture guide at the Natural History Museum. Tawny remained a great friend of Captain Marvel's until the very end and had many amusing adventures with the red-costumed hero.

What endeared Captain Marvel to millions of children, and quite a few adults as well, was his undeniable charm, good nature, and the fact that he could, and did, make mistakes, was sometimes foolish, and didn't appreciate it if people made jokes Left The fiendish Dr. Sivana, a mad scientist who planned to take-over the world, was a much-loved, regular adversary of Captain Marvel's. *Captain Marvel Adventures* © Fawcett Publications.

Below A cover spelling out the meaning of the name "shazam". Captain Marvel's super powers combine all these legends' strengths. Captain Marvel Adventures © 1942 Fawcett Publications.

Right Enemies real rather than imagined – Captain Marvel does battle with Nippo of Nagasaki, the infamous Japanese spy and a frequent foe for the Captain during the war years. *Captain Marvel Adventures* © Fawcett Publications.

Below Captain Marvel returns to the "Heat Age". *Captain Marvel Adventures* © 1951 Fawcett Publications.

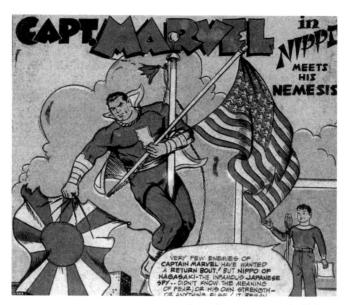

CAPT. MARVEL ADVENTURES . Executive Editor WILL LIEBERSON . WENDELL CROWLEY Art Editor The follow itstanding magazines are easily identified to he words A FAWCETT PUBLICATION. LASH LARUE WESTERN . ROCKY LANE WEST STERN - THE MARVEL FAMILY -I WESTERN - NYGKA THE JUNGLE GIRL MIK WESTERN - MONTE HALE WEST N - SIX-GUN HEROES - FAWCETT & COMICS - TEX RITTER WESTERN EL FAMILLE GIRL that these comic magazines W A Soweett, p. President IE GR STE EPA IN CTED HEAT HOLY MOLEY THAT MAN 15 BEING BOILED HELP

BOY NEWS REPORTER BILLY BATSON CONSTANTLY SEEKS INTERESTING PEOPLE TO INTERVIEW ON HIS STATUS Y PROGRAM! YOU SAY THAT STONE TABLET IS OVER THIRTY THOUSAND YEARS OLD PROFESSOR JOPLIN 7 00

APTAIN MARVEL ADVENTURES, Nov. 1951. Vol. 21. No. 125. is publiched monthly by Pavcent Publications, Inc., Favcent Place, Greenwich, Cannerde Stevenson (Lassenter October 29, 1965, at the post pffcc. Creanwich, Cann. Under the act of March 3, 1979, Additional entry at Laujeville, KU special 1981 by Pavcest Publications, Inc., This regulated at U.S. Patent Office. Linux 1991, Regulated St. 1979, Additional entry at Laujeville, KU special 1981, St. 1979, Additional entry at Laujeville, KU special 1981 by Pavcest Publications, Inc., This regulated at U.S. Patent Office. Linux 1991, Regulated St. 1979, Additional entry at Laujeville, KU special special concerning special sp

about him. In a nutshell, he was an ordinary guy that people could identify with.

Beck was always modest about the part he played in creating Captain Marvel, telling all who were so eager to listen that it was Bill Parker who deserved all the credit. "I was just another cog in the machine," he once said. But it was Beck who gave life to the stories Parker wrote, using his innate knowledge of children's minds and what they would appreciate in a comic book hero. Captain Marvel was essentially a child, as Beck once pointed out when asked to compare Superman with his and Parker's creation. "Superman was a full-grown man, actually a creature from another planet." Beck said. "While Captain Marvel, by contrast, was really a small boy, Billy Batson, who had no unusual powers at all until he said the magic word "Shazam!" and turned into Captain Marvel. The biggest difference between Superman and Captain Marvel, however, was that Captain Marvel knew he was in a comic book and loved it, while Superman always seemed to be ashamed of appearing in one."

While Captain Marvel was taking his bow, Fawcett was preparing its second and third comics, both cover-dated March 1940. One was *Master Comics* the other *Slam Bang Comics*. *Master Comics* featured Master Man, a superhero more in the mould of Superman. He lasted six issues until National Comics brought in its lawyers for the second time in under a year. National was extremely worried that Fawcett's supermen might affect sales for its own array of superhero comics. So, first of all it went for Master Man, issuing a cease and desist order alleging copyright infringements. Certainly National had a case, for Master Man was very similar to Superman and Fawcett dropped the char-

58

acter, replacing him with Bulletman shortly after.

Bulletman was an interesting hero. Police Sergeant Pat Barr is killed by gangsters and on his deathbed he implores his son Jim to join the force and continue the family tradition of fighting crime. Jim fails his fitness test but is able to work in the scientific police laboratory. He has learned a lot about bullets and devises himself a gravity regulator helmet shaped like a bullet. At the same time he discovers a serum that destroys all germs and injects himself with it. The serum turns Jim into a musclebound fighting machine.

The helmeted crusader first appeared in *Nickel Comics* (May 1940). *Nickel* ran for only eight issues, contained 32 pages not including covers, and was priced at five cents a copy. It was a brave experiment, the comic coming out every two weeks featuring Bulletman as the lead. *Nickel's* other heroes included Red Gaucho, who was born in South America of U.S. parents and fought bandits and rebels south of the border. There were also space ace Captain Venture and Warlock the Wizard. Roscoe Fawcett told the wholesalers that they would get a five-cent comic every two weeks, and promised that if *Nickel Comics* worked it would be made into a weekly. Unfortunately, retailers and distributors weren't able, or didn't want, to work a two-week schedule into their normal deadlines, so an interesting experiment died. As for Bulletman, he went on to appear in his own title, accompanied by Susan Kent,

Below Captain Marvel finally underlined his ordinary Joe credentials by retiring into marriage in 1953. While Fawcett had launched the next generation during the War with the equally successful spin-off strip Captain Marvel Jr. Master Comics © 1942, Captain Marvel Adventures © 1953 Fawcett Publications.

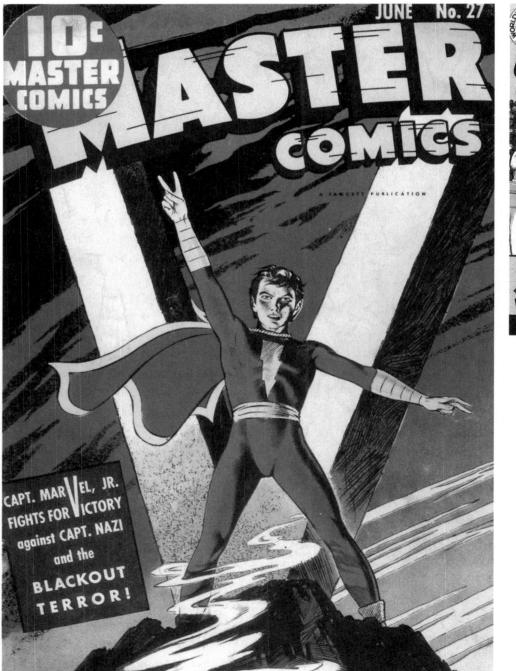

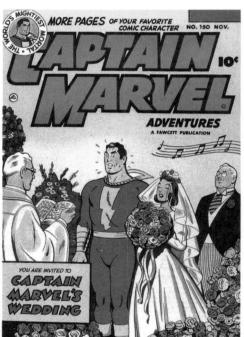

Below Fawcett premiered its new superhero Bulletman, "the flying dectective" in Nickel Comics in May 1940. Better Publications entered the market with a number of titles including Exciting Comics with their own superhero The Black Terror, "nemesis of crime" who sported a skull and crossed bones on his chest and, later, a Sheena clone – Judy of the Jungle. Bulletman © 1942 Fawcett Publications. Exciting Comics © 1948 Standard Comics

Barr's girlfriend, who discovers his identity and becomes the delectable Bulletgirl. The bullet-shaped helmets they wore were bordering on phallic symbolism – although only the most streetwise children would have got the message.

Captain Marvel's 1940 introduction was the spearhead for numerous other superheroes. Better Publications came out with a trio of new titles, the first being *Thrilling Comics* (February 1940), *Exciting Comics* (April 1940), and *Startling Comics* (June 1940). The three comics boasted a range of superheroes such as Doc. Strange, The Black Terror, The Fighting Yank, Pyroman, Miss Masque, and several other second-string characters. The Black Terror lasted the longest of Better Publications' heroes, and managed to find employment bashing civilian criminals after gaining experience socking Nazis and Japanese during the war. Black Terror even had his own comic and was a big seller.

Another new company jumped on the comic bandwagon. This was Prize Publications and its first title was *Prize Comics*. Dated March 1940, *Prize* came forth with the Black Owl, The Green Lama, and a comic Frankenstein by Dick Briefer. The Green Lama eventually went to Spark Publications and was drawn by the magnificent Mac Raboy, whose artistic prowess became familiar with Captain Marvel Jr. Frankenstein started out as a cartoony giggle but evolved into strictly horror in the early fifties.

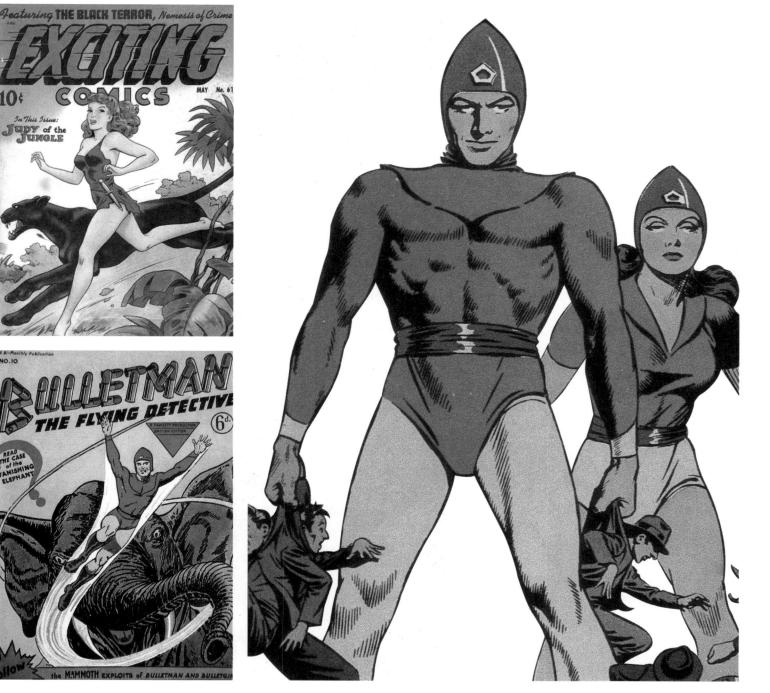

Holyoke Publications gave the world The Green Hornet in December 1940 and lost the character to Harvey Publications by issue number seven. The Green Hornet is an adventure hero with a difference. He dons a green raincoat, green hat, and green mask to hide Britt Reid, newspaper publisher, the Hornet's other self. His trusted valet Kato is a master chemist and is invaluable in helping Green Hornet fight Nazis and criminals. Hornet ended in 1949, was revived by Dell for three scattered issues (1953 to 1967), and came back again with Now Comics in 1989, lasting until 1994. Holyoke Publications also came out with Crash Comics, cover-dated May 1940. The comic included the Blue Streak and the first appearance of Catman. Catman and his sidekick Kitten would soon appear in Catman Comics, when Holyoke cashed in on Catman's popularity.

Ace Magazines began its publishing career with Sure Fire Comics (dated June 1940), and Super Mystery Comics (July 1940). Sure Fire featured the short-lived Flash Lightning and "Super Mystery" Magno the Magnetic Man. Yet another publisher, Novelty Publications, had White Streak in Target Comics (February 1940) and Blue Bolt in Blue Bolt Comics (June 1940). And there are still more.

Eastern Color gave birth to a subsidiary company, the Columbia Comics Group. For May 1940 Columbia launched *Big Shot Comics* which featured Skyman, the Face, and the Clock. This was followed by Heroic Comics in August and included Hydroman by Sub-Mariner's creator, Bill Everett.

Newsstand operators were having to make more room in their kiosks to take on the vast numbers of new comic books pouring onto the market. Most featured superheroes but there were a few others. Mindful of the war raging in Europe, Dell Publishing Fiction House entered the comics market in 1940 with the first science fiction comic book. *Planet Comics, Fight Comics,* and *Wings Comics* were all developed from its successful range of existing pulp magazines. *Planet Comics* © 1948 (top) and 1946 (bottom) *Fight Comics* © 1949 (Canadian edition), *Wings Comics* © 1943 Fiction House Magazines.

ELLS TH

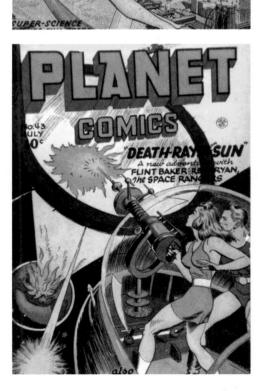

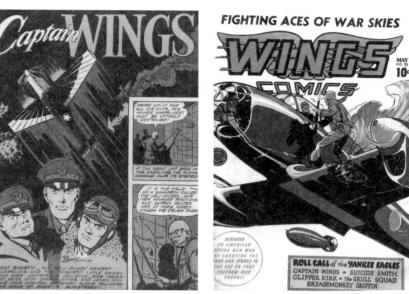

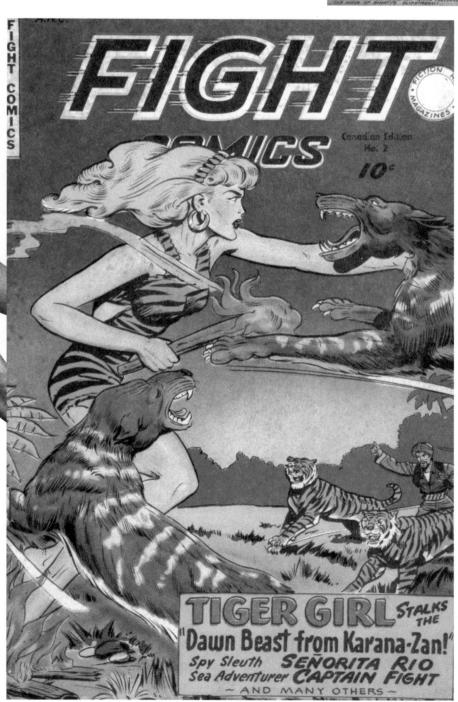

produced *War Comics*, which first appeared in May 1940, the first war comic ever to be published. Fiction House brought out *Planet Comics*, the first science fiction title dated January 1940, and *Jungle Comics* and *Fight Comics*, both cover-dated January 1940. *Wings Comics* appeared in September 1940.

None of the Fiction House titles carried superheroes; in fact Fiction House resisted the temptation right to the end of its publishing life. All its comics evolved from its successful range of pulps: *Jungle Comics* began as *Jungle Stories*, *Planet Comics* came from *Planet Stories*, and *Wings Comics* used to be *Wings Stories*. None of the pulps had invulnerable heroes either. Almost all Fiction House comics concentrated on adventure tales and lashings of sex in the form of scantily clad heroines suffering bondage, being attacked by jungle animals, and carried off into the jungle by tribesmen. Publisher Thurman T. Scott probably thought, why bother with supermen when you could have all these great looking girls?

All the art for the Fiction House comics came from the Eisner-Iger shop, Will Eisner doing many of the early Fiction House covers with a little help from Lou Fine. Many argue that Will Eisner is the most influential artist, writer, creator, and businessman in American comics. Born in Brooklyn, 6 March 1917, the son of an Austrian immigrant who built and painted stage sets and backdrops, Eisner lived and grew up in the shadow of the theater, which perhaps gave him an unreal look at the world. As a youngster he sold newspapers on Wall Street to help the family finances, and developed a voracious appetite for the daily comic strips. It wasn't long before he realized that this was what he wanted to do; create, draw, and write comic strips.

Soon he was drawing a weekly comic strip for his

62

DeWitt Clinton High School newspaper and doing linoleum-cut drawings for a small literary journal. His first ever paid art job was a comic strip ad about a degreasing solvent soap. He got a scholarship to the New York Art Student's League where he studied drawing and anatomy. This led to a job as an advertising artist for the *New York American* newspaper. Other art jobs came and went and by 1935 he had built up a portfolio of comic strips which he hawked around newspaper syndicates without success. Then he met Jerry Iger, editor of *Wow What A Magazine*, who was impressed enough to hire Eisner to draw for the magazine and help him edit it.

Wow died after four issues and Eisner and Iger were out on the street. Eisner picked up several jobs

doing cowboy comic strips for the Comics Magazine Company's Western Picture Stories title. He created a hard-hitting detective strip called Hammer Donovan for the company's Detective Picture Stories. Then Eisner hit upon the idea of a studio to package comic strips for the new comic book publishers. He discussed the idea with Jerry Iger and together they formed the Eisner-Iger comic art shop, hiring several other artists.

Eisner-Iger did a lot of work for Victor Fox in 1939. Some of the characters Eisner created for *Wags Magazine* were recycled to fit Fox's *Wonderworld Comics* and *Mystery Men Comics*. One such, the Flame, returned to life wearing a mask and possessing super-powers. Then came the D.C. Will Eisner, possibly the most influential man in the history of comics, created, among many other things, the diminutive superhero Doll Man for *Feature Comics* (who was given his own title in 1941) and many of the characters for *Hit Comics* out of his Eisner-Iger studio. *Doll Man Quaterly* © 1946, *Hit Comics* © 1940 (right) and 1941 [left] Quality Comics Group.

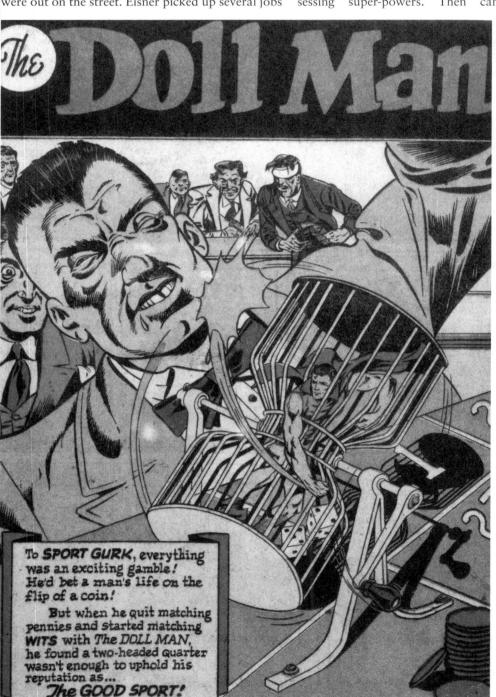

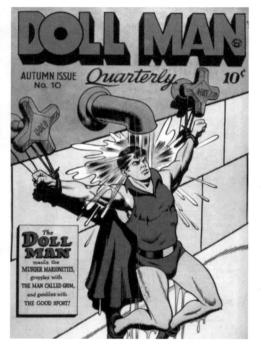

suit against Fox over Wonder Man, and Eisner testified that Fox had asked the Eisner-Iger art studio to copy Superman for his comic. The testimony was enough to show Fox had plagiarized Superman and he lost. Immediately after the case was over, Fox withdrew his contracts from the studios and walked off owing Eisner-Iger over \$3000, which was a great deal of money in those days.

Eisner-Iger had one excellent client and that was "Busy" Arnold of Quality Comics. Eisner himself created Doll Man for *Feature Comics*, the Ray for *Smash Comics*, the Black Condor for *Hit Comics*, and the wonderful Uncle Sam, the patriotic gent that once appeared on James Montgomery Flagg's military recruiting poster dressed in red, white, and blue stars and stripes complete with red, white, and blue top hat. Like many of the above heroes, Uncle Sam was the headliner in *National Comics*. Lou Fine, one of the greatest artists to come out of the Eisner-Iger shop, worked with Eisner on a few comics but Eisner thought him so good that he turned him loose on many of "Busy" Arnold's Quality titles. Among his most memorable creations were the first 17 covers for *Hit Comics* and they remain some of the best comic book art ever done.

Arnold's comics were, as their title suggested, quality comics with the best artwork. During early 1940 Arnold got the idea to provide newspapers with a weekly comic book section to help them boost their circulations. He struck gold with the Des

64

Moines Register-Tribune Syndicate, who already admired Arnold's line of comic books, and he entered into an agreement to produce a 16-page comic book called *The Weekly Comic Book* for newspapers. He called in Eisner to write and draw the main feature and package the second-string comics. Later in 1940, due to the pressures involved in producing the weekly comic, Eisner sold his interest in the Eisner-Iger studio to Jerry Iger, but took some of the artists with him over to Quality.

Once again comic history was made when Eisner created one of the world's great comic strip detectives, the Spirit. A unique character, the Spirit was the product of a highly imaginative mind. The origin story finds Denny Colt, a private detective, trying to stop the fiendish Dr. Cobra from poisoning the city water supply. In the ensuing struggle, Denny falls into the vat of chemicals and to all intents and purposes, dies. Denny is buried but two days later a mysterious figure turns up at Police Commissioner Dolan's office and announces himself as the Spirit who is determined to bring Dr. Cobra to justice. Dolan looks at him and asks for his real identity. Whereupon Denny Colt smilingly reveals himself and explains that the chemicals put him into a "state of suspended animation! Believing me dead you fellows buried me...I came to several hours later and broke out of my grave!" Denny's plan is to stay "dead" and work as the Spirit, living off the rewards for apprehending criminals and making his home an

The Spirit started life as a syndicated newspaper cor strip but was given his own comic in 1940. The Spirit @ 1940 (left) and 1941 (right) Quality Comics Group.

underground apartment at his grave in Wildwood Cemetary.

Eisner refused to give the Spirit super-powers. The Spirit was tremendously successful, and with good reason. The artwork was beautifully drawn with a great deal of attention to light and shade to achieve dramatic effect. The splash pages (the first page with a full-length opening panel) were each a work of the most imaginative art ever seen in comics.

Eisner was drafted into the army in 1942 by which time he had written, inked, and drawn 100 episodes of the Spirit. Once in the army Eisner wrote the stories but sent rough art back to Lou Fine to complete. By the end of 1942, Eisner was unable to continue and the Spirit was turned over to other Quality artists (mostly Lou Fine), and writers like William Woolfolk and Manly Wade Wellman. While in the army, Eisner's artistic prowess was put to good use, drawing cartoons for his camp's newspaper, and, when he was eventually stationed in Washington D.C., he started doing educational strips for maintenance and automotive procedures for an instruction magazine called *Army Motors*. Later he began drawing and editing another army instruction journal, called *Firepower*. Eisner also developed comic strips featuring G.I.s, which could be used as army teaching aids.

By the end of the war, Eisner was back on track with the Spirit. He did at least 1500 pages, aided by

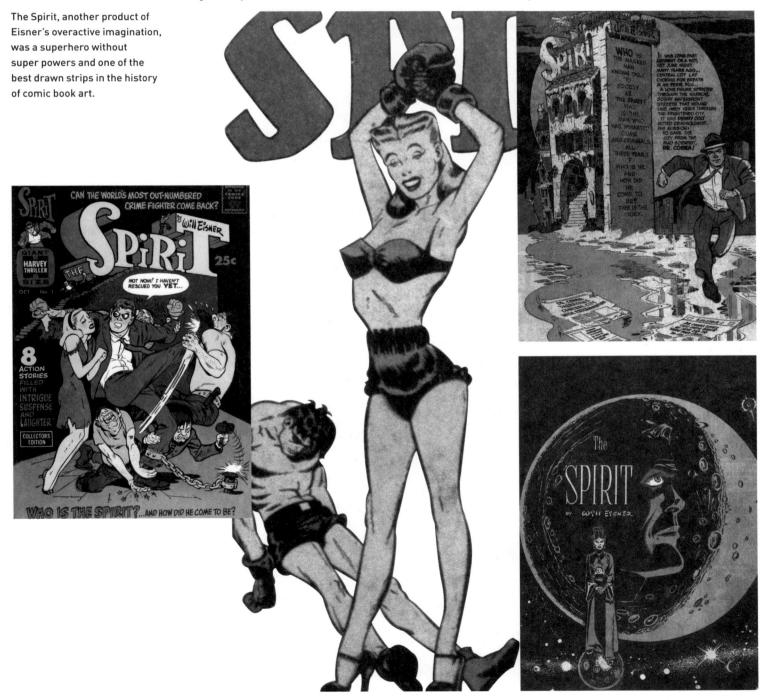

assistants who might do backgrounds and the occasional penciling or inking. Some of Eisner's best Spirit stories were done between 1946 and 1951, and many of them featured some beautiful *femmes fatale* that have never been bettered. Although heavy-duty violence featured in a number of Spirit stories, it was treated in a tongue-in-cheek way that could be described as black humor.

Many of the Spirit tales were reprinted in Quality's *Police Comics* which also included the tremendous work of the truly surreal Jack Cole, who drew Plastic Man, a superhero character that Salvador Dali would most certainly have approved of. Plastic Man, who first appeared in 1941, started out as a small-time crook called Eel O' Brian. One night, so his introductory story goes, Eel and his gang are about to rob the Crawford Chemical Works. A guard surprises the hoods who turn to flee. One of the guard's bullets catches Eel, who falls into a vat of acid chemicals. When he gets out of the vat Eel finds his body has become plastic and that he can stretch every which way...he can elongate himself across roads, over cars, become a rubber tire, or an escalator. Cole invented Plastic Man and wrote, drew, and inked the stories until 1945. When other artists were brought in to assist, Cole was so upset that he broke down and cried.

Returning to Eisner for the moment, the Spirit returned for a special Sunday issue of the *New York Herald Tribune*. A five-page story was created by Below Police Comics was home to a number of Spirit reprints and its own burgeoning star: Plastic Man, a product of the surreal mind of artist Jack Cole. Police Comics © 1942 (left) and 1946 (right), Plastic Man © 1951 Quality Comics Group.

66

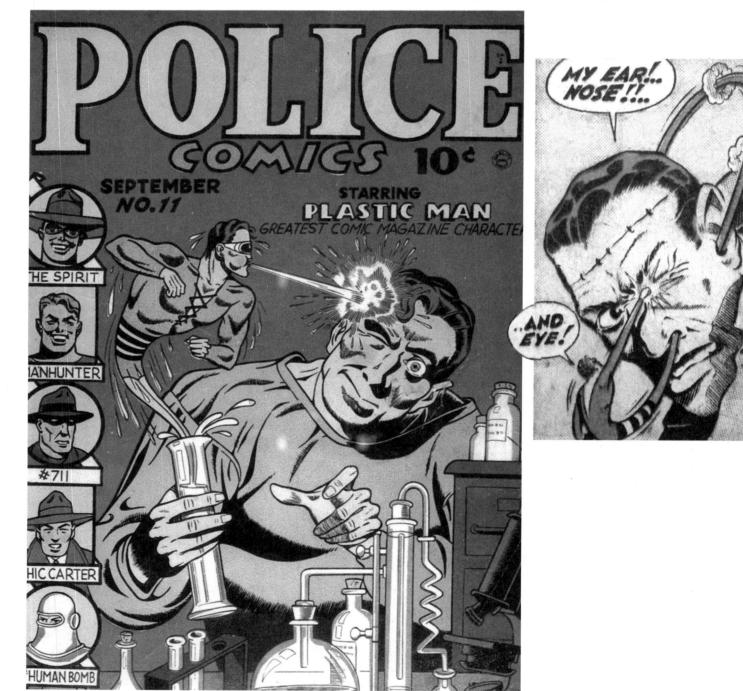

67

Eisner for the paper which came out on January 6, 1966. Leon Harvey, publisher of Harvey Comics, liked what he saw, met Eisner, and produced two special Spirit books, each starting with a new story from Eisner. From 1974 to 1976, Warren Publishing reprinted Spirit stories in 16 issues of a black and white magazine and later still, Kitchen Sink Press published a series of Spirit reprint comic books. Will Eisner's imaginative and beautifully drawn Spirit has become one of the most enduring comic characters.

By the end of 1940 much of Europe had fallen to Hitler's Blitzkrieg. Only Britain remained, its people thankful their country was an offshore island. The Royal Air Force had broken Germany's aerial assault in the Battle of Britain. Although America

UT OF THE PAST

TO

ACK COLE

wasn't yet in the conflict, many of its comic book characters were. By spring 1941 the superheroes were warning America of what was soon to come. There was little doubt that many Americans had resigned themselves to the possibility of war, but it was the publishers of comic books who put into pictures what, in their minds, was a certainty. And the likes of Sub-Mariner, Human Torch, and Captain America blazed the way that America itself would soon follow.

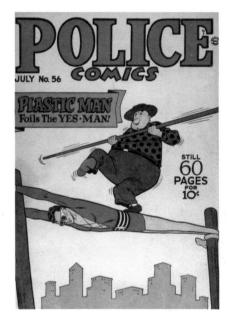

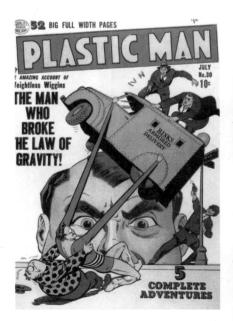

Chapter Four

THE COMICS GO TO WAR

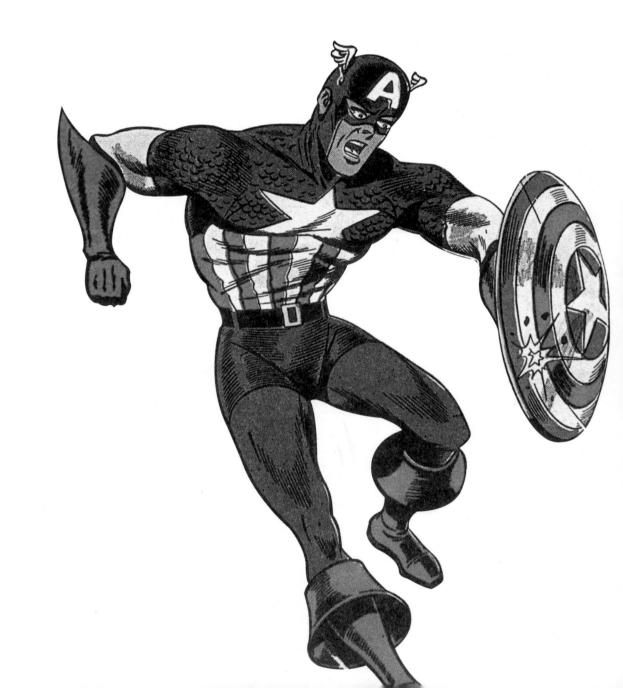

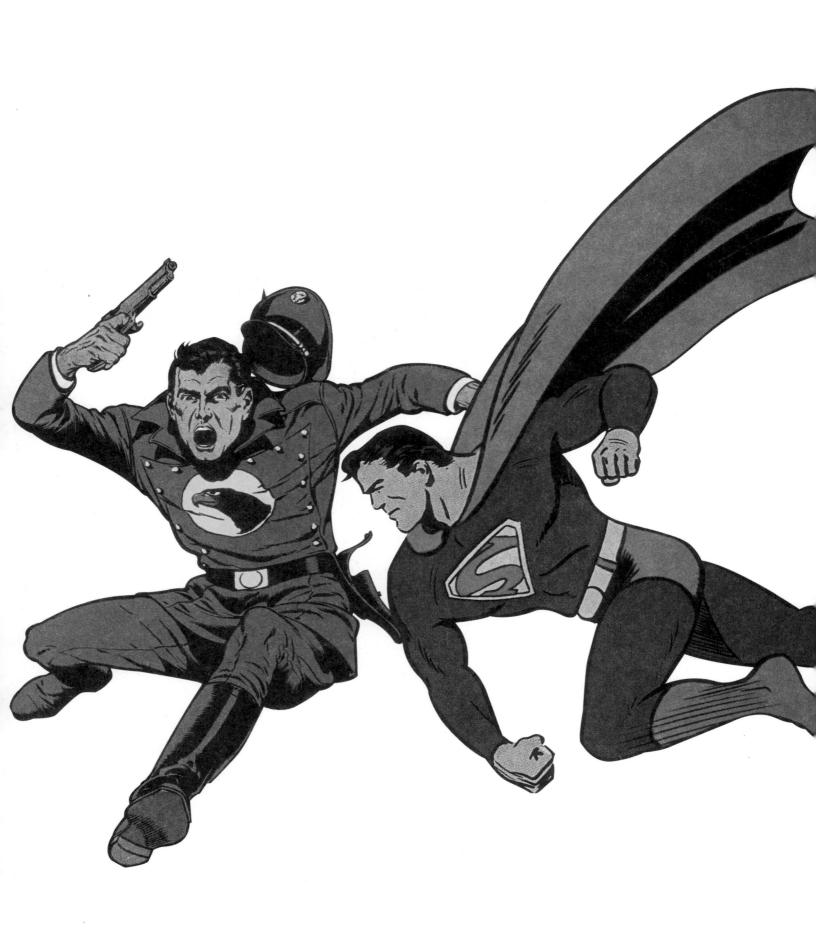

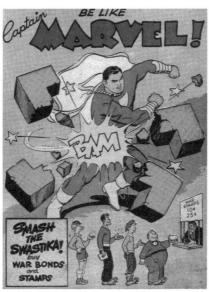

Superman, Captain Marvel and others do their bit for the American war effort. A superhero wasn't worth his salt if he wasn't prepared to engage the Japs and the Germans in the name of Uncle Sam. Captain Marvel Adventures © 1942 Fawcett Publications. Superman © 1941 D.C. Comics, Inc. Uncle Sam Quarterly © Quality Comics Group.

IN 1938, PUBLISHER MARTIN GOODMAN HAD ALREADY recognized the menace growing ever stronger in Europe. He was concerned that the young American reading public should be made aware of the dangers of Nazism and Fascism. In August 1938, a little more than a year before Goodman's first comic book, he had published *Marvel Science Stories*, a pulp magazine. His anxiety about the war was expressed in the first issue of the magazine's editorial: "What will the rebirth of America be, when one day the military forces of the world combine to devastate the greatest nation the world has ever known?" World war, prophesied the magazine, was just around the corner. How right it was.

An interesting observation that might partially explain why comic book heroes were fighting the war was the fact that many of the publishers, writers, and artists were Jewish. They knew about Hitler's policies concerning the Jews and other minorities and foresaw the shape of things to come. Had America done so, perhaps many more lives would have been saved.

Who was Martin Goodman? He was born in Brooklyn in 1910 and became interested in periodicals from a very early age. According to Les Daniels's book *Marvel – Five Fabulous Decades of the World's Greatest Comics*, Goodman would cut and paste stories together to create his own magazines. Eventually he went into publishing, but not before he had discovered America as a virtual hobo. It has been said that Goodman knew every town and his experience of those towns helped him understand his markets.

Returning from his travels, Goodman became a salesman for a publishing group, and in 1932 formed his first publishing company with Louis Sil-

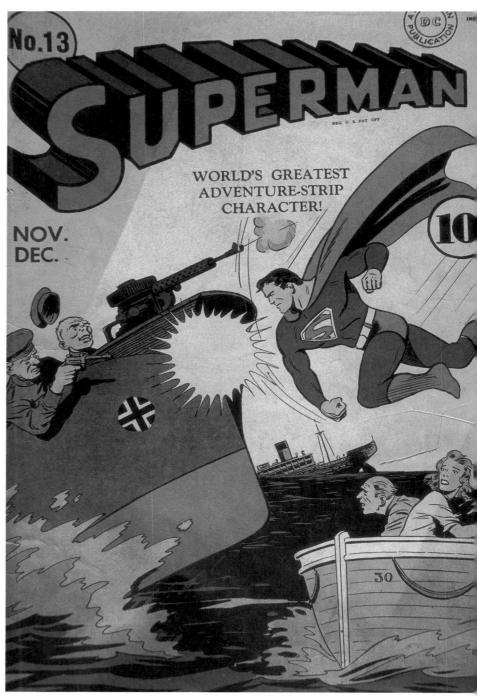

70

berkleit. Although a man with ideas, Goodman was always prepared to sail with the wind and publish whatever was popular at the time. In 1932 it was westerns and the partners published several titles. Goodman once said that if you have a successful title and add a few more similar ones "...you're in for a nice profit." Disagreements found Silberkleit leaving the company in 1934 and Goodman soldiered on by himself.

As we have already seen, Funnies Inc. salesman Frank Torpey persuaded Goodman that comics were the way to go. Torpey, whose company had artists and writers packaging comic books for various publishers, wanted Goodman's business. His persistence hooked Goodman, who agreed to publish comics. He bought his first package, which happened to be *Marvel Comics*. Cover-dated October 1939, *Marvel Comics* was so popular that it was reprinted the next month. Goodman was so impressed that he hired Torpey as his salesman.

That first copy of *Marvel Comics* broke new ground in the superhero stakes. Bill Everett, who worked as a comic artist and writer for Funnies Inc., invented, drew, and wrote Sub-Mariner, a marine being with a strange origin. His mother had been an undersea princess called Fen, a member of a race called the Sub-Mariners. One day an American expedition doing research in the Antarctic accidentally damaged and destroyed part of the Sub-Mariner realm. Fen, in an attempt to stop the

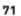

researchers, climbed aboard their ship. Then the unexpected happened; she fell in love with the ship's captain. She married him and conceived a child. But when a fleet of American research ships blasted their way through the ice and destroyed Fen's people and their kingdom she left the captain to bring up her child on her own. Hating the human race for what they did to her kind, she told her son Namor of the humans' evil. With hatred in his mind, Namor set out to destroy as many humans as he could.

Bill Everett was a rebellious 21-year-old when he created Sub-Mariner. Maybe a lot of what he wrote regarding the Sub-Mariner was his way of spitting out his anger. In the words of Sub-Mariner: "What fools these mortals be! Warring among each other to satisfy the arrogant egos of a few stupid governments! I'll show them what war is like..." Through the character of Sub-Mariner, Everett was pleading for understanding from those governments that were avoiding the Nazi danger by burying their heads in the sand.

The Human Torch became perhaps the most popular superhero from Goodman's growing comic book empire. Along with Everett's Sub-Mariner, the Human Torch first made his fiery appearance in *Marvel Comics* No. 1 (October 1939). In fact, the Human Torch made the cover of that historic first issue.

Carl Burgos, his creator, said the Human Torch came about as the result of a nightmare. The reality

Below Bill Everett conceived the Sub-Mariner character for the first edition of *Marvel Comics.* No Nazi U-Boat was safe from his aquatic clutches. *The Sub-Mariner* © 1941 Marvel Comics Group.

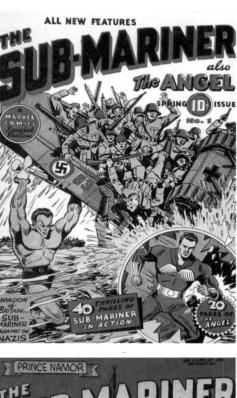

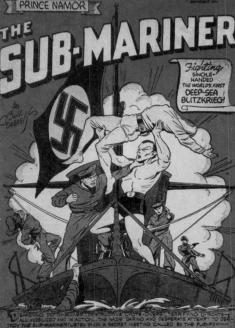

Below Sub-Mariner's 'sea beauty' sidekick Namora added glamour to his strip and was finally rewarded with her own comic in 1948. *Namora* © Marvel Comics Group.

Right Doing battle with the Nazis over American skies – the Human Torch appeared in the first edition of *Marvel Comics*, but, like Sub-Mariner, he was soon popular enough to warrant his own title. *The Human Torch* © Marvel Comics Group. was more prosaic; his beginnings, according to his good friend Bill Everett, may well have been in a Manhattan bar. Although the name Human Torch implied he was human, he was not. A Professor Phineas Horton created an android as an exact replica of a human. The trouble was, Horton discovered, that whenever his android was exposed to oxygen, it burst into flames. The good professor sealed his creation in concrete. But an air leak developed enabling the android to escape. He became a virtual incendiary bomb setting fire to everything. After many self-doubts, the android learned to control his flames, enabling him to switch on or off whenever he felt like it. For a while the Human Torch covered his identity as Jim Hamond, police officer, and only became fiery when there were crooks to catch. As did almost all the superheroes, the Torch acquired a junior sidekick called Toro. Toro had lost his parents when they burned to death in a train crash. A traveling circus adopted the orphaned boy who seemed to have an immunity to fire, and he became part of a fire-eating act. One day Torch flew near the circus and saw the lad bursting into flames. He got to know Toro and helped him to control his flames. From then on the Human Torch and Toro became a fiery duo that burned up the crooks.

By 1941, both Human Torch and Sub-Mariner, the most original comic book superheroes, had acquired their own comic books. Burgos's character

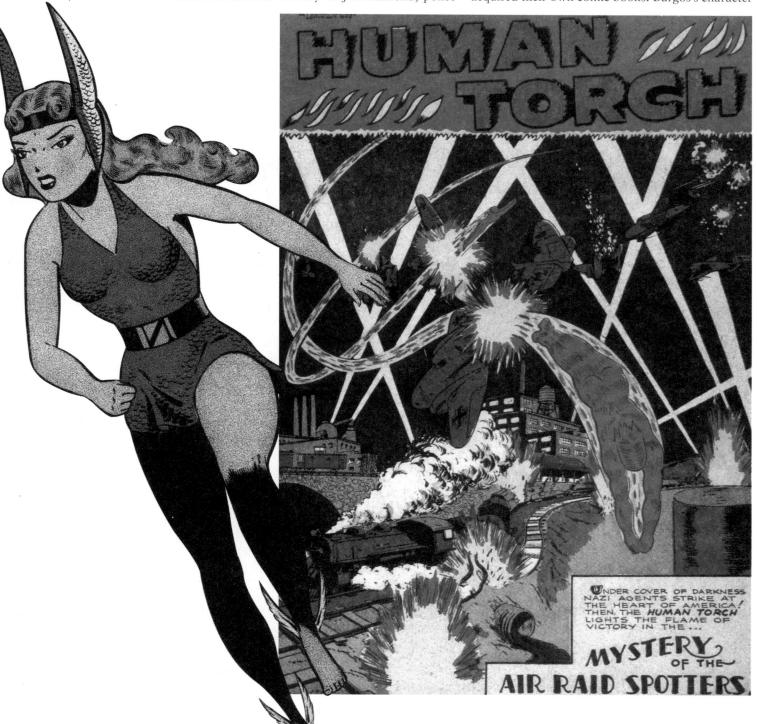

Below The Human Torch and his flaming sidekick Toro hot on the trail of their criminal adversaries. The Human Torch © Marvel Comics Group.

was appearing in six different titles while Sub-Mariner managed double that. Not all the appearances lasted beyond one issue but the Sub-Mariner appeared regularly in half-a-dozen books, the longest running being *Marvel Mystery Comics*.

Most of the comic book publishers had themselves a bunch of superheroes, but having sensed war was around the corner they brought out still more. The big thing was patriotism, so any characters that had super-powers or athletic prowess were requisitioned to fight the Nazis and the Japanese. Even the comic book packager Harry Chesler got into the patriotic act with his own line of comics, including Yankee Comics, Punch Comics, and Dynamic Comics. Each title contained forgettable superheroes featured in forgettable stories, and consequently none of them lasted very long. There was one issue of Punch which is memorable. It has men and women hanging onto a giant eagle and one of the women is bare-breasted. This was the first appearance of a woman in a state of undress in comic books; naturally this issue is much in demand by collectors today.

The comic book heroes pushed the patriotic ideal for all they were worth. Martin Goodman needed no encouragement to go to war in the pages of his comic magazines. In U.S.A. Comics No. 2 (November 1941), Simon and Kirby drew Captain Terror whacking German troops who are pouring through a hole into the New York subway. The hole was made by a huge boring machine driven by no less than Hitler himself. Fanciful thinking perhaps, but in the comics Hitler was always in the front line at the right time to receive a punch to the jaw.

Joe Simon and Jack Kirby are comic book icons. Together they were responsible for more comic book

Jack Kirby, who began as an animator with Max Fleischer, drew the *Blue Beetle* before teaming up with Joe Simon to create the quintessential patriotic superhero, Captain America. *The Blue Beetle* © Fox Features Syndicate. *All Select Comics* © 1945 Harvey Publications.

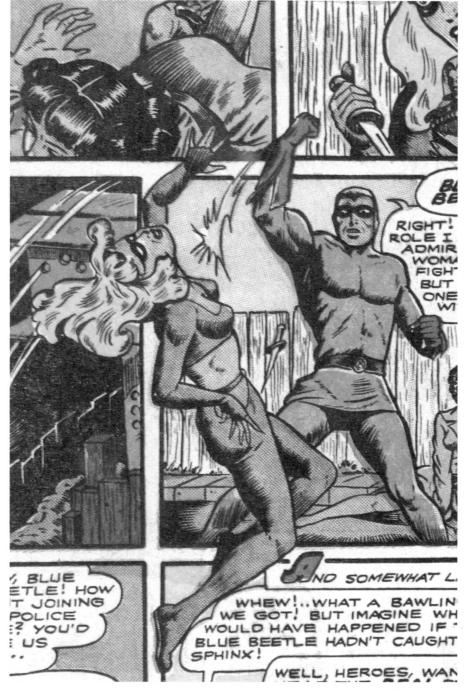

legends than anyone else. Both men wrote the stories and did the art, a career that would last over a quarter century. Jack Kirby began his cartoon work with Max Fleischer Studios as an animator in the summer of 1935. From there he went to a small syndication company, Lincoln Features, doing cartoons and adventure strips like Detective Riley and The Black Buccaneer. In 1938 he joined the Eisner/Iger shop but continued doing strips for Lincoln.

The first issue of *Marvel Comics* had been a great success, so Goodman hired tall, 24-year-old Joe Simon from Funnies Inc., the art shop that packaged, wrote, and drew *Marvel Comics*. He wanted Simon to draw, write, edit, and develop new comic books. Simon came up with *Mystic Comics* and *Daring Mystery Comics*, both featuring a host of new and generally forgettable superheroes. Publication schedules for both comics were nothing if not haphazard, sometimes they did not appear for months on end.

While Simon was trying to find a memorable super character, Jack Kirby joined Fox Features. Here he helped with production and drew the newspaper strip version of Victor Fox's successful Blue Beetle. Fox was not the best payer in the business, if he bothered to pay at all, and Kirby was earning a measly \$15 a week for drawing the daily strip. However, Kirby made extra by drawing for Fox's comic books, for which he was paid \$2 a page. Fox, according to Kirby in an interview with Mark Evanier in 1986, "was a little guy with a big cigar and he'd walk back and forth saying, 'I'm the king of the comics! I'm the king of the comics! Work faster!"" It was while he was at Fox that Kirby learned fast production techniques and was able to draw ten pages a day. It was Kirby's speed and dedi-

Captain America was conceived at the height of wartime patriotic fervor and was a pure embodiment of the American Dream fighting the Nazi foe. *Captain America Comics* © 1941 Marvel Comics Group.

cation that impressed Simon enough to ask him whether he would consider a partnership. Kirby consented, but still drew for Fox until there was enough work freelancing.

One of Simon and Kirby's regular jobs wa's drawing and writing *Blue Bolt Comics* for Novelty Publications. It was while working on *Blue Bolt* that the duo became fully fledged partners and the legendary signature "Simon/Kirby" first appeared on a comic. Then came the day when Simon began work with Timely Comics (Goodman's comics company), and it was here that Simon and Kirby's greatest comic book character of all took shape. "He symbolized the American Dream," recalled Kirby in reference to Captain America. "Captain America was an outpouring of my own patriotism," he continued. "I found myself doing with Captain America what I would do myself."

Captain America was all that Martin Goodman could have hoped for. When Simon and Kirby suggested that Captain America should do battle with the Nazis, Goodman enthusiastically agreed. If any superhero was dressed for the part, Captain America was. He was THE super-patriot, the quintessential American fighting gloriously for his country and freedom. He was dressed in red, white, and blue, the upper portion of his uniform rendered in blue, skintight chain mail. From the chest down, his suit was in red and white stripes like the 13 states of the American flag. Then came a black belt, skin-tight blue pants and red buccaneer boots. His hands were encased in elbow-length red gloves, there was a large white star emblazoned across his chest, and he wore a tight hood and mask that revealed only the lower part of his face. On his arm he carried a red, white, and blue shield decorated in stars and stripes. In

early Captain America comics, the shield was triangular but was soon replaced by a round one displaying a star in the middle encircled by red and white stripes. His skull cap hood featured the wings of Mercury above his ears, and a white star on his forehead. This was Captain America, Sentinel of Liberty, freedom fighter for democracy.

The boy companion had begun with Batman and soon spread to a multitude of superheroes. Batman had Robin, the Human Torch had Toro, Sandman had Sandy, and Mr. Scarlet had Pinky. Boy wonders and their superhero adult companions were regarded with great suspicion by certain individuals: how could these characters live alone with a boy? But there was nothing sinister – the publishers realized that youngsters would more readily identify with superheroes their own age. So Captain America had his own extremely popular companion, Bucky, complete with a blue shirt with white collar, red leotard, blue boots, red gloves and little black mask.

The first issue of *Captain America* was coverdated March 1941, which meant the comic hit the stands in January. The mayhem on its cover was typical of most Timely covers just before and during the war. Captain America has smashed his way into Adolf Hitler's closely guarded operations room. Nazi storm troopers blaze away at the intrepid Captain, but the bullets are deflected by his shield. Hitler is staggering backward as he receives a massive punch to the jaw, triumphantly delivered by

Captain America. Great stuff!

The comic books had gone to war over a year before their homeland, and the ferocity displayed by the heroes to the Axis powers was formidable. It was as if the publishers were trying to embarrass the American government into getting off its isolationist horse and viewing the world for what it was.

1941 gave America a number of new superheroes many of whom would last only one issue of whatever comic they were in. Not so with M.L.J. Publications' Hangman, possibly the most violent superhero of all. This very sinister gentleman first appeared in the July 1941 issue of *Pep Comics*.

Bob Dickering, the "Hangman", had a brother called John who also happened to be a superhero

called the Comet. Drawn by Jack Cole, he debuted in *Pep Comics* No. 1. Like all superheroes, the Comet was garbed in a colorful, skin-tight costume bedecked with stars, hood, and fancy goggles. The Comet had the dubious distinction of being the first superhero to be killed. The story was in *Pep Comics* No. 17. A bunch of crooks were out to murder the Comet but grabbed his brother Bob by mistake. The Comet came to save his brother, but the crooks opened fire and mortally wounded him. He was taken to his girlfriend, newspaper reporter Thelma Gordon's apartment. As he lay dying, the Comet turned to his brother and tearful girlfriend and whispered: "You two stick together...kind of a memorial to me...Goodbye Bob—Bye Thel...Aahh!" His face

Left Hangman was possibly the most violent superhero of all – an embittered executioner out to avenge the death of his brother. Hangman Comics © 1943 M.L.J. Magazines.

Right Panel artwork from an early Hangman strip. Hangman Comics © M.L.J. Magazines.

etched with sadness, Bob turned to Thelma and made a pledge: "I'll carry on for him, Thel," he vowed. I'll bring his murderers to the hangman...I'll be their HANGMAN!!"

Bob Dickering, the Hangman, is a vengeful executioner. His cape and masked costume are the same colors as Batman's – surprisingly National Comics' team of lawyers missed this bit of obvious plagiarism. As far as personality went, the Hangman had no peer. He lacked compassion, he executed the criminals. His was a tide of revenge motivated by the death of his brother. The stories were dark and forbidding enough to disturb youngsters' sleep. Soon they would have nightmares when the excellent artist, Bob "Fuje" Fujitani took over the artwork in issues seven and eight, especially in one horrific tale that begins Hangman's final issue. The story concerns a maniac who strangles a woman to death in front of her young son. Then he turns on the little boy who falls out of the upstairs window. Fortunately he is saved by the Hangman, who summarily dispatches the villain.

Written at first by Cliff Campbell, a crime and horror story-teller for the pulps, the Hangman's personality was given an embittered edge; later William Woolfolk and Otto Binder developed the violence and blackness originally created by artists George Storm and Harry Lucey and carried on in a film noir atmosphere created by Fujitani. Look out for the three splash panels in *Hangman* No. 8. Hangman

lasted for three years, appearing in 31 issues of *Pep Comics, Special Comics* No. 1, *Hangman Comic* Nos. 2 to 8, and *Black Hood Comics* Nos. 9 and 10. Black Hood replaced Hangman and was more compassionate than his dark predecessor.

Politically, Leverett M. Gleason was a rare breed in New York's publishing world. He was a committed liberal whose beliefs ran way to the left of center. He was gentle, helpful, and deplored what was going on in Europe. Gleason had been in comics since 1936 when he was a packager for Tip Top Comics. He joined Arthur Bernhard in early 1941 as editor and business partner. Both men shared the same leftwing views, which became apparent in some early issues of their comics. Arthur Bernhard, who had been in publishing during the thirties, had formed his company to publish comics in late 1939. Like his business partner Lev Gleason, Bernhard was Jewish and a committed liberal. He found the European situation more than a little disturbing and joined other comic book publishers in wanting to warn the nation of imminent disaster.

Bernhard hired artist and writer Jack Cole to put together a comic named *Silver Streak Comics* after his Pontiac Silver Streak car. *Silver Streak Comics* first appeared in December 1939. Cole always liked outrageous, surrealistic characters, be they heroes or villains. For *Silver Streak* he invented the "Claw," who had the intellect of Fu Manchu, the personality of a hungry Tyrannosaurus Rex, and possessed long, sharp claws as well as equally sharp teeth. He could grow as high as a six-storey building, and his Big Breakfast was a warship or two. Children would shiver beneath the sheets after viewing the monstrous Claw by flashlight!

Jack Cole needed another character for Silver

Streak Comics, perhaps one to take on the Claw. Almost as if fate took a hand Jack Binder, who worked at the Chesler shop, delivered a new costumed hero for Cole to look at. Cole liked what he saw. The character was called Daredevil and wore a yellow and blue leotard. Cole changed the costume to a red and dark blue outfit, the colors split down the center with red on one side, the dark blue on the other. Daredevil wore a vicious spiked belt around his middle, presumably to discourage the bad guys from getting too close.

Daredevil's name was Bart Hill, and his father was an engineer who had devised an incredible invention. Naturally, a bunch of hoodlums wanted the invention, broke into the Hills' home, killed the parents, and tortured little Bart with a boomerangshaped branding iron that left a deep brand in his chest. The shock of the ordeal left young Bart mute. Vowing vengeance against the killers, Bart built up his strength with acrobatic training. He carried a boomerang, his only weapon apart from his fists and feet. His first battle was a fierce initiation; he faced the Claw. With no explanation offered as to why, Daredevil got his voice back. For the next five issues, Daredevil fought the Claw tooth and nail in some of the most violent cartoon sequences yet to hit the comics. But the best was yet to come. Realizing how popular Daredevil was, Gleason gave the character his own book.

"Busy" Arnold, publisher of Quality Comics, was impressed with Cole's frenetic, surrealistic art. He was looking for somebody to draw his new detective feature called "Midnight," so he approached Cole with an offer he couldn't refuse. History, as we have already seen, was made when Cole created Plastic Man. Meanwhile the final Claw versus Daredevil Left *Pep Comics* home for 30 issues of the nightmareinducing Hangman. *Pep Comics* © 1941 M.L.J. Magazines.

Right Silver Streak Comics – named after artist Jack Cole's Pontiac – the launch-pad for two more of his bizarre creations: the Claw and Daredevil. Silver Streak Comics © 1941 M.L.J. Magazines.

battle was drawn by artist Don Rico. Gleason and Bernhard needed editors fast to put together Daredevil's own comic, which was of special importance to Bernhard. He wanted a comic featuring Daredevil fighting Adolf Hitler.

Charles Biro and Bob Wood were as different as chalk and cheese. Biro was a big man, extrovert in personality, an inveterate reader, but with an innate sense of marketing along with his drawing and writing talents. Bob Wood, on the other hand, was short, slender, very introverted, and a compulsive, hopelessly addicted gambler. The pair met each other when they were both working at the Harry Chesler art shop and became good friends. Lev Gleason asked them to work for him and they accepted...now Bernhard would have his comic.

"Daredevil Battles Hitler" screamed the title in red, black, and green against a yellow background. The cover showed a retouched photograph of Adolf cowering as Daredevil throws his boomerang and other superheroes strike menacing poses. In the bottom right-hand corner of this striking cover, drawn by Biro and Wood, is the Claw leaning over a black placard which proclaims: "The most TERRI-FYING BATTLE ever waged – HITLER stacked the cards against humanity - BUT - DAREDEVIL deals the ACE OF DEATH to the MAD MERCHANT OF HATE!" It was everything Gleason and Bernhard could wish for - the comic warned, as others had, of the troubles ahead. Daredevil Battles Hitler was a sell-out issue. Biro was to say later that, following the anti-Nazi tales in their comics, he had been threatened by Nazi sympathizers who suggested he would be strung up when Hitler took over America. Of course Biro laughed at the threat.

By 1940 America had 168 various comic book

titles put out by 24 publishers. The combined monthly sale of the comics was between 12 and 15 million copies. At a dime a comic this meant an annual revenue of \$15 million to the publishers. According to an article originally written for the *New York World Telegram* newspaper in 1942 and reprinted in the impressive magazine *Comic Book Marketplace* in 1996, each comic averaged four readers, which meant about 50 million readers a month. But people were becoming concerned that the comics were perhaps not the best thing for children to read, that they were too violent. An editorial in the May 8, 1940 issue of the *Chicago Daily News*, written by a Sterling North, described comics as a "poisonous mushroom growth."

North continued that the comics "were badly drawn, badly written, and badly printed...pulp paper nightmares." He described the comics as "hypodermic injections of sex and murder" and blamed the publishers for being "completely immoral...for the cultural slaughter of innocents." Strong stuff indeed. Nevertheless North was probably right in bringing the comics to the attention of parents. Some, such as Hangman, Captain America, Daredevil, and Airfighters, were pretty violent. Airfighters, by the way, was published by Hillman Periodicals and the first issue was cover-dated November 1941. It had a series of memorable heroes, particularly Airboy and Black Angel, who exuded sex appeal in her tight-fitting pilot's costume.

Whether the violence did any harm to children is a very debatable point to which we will return later. The Brothers Grimm fairy stories or, for that matter, the Old Testament of the Bible are infused with violence, cruelty, and torture. A normal child likes Above Captain Midnight's foldaway wings, which allowed him to jump from planes and glide safely to the ground, made him quite an asset in the airborne war against the Luftwaffe. *Captain Midnight* © 1946 (left) and 1944 (right) Fawcett Publications.

Right Captain Marvel, Jr. was just a young boy, Freddy Freeman, left for dead by the evil Captain Nazi. Rescued by Captain Marvel and given superhero powers by the great wizard Shazam, Captain Marvel, Jr. devotes his strength to the battle against the Axis powers. *Captain Marvel Jr* © 1943 (left) and 1942 (right) Fawcett Publications. adventure to be bloodthirsty and violent because it perhaps helps to dispel natural aggression. The comics may have worried mature adults but there seemed to be little proof that a nation of children turned to crime, rape, and murder after reading them.

Fawcett's *Captain Marvel* continued to dominate the newsstands. After the pile-driving success of Captain Marvel, who was given his own book in January 1941, Fawcett capitalized by bringing out Captain Marvel, Jr., a slender boy in blue who wore yellow boots and a red cape edged in yellow, in *Whiz Comics* issue 25, December 1941. In the late summer of 1942 Captain Marvel also introduced a Captain Midnight on the cover of the first issue of his new comic. Dressed in a tight-fitting red costume with pants that looked like riding breeches, tight black boots, matching gloves and a dark blue flying helmet, Captain Midnight's foldaway wings enabled him to jump out of airplanes and glide safely to the ground. For eight hectic years, Captain Midnight waged a war against crime, before interest in him waned, as it had done with most superheroes, and he faded away into obscurity with issue No. 67 of his comic, dated Fall 1948.

Captain Marvel, Jr.'s beginning was nothing if not violent. Teenager Freddy Freeman is out fishing with his grandfather on a small boat. They see a man fall into the sea. They do not realize that the man is Captain Nazi, who had been knocked out by

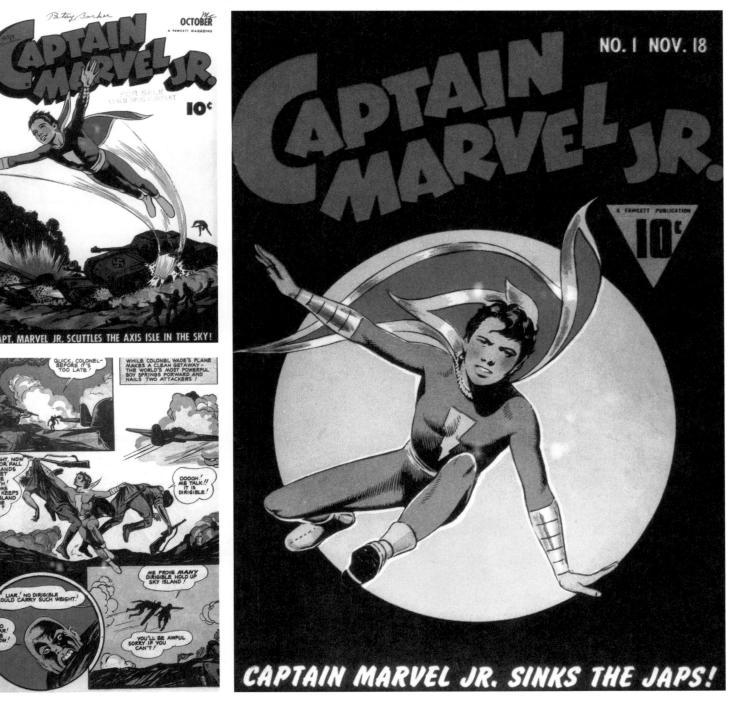

Drawn by Mac Raboy, Captain Marvel, Jr. was less cartoony and more realistic than his elder namesake and produced some of the finest and most detailed comic cover artwork ever seen. His look, dress and feats were idolized by the young comic-mad Elvis Presley. Captain Marvel, Jr © Fawcett Publications.

Captain Marvel after a grim air battle. Freddy's grandfather pulls the man aboard his small boat. The cruel Captain Nazi shows his true colors by killing Freddy's grandfather and breaking the teenager's back with an oar. Leaving Freddy to drown, Captain Nazi screams: "Cursed Yankees! We'll kill them all someday!"

Captain Marvel sees the stricken Freddy's dilemma, pulls him from the sea, and rushes him to the nearest hospital. But Freddy's back injury means he will be crippled for life. Captain Marvel, always compassionate, scoops up the unconscious Freddy and takes him to see Shazam, the great wizard who had given him his powers. "I've brought you a boy who is dying as a result of Capt. Nazi's cruelty. You must help him as you once helped me." With a mighty clap of thunder and lightning Freddy wakes to see his hero. With the exclamation "Captain Marvel!" Freddy is transformed into the lithe, slender figure of Captain Marvel, Jr. After several battles with Captain Nazi over the years, Captain Marvel, Jr. finally defeats him.

Freddy Freeman and Captain Marvel, Jr. came about due to the imaginative skills of Fawcett's comic staff and one man in particular. Ed Herron was one of the editors, who once sold scripts to Victor Fox at five dollars a time. Then he worked for Chesler Studios for a while, before landing a job at Fawcett. Herron holds the record for the longest superhero battle in history when he pitted Captain Marvel and Bulletman against the terrible Captain Nazi. It was a battle royal that continued over three issues of *Master* and *Whiz* comics. And during the battle, he introduced Captain Marvel, Jr.

Captain Marvel, Jr. was not fated to be a junior sidekick like all the other youthful heroes. Captain

Marvel, Jr. had to be different from Captain Marvel in shape and in character. He would not be drawn in the cartoony style of C.C. Beck and Pete Costanza (Costanza began by helping Beck but soon was drawing Captain Marvel stories himself), but in a more realistic manner. Herron called upon Mac (Emanual) Raboy, a master of comic art, to draw Marvel, Jr.

Raboy, like Herron, had worked in the Harry Chesler shop before coming to Fawcett to illustrate Bulletman in 1941. Herron moved him from Bulletman to draw covers and stories of Captain Marvel, Jr. in Master Comics. There is no doubt that Raboy drew some of the greatest comic covers anyone had ever seen. Like a number of artists in the top echelon, Raboy was slow to deliver on time. His attention to detail and painstaking care slowed him to the point that he was unable to cope with Captain Marvel, Ir.'s own comic, which came out cover-dated November 1942. This disappointed Herron. Although he admired Raboy's work, deadlines were deadlines, so Al Carreno was hired to illustrate the title. At one point Raboy did his cover art the same size as the actual comic page in an effort to speed his production up (normally the art was drawn a half or whole size larger). That didn't work and the pressures exerted by deadlines finally found a chainsmoking Raboy leaving Captain Marvel, Jr. in 1944. Eventually Raboy would draw the Green Lama, a Buddhist superhero for Ken Crossen's Spark Publications, illustrating both covers and stories.

Some of Raboy's Captain Marvel, Jr. covers for *Master Comics* and *Captain Marvel*, Jr. were beauti-fully rendered. The patriotic cover for *Master* No. 41 shows an incredibly slender boy surrounded by a reddish halo, walking through the smiling faces of

soldiers, sailors, and airmen. In *Captain Marvel, Jr*. issue No. 10 the cover is made up of two sections split in two. Under the title there is a full face portrait of a smiling Capt. Marvel, Jr. set against a red backdrop. To the right, on a white background, is a miserable full-face portrait of Adolf Hitler, his face cupped in his clenched hands.

Captain Marvel, Jr. was undoubtedly one of the best superheroes of all. His peak was during the war years, though his comics sometimes shone with the artistry of Bud Thompson and Kurt Schaffenberger in the years up to his end in 1953. One person who was very upset to see Captain Marvel, Jr. disappear into the wide blue yonder was Elvis Presley. The teenage superhero was Presley's idol from start to finish. He modeled his hair style on Captain Marvel, Jr. and later, during his Las Vegas years, Presley mimicked Junior's capes, albeit in an outrageous, exaggerated manner.

Harry Donenfeld of National/D.C. was desperately worried. He and Liebowitz went to their lawyers; Captain Marvel had to go. But why? Quite simply, Captain Marvel's sales were colossal, and were eating into Superman's profits. Toward the end of 1941, Fawcett Publications received a cease and desist order to stop publishing Captain Marvel on the grounds of plagiarism.

National/D.C. had no right to sue Fawcett. Apart from the fact that both Superman and Captain Marvel had super-powers and could fly, there was Below left Captain Marvel, Jr. was every comic-reading teenager's dream – from lame newsboy to the world's most sensational boy. *Captain Marvel, Jr* © Fawcett Publications.

86

Below Many comics, like Quality's *Military Comics*, eschewed superheroes altogether in favor of everyday heroes: gung-ho all-American action soldiers in a fight to the death with the enemy. *Military Comics* © 1943 (top left), 1944 (bottom left), 1945 (right) Quality Comics Group. no similarity between the two. Their origins were completely different; one came from a distant planet, the other was created by magic. One was more of a cartoon character, the other serious, the stories and art attempting realism. Initially the charge was booted out of court, but National appealed. Charge and counter-charge began a twelve-year legal battle that Fawcett would eventually lose in 1953. Possibly Fawcett could have pressed on, but the furore against comics was such that the company decided to cease publication of all its titles with the exception of adult, well-respected magazines like *Mechanix Illustrated*, *True Magazine* and others.

It wasn't all superheroes that came to the fore in

those exciting early years. There were funny animals, adventure, jungle, and sci-fi comics to name a few. And there was even war. Mindful of the way events were headed, Dell brought out a patriotic little number entitled U.S.A. is Ready (1941), and introduced another, already mentioned elsewhere, simply called War Comics. Quality put together Military Comics, which featured sections called "Army" and "Navy." And Hillman had Victory Comics...The Fighting Forces of Uncle Sam in Deadly Combat!

As noted earlier, there was growing criticism against the plethora of comic books available, and some of the companies took notice. The Parents Magazine Institute, anxious that children's reading

88

habits were being corrupted, published what became the first educational comic on the newsstands. This was *True Comics* (April 1941), which delved into history and published comic book stories of real-life heroes. The life of Britain's prime minister, Winston Churchill, covered 17 pages of the first issue, which sold 300,000 copies in its first ten days. It could be said that George Hecht, the publisher, used Churchill as a message to the U.S. congress to get moving and do something.

Much to everybody's surprise *True Comics* continued to be popular, encouraging the Institute to bring out a companion called *Real Heroes* (September 1941). Again, the comic sold well so the company brought out one for girls. Up to 1941, all comic books were aimed at male readers. *Calling All Girls* followed the same format as their male counterparts with tales of real life. Meanwhile Ned Pines's Better Comics, publishers of *The Black Terror* and others in a similar vein, saw the interest in factual comics, and came up with *Real Life Comics*. All proved very popular, though it is possible that they were made so by parents buying them for their children who would have preferred *Captain America* or *Superman*.

Albert Kanter, of Gilberton Publications, also felt that the increasingly maligned comic book could be put to good, reasonably educational uses and make money at the same time. He had the inspired idea of producing comics retelling the classics. Works like Below The much maligned comic book could be educational as well as patriotic. Albert Kanter's *Classics Comics* and subsequently *Classics Illustrated* retold great literature in comic book form. *Classics Illustrated* © Gilberton Publications.

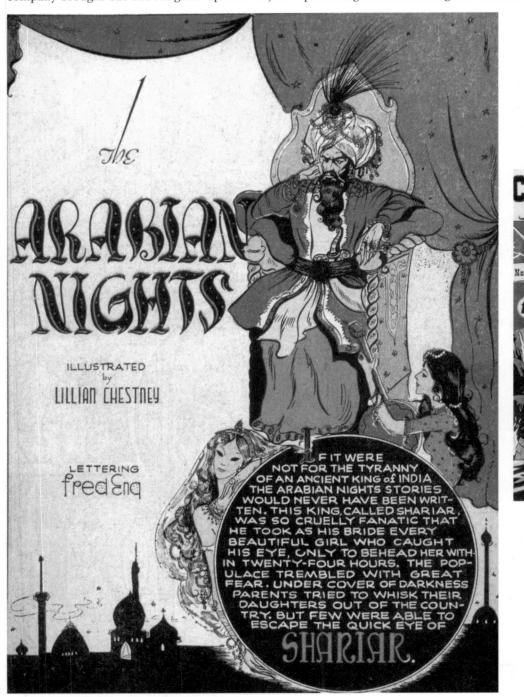

89

Shakespeare's Julius Caesar, Emily Brönte's Wuthering Heights, Dickens's Tale of Two Cities, all could be turned into comics, which is exactly what Kanter did. The first Classics Comic turned up in October 1941. It was The Three Musketeers by Alexandre Dumas. Somehow the meat was taken out in the hasty adaptation of the book, and it was not well drawn, yet the comic sold.

Below The first 'classics comics' were hastily adapted and not particularly well drawn, but as time went on the research and the artwork improved. *Classics Illustrated* © Gilberton Publications. As time went on comics based on the classics got a little better, but it was not until the fifties when new, better researched, better drawn editions came out that *Classics Illustrated*, as it was known from 1947, could be taken seriously. Gilberton Publications had a winner on their hands. These comics may have made the original authors turn over in their graves but at least they let youngsters know there was other literature besides *The Black Terror* or *Hangman*.

A "day of infamy" dawned on December 7, 1941. Japan, in a sneak attack, blasted the American Pacific fleet at its berth at Pearl Harbor, Hawaii. Thousands of sailors died, many warships were destroyed. The U.S. Congress pulled its head out of the sand and woke up, embarrassed and sweating. It need never have happened, but it did. Comic book publishers had been right all along, yet nobody in high places had taken any notice.

Finally, America declared war.

. THE BIOGRAPHY OF THE AUTHOR

Chapter Five

LET'S GO GIRLS

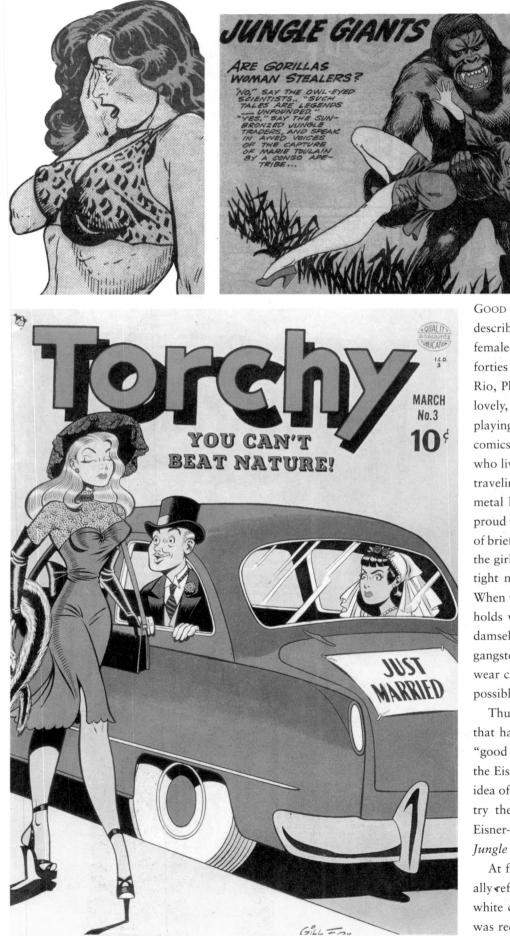

Left "Good girl art" – the comic book was always used as an easy way of getting the female form in all its curvy glory into print and the sweaty hands of teenage boys. *Torchy* © 1950 Quality Comics Group. Far left Anne, mate of Kaänga in *Jungle Comics* © Fiction House Magazines.

GOOD GIRL ART IS A TERM CURRENTLY USED TO describe the scantily clad, amply proportioned females who featured in the comic books of the forties and fifties. Sheena, Rulah, Camilla, Senorita Rio, Phantom Lady, Lorna, Mysta, the list is long, lovely, and very definitely sexy. Here were girls playing out young males' fantasy roles. In jungle comics they dominated the animals and the peoples who lived there. In science-fiction comics the spacetraveling women got away with wearing up-lift metal bras that Howard Hughes would have been proud to have invented for Jane Russell, the briefest of briefs, and fetching high heel boots. In war comics the girls hung suspended from an airplane, wearing tight mini-skirts, and flashing their stocking tops. When women became the vogue in comic books no holds were barred. They played private detectives, damsels in distress, foreign spies, western women, gangsters' molls, and criminals. Almost all would wear cheesecake clothing, or more often as little as possible.

Thurman T. Scott revived the Fiction House pulps that had ceased publication in 1932 by pioneering "good girl art" in comic books. In September 1938, the Eisner-Iger shop had approached Scott with the idea of publishing comics. He listened and agreed to try the title *Jumbo Comics*, as suggested by the Eisner-Iger team. He then added *Planet Stories* and *Jungle Stories* to the line.

At first there were no jungle babes. Jumbo actually referred to the large format size of the black and white comic. The size went against "Jumbo" so it was reduced to normal comic measurements. Then Iger showed Sheena to T.T. Scott. Sheena was being drawn by his shop as a daily strip for an English newspaper. British newspaper comics were much more liberal with sex than American strips – punching a woman in the face was O.K. but naked breasts? No dice. The leading English tabloid paper, the *Daily Mirror*, already had a daily comic strip featuring Jane, the risqué lady who bared all.

It goes without saying that Thurman sympathized with the British viewpoint...the more revealed, the better the sales. He had no hesitation in running Sheena in *Jumbo Comics*, for he appreciated a pretty woman and knew many others did, too. The Eisner-Iger studio put together a compilation of the Sheena strip originally drawn for the English daily. Sheena hit pay dirt. Her strip became all-American with new stories and art and finally in color. Without Sheena it is possible that *Jumbo Comics* would have vanished off the scene. Soon the handsomely proportioned Sheena with the long golden tresses, gold bangles around her ankles, attired in a becoming but skimpy, leopardskin outfit, was the belle of the comics' ball.

Sheena was so popular she became an institution. She was given her own quarterly comic book in 1942, and in 1955, two years after she finished in comics, actress Trish McCalla found fame and fortune starring as Sheena in a syndicated television series. McCalla attends comic conventions today, where she is still regarded with adoration by fans who remember her television show all those years ago.

It was obvious with her success that Sheena wouldn't remain Number One in a Field of One for

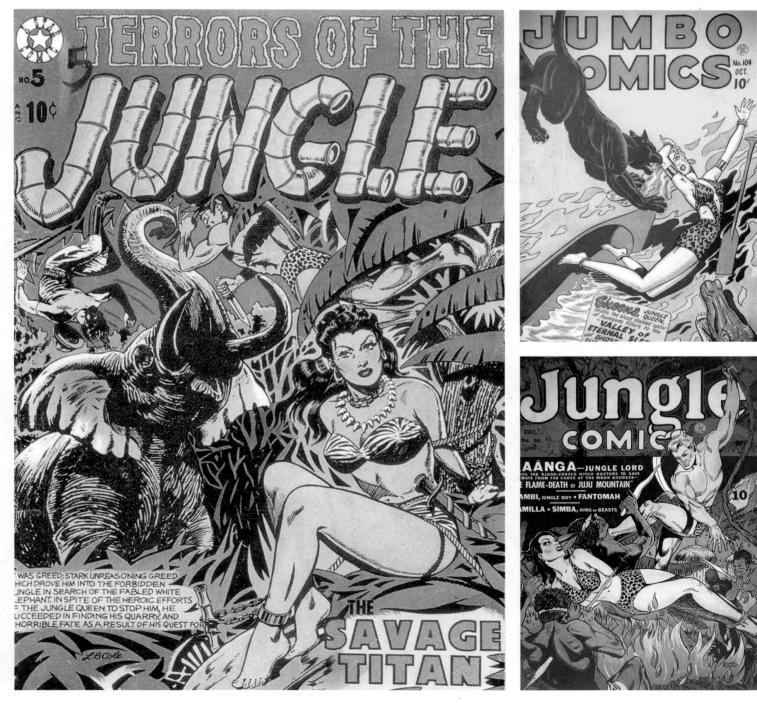

Below Sheena, the scantilyclad jungle heroine of *Jumbo Comics*, originally adapted from a British newspaper, became a huge success with the male population and soon had a host of voluptuous imitators. *Terrors* of the Jungle © 1953 Star Publications. *Jumbo Comics* © 1948, *Jungle Comics* © 1942 Fiction House Magazines. very long. T.T. Scott wanted to cash in on Sheena's popularity and came out with *Jungle Comics* (January 1940). Like *Jumbo*, *Jungle Comics* was packaged by Eisner-Iger. Its lead story was Kaänga, Jungle Lord. Kaänga was a decided rip-off of Tarzan, though thankfully he didn't pound his chest and bay to the sky when he triumphed in battle. His mate was Anne, a delicious brunette who seemed to get her kicks from bondage. Anne was almost always tied to trees, stakes, or large wild beasts, or she was being carted off by natives wearing tiger masks or hoods.

Another lass who appeared in *Jungle Comics* was Camilla. She wore a sassy zebra skin that revealed enough flesh to make her interesting to young men and pubescent boys. Like Sheena she was a free agent who preferred to dominate the proceedings. In later issues of *Jungle* Camilla's costume shrank considerably; her suggestive poses rendered by Bob Lubbers and top good girl artist, Matt Baker, seemed to belie the need for any costume at all!

In *Jumbo* the sensual delights are even greater. There's Sheena who revels in her athletic prowess revealing her body in poses sure to excite. Even better is the wonderful and humorous Sky Girl, almost always drawn by the girly king, Matt Baker. His illustrations of Sky Girl's rear, the way her short dress suggestively rides up her thighs, and the numerous times the top half is torn to show off slinky underwear, and her open legs positions, show Below left Often the artwork's blatant sexual symbolism left little to the imagination. *Jungle Comics* © 1948 Fiction House Magazines.

Right In the fifties the comic book Sheena became so popular she made the leap from the page to small screen stardom, played by Trish McCalla. Jumbo Comics © 1944 (left) and 1948 (right). Sheena, Queen of the Jungle © 1952 Fiction House Magazines.

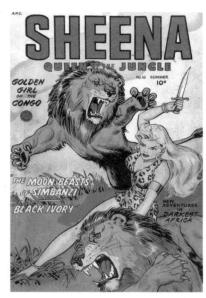

JUMBO

SHEENA. JUNGLE QUEEN The PYGMY'S HISS IS POISON!

95

this really wasn't the stuff for kiddies to read...though there's no doubt they did. Girls featured in all the main stories, from the Hawk's buccaneering sea adventures to AX-5, special agent. *Jumbo*, one of the best of the good girl comics, continued for 15 years before it finally ended.

Besides Jungle Comics, two other Fiction House titles hit the streets for January 1940. One was the first bi-monthly science-fiction comic to come into being. Planet Comics, as it was called, ran continuously until 1953 and produced some excellent sci-fi stories during its 13-year run. The other comic was *Fight Comics*, which featured bosomy Tiger Girl in the by now regulation skimpy-wear. Tiger Girl was a great hit when she arrived later in *Fight's* run, partly due to fabulous art by Matt Baker. Before Tiger Girl got the top spot in *Fight*, U.S. secret agent Senorita Rio provided the major titillation. A leggy brunette who went in for tight skirts and black suits, Senorita Rio frequently changed costumes in her many tales of beating German agents in South America.

The beautiful Senorita was often drawn by Lily Renee, one of a trio of excellent female artists employed by the Iger shop (the other two were Fran Hopper and Marcia Snyder). As an aside, Renee illustrated *Arabian Nights* issue No. 8 in the *Classics Comics* series. The artwork is beautiful and very imaginative; Renee conveyed all the magic of the *Arabian Nights*. Even if you are not a collector of the classics, this is one that should be included in any comic book collection. Lily Renee's contribution to the comics has been much under-rated and she should be recognized for the great artist she was.

Wings Comics (September 1940), and Rangers Comics (October 1941), were not so concerned with women and sex in the beginning. Wings got right

T.T. Scott's Fiction House titles Jungle Comics, Planet Comics and Fight Comics pioneered good girl art with classic characters such as the feisty Tiger Girl drawn by girl specialist Matt Baker. Planet Comics © 1943, Fight Comics © 1947 Fiction House Magazines.

down to fighting the Axis powers, boasting that they went to war before their country. As for Rangers, it had Firehair, a red-haired, bosomy girl who fought Indians and bad cowboys with gusto. Wings eventually turned from just being a war comic to being a good girl art war comic with Captain Wings spending more time with leggy blondes than perhaps he should.

Throughout the war years T.T. Scott's steamy stable of near-naked heroines, posing in as many salacious positions as humanly possible during their battles with natives and animals, were virtually exclusive in the comics field. There were other girls such as Phantom Lady, who was a fairly demure young woman fighting crime in the pages of Quality's Police Comics. She was actually Sandra Knight, well-to-do daughter of Senator Henry Knight. Bored with the round of parties and fetes and frivolous events, she got herself a costume and turned into a secret crime-fighter, making life hell for the criminals living around Washington D.C. Phantom Lady is thought to have been created in the Iger shop.

Quality's Phantom Lady lasted from 1941 to Police Comics No. 23 (October 1943) when Iger and Everett Arnold, Quality's energetic boss, went their separate ways. For some reason Phantom Lady went with Iger, only to reappear in a much more provocative, sexy manner in 1947. Iger had obviously done a deal with Victor Fox, who turned her into one of the most controversial queens of comic book sleaze ever seen.

By 1941 there were 160 different comic book titles on the market, the superhero genre being the largest group. Almost exclusively male with a male following, there seemed to be no interest in creating

a female heroine for young girls to identify with and enjoy. That was until William Moulton Marston came on the scene.

Dr. William Moulton Marston was apparently the last person in the world to write about a comic book superheroine. He was a doctor of psychology from Harvard who had written several books on the subject as well as numerous newspaper and magazine articles. He was credited with discovering the systolic blood-pressure test in 1915 which led to the discovery of the lie detector. He taught and lectured at Radcliffe, Tufts, Columbia, and the New School of Social Research.

Surprisingly, however, the psychologist was very interested in the comics. Looking over the news-

I COULD HAVE FORESEEN

MOST OF THIS ... IMAGINE

stands, Marston was appalled to find there were no heroines of any significance. "Women's strong qualities have become despised because of their weak ones," Marston wrote. "The obvious remedy is to create a feminine character with all the strength of a superman plus all the allure of a good and beautiful woman."

It was all very well to suggest there should be a female counterpart to Superman, but would the men running the comics industry go for feminine crimesmashers, especially having seen the few filler heroines bite the dust after a couple of appearances? How would young boys react to a female Superman? Marston's response was not exactly the stuff to allay worried parents' doubts about their children's

.... DOLLING UP IN A

BLACK WIG, LOOK ME ... THE CLEVER SECRET by night in the pages of Police ING FOR A SPY .. AGENT ... TRAIPSING OFFTO Comics; and (bottom right) WASHINGTON EVERY NIGHT .. Kaänga's wild and shapely mate Anne from Fiction House's Jungle Comics. Police Comics © Quality Comics Group. Jungle Comics © Fiction House Magazines. OUR VOICELESS FRIEND ... I HOPE HE'S THE HANTOM ADY!

Right Senator's daughter by day, the sexy and demure Phantom Lady fought crime

AND

50 LONG, KAANGA-TAKE GOOD CARE OF

BETTER PUPIL THAN

TURNED OUT TO

BE!

6 FE

NEAL

HAVIN

GOL

reading matter: "Give young boys an alluring woman stronger than themselves to submit to and they'll be proud to become her willing slaves."

In the face of mounting criticism against comic books, one or two publishers decided to give their fare credibility by retaining educational figures to endorse their comics as "wholesome." Maxwell Gaines, the publisher of All American Comics Inc., retained Marston as a consultant. He hired Marston to give his few titles a decent image and he wanted the doctor's advice on the educational comics he was thinking of marketing. Marston would certainly add status to comics featuring history, science, and the Bible.

One day, whilst in Gaines's office, Marston surveyed his range of comic characters, which included the Flash, Green Lantern, and Hawkman. "Why is it," Marston reportedly asked Gaines, "that there are no women superheroes?" Gaines had never thought of this before. Superheroes had always been men, right? While there was always the problem that boys might not like a superwoman, there might still be room for the right sort of woman superstar, so he discussed the idea further with Marston. An agreement was reached; Marston would go away and create a superwoman character. His pen name would be Charles Moulton, the middle names of Gaines and Marston.

Wonder Woman's first appearance took place in All Star Comics (No.8, December 1941). This was Gaines's most popular comic and would allow Wonder Woman maximum exposure. Her success was strong enough for Wonder Woman to be promoted to the lead story in Gaines's new title, Sensation Comics, dated January 1942. In the summer of 1942, Wonder Woman was given her own comic, but she appeared frequently in *Comic Cavalcade* as well.

Editing Marston's scripts was the responsibility of youthful comics genius Sheldon Mayer. The pipesmoking, bespectacled young man had to curb Marston's enthusiastic excesses, realizing much of bondage overtones in his scripts were unacceptable in a children's book. Still, there was enough left in to give the critics a field day.

Editorial censorship aside, Marston had complete control over his creation, even down to selecting the artist who drew Wonder Woman. This was Harry G. Peter, who had started working as a staff artist for a San Francisco newspaper in 1906. His art followed the late nineteenth-century decadent style fashionable early in the twentieth century, and it was a style Peters never dropped. Rather he developed it and honed it in his subsequent work for various humor magazines, and it was his simplistic, heavy lines that Marston felt would be ideal for Wonder Woman. Although Peters's work has been variously described as wooden and awkward, his drawings, Marston surmised, had a childlike quality youngsters would find appealing. He was right; even after Marston's death in 1947, Peters continued with Wonder Woman until 1957.

Wonder Woman's origin is clearly the work of an over-heated imagination: "Wonder Woman's story is the story of her race. It reaches far back into the Golden Age when proud and beautiful women, stronger than men, ruled Amazonia and worshipped ardently the immortal Aphrodite, goddess of love and beauty. Out of that legendary glory, which present day Amazons still preserve in secret, comes Wonder Woman, the most powerful and captivating girl of modern times...." That's just the beginning.... Wonder Woman, the first ever female superhero, premiered in Maxwell Gaines' *All Star Comics* in 1941, then was swiftly promoted to his lead title *Sensation Comics*. *Sensation Comics* © 1945 D.C. Comics, Inc.

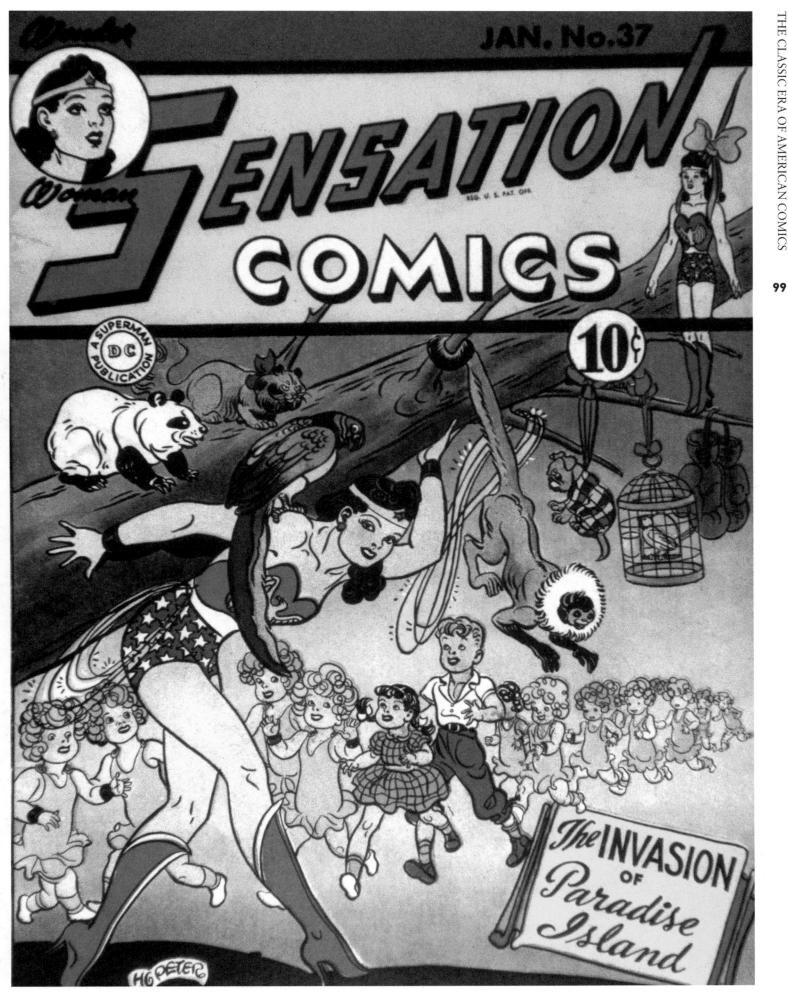

THOUGH DIANA HAS NO KNOWLEDGE OF THE STOWAWAYS, SHE FEELS INSECURE AND TRANSFORMS HERSELF SWIFTLY INTO WONDER WOMAN. I FEEL AS THOUGH SOMEONE WERE WATCHING ME - I'LL TAKE OFF QUICKLY

The early Wonder Woman strips have developed something of a name for their thinly-veiled use of bondage: whips, chains, handcuffs and lassoes run riot through its pages. Sensation Comics © 1945 D.C. Comics, Inc.

Wonder Woman comes from Paradise Island, the secret home of the Amazons. No man is ever allowed to set foot on this all-girl island. She is born when Paradise Island's ruler, Queen Hippolyte, makes a statue of a baby girl, and the goddess Aphrodite gives the baby statue life. The Queen christens her baby daughter Princess Diana. The princess reaches adulthood and we are told "is lovely as Aphrodite, as wise as Athena, with the speed of Mercury and the strength of Hercules."

Princess Diana had one fatal flaw. She fell in love with Captain Steve Trevor, whose airplane crashed onto Paradise Island. Her love proved so strong that Diana left the island and lost her immortality in order to escort Steve home to America. Once in America she assumed the role of Diana Prince, a nurse, to enable her to stay with Steve. But when called upon, she was Wonder Woman.

Wonder Woman's patriotic costume consisted of tight blue, star-studded shorts, red, almost knee length, high heel boots edged in white at the top and a red corset-type garment cut to the waist at the back. A large golden eagle adorned the front of the garment. On her head Wonder Woman wore a gold band with a star at the center. On her right thigh she carried a furled lassoo, an item she often used.

Marston's penchant for bondage, whips, and chains comes across all too strongly in the earlier Wonder Woman comics. In one 16-page story, according to Mike Benton in his splendid *Superhero Comics of the Golden Age*, bondage scenes run riot. There are at least a dozen incidents with women handcuffed in their underwear, one blindfolded woman chained to a bed, another bound and gagged to a chair, and Wonder Woman chained in the classic position of hands above head, manacled to a wall.

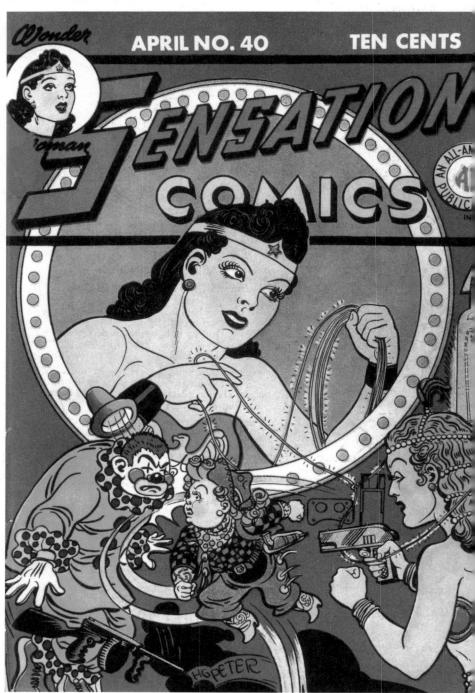

100

THE CLASSIC ERA OF AMERICAN COMICS

role models: Brenda Starr was a Superior Comics-produced newspaper reporter, crimefighting heroine, while Patsy Walker was a more lighthearted teen character in the *Archie* vein. *Patsy Walker* © 1946 Marvel Comics Group. *Brenda Starr Comics* © 1948 Superior Comics Ltd.

Below More female comic book

America had gone to war. There was no more talk of the Dodgers, or movies, or Bing's latest hit – the war was on everybody's lips. The nation switched from isolationism to a positive role in the world, and Americans, like the comic book heroes, were itching to be up and at 'em! Manufacturing industries moved from peace to war at the drop of a hat, Detroit converted from making cars to tanks overnight, and the Depression disappeared.

By 1943 America's precious youth had left the Kansas farms, Indiana's cornfields, New York's skyscrapers, and California's sun for lands far, far away, lands the Montana ranch hands had never heard of. Many went to the Pacific, the rest crossed the Atlantic to Britain to build up for the proposed invasion of Europe. To ensure the hundreds of thousands soldiers, sailors, and airmen were given all the amenities of home life, each base provided everything from Coca-Cola to...comic books. Sales of the 143 titles on the newsstands in 1942 were rising at an unprecedented rate with 15 million comics being sold every month. With sales to a captive market overseas, circulation rates kept going up, up, and up.

Fiction House good girl comics were just the thing our boys needed over there. The company's *Big Six of the Comics*, as Fiction House promoted itself, had combined sales totaling 737,000 a month by September 1942. Just like movie star actresses such as Betty Grable, Sheena was lording it in the barrack rooms across Britain and the Far East.

101

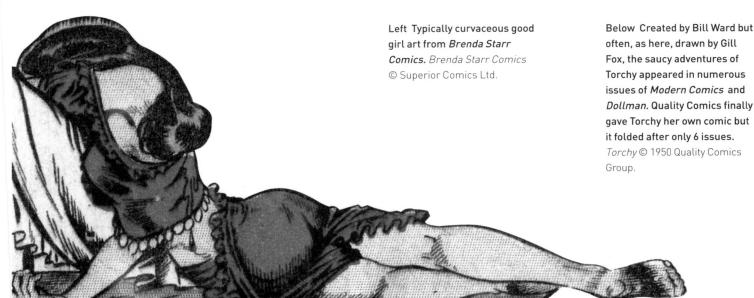

Senorita Rio traveled in soldier's kit; in the crumpled, and frequently re-read, pages of *Fight Comics* the lovely Senorita's seductive looks promised great times back home. When finally the men were slogging across a war-ravaged Europe, candy, gum and strips of sexy Sheena were all there was of home. For that reason alone, Thurman T. Scott and Jerry Iger, probably without realizing it, did much for the sanity of innocent youngsters forced into a living hell.

Compared to Superman's 1,100,000 bi-monthly sale, Fiction House's 737,000 for six titles is quite small. This figure was to nearly double in the next couple of years, thanks partly to sales to the vastly increased number of U.S. forces stationed around the globe. At the time these figures were issued, Parents Magazine's True Comics, Real Hero Comics, and Calling All Girls were chalking up 750,000 a month, Quality's nine titles, including Police Comics, sold 1,100,000 monthly, Marvel's ten comics sold 1,250,000 while Street & Smith, who published The Shadow, Doc. Savage, and Supersnipe, and five other comic books, chalked up monthly sales of 1,285,000. Nevertheless, Harry Donenfeld's National Comics outsold everybody else with sales of 1,375,000. Except Fawcett. By July 1943, Fawcett's 14 comics had a combined circulation of over 7,400,000. And Captain Marvel Adventures passed Superman to become the biggest selling comic of all time.

Following criticisms of the comic media by the likes of Sterling North and other well intentioned people, Maxwell C. Gaines went on CBS radio on April 22, 1942 to broadcast a rebuttal in defense of the pictorial literature he is mostly credited for. This is a rare and historic document originally published

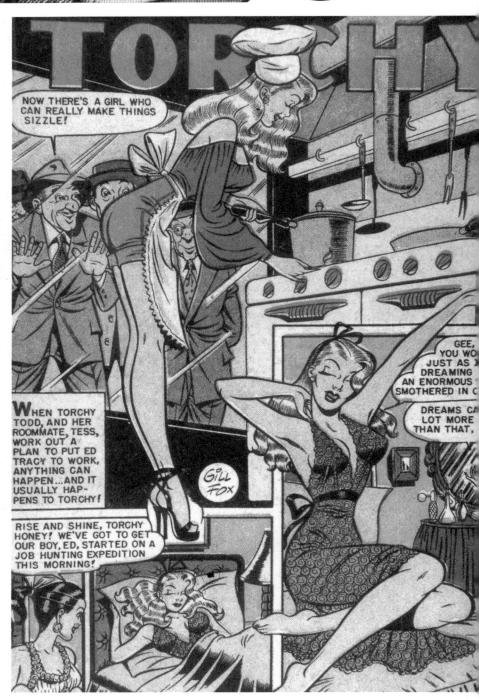

Left Slave Girl Comics drawn by Howard Larsen and published by Avon, appeared for only two issues. Set in ancient Arabia the artwork's background minarets often had a strangely phallic look to them. Slave Girl © 1949 Avon Periodicals.

in Comic Book Marketplace magazine in June 1996.

In his address, he claimed that comic books were becoming recognized, by psychologists, child experts, educators, and even the federal government, as a way of "reaching and understanding the child, particularly those between the ages of eight and fourteen. A letter, which bore the personal signature of Henry Morgenthau, Jr., a Secretary of the Treasury, and addressed to the boys and girls of America, was about to be reproduced in over a hundred comic magazines (from June to July 1942), and purchased by approximately 25 million children, or their parents. The letter would outline ways of helping the country in the war effort, by buying War Savings Stamps. Gaines stated that this letter was "just the opening gun in our concerted and continuous campaign to further impress upon the boys and girls of America the need for their full cooperation in our total war effort."

Gaines went on to rebut the view that children should be "protected" from information about the war, by citing the arguments of Dr. Lauretta Bender, Psychiatrist in Charge of the Children's Ward at Bellevue Hospital in New York, and Acting Head of the Department of Psychology at New York University: "Children will have a greater sense of security and will experience less fear if they have a definite, prescribed job to do in the war program. They must have a feeling of participation and in this way, will achieve a feeling of responsibility."

He went on to argue that many leading educational psychologists believed that comic books could be used by upper-grade teachers since they provide reading and vocabulary-building experience for children who might otherwise not get it. Comic books could act as an out-of-school supplement to the child's reading experience. The Book Review page in all of the Superman-D.C. comic publications had been, according to Gaines, "successful in getting many children to visit their public and school libraries more frequently."

Gaines's talk is, one would suppose, quite honest. Certainly, the child psychologists he dragged up were retained by National/D.C. and All-American, so they would obviously be in sympathy with those who were paying them money - Gaines at least admitted they were on the "Editorial Advisory Board." But D.C./All American comics were "clean" compared to some - Lev Gleason springs to mind. Check out Boy Comics issue No. 4. The splash page of the "Crimebuster" story, drawn by Charles Biro, is not the stuff Gaines was talking about. It shows a hooded executioner about to behead a lovely girl. Her arms are bound behind her, her head resting on the block. Behind her there are seven more lovelies all bound, sexily attired, and waiting for the chop. Perhaps they will be saved; Crimebuster is racing to their rescue, though there appears little hope for the girl with her head on the block.

Gaines, it has to be said, was more responsible than many comic book publishers of the day. Only a few comic producers were creating comics with subject matter that was intended to be 'suitable' for children: National/D.C., All American, Dell in particular, Gilberton, Fawcett, and Quality. In an effort to boost sales, many producers, among them Gleason, Marvel, and Fiction House, tended to be more violent, with lashings of sex and terror. Comics such as *Hangman* and *Captain America* provided gruesome characters and stories, but the children loved them. They wanted to be frightened; they knew it wasn't real. Only the parents were scared! Chapter Six

ANIMAL CRACKERS

THE CLASSIC ERA OF AMERICAN COMICS

106

"THEY WERE SO FAR AWAY THAT I NEVER MET THEM. But their pay checks were always good," Carl Barks laughed, his eyes twinkling with the humor that has made him one of the greatest comic artists of all time. He was talking about his long association with Western Printing and Lithograph Company, printers and owners of Dell Publishing. The career of Carl Barks culminated in his creation of the world's most beloved miser, Uncle Scrooge McDuck, and his wonderful drawings and stories of Uncle Scrooge, Donald Duck, Huey, Dewy, and Louie and the everlucky Gladstone Gander.

Dell Publishing was the leading exponent of funny animal comics. George T. Delacorte, founder of Dell Publishing, thought there was a future in comic books as far back as 1929 when he published a 24-page weekly tabloid similar to the Sunday newspaper comics. A third of its pages were printed in color, the rest black and white. *The Funnies* contained quite a lot of original material and sold for ten cents. Sales were never very good and *The Funnies* died after 36 issues. Four years later, Dell, under the guidance of Maxwell Gaines, published *Popular Comics*. It was, as noted in the first chapter, almost identical with Gaines's *Famous Funnies*, published by Eastern Color. Later in 1936, Dell published *The Funnies* in comic book format, and *The Comics* early in 1937. All three were packaged and printed for Dell by Gaines at the McClure Syndicate plant. Dell's vice-president was Helen Meyer. An astute

Below Dell started out in the comic market publishing reprinted "funnies" from the Sunday newspapers under the guidance of Maxwell Gaines. Famous Funnies © 1941 Eastern Color Printing Co.

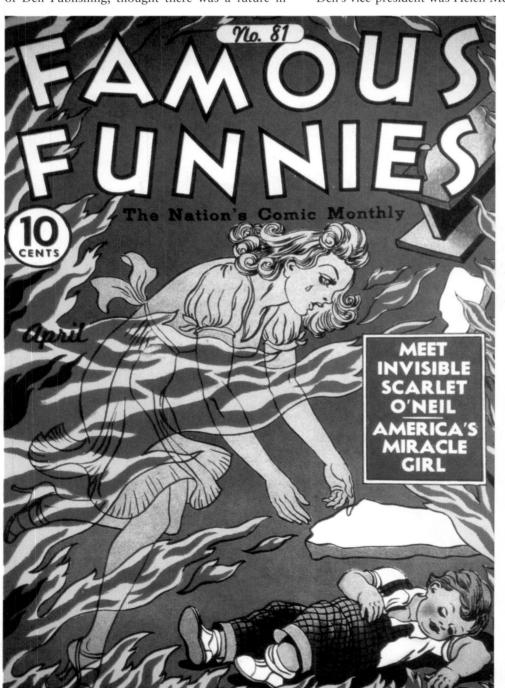

THE CLASSIC ERA OF AMERICAN COMICS

business woman, Meyer saw how well Walt Disney newspaper cartoons of Mickey Mouse and Donald Duck were received, and how successful Disney cartoon feature films sold out at the box office. Meyer went to Walt Disney Studios and came away having successfully negotiated a licensing arrangement for Dell to produce Disney characters in comic book form. In October 1940, the first issue of *Walt Disney's Comics and Stories* appeared, and was an instant hit. In fact, the deal Meyer struck with Disney was one of the best in comic book history. Some of the publications of Disney movies in comic book form, like *Snow White and the Seven Dwarfs*, *Pinocchio*, and *Bambi* were, and still are, artistic treasures always to keep.

Below The license Dell secured in 1940 to produce Disney characters in comic book form was one of the most lucrative in comic book history. *Walt Disney's Cinderella* © 1950 The Walt Disney Co.____

Following the great success of the Walt Disney comics, Dell's enhanced credibility made it easier to obtain similar contracts with Warner Bros. Studios and Walter Lantz Studios to publish all their characters under license. In the fall of 1941, Warner Bros.' *Looney Tunes and Merry Melodies* comic first appeared, featuring Bugs Bunny, Porky Pig, and most of the cartoon gang from Warner's. The first Walter Lantz comic, *New Funnies*, was cover-dated July 1942.

Dell entered into an agreement with Western Printing & Lithographing Company who put together all the comics and printed them at their Poughkeepsie, New York plant. Editorial work was carried out in Dell's New York offices. As an

historical aside it is worth commenting on K.K. Publications and Whitman Publishing, both of whom were tied in with Dell and Western Printing. Kay Kamen worked for Disney Studios as their merchandising guru in New York. His job was to hand out the licenses for Disney cartoon characters to those who wanted to manufacture toys, games, books, and numerous other items created in the likeness of Donald, Mickey, and the rest. Kay Kamen, under the initials K.K., was the publisher even though Dell actually was. K.K. had come about in a deal with Whitman Publishing in 1935 when the pair shared publishing Mickey Mouse Magazine, a large format comics and stories magazine that came out in 1935. In 1940, the regular comic, Walt Disney's Comics and Stories, replaced Mickey Mouse Magazine.

By 1942 Dell had become a very profitable company with a virtual stranglehold on all the major licensing deals. Its comic output was flourishing with new titles being added on a regular basis. Walt Kelly, who worked as an animator for Disney, returned to the East and did a feature called "Kandi the Cave Kid" for *Looney Tunes*. At the time, almost all artwork was credited to Warner Bros. cartoon producer, Leon Schlesinger, who could not write or draw. Yet it was his signature that appeared on the covers of *Looney Tunes* and on the splash pages of the strips in the comic.

Carl Barks was born March 27, 1901 in Merrill, Oregon. It is a small town set in a valley beneath the tree-covered hills. At the age of 15 he enrolled in a mail order cartooning course, decided it wasn't for him and didn't finish it. For the next few years, Barks traveled around working as a logger and steel worker, among other things. But his interest in art never abated, and in the late 1920s he began to sell

108

THE CLASSIC ERA OF AMERICAN COMICS

Left and right Mickey Mouse, Bambi and Donald Duck – key titles in the Dell-Disney comic deal. Walt Disney's Mickey Mouse © 1949, Walt Disney's Bambi © 1948 The Walt Disney Co.

Below Bugs Bunny and Porky Pig – after Dell's Disney success, an exclusive license with Warner Bros. cartoon franchise followed in 1941. Looney Tunes and Merry Melodies Comics © Warner Brothers Cartoons.

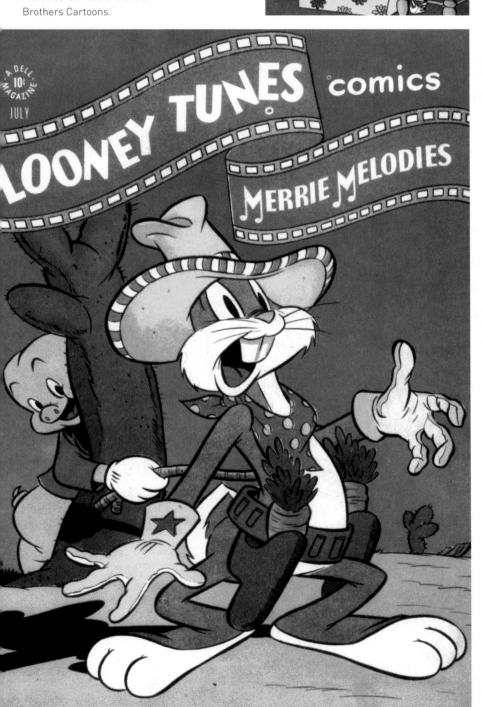

his cartoon drawings. His work appeared in humor magazines (one was called *Judge*), but he found that slightly risqué work was well received in a number of more lowbrow publications. One such journal was the *Calgary Eye Opener*, based in Minneapolis, whose editor and publisher much admired his cartoons of women in states of undress. In 1931 the magazine offered him a staff job and there he remained until 1935.

Then Barks heard about a job at the Disney Studios in Hollywood. He applied for the position of an "in-betweener," that is the person who creates drawings that fill in the movement between the key drawings done by more experienced artists. For this Barks was paid \$20 a week, but was soon earning more when the studio discovered his story creativity. He graduated to the story department, where he wrote the plots for Donald Duck cartoons. Although Barks enjoyed the work, the Los Angeles environment and air conditioning in Disney's studios played havoc with his sinuses. In 1942 Barks tendered his resignation and moved to the San Jacinto desert where the dry climate was better for his health. There, he raised chickens and returned to freelance cartooning.

Before leaving Disney, Barks and Jack Hannah, another artist at the studio, drew what would be the world's original Donald Duck comic book for Dell-Western Printing. Written by another Disney studio staff member, Bob Karp, *Donald Duck Finds Pirate Gold* was produced in Dell's Four Color (F.C.) series and was Issue No. 9. The Four Color series was made up of mostly one-shot comics, though popular characters might have new issues periodically. If the comics were extremely popular, they would be moved to a regular (monthly or bi-monthly) footing.

Donald Duck finds Pirate Gold came out in 1942 and it was an immediate success for Dell. Shortly after, Barks was approached by Western Printing, given a script, and asked to draw a ten-page story for Walt Disney's Comics & Stories, the very successful comic published under license from Disney, by Dell-Western. Carl read the script, made changes, and drew the first all-original Donald Duck story for Comics and Stories. That was enough. Dell hired him, and for the next 24 years Barks wrote and drew all the ten-page Donald Duck tales in the comic.

During this time Barks developed Donald Duck from the irascible, bad-tempered creature the movie cartoons made him out to be, into a rather bumbling person who gets himself into trouble without realizing until it is too late. Barks said himself that his characterization of Donald was to make him "like the average human being." Huey, Duey, and Louey were Donald's mischievous nephews who diligently studied their Junior Woodchucks Field Book, and saved their Uncle from many a plight. Barks invented Duckburg to give the ducks an established home town that was like so many across America. He brought to this town Donald's long-suffering girlfriend Daisy. Barks invented many memorable characters; there was Gyro Gearloose the inventor, and the devil-may-care, lucky Gladstone Gander. But the duck that put Barks's name in lights, who has become one of the most loved cartoon characters of all time, is Uncle Scrooge McDuck.

Left The sea monster from "No Such Varmint" in Walt Disney's Donald Duck. Walt Disney's Donald Duck © 1951 The Walt Disney Co.

Below Ex-Disney animator Carl Barks successfully drew original Donald Duck strips for Dell for almost a quarter of a century. Walt Disney's Donald Duck © 1946 The Walt Disney Co.

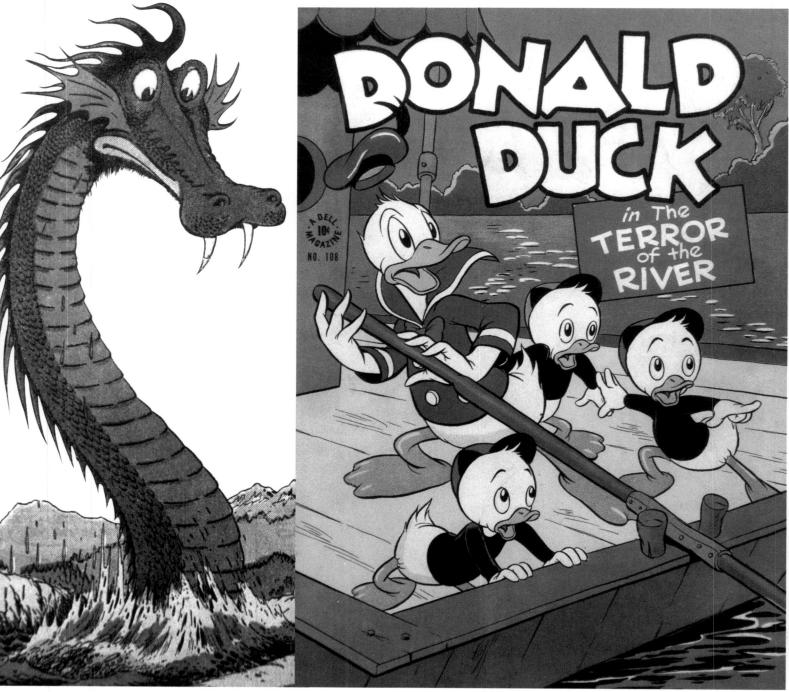

THE CLASSIC ERA OF AMERICAN COMICS

Below Carl Barks went beyond the Disney screen incarnations inventing Duckburg – the home town of Donald; his nephews – Huey, Duey and Louey; and avaricious Uncle Scrooge. Walt Disney's Uncle Scrooge © 1954 (left) 1960 (right) The Walt Disney Co. A full-length adventure appeared in *Donald Duck* in 1947. Called "Christmas on Bear Mountain" (F.C. No. 178 December 1947), it introduced Uncle Scrooge to the world for the first time. Uncle Scrooge had a vast fortune which he kept in gigantic money bins in a huge office complex shaped like a safe. Because he was so paranoid about his money Scrooge was always devising means to protect it, often employing his long-suffering nephew Donald to help him. Scrooge's great enemies were another wonderful Barks creation, the Beagle Boys. Always wearing little masks, all with prison numbers on their clothes, the Beagle Boys were continually after Scrooge's money. And for good reason. In 1953, Scrooge's fortune was estimated at a staggering five hundred million, trillion, trillion, trillion, trillion, trillion,

Scrooge was not afraid to tell everyone how he made his fortune. He was a tough, sometimes unruly, Scot who made money wherever the opportunity arose. He made money on the seas, in cattle, in the mines, in oil and other ventures. He used to tell his nephews that they would love money the way he did if they worked as hard as he had. He amassed his fortune, he told the boys, "by thinking a little harder than the other guy...by jumping a little quicker."

Uncle Scrooge appeared in many of the adventures with Donald and the nephews. In fact he organized them, paying Donald a bean-counter pittance to go along with him. Donald, being Donald,

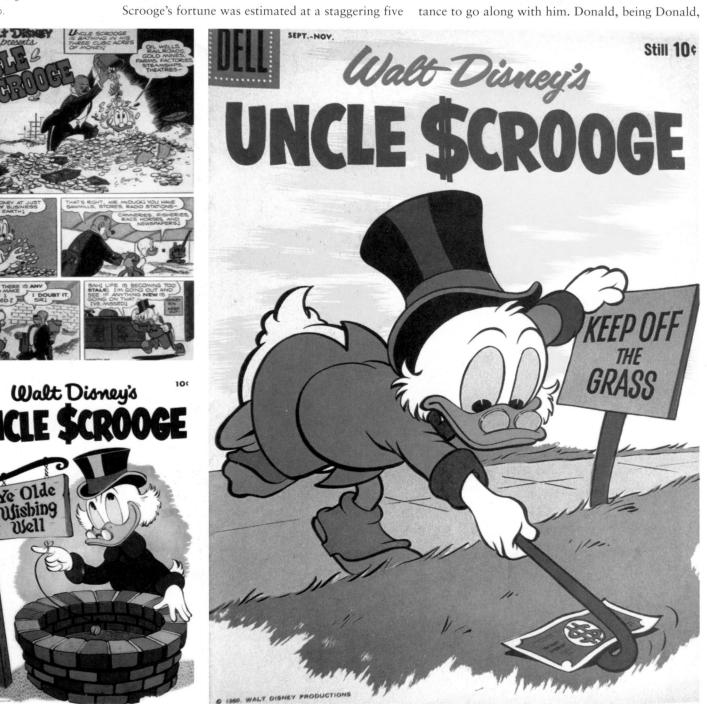

always accepted, but not without a little grumbling along the way. Some of the greatest comic books of all were the Donald Duck Four Colors starring the tough old Scot, such as*The Pixilated Parrot*, *Voodoo Hoodoo*, *The Magic Hourglass*, and *Christmas for Shacktown*.

There were at least 28 Four Color Donald Duck comic books, all but two written and drawn by Carl Barks. There are 24 years of ten-page Donald Duck stories in *Walt Disney's Comics and Stories*. Every one is a masterpiece of pure art and storytelling. Barks said he kept his writing simple to encourage people to read, but every text balloon on the pages has something to say. His observation of the world about us, people's foibles, habits, and characters all come out in his stories and drawings of the wonderful ducks. It is impossible not to laugh with his Donald Duck stories.

Carl Barks retired from comics in 1967. Since then he has produced duck paintings, such beautiful works that one sold for a record \$250,000. The first Barks duck painting sold for a mere \$150 in 1971 but most will sell for over \$100,000 today. The paintings are generally scenes from the comics he drew long ago, but the light and shade and the colors inherent in the works are breathtaking. Since his retirement Carl Barks has traveled the world to meet his millions of fans. His tales have been printed in a dozen different languages, and reprinted again and again. He was inducted into the Jack Kirby Hall of Fame in 1987 and was given the Disney Legends Award for a lifetime's achievements.

Collectors can rest assured that all his comic book work has been faithfully reprinted in books and in comic book form. Gladstone Publishing, run by Bruce Hamilton, a huge fan of Barks's work, had an

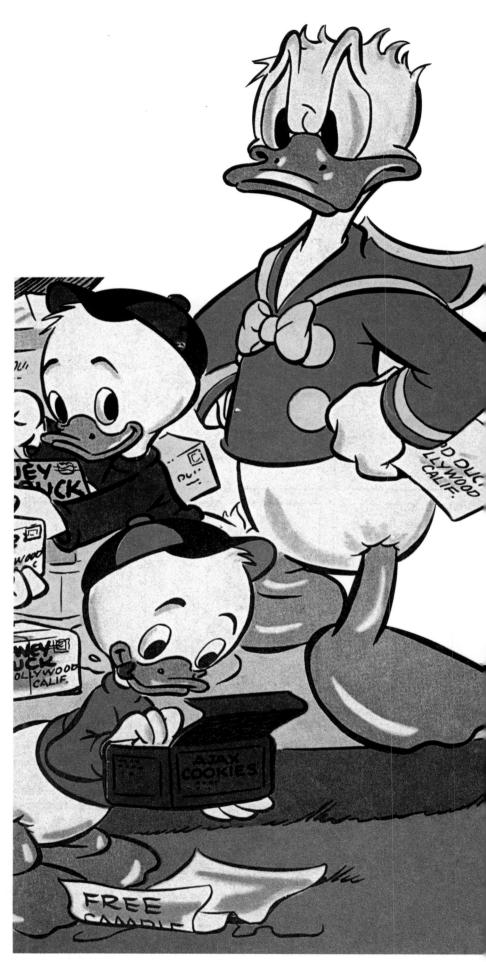

Left Wacky Duck – one of a host of imitation comics trying to cash in on Dell's Disney animal success. Wacky Duck © 1947 Marvel Comics Group.

More of Carl Bark's Donald Duck classics. *Walt Disney's*

Comics © 1949 (left) Walt Disney's Donald Duck © 1952 (above left) 1943 (above right) The Walt Disney Co. obsessive commitment to ensure Barks would never be forgotten. Hamilton, who has since sold his interests in Gladstone to Gemstone Publishing in Maryland, should be commended for ensuring that the name of Carl Barks will go down in American cultural history as one of the greatest American artists of the twentieth century.

Other funny animal artists include Walt Kelly. He was born on 25 August 1913 in Philadelphia, but Walter Crawford Kelly's family soon moved to Bridgeport, Connecticut. His interest in drawing began when he was three. His cartoons were influenced by his favorite newspaper comic strips such as Krazy Kat, Regular Fellows, and Skippy. His first jobs had nothing to do with art. In the thick of the Depression, in 1930, 17-year-old Walt started out with a job in a ladies' underwear factory sweeping out the loft and wrapping up scrap cloth. Soon he went to the Bridgeport Post, the local newspaper, and was employed as a journalist. For an extra five dollars a week, Kelly drew a daily comic strip about P.T. Barnum, the circus entrepreneur. Now he was beginning to move slowly up the ladder.

After two years with the paper, Walt got fed up drawing and redrawing P.T. Barnum's life over and over – the writer, obviously having run out of ideas, kept bringing Barnum back from his deathbed – so the next time Barnum was reprieved, Walt Kelly left. Kelly worked his way through a succession of deadend jobs, but he kept on practicing his art. He had discovered the artistry of illustrator Arthur Rackham and idolized his beautiful but strange illustrations for children's books. Kelly wanted to become a fairytale artist as well. Unfortunately such work was hard to come by, but Kelly persevered, taking his portfolio around to Major Malcolm

113

Wheeler-Nicholson and his new National Allied Publications. The major gave him work doing a pair of double-page spreads drawing scenes for *Gulliver's Travels* in the first two issues of *New Comics* (December 1935/January 1936). He would be paid five dollars a page upon publication, Wheeler-Nicholson promised. Kelly's work mostly appeared in black and white because Wheeler-Nicholson couldn't afford color throughout a 68-page comic. Kelly's first color comic job was to draw The Little People, Irish Tales for *More Fun Comics* (February 1936). Kelly was doing good work for Wheeler-Nicholson's comics and was more than a little miffed when the Major's checks bounced.

Kelly was resourceful, and moved out west, where he got a job with Walt Disney Studios. Here Kelly worked for six informative years. Half the time was spent in the story department, half in the animation studio. He was able to work on the great Disney classics like *Pinocchio*, *Snow White*, *Fantasia*, *Dumbo*, and a number of short Mickey Mouse and Donald Duck cartoons. He enrolled in the weekly life art class at the studio, but he learned mostly from being with what he described as "amongst the best cartoonists that I have ever seen in a group."

In 1941, Kelly left Disney and returned to New York after hearing that Dell/Western Printing were looking for artists and writers to work on a new line of children's comics. Editor Oskar Lebeck immediately hired Kelly and put him to work on Kandi the Cave Kid. Lebeck wanted Kelly to do a comic strip for a new title, *Animal Comics*, that he was putting together. That story would prove to be the beginning of Walt Kelly's fame and fortune. It was called "Albert Takes the Cake" and Albert was a talking alligator who was friends with a little black boy

called Bumbazine – Kelly got the name from a black fabric he worked with in his first job.

で、「「「 」

In "Albert Takes the Cake" (Animal Comics December 1941), we meet Pogo Possum. Bumbazine, who has the ability to talk to the animals, learns that Pogo's birthday is due and bakes him a cake. Albert also learns about Pogo's birthday and Bumbazine's freshly baked cake. The alligator loves cake and decides he wants it all. He eats the cake, then decides to eat the party guests as well. Fortunately everyone escapes because Albert sinks to the bottom of the swamp, weighed down by over-eating.

The second issue of Animal Comics didn't appear for a year, but Kelly was drawing Kandi, occasionally Bugs Bunny, and other strips. He still wanted to do fairytales and was able to persuade Lebeck to launch Fairy Tale Parade. A Four Color comic, Fairy Tale Parade was exactly what Kelly had been waiting for, a comic that would adapt fairytales to the comic book format. Lebeck gave Kelly the job of designing the comic the way he saw fit. What resulted was a sheer delight. Aimed at very young children, Fairy Tale Parade consisted of classic fairytales like Thumbelina, Cinderella, and The Tail of Rufus Redfox. The comic pages were given attractive borders of fairies and elves and little rabbits, while some of the pages consisted of just one or two pictures and handsome but eminently readable text. A nursery rhyme would have several pictures, free of frames, and interspersed with the words. Cartoon strips sometimes had ragged borders and sometimes a half border.

But it was Kelly's art that made these comics the treasures they have become. His drawings of naked little elfins, of Humpty Dumpty, of pigs, elephants and fairies, show the influence of both Arthur

As time went on, almost everybody believed it, and the boy and girl had to tell their story a thousand times over.

Walt Kelly, who started life with the Disney studios, magically adapted the classics for *Fairy Tale Parade* in a style influenced by Arthur Rackham and E.H. Shepard.

Fairy Tale Parade © 1946 (above left) and 1943 (above right) Dell Publishing Co.

Weeks, months, years went by, when one morning the bells of one village storted ringing-then anothers and another's.

The kingdoms were being invaded by fierce warriors, coming to rob, burn and conquer. They were riding through the valleys like a storm flood.

Left and below Walt Kelly contributed strips to Raggedy Ann & Andy and Santa Claus Funnies. Raggedy Ann & Andy © 1946, Santa Claus Funnies © 1948 (left) Dell Publishing Co.

Rackham and Winnie the Pooh artist E.H. Shepard. There is little doubt that Walt Kelly was one of the very best children's artists, ranking alongside Rackham, Shepard, Beatrix Potter, and Bestaff. His comic strips and illustrations evoke the lost innocence of childhood. Lovers of beautiful things should seek out Fairy Tale Parade, Santa Claus Funnies, Mother Goose & Nursery Rhyme Comics, Easter Bunny Parade – all are Four Color Dell comics. Kelly also drew five years' worth of Walt Disney's Comics and Stories covers.

One Kelly comic few know much about is *Our Gang Comics*. Based upon a popular M.G.M. comedy movie series, *Our Gang* is about a group of kids and their amusing adventures. Kelly wrote and drew 55 stories for *Our Gang*, one of his longest continuity series and one of the most popular. Another winner was the Mother Goose series, which Kelly especially liked doing. He even contributed to the *Raggedy-Ann & Andy* comic, another fine publication put out by Dell.

Even though he was doing so much for Dell, it would be Pogo and Albert who would guarantee Kelly's livelihood for the rest of his life. In 1943, the second issue of *Animal Comics* finally appeared and Albert the Alligator and Bumbazine continued as before. When Kelly decided to drop Bumbazine he promoted Pogo Possum to Bumbazine's role and the possum became an attractive, childlike animal with a warm heart. Other creatures joined the Pogo cast in the swampland; Howland Owl, Churchy LaFemme, and many more. Because Pogo and his friends lived in the swampland, it was obvious they were southern characters. So Kelly devised a southern accent that was obviously a loose Cajun dialect.

Dell issued two Albert and Pogo Possum comics,

one in May 1946, the other a year later. Dell had never before published an entirely original animal comic that was not licensed, or from movies, or newspaper strips. Both comics sold quite well, but Dell canceled *Animal Comics* in late 1947. It was probably the growing violence offered by other publishers that killed many good titles such as *Animal Comics*.

Kelly was swamped with work from Dell and had become the art director for the *New York Star* newspaper in 1948. He drew a series of political cartoons lampooning the presidential campaign and won the Heywood Broun Award for Best Political Cartoons. He drew 35 issues of a 16-page promotional comic called *Peter Wheat* for bakeries. But Kelly wanted a change and, with a Pogo Possum portfolio in hand, hit the trail to the newspaper syndication offices. Robert N. Hall of the Post-Hall Syndicate loved Pogo and took the strip in May 1949.

Pogo was a big hit. As more and more newspapers climbed on the Pogo bandwagon, Dell asked Kelly to do a regular Pogo comic book. Kelly now had so much work that he hired an assistant to help out. This was George Ward, who had worked in the now defunct *New York Star*'s art department. He would do inking and lettering for Kelly.

After almost 14 years with Dell, Kelly decided to leave when he found it had jacked the price of *Pogo the Possum* from 10 to 15 cents a copy, probably to capitalize on the character's nationwide popularity.

Below Pogo Possum and his fun-loving swampland friends became a national favorite serialized in over 400 newspapers at their height. *Pogo Possum* © Oskar Lebeck.

The final straw was when Dell issued a 100-page "Giant" comic, reprinting eleven stories that were formerly published in *Animal Comics*, to cash in on Pogo's popularity – the strip was now seen in 400 newspapers daily, as well as in the colored comic sections on Sundays. Then Dell tried to prevent a series of paperback Pogo books, claiming only the company could produce them. Kelly won and Simon and Schuster published the paperback series instead.

Kelly closed the door on comic books in 1954 and the last issue of the Pogo comic book went on sale. He never returned to the comic industry. He was successful, had been able to give his wife and three children financial security, and had realized his dream. Walter Crawford Kelly died of diabetic complications in hospital on October 18, 1973. He was 60 years old. He had left behind a legacy of magnificent stories and cartoon art which ranks with the very best in its originality and sheer beauty. He was inducted into the Jack Kirby Hall of Fame in 1992. Kelly, like Carl Barks, has become a legend.

With Dell now outselling every other comic book publisher in sight, many decided they must get into the funny animal business as well. Marvel Comics, who had been doing very well with *Marvel Mystery comics*, U.S.A. Comics, All Winners Comics, Captain America Comics, and Young Allies, the latter a patriotic youth comic featuring the Marvel superheroes' sidekicks, felt a slight change of pace might be all to the good. First came All Surprise

> Left and below The success of Disney and other funny animal strips meant that having an animal comic in your portfolio became a must. *Animal Comics* © 1944 (left) 1946 (right) Bobbs/Merrill.

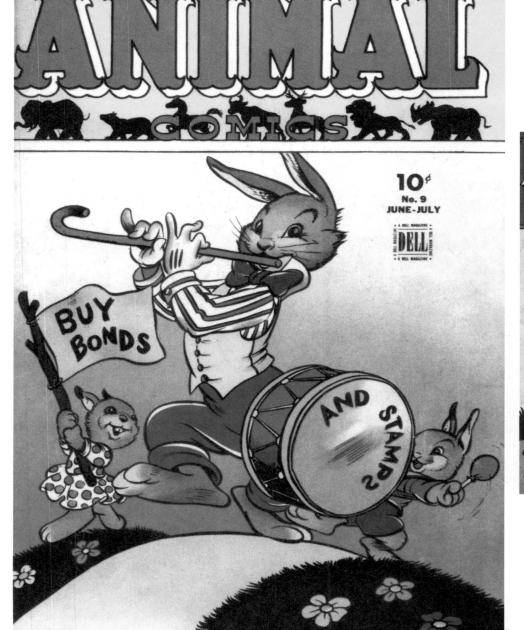

UMPIR

BEIN' A

Above Pogo and his friends spoke in an endearing Cajunstyle southern dialect. Pogo Possum © Oskar Lebeck. *Comics* featuring Super Rabbit, Gandy, and Sourpuss (fall, 1943). A year later, Super Rabbit was given his own comic lasting until issue No. 14, November 1948. The No. 1 issue of *Super Rabbit* had a cover showing a somewhat strange looking rabbit holding Hitler by the arm in one hand, and Hirohito in the other – terrible art but an interesting concept. *Animated Movie Tunes* starred Super Rabbit, Ziggy Pig, and Silly Seal, but only lasted for a couple of issues. These characters also appeared in *Comic Capers*, along with the Creeper and Sharpy Fox. It lasted six issues.

A particularly interesting comedy comic was Basil Wolverton's Powerhouse Pepper. Powerhouse Pepper was a bald-headed prizefighter who was not that brainy but had a heart of gold. He became a troubleshooter who was able to adapt to many tasks, ranging from cowboy to race car driver. Wolverton, who described himself as a "Producer of Preposterous Pictures of Peculiar People," was just that...only the art was ingenious. He was born on July 9, 1909 in Oregon, and began drawing at the age of four. He became a vaudeville artist when he left high school. He did tap dancing and played the ukelele using his own comedy songs with very irreverent lyrics and titles. Wolverton got a job with the Portland News as artist and reporter but left in 1929 to take up a career as a cartoonist.

As the years went by, Wolverton developed his reputation as a cartoonist. By the mid-thirties he was supplying illustrations for science-fiction pulp magazines like *Amazing Stories*. In 1939 he came across a comic published by Centaur, called *Amazing Mystery Funnies*. He submitted ideas for a sciencefiction adventure to the editor and was delighted to be offered an adventure strip called "Space Patrol," which began in the December 1939 issue.

NOSSIR! MY MAMMY

FOR YOU!

HAD BIGGER PLANS FOR ME THAN YOURS DID

> Shortly after, Wolverton's editor, Lloyd Jacquet, began a comic book shop called Funnies Inc. and asked Wolverton to think up another space adventure strip. He created Spacehawk, which was accepted by Target Comics (Funnies Inc.), and the space adventure ran for 29 issues. During the time he worked on Spacehawk, Wolverton was asked by Funnies Inc. to create a superhero for Martin Goodman's U.S.A. Comics. He made up a subterranean character called Rockman, U.S.A., which ran for two issues. Goodman's Marvel Comics wanted a comedy feature for its Comedy Comics and once again Funnies Inc. gave the job to Wolverton. This time Wolverton invented Splash Morgan, a take off on Flash Gordon, obviously. Wolverton's zany humor takes off when Splash is blasted to Mars in a garbage can. Splash meets Professor Pickens, the world expert on tooth picking. The pair join forces to battle the idiotic Martian armies led by Adolf Hitler and Joseph Stalin lookalikes.

> More zany strips followed before Powerhouse Pepper arrived. Wolverton happily admitted Powerhouse was his favorite strip, and it was also his most popular. The first issue of *Powerhouse Pepper Comics* came out in 1943 but wasn't seen again until 1948, although Powerhouse did appear in *Gay Comics* and *Tessie the Typist*, a teenage humor comic.

> Marvel Comics featured Wolverton's lunatic but brilliant art in various comics: Flap Flipflop the Flying Flash appeared in *Kid Komics* (February 1943), Dr. Dimwit in *Sub-Mariner* (spring 1943), Doc. Rockblock appeared in *Tessie the Typist* (May 1944), and there was a truly surrealistic piece for the summer 1942 edition of *Human Torch Comics*. This

was Private Peeps Preposterous Punks Who Prowl This Planet. Another famous Wolverton comic strip was the Culture Corner. Wolverton wrote and drew 63 half-page episodes of lunatic lectures on how-todo-it subjects that were conducted by Croucher K. Conk Q.O.C. (Queer Old Coot), for Fawcett's Whiz Comics.

All Wolverton's characters were ugly, hideously ugly. They looked like the human race through a mad person's eyes. Their faces were almost always horribly distorted with long, wart-covered noses, droopy spaniel-like ears, manic eyes, and lumpy foreheads. Wolverton could also draw amazing film star, political, and historical caricatures. His work was published in *Life* magazine where he won a national cartoon contest. *Life* commissioned him to draw current world leaders and Wolverton obliged with gusto. Soon he was working for advertising agencies in Portland and Hollywood as well as the major film studios.

Wolverton went on to work for Entertaining Comic's *Mad* and *Panic* comics which, by their very nature, suited his insane style to perfection (see Chapter 10). Some of his *Mad* covers and interior art are classics of the comic medium. Look out for *Mad* No. 11 and *Mad* No. 17 for asylum-perfect examples of Wolverton's extraordinary art. Wolverton's work even included *The Bible Story* which was produced from 1961 to 1968 as a six-volume set. He also drew for a couple of underground comics before a massive stroke floored him. He died in 1978 but his manic view of our planet, in which the line separating sanity and lunacy is precariously fine, lives on.

Compared to Dell's funny animal comics, and with the exception of the occasional Basil Wolverton piece, Marvel's repertoire was indifferent. None Below Basil Wolverton's Culture Corner (a spoof "howto" strip) for *Whiz Comics* is a great example of his lunatic style and grotesquely caricatured view of the world. *Whiz Comics* © Fawcett Publications.

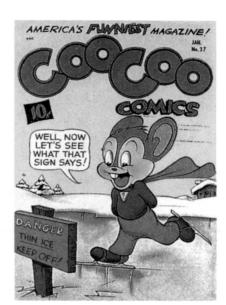

Right Coo Coo Comics effectively combined the funny animal and superhero fads to bring us Super Mouse while one of St John's top sellers was Mighty Mouse. Coo Coo Comics © 1948 Standard Comics.

lasted too long although new titles were introduced from time to time. The same could be said for Pines Comics (Better Publications), but at least some of the titles were quite good. *Coo Coo Comics* ran from 1942 until 1952, when it ended with issue No. 62. *Coo Coo* is notable for introducing the first funny animal superhero in the form of the high-flying Super Mouse. Legendary artist Frank Frazetta made several of his none too common appearances in *Coo Coo Comics* with a six-page story in issue 41, and illustrations for text stories in other issues. Copies of *Coo Coo Comics* were found in King Farouk of Egypt's bedroom. Farouk loved American comics and had quite a collection, especially good girl and funny animal titles.

Nedor/Better/Pines tried with three other funny animal comics in 1943. *Real Funnies* died after three issues but *Goofy Comics* (no relation to Disney's character) lasted for ten years. *Happy Comics* (August 1943) continued until December 1950 then became *Happy Rabbit* from issue 41. Frazetta strip cartoon art appeared in issues 32 and 33 of *Happy Comics* and they are very reasonably priced in a collectors' market which is generally spoiled by high prices. A new publisher, American Comics Group (A.C.G.), founded by Fred Iger and Ben Sangor, brought out a pair of funnies, *Giggle Comics* and *Ha Ha Comics* in October 1943. Both were originally published by Creston Publications before A.C.G. took them over.

Three funny animal characters that were not too far down the ladder from Dell's top sellers were St. John's *Mighty Mouse* and National Comics' (D.C.) *Real Screen Comics* starring the Fox and the Crow.

When funny animal comics took off at the end of the war, Whitney Ellsworth, a long-time editor for

National Comics, looked around to see what movie animal characters were available. Most of the movie studio funny animal licenses had been snapped up, mostly by Dell. Ellsworth found Columbia Pictures was all that was left, but at least they had a few cartoon animals that were quite interesting. James F. Davis was an animator in Hollywood and became the principal, and by far the best, artist for The Fox and the Crow comic cartoons. These featured Fauntleroy Fox and his nemesis, the Crow, who was an eternal con-artist who lived to trick the Fox as often as he could...and was almost always successful. Besides drawing The Fox and the Crow, Davis headed the funny animal comic art shop of Fred Iger and Ben Sangor (who later became the successful American Comics Group) on the West Coast. At one stage he had 65 artists and writers working for him night and day. The shop handled all National Comics' funny animal work and all Nedor/Pines as well.

Paul Terry's Mighty Mouse was another famous and enduring comic book funny animal. Created by Terry, Mighty Mouse was licensed by Terry's own company, Terry Toons. All Terry's characters, from Mighty Mouse to Heckle and Jeckle, were 20th Century Fox animated cartoons and later on CBS licensed them for Saturday morning TV. Mighty Mouse was a super mouse. He had a yellow costume and red cape and had all the powers the superheroes did. Timely/Marvel, under the editorship of funny animal artist Vince Fago, issued the first four Mighty Mouse Comics from 1946 to 1947. Mighty Mouse was the first licensed character Marvel published. Then St. John Publishing took over and really made something of the character, even running to 100page annuals and 3-D comics. Their 3-D comic had "World's First!" emblazoned on the top of the cover, but St. John may have been overly optimistic about this; a lot of three-dimensional comics, including *Superman*, came out at about the same time.

Another superhero animal was Hoppy the Marvel Bunny. Hoppy was part of the Marvel Family led by Captain Marvel. In fact, Captain Marvel introduced him to the world on the cover of the first issue of *Fawcett's Funny Animals*. Fawcett had never done a funny animal comic before and was discussing the possibility of producing one. The company wanted someone with practical knowledge of animation and funny animal art to put the comic together. Roscoe Fawcett knew of an ex-Disney , named Chad Grothkopf, who had returned East to work on an animated cartoon feature for NBC's tiny new TV operation.

Fawcett and Ralph Daigh, Fawcett's editorial director, met with Grothkopf and they put together a bunch of animals, the main one being Hoppy the Marvel Bunny. Others included Sherlock Monk the detective and Willy the Worm. Grothkopf was given absolute freedom to do the comic the way he saw fit, and worked with around a half-dozen freelance writers and artists. The result was *Fawcett's Funny Animals* and it was cover-dated December 1942. Well designed and drawn, the comic lasted until Fawcett's end in 1953, but continued under the Charlton label.

Jingle-Jangle Comics was different. Published by Eastern Color, Jingle-Jangle was a mixture of funny animals and humans, and it was aimed at the very young. It was a beautifully produced and illustrated comic featuring top cartoonist George Carlson. Carlson thought of the comic's title "Jingle-Jangle" with the idea of making a children's book of it, then a Above *Real Screen Comics* and *Terry Toons* featuring Mighty Mouse continued the trend of licensing animal characters from the big screen – Columbia Pictures and 20th Century Fox respectively. *Real Screen Comics* ©1952 D.C. Comics, Inc. *Terry Toons* © 1946 Paul Terry.

Right *The Fox and the Crow – Real Screen Comics'* most famous strip, drawn by ex-Hollywood animator James F Davis – was a classic cartoon double act with the Crow always putting one over on the rather gullible Fauntleroy Fox. *The Fox and the Crow* © 1952 D.C. Comics Inc.

Sunday newspaper page. Both ideas fell on deaf ears but Eastern Color wanted it turned into a comic.

Carlson worked in close harmony with editor Steve Douglas. He would submit a one-page synopsis for each story idea to Douglas for approval. Then he did detailed outlines of the stories accompanied by colored pencil sketches. Once these passed scrutiny, Carlson set to work on the finished product. He was paid \$25 a page for the twelve pages he did for each issue. His main character was the Pie Face Prince, who featured in beautiful tales of whimsy and imagination. Carlson's other feature was simply called Jingle Jangle Tales and told fairytale stories in his inimitable style. *Jingle Jangle Comics* lasted for 42 issues and ran for almost eight years. If you enjoy art in the comics, you need to collect a few of these.

Harvey Comics produced a series of delightful children's humor comics that began with Joe Palooka, Ham Fisher's kindly boxing champ. Joe Palooka was initially a newspaper strip published in comic book form by the short-lived Columbia Comic Corporation from 1942 to 1944. The second series by Harvey started to print original stories which led to Little Max and Humphrey, both of whom were given their own titles. Much later came Casper the Friendly Ghost, Little Lotta, and one of Harvey's most popular, Richie Rich. A small boy, Richie Rich is just that...rich! Perhaps it was the profits Harvey was making with Richie Rich that encouraged an outpouring of Richie Rich titles. Richie Rich Jackpots, Richie Rich Million Dollar Digest, Richie Rich Dollars and Cents, Richie Rich Millions, Richie Rich Riches, Richie Rich Vault of Mystery, Richie Rich Gold and Silver, and many more. Another popular Harvey title was Blondie & Dagwood, cloned from

Right Jingle Jangle Comics were funny strips mixing humans and animals, aimed at a very young audience. Jingle Jangle Comics ©1944 Eastern Color Printing Co.

Below Archie Andrews, the honest-to-goodness, all-American high-school teen, charmed a nation by always getting into hilarious scrapes – especially with his blonde girlfriend Betty Cooper and the delectable brunette Veronica Lodge. Archie ©1945 Archie Publications.

Chic Young's newspaper strip.

As the superhero glut waned, publishers were thinking of humorous comics for an older audience. M.L.J. already had the sinister and violent *Hangman*, *The Shield & Wizard* and a couple of other likeminded characters in the stable, and decided they didn't want any more of the caped, hooded heroes. Instead, M.L.J. began to feel there was a need for a comic book to appeal to teenage readers, a teenage character whose interests revolved around pretty girls, who had best friends, who went to high school with his pals...generally a pretty ordinary guy. And in *Pep Comics* No. 22 (December 1941) the world came to know Archie of Riverdale High.

John Goldwater, the J. in M.L.J., was the person

who dreamed up Archie Andrews. He had a friend in high school named Archie, while further inspiration came from Mickey Rooney's *Andy Hardy* movie series. Throwing all these elements into the proverbial pot, Goldwater got Archie. He hired writers and artists, including Bob Montana who would become the principal artist for Archie and his friends.

Although *Pep Comics* was mostly action-packed superhero fare, Archie hit the spot. Youngsters were soon hooked on this youth who got into scrapes and wanted to impress Betty Cooper, the new girl in the neighborhood, even though his pal, Jughead Jones, tried to warn him off. Archie's girlfriends, Betty Cooper the sweet blonde, and Veronica Lodge, the stunning, and very rich brunette, both had big eyes

and gorgeous figures. Archie was equally fond of both, which of course led to the girls competing over the young man who couldn't ever make up his mind which girl he should take to the Prom, or the movies – just like any red-blooded American male.

Archie is still going strong and has become a part of American folklore. He lives in Riverdale, we see him with a legion of characters and friends: Moose Mason, a slow-witted but friendly giant; his little girlfriend Midge; Pop Tate, the proprietor of Pop's Choc'Lit Shoppe; Reggie Mantle, the smooth rival of Archie; Dilton Doiley, the intellectual brains who reads everything; Mr. Weatherbee the rather pompous Riverdale High principal; Miss Grundy the schoolteacher spinster. Archie and his friends are small-town America and small-town America recognizes itself in Archie.

M.L.J. changed its name to Archie Publications in 1946 having phased out most, if not all its superheroes. Archie Publications was going to concentrate on Archie, now one of the most successful comics of all time. Offshoots began to appear: there was Archie's Pal Jughead, Betty & Veronica, Laugh Comics, Pep Comics (all Archie now). There was also Life with Archie, Archie's Joke Book, Archie's Mechanics, Archie's Madhouse, and a number of Archie Christian comics published as one-shots in the seventies by Spire Christian Comics. Archie's girlfriends, Betty and Veronica, lent their services to fashion pages in the comics and else-

Archie started life in *Pep Comics* in 1941 and soon went on to become a mini-industry with a whole host of Riverdale High spin-offs: *Archie's Pal Jughead*, *Betty and Veronica*, *Wilbur, Laugh Comics* and many more. *Archie's Pal Jughead* ©1954, *Laugh* © Archie Publications.

126

where, but one girl, the glamorous Katy Keene, created by Bill Woggon, turned up in Wilbur Comics, another Archie Publication (issue 5, Summer, 1945) and became the most sought after comic book pin-up of all.

Perfectly formed, Katy Keene was a tall, darkhaired beauty queen who simply drove men wild. Like Archie before her, Katy had a selection of friends and rivals in the comics: her kid sister, mischievous and unruly, who Katy is always trying to keep out of trouble; Gloria Granbilt, her wealthy rival; pretty Lucki Lorelei; K.O. Kelly, who is Katy's boyfriend; K.O.'s main rival, Randy Von Ronson, a wealthy young suitor trying his best to woo Katy away from her rough diamond beau. Katy Keene was a hit from the first time she appeared.

The tremendous success of these teen comics soon had other publishers rushing to the drawing boards and typewriters. Marvel didn't take long to publish *Millie the Model*, which lasted from 1945 to 1973, and spawned other teen-based comics like *Patsy Walker* and *Nellie the Nurse* along the way. D.C. had *Leave it to Binky*, a teen humor comic in the Archie vein...it lasted from 1948 to 1970.

There were so many funny animal and teenage comics in the first 20 years of comic book history, that it is impossible to mention them all. With violence at a minimum, these beautiful works of pure comic art truly epitomized the comic book.

127

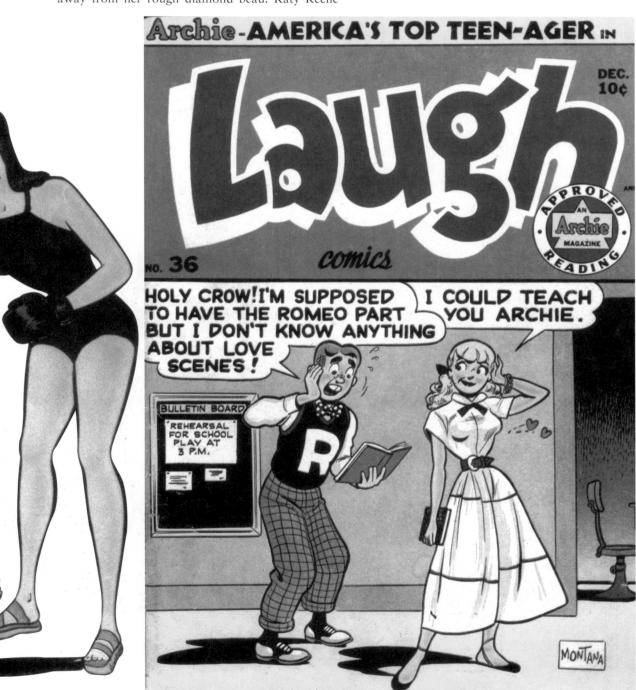

Chapter Seven

GIVE ME A HOME Where the Buffalo Roam...

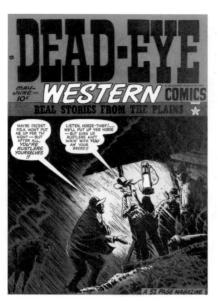

For a very long time the cowboy was king in American popular culture. Though western comics ran strap lines like "real stories from the plains," they invariably took their cue from Hollywood's romantic, mythologized version of the West. *All Star Western* © 1955 D.C. Comics, Inc. *Dead-Eye Western* ©1949 Hillman Periodicals. There was a time not too long ago when the cowboy was king in popular American culture, thanks in part to Hollywood's distorted view of the west. In the movies the heroes wore designer clothes covered in tassels, decorative boots, engraved gun belts, carried silver-plated six shooters...and looked thoroughly ridiculous. In the real west, the one Hollywood rejected, the cowboy was a scruffy, unclean individual, his pistol either tucked in the waistband of his trousers or in a practical but boring holster. There were gunfighters, there were marshals, but neither could be described as particularly handsome, and rarely clean shaven.

Cowboy comics normally followed Hollywood. As they did with the funny animals, comic publishers obtained licenses from the studios, sometimes from the actors themselves, to enable them to use photographs of the stars on the covers of the comic books.

Since the twenties there had been numerous cowboy heroes galloping across the movie screens of America. Film-makers capitalized on the popularity of the Wild West, the romance of the cowboy, lean and tanned in the saddle, who spurned the advances of women to ride free over the hills and far away into the western sunset. Many western legends had been born: Billy the Kid, the James Brothers, Wyatt Earp, Pat Garrett, Gunfight at the O.K. Corral – so many tales had been told of an era not far removed from many people's lives.

Authors like Zane Grey popularized the romantic notion of the west, pulp magazines blew up supposed true stories into epics as great as the Civil War, and at the turn of the century Buffalo Bill had his western circus to exaggerate his exploits. Children loved playing cowboys and Indians, gunfighters and sheriffs, and hoped that Santa would leave them a

cowboy suit, natty gunbelt, and silver six gun that fired caps under the tree. So it was only a matter of time before the comics industry decided that cowboy comics, particularly comics featuring Hollywood stars, would be a practical and profitable proposition.

Although he died in 1940 following a car accident in his Cord convertible, Tom Mix was one of Tinseltown's biggest cowboy stars. In fact, Tom Mix had been a real cowboy before he went to Hollywood, thus enabling him to bring a bit of authenticity to his role. Following his death, the Ralston-Purina Company put out a 36-page comic book featuring the life of Tom Mix, which was available for the cost of two Ralston box-tops. This was obviously a successful venture because Ralston produced twelve *Tom Mix* comics in all, the series ending in 1942.

Of all the cowboy heroes Tom Mix was the most amazing. The comic shared the same artists (John Jordan and Carl Pfeufer) as *Don Winslow of the Navy*. Jordan normally inked Pfeufer's pencil outlines and between them they made the strips come alive, especially the fight scenes, of which there were many. Unlike a number of comic cowboys, *Tom Mix* went to great pains to develop several characters who became very much a part of each story, such as Sheriff Mike Shaw and Washington, Tom Mix's cook. In almost every story some baddie bashed Tom Mix on the head with a gun butt. "Conk!" But Mix was never fazed by the number of cracks on the cranium; he came through every time. "Conk!"

Tom Mix was not the first western comic to feature a movie cowboy and by no means the last. The first western comic had been published by the Comics Magazine Company in February 1937. Called *Western Picture Stories*, it lasted four issues.

A year later Centaur Publishing Co. changed its *Star Ranger* comic to *Cowboy Comics* with issue 13, July 1938. The first issue of *Star Ranger* had featured a cowboy strip, but it was really an adventure comic.

Fawcett Publications introduced many western heroes licensed from movie companies. Hopalong Cassidy was their first. Played by actor Bill Boyd, Hopalong was a perennial Saturday-morning movie favorite, and Fawcett introduced him in comic book form in early 1943. For some reason Hopalong didn't appear again until the summer of 1946 and continued non-stop until issue 85, November 1953. Hopalong was so popular between 1947 and 1948 that his annual circulation doubled from 4 million to 8 million.

These circulation figures obviously encouraged Fawcett to bring out Rocky Lane Western (one of the better-crafted Fawcett cowboy comics), Gabby Hayes Western, Bob Steele Western, Young Eagle (when does an Indian not look like an Indian? Check the paleface features of Young Eagle for the answer), Tex Ritter Western, Monte Hale Western, Bill Boyd Western, Six Gun Heroes, Western Hero, and Lash LaRue Western. Not to be forgotten are Fawcett's two movie comics, Fawcett Movie Comic and Motion Picture Comics. The majority of films featured were westerns – The Red Badge of Courage starring Audie Murphy, Vigilante Hideout starring Rocky Lane – and both comics featured Bob Powell art.

The only non-licensed cowboy was one Fawcett made up themselves. Taking a male model, they had him dress up in cowboy clothes, posed him by fake western scenery for cover photography and called him Bob Colt. *Sensational New Western Hero* headlined the covers, but nobody was fooled. Bob Colt lasted only ten issues and so did Young Eagle,

As with animal comics, the western comic was keen to tie in with established movie stars and characters. Tom Mix, Bill Boyd, Gene Autry, Roy Rogers, the Lone Ranger and many others had their own licensed comics. *Bill Boyd* (English edition) © Fawcett Publications. *The Lone Ranger* © 1951 Lone Ranger, Inc. *Roy Rogers* © 1948 Roy Rogers. *Gene Autry* © 1947 Gene Autry.

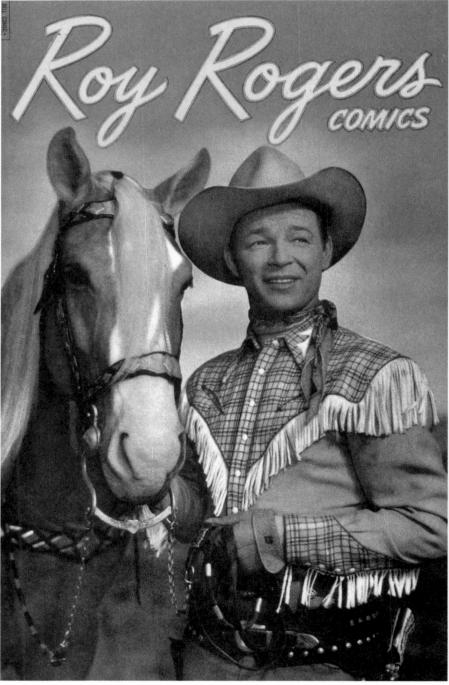

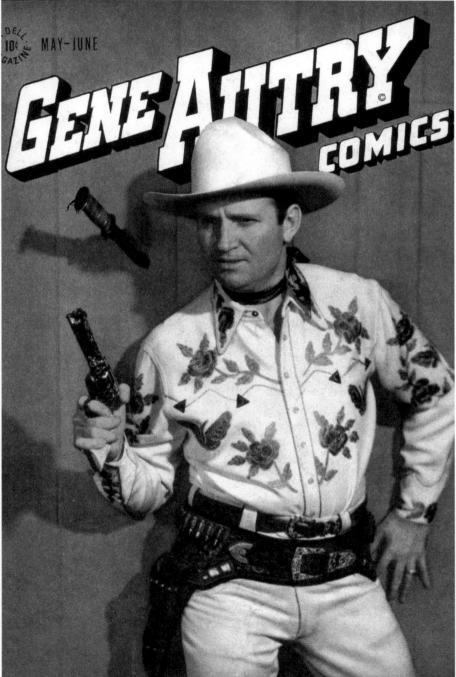

another made-up hero. An especially rare Fawcett western came out in the fall of 1940. Called *Western Desperado Comics* (it had formerly been *Slam Bang Comics*) it was Fawcett's earliest western. The likelihood of finding a copy is remote, to say the least.

Dell, meanwhile, snapped up Roy Rogers, Gene Autry, The Lone Ranger, Tonto, Rex Allen, Cisco Kid, Johnny Mack Brown, and a string of others. Most were movie cowboys though some had the added advantage of TV and radio appearances as well. Unfortunately the artwork in the Dell cowboy comics wasn't that good; Gene Autry was drawn by Russ Manning or Jesse Marsh, both of whom also drew Dell's *Tarzan of the Apes*. The pair took turns in doing the art for *Roy Rogers Comics*, whose artistic stature was raised several notches when John Buscema took over from issue 74 to 108. Buscema's work on Roy Rogers makes these issues very desirable for collectors of the western genre.

Dell realized that Zane Grey's novels and stories boosted the populatirty of the western comic. Without further ado, Dell swung a deal with Zane Grey's estate and published a number of his titles in heavily adapted, comic book form: *Spirit of the Border* (F.C. 197, 1948) followed by *West of the Pecos* (F.C. 222), *Sunset Pass* (F.C. 230), *The Ranger*, (F.C. 255, 1949), and *Outlaw Trail*, (F.C. 11). Grey's *King of the Royal Mounted* began as a Four Color title but ended up as a regular series. Dell Publishing was now the world's largest comics producer. Between 1942 and 1962, 1354 separate issues of the beautiful Four Color series were published, ranging from *Donald Duck* to *Brer Rabbit*, the *Mask of Zorro*, and *Charlie McCarthy*.

Victor Fox realized a bit late that there was a market for cowboy comics but was only able to net

Hoot Gibson, who lasted for just three issues. Instead of movie cowboys, Fox went in for badly drawn, but brutally vicious westerns like Western Thrillers, Western Killers, Western Outlaws, and Western True Crime.

Vincent Sullivan, who had left National/D.C. to form his own comic company, Magazine Enterprises, had *Tim Holt Comics*, based on a well-known western star of the forties. An extremely good and highly original western from Magazine Enterprises was *Ghost Rider*. With white hood, cape, and horse, Ghost Rider had a Frazetta cover on three issues with beautiful interior artwork by Dick Ayers, one of the greats in comic art. M.E. also had one of the very few female westerners, *The Black Phantom*. The issue had a cover displaying a delectable girl dressed in a figure-hugging, blue costume replete with black mask, held by the arms yet pulling the villain's gun from its holster, and kicking another crook on the chin. There was only one issue of this interesting book. Two other long-running titles were *Straight Arrow* and *Durango Kid*, continuing until 1955 and 1956 respectively. Another interesting western comic was *Bobby Benson's B-Bar-B Riders*. Licensed from a radio show, it had excellent art by that prolific artist, Bob Powell, for the first twelve issues. Issue 13 had a cover by Frank Frazetta, while the 14th issue had a horrific decapitation/bondage cover and story one would not have considered finding in a western comic.

Below Marvel/Atlas were a prolific and by far the toughest publisher of cowboy comics. They produced over 50 western titles including: *Kid Colt Outlaw, Ringo Kid, Apache Kid, Two-Gun Kid* and *Texas Kid –* cold-hearted desperadoes to a man. *Texas Kid, Two-Gun Kid* © 1949, *Apache Kid* © 1951, *Kid Colt Outlaw* © 1953 (right) 1950 (left), *Ringo Kid* © Marvel Comics Group.

Everybody had westerns, especially Marvel/Atlas.

Atlas, the distribution company Martin Goodman

formed to cut out some of the middle men, produced

50 western titles over a six-year period. All the char-

acters were fictional. They were by far the toughest

of all the cowboy comics and generally the best

drawn. Blaze Carson Comics, which started in

1948, was one of the first, but Atlas really got into

its stride by 1952. Atlas had all the best rough, tough

Atlas titles included Best Western, Wild Western,

Western Winners, Western Outlaws, Two Gun

Western, Two Gun Kid, Kid Colt Outlaw, Texas

Kid, The Outlaw Kid, Arizona Kid, Apache Kid, and

cowboy heroes who always aimed for the heart.

Cowboy comics were not the biggest thing for National/D.C.; their superheroes were still mostly intact and virtual institutions. They licensed Dale Evans, Roy Rogers' wife, in a comic book of her own. It ran for 24 issues, from 1948 to 1952, before folding. A successful western comic from National was Tomahawk. Tomahawk was a frontiersman before the cowboys really began, and spent most of his time with his boy sidekick, Dan Hunter, fighting Indians. National changed All American Comics, once a superhero comic, to All American Western. Obviously some superheroes had to go. Another cowboy comic was Western Comics, featuring the Wyoming Kid and Vigilante Kid. The comic lasted 85 issues.

Below Both Kid Colt and the Ringo Kid had been framed for crimes they didn't commit and thus forced into outlaw status. Ringo was half Indian and always wore black.

S BLAZING ADVENTURES

man's offices had a thing for kids or simply ran out of ideas for names to call all these cowboys, gunfighters, and good outlaws.

Atlas had some of the best original comic book cowboys around. Kid Colt was drawn by Jack Keller in many issues but Joe Maneely, Jack Kirby, Syd Shores, Steve Ditko, Doug Wildey, and Bill Everett all lent their skills to the pages of Kid Colt. Colt was forced to become an outlaw after being framed for a crime he didn't commit. He put himself to good use by hunting down and despatching bad men to Boot Hill. So did Ringo Kid. Early issues were perfectly drawn in a unique style by Joe Maneely. Ringo Kid was half Indian, half white. His mother had died, but his father had been framed and although innocent, was leading an outlaw's life with his gunfighter son. Ringo was tall, muscular, slender, and wore all black - black hat, shirt, jeans, boots. He and his father dealt summarily with the low life of the west.

Two Gun Kid, Apache Kid and all the rest of this cowboy family called "Kid" treated the hoodlums of the west in the same way: Bang! You're dead! Over in the Fawcett and Dell camps, the villains, though sometimes actually worse than the Atlas creations, survived because the heroes had compassion and shot the guns out of their hands.

There were many other western comics. Avon was an offshoot of Avon Books. The comics division started after the war and was distinguished by the complete lack of superheroes. But there were westerns. Jesse James had his own comic in 1950; Jesse James was regularly drawn by Joe Kubert. Avon generally attracted the best artists like Wally Wood, Kinstler, Al Williamson and so on, and there was even a Williamson/Frazetta story in issue 20. Avon produced a lot of one-off comics including westerns.

Avon produced a lot of one-off westerns, including several that dramatised the bloodthirsty antics of the Apache chief Geronimo. Western Fighters was a well-drawn Hillman comic. Wild Bill Pecos, The Westerner is notable for being produced by a publisher run by a woman, Rae Hermann, in a male dominated profession. Geronimo © 1951 Avon Periodicals. Western Fighters © 1949 Hillman Publications. The Westerner © 1949 Toytown Publications.

There was Quantrell's Raiders, Geronimo, Geronimo on the Warpath, Geronimo and his Apache Murderers, and Savage Raids of Geronimo. Kinstler was the main artist for these unusual western comics. Another continuous title was Wild Bill Hickock, which ran for 28 issues.

Hillman Periodicals had Western Fighters. This was, like most Hillman comics, quite well done with generally good art and stories. The team of Al Williamson and Frank Frazetta, Krigstein, Fuje, and Ingels contributed art to most issues. Not so good was Wild Bill Pecos, The Westerner, published by a small company, the Orbit/Toytown comic group. It was run by Ray Hermann, a woman in a maledominated sphere. Her other main title was Wanted Comics, a crime title. Both comics showed pictures of wanted gangsters on their covers. Occasionally the level of artistic content went up with a rare appearance of Bernard Krigstein (three issues out of 27). Just one western comic emerged from Lev Gleason's Integrity comics. This was Black Diamond Western. Formerly Desperado from Nos. 1 to 8, Black Diamond started at No. 9 (March 1949) and continued for 51 further issues.

Before leaving the westerns, it would be sacrilege not to mention Toby Press. Supposedly funded by Al Capp and his friend, American icon John Wayne, Toby published *Billy the Kid* and *John Wayne Adventure Comics*, both westerns. Both are memorable for fine artwork, especially from the team of Williamson/Frazetta. Both first appeared between 1949 and 1950, and lasted until 1955.

The western love affair was almost burned out by 1955, many titles coming to an end as their respective publishers went under. Times were a-changing and society was moving on. 137

Chapter Eight

HORROR AND CRIME AT A DIME A TIME and not forgetting the really good bad girls

PAYS!

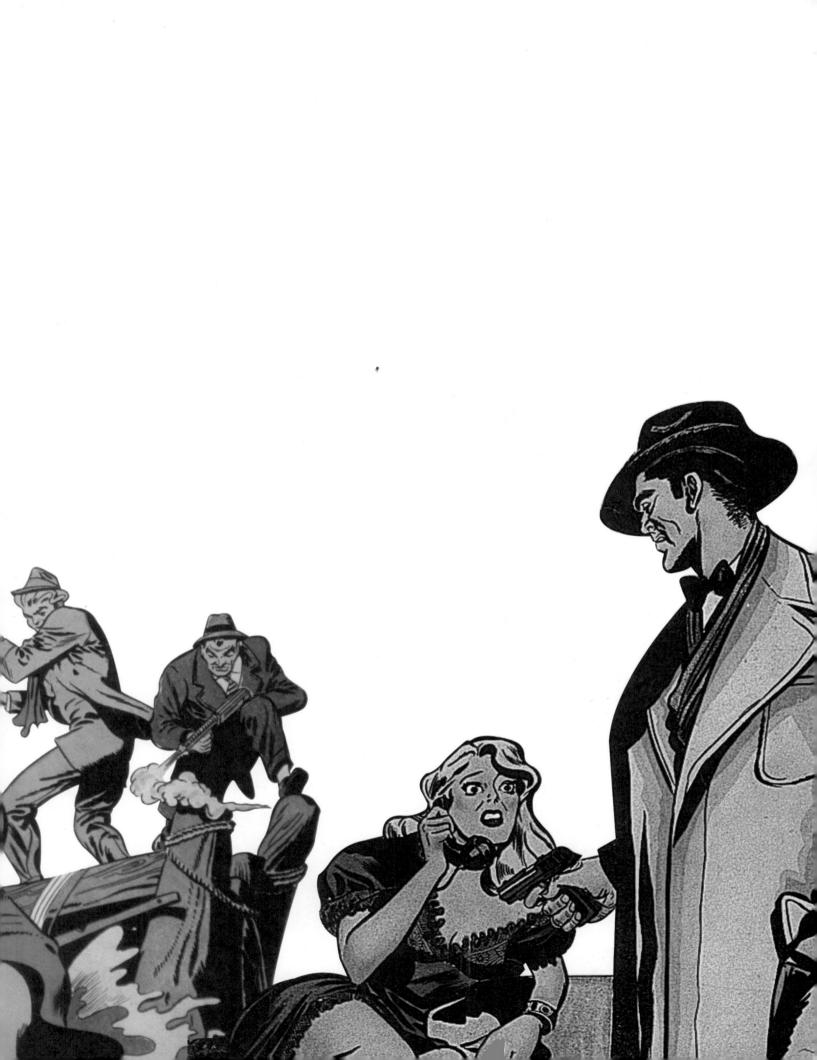

ON MAY 2, 1945, HITLER WAS DEAD BY HIS OWN HAND, and his dream of a 1000-year Reich with him. There was dancing in the streets of New York, Moscow, and London. In September, two atom bombs – the most horrendous weapons ever conceived by man – had been dropped on Hiroshima and Nagasaki, and Japan surrendered. The terrible bombs may have saved a million American lives that would have been lost if they had been forced to fight the Japanese in their homeland fortress.

The world rejoiced, the war was over, and the soldiers, sailors, and airmen could come home. But while the comic book companies cheered along with the rest, there were doubts about their future. The superheroes were out of work – they no longer had any Nazi or Tojo types to bash. *Superman*, *Captain Marvel*, and *Captain America* were lovely escapes from the real world, and this imaginative, fairytale world was changing: new comics, with more realism, had to replace all that had gone before. Lev Gleason had already found the way ahead.

Back in 1941, Lev Gleason realized the world was overpopulated with superheroes. He wanted something new, entirely different and something that would catch the reader's imagination. He approached his two new editors, the ingenious Charles Biro, and clever, but quiet, Bob Wood. The first issue of *Boy Comics* had just been completed, and even though Crimebuster, the young superhero, was the lead, Gleason saw it had great potential, due in part to the

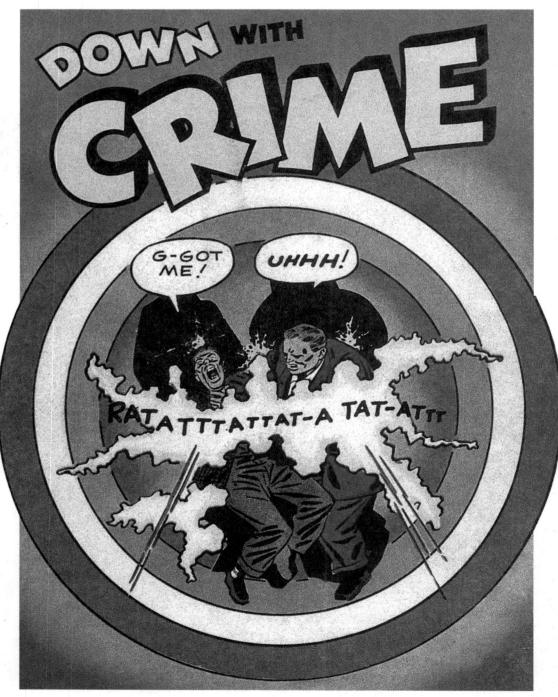

With the war at an end the glut of superheroes lost their natural enemy. As an antidote to their patriotic, escapist fantasies the comic book publishers moved on to the realism of true crime from their own city streets. Down with Crime (an advertisment) © 1949, Suspense Detective © 1952 Fawcett Publications.

Right Charles Biro (with his pet monkey) and Lev Gleason (standing) at work on their comics circa 1942.

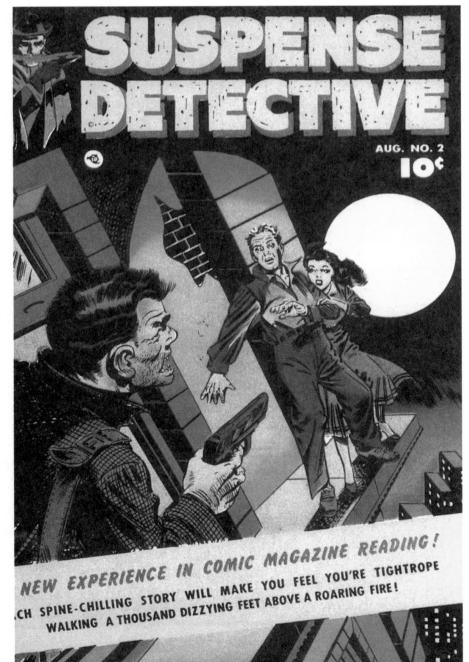

excessive violence that became a trademark for all Gleason's comics. He said he wanted a totally new and different comic...something that had not been tried before.

With Boy Comics out of the way, Biro and Wood went down to the local bar to celebrate. Both men were aware that the liberal, very left-wing Gleason had promised a share in the profits of any successful comic they did. Then it hit. Biro read in the paper about a man who had kidnapped a margarine heiress, and was now under arrest, the woman found tied and gagged in a room over a bar. Biro pointed excidedly at the man's photograph. "That's the same man who offered me a woman in his room," he gasped. Biro had refused the offer but couldn't get over the coincidence. "Supposing there was a comic book about weird stuff like this? About crimes and gangsters? We'd never run out of ideas." Wood enthusiastically agreed and that night, in a New York bar, comic book history was made. The embryo of Crime Does Not Pay was created.

Gleason loved the idea and the title. It would be a continuation of *Silver Streak Comics*, he said, starting at No. 22, and would have a June 1942 cover date. The title was lifted from M.G.M.'s successful short film series, which won an Oscar in 1936 and 1937. The comic wouldn't win any awards but it certainly made other publishers sit up and take notice. A small aside: the first issue was numbered 23 by mistake on the cover, but the imprint page inside said No. 22.

Biro and Wood created a different style of comic book, envisaging it as more like a 64-page magazine with text stories of true crime, interspersed with strip cartoon crime stories. Knowing how well comics were selling to U.S. forces and that one-third

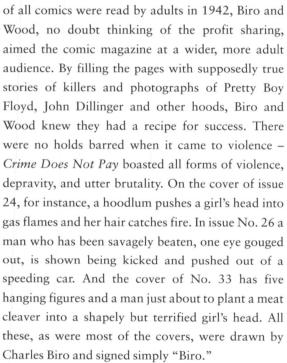

Crime Does Not Pay was an enormous hit, capitalizing on the readers' fascination with violence. The covers were bad enough but the inside pages showed cynical depravity that often went too far. Biro and Wood outdid themselves when they introduced the sardonic, satanic Mr. Crime. He was the cynical interlocutor who acted as narrator for the comic's lead story. This ghostly, terrifying individual had blazing eyes, fanged teeth, and bony, long-nailed fingers. He wore a top hat inscribed with his name, and carried a skull's head cane. He was the teacher of crime, nurturing criminals, and encouraging them to do evil. His ghostly figure flitted around his pupils, though he remained invisible to them.

"It was a grand sight that evening," Mr. Crime told his eager audience in one story. "My pupil was on the spot. But he whirled like a panther, and came

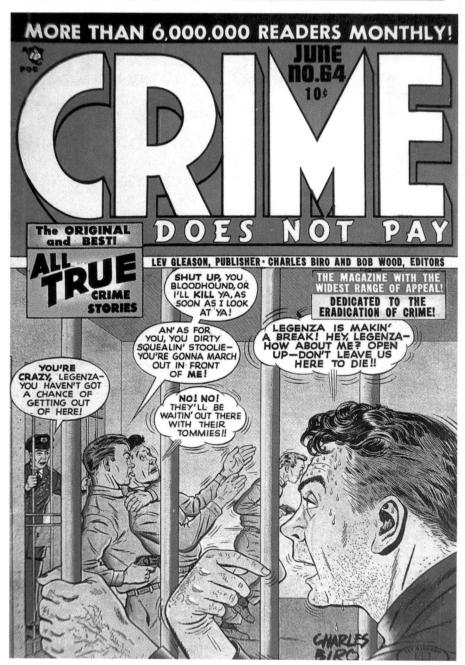

Lev Gleason's *Crime Does Not Pay*, which pioneered the post-war true crime renaissance, took its title from a series of short, Oscar-winning MGM films from the thirties. The biggestselling comic of all time, it took comic book violence to new levels of brutality. *Crime Does Not Pay* © 1948 Lev Gleason Publications.

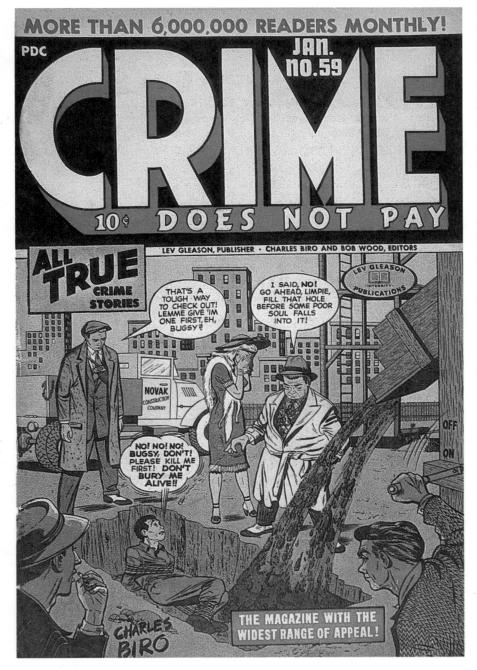

143

up blazing...ho ho I guess the cashier regretted his actions when he felt the hot lead rip into his stomach. He didn't have a chance against my Hill." The illustration shows the killer pumping bullets into the hapless cashier, who is holding his stomach, his face is contorted in pain, blood splattered all over his jacket. Mr. Crime tried his best to make successful criminals out of his pupils but always knew they would get their come-uppance in the last panels of the story.

The stories were generally of real gangsters and hoodlums who spared nothing in their violence to women – one unfortunate woman is abducted in her car, robbed, then shot dead. Another hoodlum repeats this touching theme in another story, but displays even more viciousness to the terrified woman. He tells her to get out of the car, slaps her violently across the face and says: "It's too late now, sister! You had your chance...you'd turn me in the first chance you got...and that's how it is...this is the end, pretty baby." He holds the girl by her head as she pleads desperately for her life: "...please, oh please! Don't! Don't!" The next panel is a close-up picture of the hood pulling the trigger, her eyes are closed as the bullet smashes into her quivering skull.

Gleason's *Integrity* comics (that was the logo in the little oval on each cover) were tremendously successful. There were only three titles, *Boy, Daredevil*, and *Crime Does Not Pay*. But their combined circulation in 1943 was almost one million a month and by 1947 the circulation had topped two million, the biggest seller being *Crime Does Not Pay*.

Earlier I suggested that the violence shown in some of the superhero comics was harmless for children. In that context, it was. Children realized what they were reading was fantasy material; not so with

Crime Does Not Pay. Here was brutality in real settings, with people drawn as realistically as possible. The violence could happen, and did happen, if the stories were based on fact. Comics like this might have been damaging to some children and perhaps desensitized others to blood, murder, and nastiness, especially to women. Crime comics of this type were the least savory for youngsters, and even if the readers didn't turn to crime, and of course most didn't, they may well have had some harmful effect.

Look at Mike Benton's revealing book, *Crime Comics, The Illustrated History*. One cartoon panel he uses from *Crime Does Not Pay* (No. 24) shows two figures, a man and a woman, tied by the feet and hanging upside down into a deep well. The woman's red skirt is sliding down to reveal her thighs. The bodies are in the water up to their waists. The caption reads: "Then we hung them down the well head first...to let the drug run out of their bodies. There were some bubbles at first...then they were quiet!"

There were 126 issues of *Crime Does Not Pay*. It ran for 13 years, from 1942 to 1955. It picked up quite a few good artists along the way, who drew the stories in a realistic, rather than cartoony, manner. George Tuska, Bob Fujitani (Fuje), Rudy Palais, Fred Guardineer, and Dan Barry all did regular work for Biro throughout the life of the comic. With almost a million sales monthly, Charles Biro ran a headline across the top of the comic. It said "More than

Below Glamorized tough talk from Crime Does Not Pay. Crime Does Not Pay © Lev Gleason Publications.

5,000,000 readers Monthly." Biro had concluded that, for each comic bought, there were five readers. Biro's enthusiasm may have run away with him, but there was no escaping the fact that *Crime Does Not Pay* was one of the biggest selling comics of all time.

It did not take long for the comic book critics to latch onto *Crime Does Not Pay*, and with good reason. Biro and Gleason cynically headlined the comic "A Force for Good in the Community," and the "Magazine with the Widest Range of Appeal." Even better was the letters page, which came later. It is hard to believe that many of the letters thanking *Crime Does Not Pay* for "straightening" the reader out were genuine. Many of these letters were obviously the work of the editors: "I want to compliment you on your fine magazine CRIME DOES NOT PAY, the finest magazine out. Every mother should buy it for her family. It is one magazine everyone can be proud to have in his home." Mrs. Lyle Waddle, Box 163, Sweet Home, Oregon.

"If CRIME DOES NOT PAY was required reading for high school students, juvenile delinquency would drop amazingly...." Mrs. E.J. King, 21 Alpine St., Cambridge, Mass. The first splash panel in the issue these letters came from shows two men shooting a bound and blindfolded doctor to death.

"For such a fine comic book, I offer my most sincere thanks. What better way is there to impress upon young America's mind that crime does not

145

Below A strip from Crime Does Not Pay shows the ghostly figure of Mr. Crime, the sinister interlocuter who narrated many of the tales of his criminal protégés to their bloody conclusions. Crime Does Not Pay © 1947 Lev Gleason Publications.

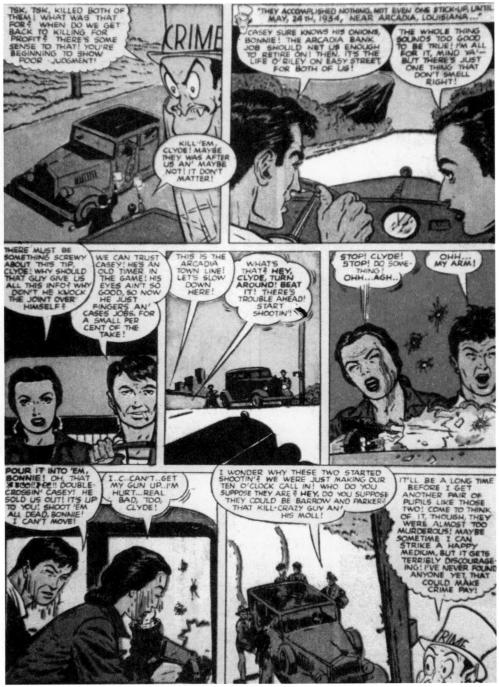

pay." Sincerely, Mrs. Gloria Bishop, Mt. Clemens, Mich. This particular issue had a convict beating an old man on the cover, while inside a man is shot in the head and a woman threatened with a red hot poker, arm twisted behind her back.

In an effort to stem the tide of lookalike crime comics, an angry Lev Gleason protested that the "fakes" were not a patch on *Crime Does Not Pay*. He even brought out his own lookalike crime comic, soon to be known as *Crime and Punishment*; this time the title came from the book of the same name by the Russian author, Dostoevsky. *Crime and Punishment* was very similar to *Crime Does Not Pay*. It even had a host figure telling the first story in each issue. However, unlike Mr. Crime, we had Officer Good Sense, a ghost cop who had been shot and killed, went to the Pearly Gates but pleaded to return to Earth to finish his work. He was allowed to return, and remained on the planet for the majority of the 69 issues of the comic.

One by one the superheroes disappeared. They had nothing to do, nowhere to go. There was desperation in the comic book ranks. What to do? Some publishers noticed that Fiction House was relatively unscathed, its sexy jungle and space girls selling as well as ever. Many more watched Lev Gleason chalking up the profits with *Crime Does Not Pay* which, in 1946, was still the only crime comic book around. Crime was the thing. Movie-makers, after a lull of several years, had returned to making hard-boiled film noir crime movies that were tough, uncompromising, and realistic. Richard Widmark, Sterling Hayden, Robert Mitchum and Robert Ryan were the great actors who made their names in these movies.

Forty different comic book publishers needed a new ploy to bring back the readers whose dimes Left A mob shoot-out from the pages of *True Crime*. *True Crime Comics* © Magazine Village. 3-D "Deep Dimension" versions of *Crime and Punishment*, another of Gleason's true crime titles. It also featured a host narrator, Officer Good Sense – a murdered cop who returned from Heaven to finish his work. Though an improvement on Mr. Crime, the comic was just as disquieting as *Crime Does Not Pay*. *Crime and Punishment* © Lev Gleason Publications.

were so important. Seeing how well the movie box offices were doing with crime films and how Gleason was doing equally well with a comic book that many found disquieting, the overall opinion was that crime comics were the way to go. In 1947 it was a trickle but became a flood by 1948, and 15 years after his death, John Dillinger was king!

Prize Publications established an agreement with the famous writer/artist team of Joe Simon and Jack Kirby to produce a new line of comics. First they took the boy superhero/adventure title *Headline Comics* and changed it into a crime comic with issue No. 23 in 1947. The first crime feature Simon and Kirby did for *Headline* was the notorious St. Valentine Day Massacre. Sales returns showed a big increase following *Headline's* change to crime, so a companion crime comic, *Justice Traps the Guilty*, came out for October/November 1947. "All True Crime Stories" claimed the cover, alongside a box which told the reader that the contents were "True F.B.I. Cases." This was the pitch most crime comics followed, that all the stories were true, or based on a true case. "In consideration of the innocent persons involved in this true tale, the names of people and places have been changed" was the disclaimer used by many crime comics. Referring to *Headline Comics* once, Simon admitted they had taken *Crime Does Not Pay* for their inspiration, but not the graphic violence and sex which they found disturbing. *Justice Traps the Guilty* was a sellout, probably,

according to Joe Simon, because the front cover showed a murderer being strapped into the electric chair. Sensationalism always hits the spot, which is why the words "crime," "guilty," and "penalty" were mostly spelled out in huge letters.

One of the truly memorable crime comics, coverdated May 1947, was *True Crime Comics* issue 2 (actually issue No. 1). Arthur Bernhard, originally Lev Gleason's partner, decided to strike out on his own and formed a new comic company called Magazine Village. Working from the same address as Gleason's comics, Bernhard went to Plastic Man creator and artist, Jack Cole, and hired him to package a crime comic. Not only did Cole package the comic, he wrote and drew much of it aided by old friend Alex Kotzky, who had helped him with Plastic Man.

There never was another crime comic like *True Crime Comics*. It eclipsed them all. It was a wild, frenetic roller-coaster ride from the first splash panel that launched one of the most notorious crime stories ever to grace a page. "Murder, Morphine and Me" was the story that had parents, teachers and half America up in arms over the excessive, disturbing violence, a nightmare of surrealism drawn with an abandon that bordered on the psychedelic.

"Murder, Morphine and Me" begins with a close up of a sluttish, cigarette-smoking girl with long, blonde hair called Mary Kennedy. Her tresses outline a pile of near naked bodies, two or three Below left *True Crime Comics* was launched in 1947 by Gleason's former partner Arthur Bernhard. Much of the words and pictures came from the surreal and inspired pen of Jack Cole. *True Crime Comics* © 1947 Magazine Village.

148

149

Below Tales featuring drugs always attracted particular censure from parent and teacher groups. "Murder, Morphine and Me" from the first issue of *True Crime Comics* became one of the most notoriously excessive crime strips ever. *True Crime Comics* © 1947 Magazine Village *Teen-age Dope Slaves* © 1952 Harvey Publications. grasping upward toward one skeletal man who is holding the needle of a large hypodermic syringe. Hoodlums are firing across her at three other gangsters, one dead, one dying, and one firing back. To the right of Mary's head sits a blue-suited man whose head cannot be seen, cigar in hand and dollar bills cascading all round him. "Editor's note..." is the caption. "This is a Must!" Once in a great while, a story comes along that is so powerful, so dynamic, it must be heard!!...Such a story is Mary Kennedy's own true account of her career in scumland's vilest enterprise...The Dope Racket! By All Means READ IT!"

Poor Mary Kennedy. Page two finds her asleep in bed as a man bursts in demanding that she wakes up.

She rubs her eyes and the reader notes the flimsy nightie. The man is begging her for a fix of morphine, "Gimme a break! Groan. Y'know I can't work with this pain tearing my insides out!..." Mary says no because the man never never pays..."...No cash! No Dope!" "You slimy leech!" the desperate man screams, lunging at her with a huge hypodermic. The next frame is a classic, frequently cited by the anti-comics brigade. It shows the man's hand holding the syringe and his other hand holding open Mary's eye, just about to plunge in the needle. But it is only a nightmare. And then Mary tells her story, a tale of drugs and sickening violence, not even matched by the worst excesses of *Crime Does Not Pay*, all brought to life by Jack Cole's frantic art. For

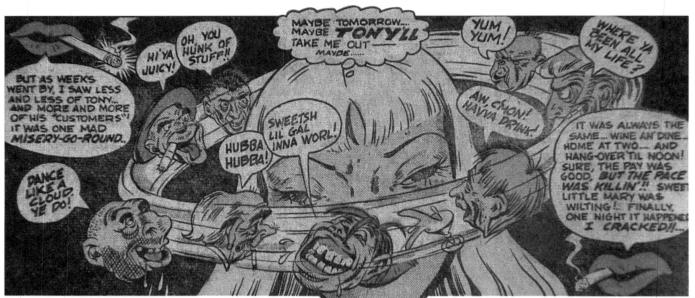

children, this is a triple-X tale, but children bought the comic, as it was in the rack alongside *Captain Marvel* and *Donald Duck*.

Another story in the same comic, called "Boston's Bloody Gang War" and drawn by Craig Flessel, also received a lot of attention. The splash page outraged the critics. The illustration shows a speeding car driving over a bumpy road dragging two men, arms tied behind their backs, their feet to the car's bumper. Both are alive and are being dragged face down. One tries to hold his head up, the other can no longer. In the car the killers are talking: "A couple more miles oughta do th' trick!" says the driver. "It better," replies one of the others. "These **** gravel roads are tough on tires!" Another hood comments: "But ya gotta admit, there's nothing like 'em for erasing faces!"

Jack Cole helped put together six issues, none of which matched the first. The demanding deadlines and the work involved putting the comic together found Cole returning to work exclusively for "Busy" Arnold's Quality line, which published *Plastic Man* and *Police Comics*. With the end of *True Crime*, Magazine Village disappeared from the comics scene.

One of the most prolific producers of comics, any type of comic, was Martin Goodman's Marvel Comics. One of the keys to his success was Stan Lee, who joined his company in 1940. Stan created many characters for Marvel, and wrote most of the stories as well. Stanley Martin Lieber was just 17 when he joined Marvel in late 1940 to assist Simon and Kirby. He was already family; his cousin was Martin Goodman's wife. At the time Lieber did everything from making coffee to proofreading and running errands. His ambition was to write novels and his

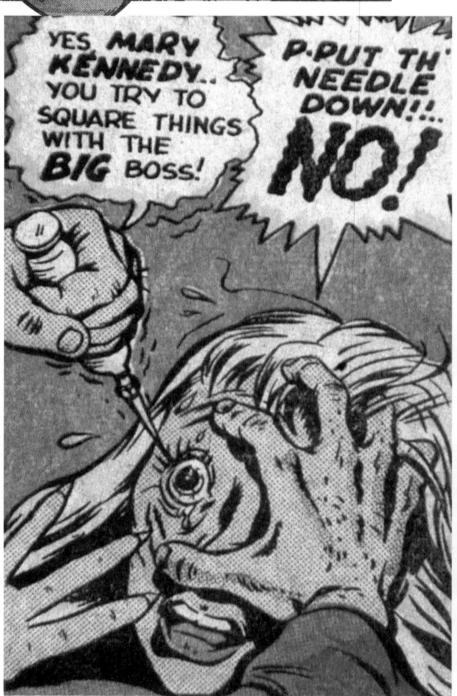

work at Marvel, he thought, was just to fill in time.

Simon and Kirby gave Stan his first chance to write. By the third issue of Captain America, Stan was given a two-page text story which he signed "Stan Lee" because he felt that "...someday I'd be writing The Great American Novel and I didn't want to use my real name on these silly little comics." Anyway, Stan never did write The Great American Novel; instead he stayed a lifetime with the "silly little comics," and changed his name legally to Stan Lee.

Simon and Kirby left Timely, Marvel's first publishing name, after a spot of bother with Goodman, who fired Simon for working for other companies. Later Simon agreed that was the main reason but the duo also had problems over their creation, Captain America. He was such a huge success that Simon and Kirby felt they should have adequate financial compensation. Their royalty deal with Goodman was only verbal and nothing was forthcoming. It was the usual thing in those days; invent a character, a publisher pays for it and all rights belong solely to the publisher. Creative minds like Simon and Kirby and Siegel and Shuster were not business-orientated. Nowadays the creators own the copyrights, but this was not the case in 1940.

With Simon and Kirby gone to National Comics where they created Boy Commandos and Newsboy Legion, Stan Lee found himself the editor of a growing list of comic books. He was only 18 when he was given this enormous responsibility, but he

151

Left Some of the offending

available to children in the

rack alongside the likes

of Donald Duck. True

Crime Comics © 1947

disturbing "Murder, Morphine and Me". These comics were

panels from Jack Cole's

Above Boy Commandos, one of Joe Simon and Jack Kirby's post Marvel creations along with Newsboy Legion. Boy Commandos © 1946 D.C. Comics, Inc.

Right Boston's Bloody Gang War, another of the offending violent strips from True Crime Comics. True Crime Comics © 1947 Magazine Village.

shouldered it with aplomb. He was writing more and more stories for the comics, sometimes dictating them over the phone to the artists who drew them. Not long after war was declared, Stan Lee joined the army, as did many of the comic book artists.

With the war finally over, Stan Lee returned to the comics. A lot had changed while they had been away. Teenagers wanted more comics like *Archie*, while the girls wanted Miss America, a pretty, teenage superheroine created by Otto Binder, the female counterpart of Captain. She wore a fetching outfit consisting of a red, puffy sleeved mini-dress with a red skin-tight body stocking. Around her waist she wore a wide black belt, and her red and blue cape had a flared collar. A stars and stripes shield adorned her chest. In 1944 Miss America achieved her own title. Teenage girls loved the magazine and bought it in droves. Stan Lee then created *Millie the Model*, *Tessie the Typist*, and *Nellie the Nurse* for the same audience.

Marvel, always a company to follow trends rather than create them, watched the crime comic explosion through the eyes of Stan Lee and Martin Goodman. It was obvious that crime comics sold, and sold well. Immediately Lee started to pump out crime comics, the first one titled *Justice Comics*, the next *Official True Crime Cases*. The latter was numbered 24 because the comic used to be *Sub-Mariner*. *Justice* was formerly *Wacky Duck* and continued that comic's numbering (No. 7 in this case). Early in

Below Exposed: True Crime Cases and "I Fight Crime," a story from Crime Patrol, subtitled "Real Stories from Police Records!", also-rans in the crime comic explosion. Exposed © 1948 D.S. Publishing Co. Crime Patrol © William M. Gaines.

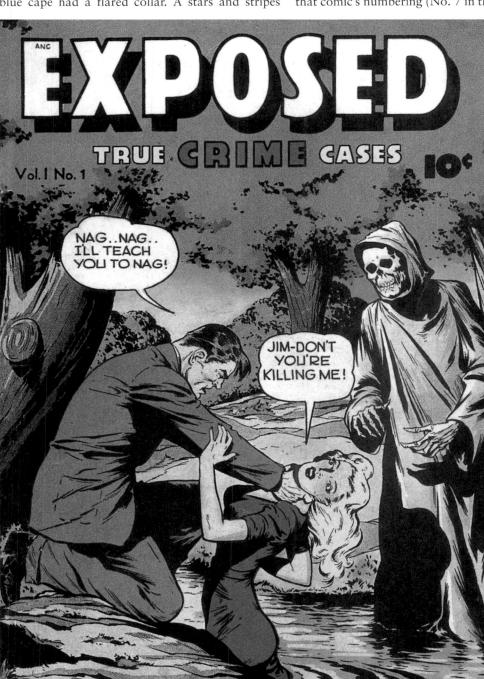

Right A grisly cover image from E.C.'s *Crime SuspenStories* featuring a recently hanged man. *Crime SuspenStories* © 1954 William M. Gaines.

Below The Blue Beetle returned after the war to take up violent crime-fighting like everyone else. Again in keeping with the times, he also developed into something of girl magnet. The Blue Beetle © 1947 Fox Features Syndicate.

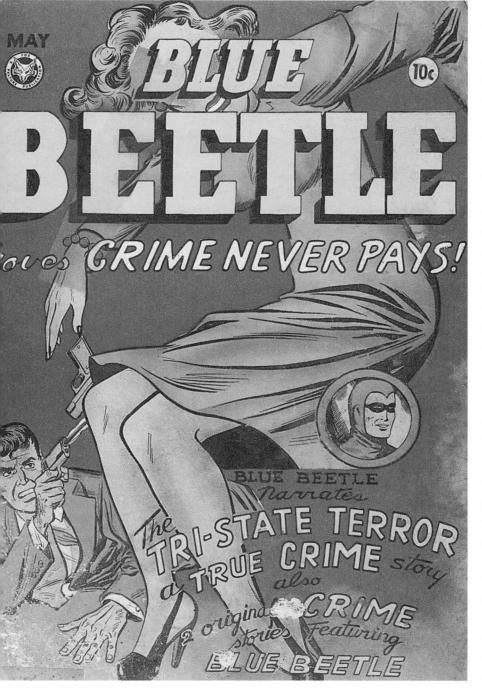

1948 Marvel premiered *Crime Exposed*, *Crime-fighters*, *Lawbreakers Always Lose*, and *All True Crime*. Marvel's crime comics, although violent, were quite clean compared to some of the smaller publishers. Overall, they were bang! crash! wallop! sort of comics with less than adult tales to tell. Yet they contained enough action to keep younger readers satisfied.

While Marvel was producing crime comics as fast as the inks would dry, National /D.C. frowned upon the idea. Their editors felt they had a reasonable reputation producing comics of a generally clean nature and wanted to keep it that way. However, in 1948 National took a pair of popular radio programs, *Mr. District Attorney* and *Gang Busters*, and turned them into tasteful, well-drawn comics that followed the radio programs closely. While National was conscientious about its offerings, Victor Fox was most certainly not.

Victor Fox had suspended publication of all his comics in 1942 but returned to the comics fold in 1944. His most popular title, *Blue Beetle*, had survived, thanks to a deal struck between Fox and Holyoke Publishing. Fox resumed publishing *Blue Beetle*, but with a difference. From 1946 *Blue Beetle* went crime-fighting and also picked up a lot of sexy girls in some form of undress or bondage, along the way. Jack Kamen, one of the top good girl artists, supplied much of the art for the revitalized *Blue Beetle*. Its seamy bondage and violent tales provoked the anger of the ever-growing anti-comics movement.

Maxwell Gaines, one of the principal pioneers of comics, had sold his interests and comics to his partner, National's Harry Donenfeld, following differences over policy. Apparently Donenfeld

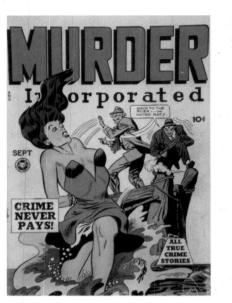

gave 50 percent of his share of the business to his accountant, Jack Liebowitz, without telling Gaines. Gaines never liked Liebowitz, considering him an unimaginative bean-counter. He was unhappy with Liebowitz's insistence that the comics carry more advertising. It is said by sources who knew the three men that the most terrible rows would break out at meetings, ending up with the partners shouting and screaming at each other. Enough was enough as far as Gaines was concerned. He offered to sell his All-American Comics line and share of the business to Donenfeld for the princely sum of \$500,000, which in modern money would be several million. Donenfeld accepted and Gaines started his own line under the heading, "Educational Comics."

Gaines had a few titles Donenfeld and Liebowitz let him keep, among them *Picture Stories from the Bible* and *Picture Stories from American History*. There were also a handful of funny animal comics such as *Animal Fables*, *Tiny Tots*, and *Dandy Comics*. In the cynical world of comic book publishing, Maxwell Gaines stood away from the pack. He believed comic books could be used as an educational tool, hence the Bible and History series.

Life in the Gaines household was strictly regulated. There were two children, Elaine and William (Bill), and Max's wife, Jesse. Max believed in discipline, rather than too much love for his children, in the tradition of his Prussian ancestry. He was especially demanding of his son, who often did not live up to his father's expectations and was at the receiving end of his father's ferocious temper. Bill once said he thought that his father's attitude probably scared him into being, as he put it, "a bumbling idiot."

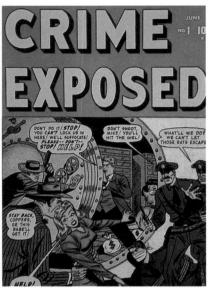

Left Murder Incorporated, subtitled "For Adults Only," was a sleazy and pretty atrociously written Victor Fox entry into the crime market, while Crime Exposed was a fairly clean-cut Marvel contribution. Murder Incorporated © Fox Features, Inc. Crime Exposed © 1948 Marvel Comics Group.

"You'll never amount to anything," yelled Max to his son one day. And Bill really didn't care. He was not in the slightest bit interested in his father's comic business, he hated comics. He suffered from asthma, had poor eyesight, and wasn't a hit with the opposite sex. When he was 22 years old in 1944, his exasperated mother all but arranged his first marriage to Hazel Grieb, his second cousin. Drafted into the Army Air Corps, Bill decided he wanted to teach high school chemistry when he was discharged, in fact anything so long as he didn't have to work in comics with his father. Then his marriage collapsed.

His mother was so upset by this turn of events that Gaines took her, Bill, and friends Sam and Helen Irwin to their Lake Placid holiday home. Gaines owned a boat and one afternoon, leaving Jesse and Helen at the house, he took Sam and Bill for a trip on the lake. It was then that the Gaines's life completely changed, setting in motion events in the comics field that would echo and re-echo for decades to come.

As Gaines peacefully powered his boat on the waters of Lake Placid, there was a roaring noise ahead of him. With a resounding, splintering crash a speeding boat rammed Gaines's vessel in a head on-collision. According to Bill, who survived the terrible accident, his father saved his life by grabbing him from the front of the craft and throwing him into the rear. Maxwell Gaines and Sam Irwin were killed. The year was 1947.

To Bill Gaines's horror, his mother told him that he must keep his late father's comics company going. He went to the offices at 225 LaFayette Street, New York, and pondered what to do. Business was bad; nobody was buying the comics and Educational Comics were down the hole to the tune of \$100,000. Far right Bill Gaines revived his recently deceased father's publishing company by pandering to the audience's needs with titles such as *Crime Patrol* and *War Against Crime*. *Crime Patrol* © 1949 William M. Gaines.

Right A graphically violent panel from *Exposed – True Crime Cases. Exposed* © 1948 D.S. Publishing Co.

155

The young man looked at the comics and was suddenly converted. He liked them! "First thing I knew, I had to read comics. Gaines once said. "Next thing I knew I was in love with them." By now he realized something drastic would have to be done to save the company. There was "a mess of titles competing with each other to lose the most money." Drastic changes would have to be made if Educational Comics was to be saved.

Out went the funny animal comics and in came *Crime Patrol* and *War Against Crime*. Another title was *Moon Girl*, featuring a science-fiction heroine. Gaines appreciated good art and kept on Johnny Craig, who had been taken on board by his father in 1947. Craig did covers and art for *Crime Patrol* and

War Against Crime, a pair of crime comics that were fairly restrained compared to some of the competition.

A few miles away, in New York, crime comics were booming. In an effort to continue making fat profits, the publishers looked around for other avenues. *Public Enemies, Select Detective*, and *Gangsters Can't Win* were among the violent crime comics served up by the little-known D.S. Publishing Co. Women got knocked around fairly frequently in these titles, none of which lasted very long. Quite a number of the more notorious crime comics didn't stay the course, perhaps publishing one to six issues before folding. Victor Fox had found his crime comics like *Murder Incorporated, Famous Crimes*, and the tasteless *Crimes by Women* were also very

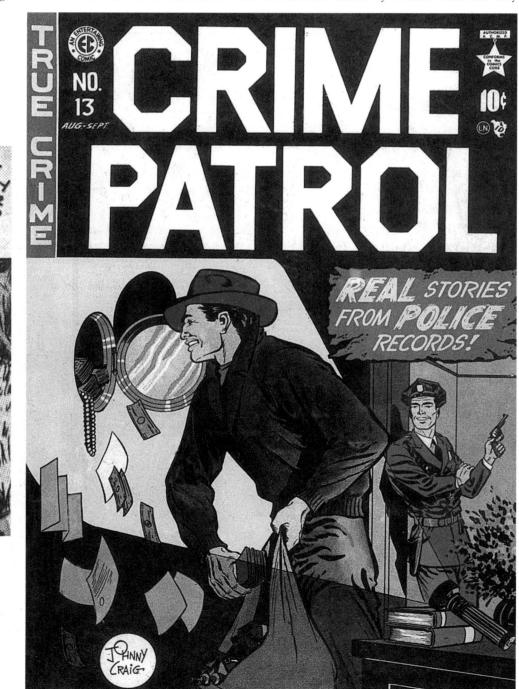

THEN WHEN I WENT TO KILL HER, I DIDN'T HAVE A GUIN. LOST MY HEAD AND BEAT HER UP, AND THEN BURIED HER, ONLY TIME I REALLY LOST MY TEMPER.

saleable, especially if they featured guns and girls. There was everything the perverted mind could want in *Crimes by Women*; girls fighting each other, bondage, domination, lingerie and stockings, and guns. It was all there for a mere dime. "Try this in ya belly, ya louse," the scantily dressed girl, thighs and breasts teasingly exposed, says as she shoots the policeman.

Fox's other crime books were pretty bad, too. Murder Incorporated started out with the inscription "For Adults Only" on the cover. All this did was to encourage more youthful buyers, which is why Fox printed the logo in the first place. By issue No. 3 it was gone. The stories and art in Murder Incorporated, like all Fox crime comics, were atrocious. The covers always had an attractive lingerie-clad woman just about to be killed or being killed. A sleazy blonde showing lots of thigh, reclining on the floor, is on the telephone trying to get help. A tough, well dressed man stands over her, gun in hand. "It is too late Liz," he snarls. "I don't think you're gonna rat on me...hang up the reciever!!!!" Believe it or not, that is how "receiver" is spelt on the cover, just one example of the spelling mistakes and bad grammar that featured in Fox publications.

Dr. Fredric Wertham M.D. watched the small boy sitting opposite him on the underground train in New York. The boy was mesmerized, lost in the pages of a particularly violent crime comic book. Of course there was nothing the good doctor could do, for there is no law stating a child cannot read whatever he chooses. What Wertham did very successfully was to start a campaign against crime comics. As a leading pyschiatrist and author of a famous book *Dark Legend: A Study in Murder*, published in 1941, Wertham became the leading spokesman against the comics industry. For parents, deeply concerned about some of the reading matter they found under their children's beds, Wertham was a shining knight on a white charger.

Born in Nuremberg, Germany on March 20, 1895, Frederic Wertham was one of five children of Mathilde and Sigmund Wertheimer. His was a middle class family of non-practising Jews who became gentiles. As a young man he went to England to study medicine at King's College, London. When war broke out, the English interned him for a short time but let him go to continue his studies. While he was in England, Wertham developed a liking for Charles Dickens, whose writings helped prompt much-needed social reform. Like many young Left and right The two magic ingredients of all successful crime titles were girls and guns. Mike Barnett, Man Against Crime © 1951 [left] Fawcett Publications. Murder Incorporated © 1949 [right] Fox Features, Inc.

Below Prize Publications' Headline Comics, originally a superhero/adventure title, made the switch like so many others to crime in 1947. It was a Joe Simon and Jack Kirby creation in imitation of Crime Does Not Pay. Headline Comics © 1954 Prize Publications.

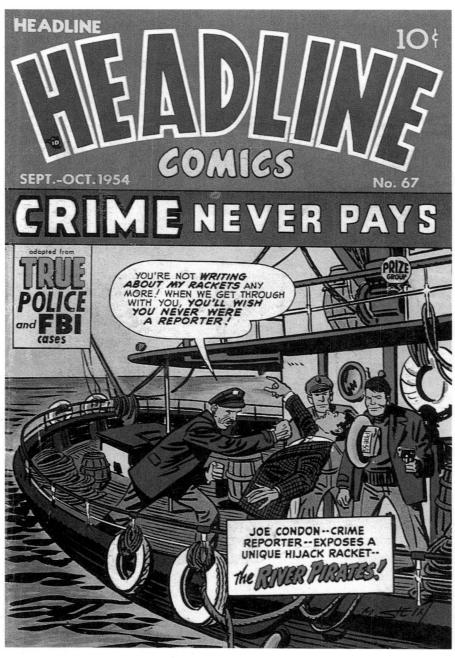

intellectuals of the day, Wertham read Marx and studied Fabian socialism.

Returning to Germany after the war, Wertham continued his studies at Wurzburg, Paris, and Vienna before joining the Kraepelin Clinic in Munich. Emile Kraepelin used advanced methods which took account of background and environment when treating psychiatric patients. In the early twenties Wertham arrived in America and was given a position with Adolf Meyer, who followed Kraepelin's school of thought and used his methods at the Phipps Psychiatric Clinic at Johns Hopkins University in Maryland. Wertham honed his skills there for seven years as a professor of psychiatry.

While he was at Johns Hopkins, Wertham met and married Florence Hesketh who worked at the hospital as an artist doing biological research. If ever a couple were meant for each other, it was Wertham and Hesketh. In 1934 they co-authored an important work 'The Brain as an Organ: Its Postmortem Study and Interpretation' to critical acclaim. The book became a standard medical text and Wertham received the first psychiatric grant ever awarded by the National Research Council. By 1936 Wertham was director of Bellevue Mental Hygiene Clinic. He founded and directed America's first psychiatric screening clinic to check every convicted criminal for the Court of General Sessions (now the New York State Supreme Court). Running neck and neck with Wertham was the growing comic book industry, now up to ten titles and six publishers after three years. In a few years Wertham's and the comic book industry's paths would cross in true comic style, for a battle to the death.

Chapter Nine

MORE GOOD GIRLS, A BIT OF ROMANCE, AND WAR TOO

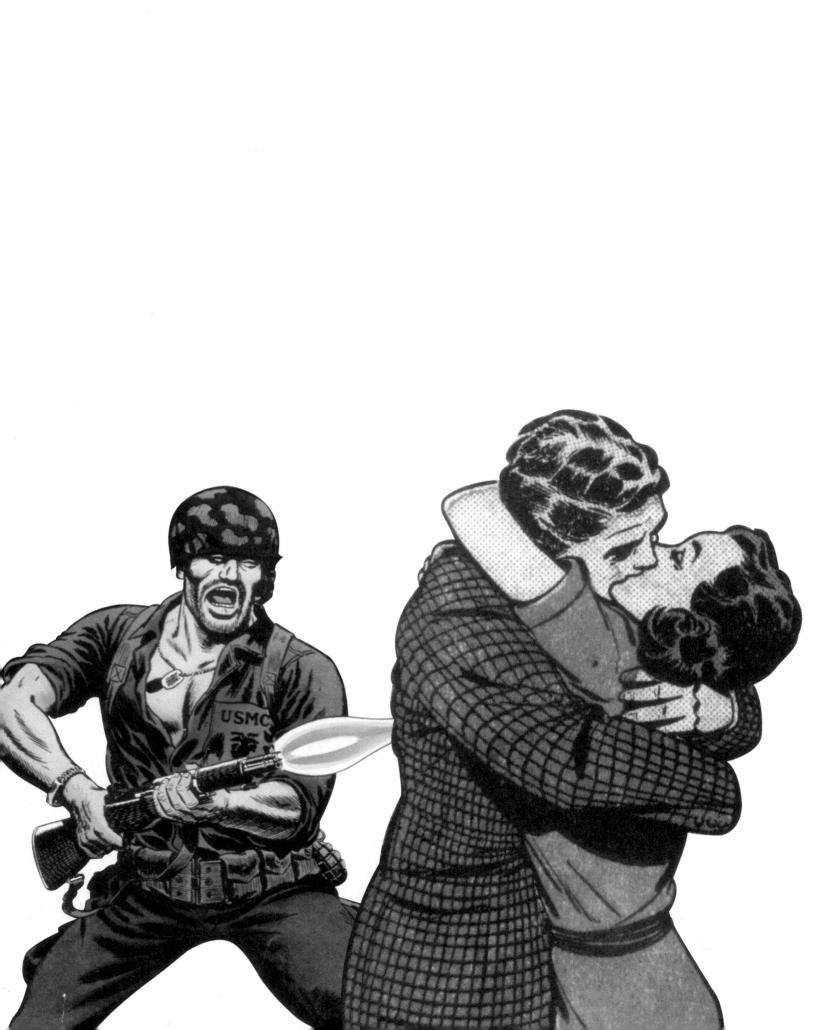

"THERE ARE MORE MORONS THAN PEOPLE, YOU know." This unflattering opinion was voiced by Mr. Sleaze himself, Victor Fox, and caused quite a stir during his defence of sex and sadism in his comics. If anything turned the public against the comics, it is this cynical remark in an interview with *Time* magazine. Industry insiders shook their heads in disbelief and tried to pretend it didn't happen. But Victor had said it, and with no thought of tact, to the very worst possible source, an influential, international news magazine.

Victor didn't care; he was off the wall. Something of a loner in the comics field, he had no scruples about what he published. He paid less than anyone else – if he paid at all – used the cheapest printing and paper and, with a handful of outstanding exceptions, generally the worst artists.

Those exceptions were Al Feldstein, Jack Kamen, and Matt Baker. Feldstein did a couple of teenage titles, including *Sunny, America's Sweetheart*. Jack Kamen was a strictly good girl artist, as was the extraordinary Matt Baker. Baker was the only black artist working in comics during the forties, but what art, what girls! Matt Baker could draw the female form in any pose he wanted and it was always right and very sensual.

Take a look at Fox Features' Phantom Lady. Her beginnings in Quality's *Police Comics* No. 1 (August 1941) were uneventful to say the least. She ran as a second-tier filler for 23 issues before Below Under the auspices of the roguish Victor Fox, Matt Baker's already wonderfully drawn Phantom Lady, one of the stars of *Police Comics*, became an even more sexy proposition. *Police Comics* © 1946 Quality Comics Group.

Victor Fox knew that sex sells, so with *Fox Features* titles like *Zoot Comics* the funny animals and superheroes were replaced by long-legged girl stars such as Rulah, Jungle Goddess. *Zoot Comics* © 1948, *Rulah* © 1949 Fox Features Syndicate.

disappearing from the scene. She turned up again in August 1947, this time with Fox Features. She was still Sandra Knight, daughter of a Washington D.C. Senator, and Don Borden was still Sandra's slightly nerdy boy-friend, and Sandra still fought crime as the Phantom Lady. But she was a very different Phantom Lady from her tenure at Quality.

Putting two and two together, that canny rogue, Victor Fox, came to the conclusion that the reason Fiction House and Lev Gleason had not ceased publication of any of their titles was the more adult fare they were producing. Fiction House had jungle, adventure, and sci-fi comics, while Gleason had the wildly successful *Crime Does Not Pay*. Women and crime were obviously the way to go.

Victor Fox had seen Matt Baker's artistry with the female form and wanted him to handle Phantom Lady, give her a sexier costume and an hourglass figure. Baker approached the chore with obvious enthusiasm. Her costume consisted of a long red cape, a low-cut blue top that was shaped a little like a heart, leaving a bare back and quite a bit of her midriff naked. Short blue pants, a wide red belt, and high-heel shoes completed the picture. With her black ray flashlight that temporally blinded crooks, the Phantom Lady became one of the hottest properties in good girl comics.

Out went the superheroes and the funny animals. *Zoot Comics* and *All Top Comics* tossed out Cosmo the Cat and Flash Rabbit for Phantom Lady and Rulah, the sexy jungle goddess. Rulah made her first appearance in issue No. 7 of *Zoot*, and became so popular that *Zoot Comics* ended with issue No. 16, but continued as *Rulah, Jungle Goddess* No. 17, which lasted until issue 27, June 1949.

This is significant in the comics field. If a

company dropped a title and formed a new one, they continued the numbering as before in order to save themselves a ton of money they would have otherwise paid to the post office for second class mailing privileges. If the comic had originally been Zoot, then Fox would have applied for second class mailing. A long-winded piece of government bureaucracy meant that the comic publisher, rather than pay every time he had a new title, could avoid this by continuing the numbering sequence. When a title disappeared, it continued as something else. By doing this, a lot of money was saved. It took time, a long time in fact, but the Post Office eventually discovered what was going on and closed the loophole. For collectors trying to decipher who followed whom, the new legislation was probably a welcome break, though the annual Overstreet Comic Book Price Guide answers all the questions admirably.

By the time 1948 came around Dr. Wertham had become a well-respected figure in psychiatry. He had opened the Lafargue Clinic in Harlem, the first free psychiatric clinic to be opened in a slum district to help disturbed and wayward youth. His books, the best-selling *Dark Legend: A Study in Murder* and *Show of Violence*, probed the minds of several famous murderers. *Dark Legend*, published in 1941, is the grim story of a 17-year-old who brutally murders his promiscuous mother. Wertham was asked to diagnose the youth and his findings led to the youth being committed to a psychiatric institution. Nine years later he was discharged, completely cured. He later married and led a happy, fruitful existence.

At the time *Show of Violence* came out in 1948, the comics industry, apart from three or four large publishers like Dell, National, Fawcett, and Gilber-

163

Rulah was the most explicit of all the jungle girl comic characters. The pages of her adventures often mixed brutality and thinly-veiled sexual perversions – bondage, torture and killing. Below is the splash page of the infamous "Jungle Bonaparte" strip. *Rulah* © 1948 Fox Features Syndicate. ton, had found sex and violence were big-sellers. Wertham, shocked by some of the comics his patients read, began to study them and what he considered their probable effects on children. He was not a believer that man's basic instinct is violence and aggression, rather that, as he wrote, "the violence that manifests itself in violent crimes is not the expression of an inborn instinct of aggression and destruction. People like to be non-violent." The worried doctor thought that negative factors in society encouraged acts of violence. The thinlyveiled sexual sadism on show in the comics published by Fox Features made Lev Gleason his bête noire, especially *Phantom Lady* No. 17. This particular copy featured a skimpily-cad Phantom Lady in bondage, her head turned to the reader, the most inviting expression on her face.

There were plenty of comics that showed lissom figures on the covers. In one edition of *Zoot Comics* Rulah strikes a provocative pose as she uses a large knife to stab, again and again, a somewhat misshapen creature purporting to be a gorilla...the artist could draw girls but not gorillas. This particular copy of *Zoot* is filled with a variety of sexual perversions that could only have gratified disturbed minds.

Issue No. 15 (June 1948) was a real shocker. All three stories featured Rulah, Jungle Goddess in pages of brutality mixed with a number of Freudian perversions. One tale ran for ten pages and was

called "The Jungle Bonaparte." The splash page shows a hooded executioner about to decapitate a young, almost naked but hooded girl crouched over a bloody chopping block, her hands tied behind her. Seated on a throne above the execution scene is a manic-looking character dressed like Napoleon. The hapless girl's costume identifies her as Rulah, and leaping at the executioner is Rulah's pet panther, Saber. The succeeding pictures show the madcap "Napoleon" plotting to take over the jungle, then the world. He is the descendant of survivors of a French shipwreck some 150 years ago. The survivors were all lunatics being shipped to the colonies.

Napoleon, it turns out, has his Queen Josephine.164 She is very jealous and any pretty girl who falls into

the hands of Napoleon's red coated guard is executed, either by firing squad or decapitation. Although Napoleon likes a pretty face, what he really enjoys is watching the girls die. Eventually Rulah defeats Napoleon but not before a selection of panels have reveled in bondage, perversions, cruelty, and explicit scenes of decapitations and shooting. One detailed illustration shows a girl in bondage, breasts and buttocks carefully detailed, and the executioner's ax slicing down towards her neck. Another has Rulah in a series of very Freudian pictures cavorting with a large python, while yet another panel depicts Rulah crouching on the ground in an obvious sexual pose.

Originally drawn by Matt Baker (the artwork here is by Bill Gibson) Sky Girl's comical adventures were always just an excuse to have her clothes ride up or fall off entirely. They certainly weren't drawn with kids in mind. Jumbo Comics © 1949 Fiction House Magazines.

There has been a lot made of Phantom Lady

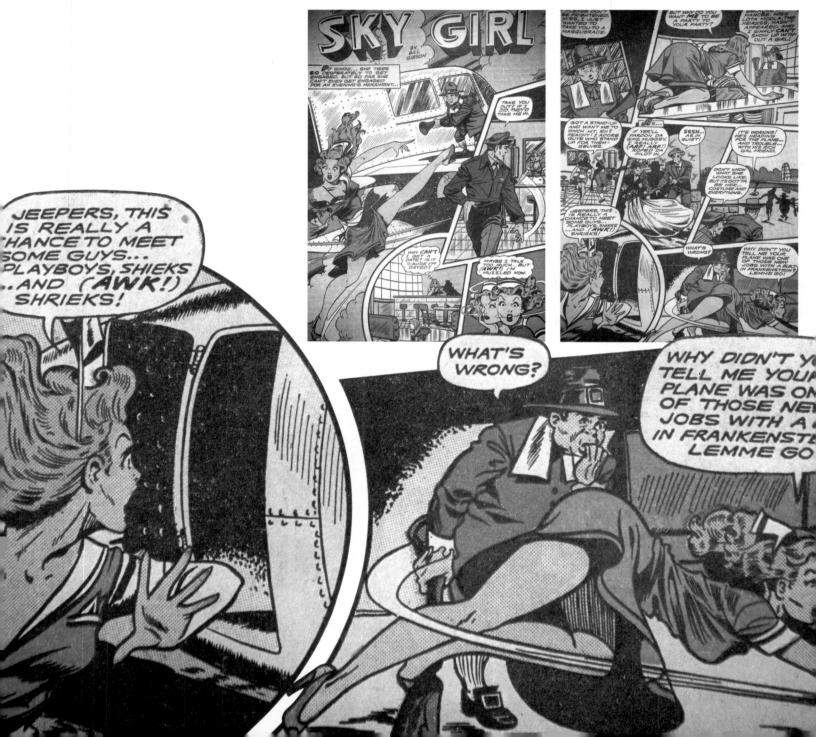

This Seven Seas Comics cover artwork from the Universal Phoenix Features stable is an early example of Matt Baker's undoubted ability with the female form. Seven Seas Comics © 1946 Universal Phoenix Features.

Bottom More wanton than phantom – Baker's "tantalizing" depiction of the voluptuous crime-fighter. *Phantom Lady* © 1948 Fox Features Syndicate. *Comics*, Fox's Number One heroine. Matt Baker's art is one reason, and the cover of issue 17 the other. Women were Baker's forte; when it came to men or to cars, his art was not on the same level. His women were exciting; they were a sexual wake-up call, the stuff of young boys' pubescent fantasies. Although tantalizing, Baker's bondage cover on No. 17 perhaps went a little too far. Her breasts are overly large, pressing tightly against her scanty costume, her shoulder arched provocatively against the thick piece of rope riding above her breasts. The ropes about her actually appear to be falling away as if the Phantom Lady has freed herself from them. Whatever the effect, it was deemed sexually stimulating when the comic first appeared in 1948.

Compared to Fox women, Fiction House heroines were in a different class. Their anatomy was wholesome and sexy, yet rarely over the top. Women fighting other women, a normal habit in Fox comics, was rare, although bondage was certainly common – especially with Anne, the brunette "mate" of Kaänga, Jungle King, who had his adventures in *Jungle Comics* and later in his own title drawn by John Celardo. Sheena was Fiction House's true star, blonde, beautiful and buxom. She was seldom seen in bondage – she was obviously meant to be a domineering force in the jungles that were her domain. Yet with the exception of Sheena and Nyoka, Fawcett's rather prudish jungle girl – she aways wore shorts and shirt and probably voted Republican –

165

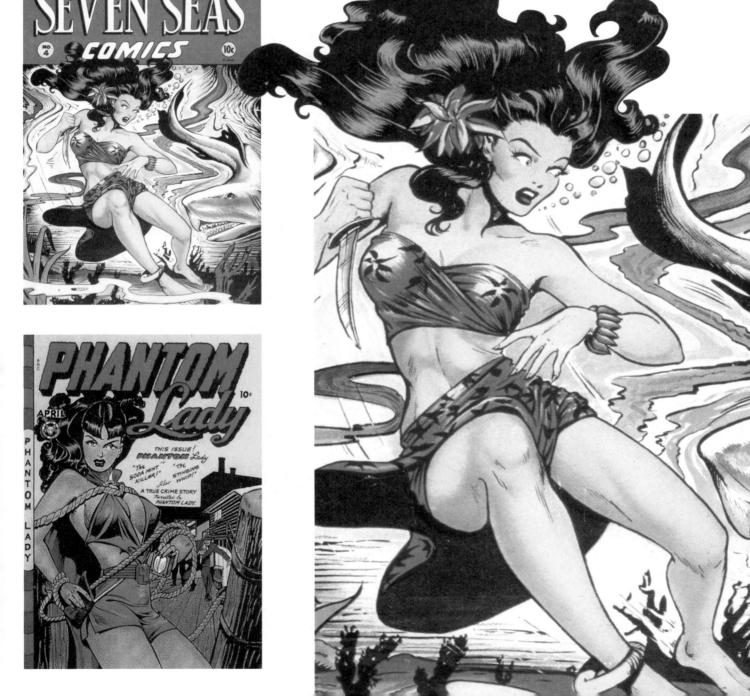

almost the entire jungle girl poulation had gone by 1952. Most good girl comics had lasted five or six years but the anti-comics folk helped put paid to them. Comic book publishers were desperate to do anything to please this ever-growing lobby led by Wertham, the Catholic Church and *Time* magazine. And the public wanted something different. It was certainly not the time to introduce a new heroine, but Stan Lee, the power house over at Atlas/Marvel, decided to create one.

Stan Lee was always looking for new ideas. If he had an exceptional artist who specialized in cowboys, or war, Stan would try and create a comic for them. This was certainly the case when Werner Roth walked into Stan's New York office. He looked over Werner's samples and knew that here was talent, a talent that could draw women far better than most. But Stan had no comic that involved women. "When you have a good artist like Werner Roth, you want to use him," Stan said. "So I took his samples to show Martin Goodman. I suggested we should use Werner, even create a comic for him. Which we did, and that was how Lorna the Jungle Girl was born."

Just as Lorna was being readied for a July 1953 cover-date introduction, Sheena – America's oldest jungle girl – left the stage she had ruled since 1938. She popped up in the last *Jungle Comics* No. 163, summer 1954, her final encore for her fans. Nyoka, a perennial favorite with the "born again" types and those who favored her conservative shorts and shirt jungle dress, lasted until the June 1953 issue, about which time Fawcett, her publishers, threw in the towel, quitting while they were still ahead and because they were losing the Captain Marvel/Superman lawsuit. Nyoka was bought by Charlton, who reintroduced her in November 1955, but she was

Lorna, Marvel's stab at a jungle girl, written by Stan Lee and drawn by Werner Roth, ditched kinky sex and violence in favor of good taste and conservation. *Lorna, The Jungle Girl* © 1953, 1954, 1955 Marvel Comics Group.

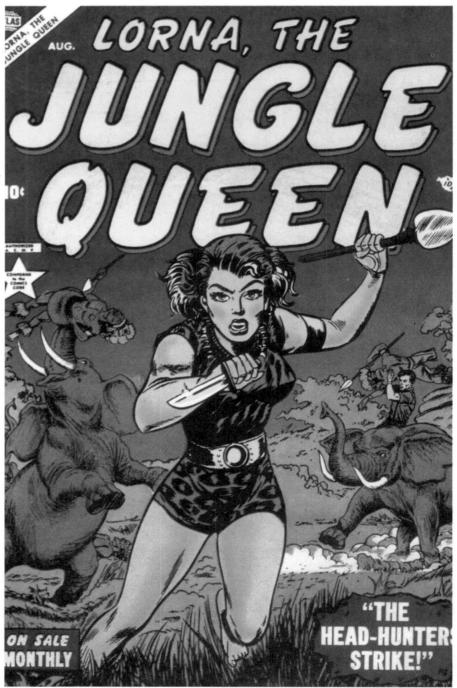

ORNA, THE

retired exactly two years later. She was the last jungle girl of the pre-code crop.

Werner Roth's work on Lorna was exquisite. Unfortunately he never did any of the covers, and the first half-dozen or so were not particularly inspiring. Two or three of them made Lorna look quite ugly, perhaps putting potential buyers off looking inside the comics. Had they done so they would have found one of the sexiest, most beautiful jungle girls of all.

Lorna had accompanied her father on a trip to Africa and, when he tragically died during the excursion, Lorna, already in love with Africa, decided to stay. Her father's African guide gave Lorna advice and protection in the first four or five issues of her comic, which was titled *Lorna*, *The Jungle Queen* (from issue 6 the title became *Lorna*, *The Jungle Girl*). By issue No. 2, Lorna met Greg Knight, hunter and guide, a handsome man who always told Lorna to keep out of the jungles, and to not interfere with some of the dangerous business he had to hand. Of course Lorna never paid attention, and invariably saved gorgeous Greg from the dangers he warned her against.

Jungle girl comics were like the killing fields of Cambodia, especially where wildlife was concerned. Sheena, Kaänga, Rulah and the rest killed anything on four legs that moved, with spear, knife, or bare hands. Lions, tigers, rhinos and crocodiles, even apes, all suffered. If the jungle heroes and heroines had been real, they would have been a prime cause of the endangering of species, perhaps even making some extinct. Thank heaven they were fiction!

Apart from the first few issues, Lorna was not like that. Stan Lee remarked that he did not like killing and in this he was a pioneer of sorts. Before anybody

had really heard of conservation, Lorna was knocking guns out of hunters' hands and throwing herself in front of threatened animals. Greg Knight even built a compound for endangered species, proving that jungle life could be exciting without the killing.

After issue No. 12, Jay Scott Pike took over the artwork. His Lorna was still beautiful but more slender, less top heavy. Sometimes the men and the backgrounds looked rushed, though this may have been the fault of the scripts, which had become mediocre by issue No. 13. Bad scripts or no, Lorna lasted 26 issues, and apart from Nyoka, was the only jungle girl to have a continuous print-run in Great Britain. She served her audience well and was one of the very best examples of the jungle girl genre. In 1947 the innovative team of Joe Simon and Jack Kirby was trying to find something new that would be immediately successful. Then it hit them. A romance comic – nobody had ever done one before – a romance comic aimed directly at the later teen market. It surely couldn't miss. Prize Publications liked the idea and told Simon and Kirby to go for it. *Young Romance* was the first romance comic to appear on the newsstands of America. On the covers it displayed the advisory, "Adults Only." In the comic there were plenty of panels showing girls in states of undress, and even pulling stockings on. The first issue was cover-dated September/October 1947.

Harry Donenfeld, still trying to fight Captain Marvel who was sailing along quite happily, had his Below Unlike the other jungle girls who killed anything that moved, Lorna was on the side of all but the most dangerous animals and spent most of her time fighting against predatory hunters. Lorna, The Jungle Girl © Marvel Comics Group.

Below Young Romaince was the first romance comic to appear on American newsstands in 1947. It included its share of risqué material and came with an "Adults Only" warning. By 1949 there was a host of imitators, such as Romantic Adventures, though few lasted that long. Young Romance Comics © Prize Comics Group. Romantic Adventures © American Comics Group. own independent distribution company and distributed Prize comics, including the new Young Romance. One of Donenfeld's National Comics Publications' biggest rivals was Marvel's Martin Goodman. Shortly after Young Romance appeared, Goodman was reportedly aghast at the title, the word "Adult," and the sexy looking girls within the comic's pages. He tore a letter off to Donenfeld, accusing him of rank obscenity and using the word "Adult" on the cover. "You are distributing obscene material," Goodman furiously wrote.

Donenfeld had already been a soft porn magazine publisher, and denied that what he was distributing was obscene. In fact he was already thinking of producing his own romance comics. As for Goodman, his accusations were designed to scare Donenfeld off – it wasn't long before his company had more romance titles than any other group.

Wally Wood, Bernie Krigstein, Bill Everett, and Bob Powell were some of the top notch artists who lent their talents to the love comics boom. A whole string of them popped up during 1949, and were instantly successful with teenage girls, and soon the whole industry jumped on the bandwagon. *Love at First Sight* (Ace Magazines October 1949), *Love Dramas* (Marvel October 1949), *Love Lessons* (Harvey Comics October 1949), *Love Confessions* (Quality October 1949), *Love Memories* (Fawcett no month 1949), *Love Stories* (Fox Features No. 6, no date 1950), *Romantic Love* (Avon October

169

1949), Romantic Marriage (Ziff-Davis no month 1950), and Romantic Confessions (Hillman October 1949), were just a few of the dozens of love comics that hit the stands in the beginning. Most didn't last all that long, though a few went more than five years. Most romance comics are relatively inexpensive on today's collector market and it is worth having a few examples in your collection.

Another genre that hit big for a short time were the war comics. When North Korea invaded the South in 1950, and United Nations forces, including troops from the U.S., Britain, Australia, and India went in to quell the invasion, America was reaching its peak of hysteria over communism, prompting a flood of war titles. According to the comics, only America fought in Korea, although Fawcett's *Soldier Comics* paid some sort of homage to Britain by including a Scots soldier in one tale.

Atlas had the most war titles, beginning with War Comics (December 1950), followed by Battlefield (April 1952), Battle Ground (September 1954), and Battle Front (June 1952). Artwork in the very gungho, somewhat racist Atlas titles, was invariably good, with the likes of Joe Maneely, Joe Sinnott, Russ Heath, and John Severin lifting the war comics and their generally ridiculous stories onto a higher plain. This couldn't be said for many others, although National Comics' Our Army at War (August 1952), Our Fighting Forces (October 1954), and Star Spangled War Stories (August 1952) were consistently well drawn and better scripted.

Atlas brought out a pair of awful books that Senator Joe McCarthy probably read in his bathroom. They were about three macho individuals sporting several days' growth of beard – an essential ingredient in comic book war stories – who were Once the Korean war was underway in 1950, gung-ho war titles began making a renaissance. Unshaven, killing-machines with names like Battle Brady and Combat Kelly fought tooth and nail against the red-menace of communist insurgency. Soldier Comics © 1952 Fawcett Publications. Marines in Battle © 1954, Battle © 1952, Battle Action ("featuring Battle Brady")

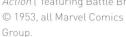

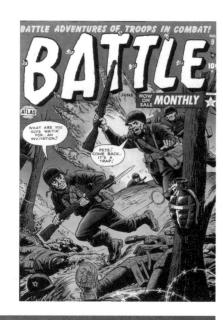

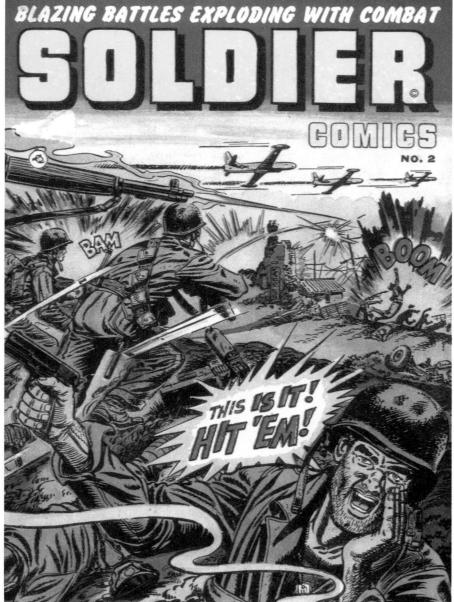

171

called Battle Brady, Combat Kelly, and Combat Casey. All three were hilarious G.I. caricatures: dreadful specimens of humanity who fostered thoughtless hate to kill the "commie rats." Combat Casey made this pretty plain in one issue as he knocked a North Korean's teeth out, then kicked him in the jaw: "Lemme show you how to bend over backwards," he spits. "Here's a kick in the belly for your thoughts, Comrade." Another so-called hero fired his tommy-gun at the Koreans, snarling "Dirty gook buzzards! I'll show you crummy bums how a man fights a war!"

Fawcett stirred the pot with *Battle Stories* (January 1952), and *Soldier Comics* (January 1952). Both had reasonably drawn stories and the occasional well written one, but generally they followed the anti-red fervor common at the time. One tale, beautifully drawn by Bob Powell, was "Sniper." The anti-red elements were there but the artwork was superb enough to blot out the sanctimonious script. An interesting novelty displayed in many war comics were the sound effects: "BRACABRA-CABRAC!" and "TAK-A-TAC-A-TAC! BAROOM! CRUMP! WHEEEEEE-CA-RUMP!"

Magazine Enterprises put out American Airforces. St. John had Fightin' Marines. Ace went one better with a comic called World War III ...was this wishful thinking? A small company called Stanmore had Battle Attack (October 1952), and Battle Cry (May 1952). Both were instantly forgettable. Harvey tried to make something of their war titles, one being Warfront (September 1951), but they were really more of the same formula featuring artwork that was rarely memorable. Others included a one-shot issued by Standard called Battle Front for June 1952. Perhaps the reason for it being a one- shot was

that it coincided with Atlas's *Battle Front* in the very same month. Standard/Nedor/Better probably got a rude letter from Martin Goodman telling them to cease and desist, though this is purely supposition. Ajax/Farrell had their own war book – everybody did – called *Battle Report* (August 1952), but it was a substandard offering.

There were only two war comics that were any good. One was *Two Fisted Tales*, the other, *Frontline Combat*. They were totally anti-war, beautifully scripted, and had the best comic artists in the land working on them. They were both Entertaining Comics (E.C.) titles (see Chapter 10), a company that did not look for favors or try to appease the politicians. It is likely that most other publishers, already under attack, decided to get the whacko politicians on their side by following their hysterical lead.

Science-fiction had been a major and successful staple of the pulps. Many great writers like Asimov and Bradbury began with the pulps, and comic publishers thought the same might happen with comic book science fiction. It didn't, which was a shame because the few titles that existed were generally on a higher intellectual plain than most comic books.

An early sci-fi comic was *Planet Comics* from Fiction House. It was one of the longest-running of the species, lasting over 13 years. It was quite successful due to the liberal helpings of sexy women cavorting through space with scarcely nothing on. Two other titles were National D.C.'s *Mystery in Space* and *Strange Adventures*. Both were well drawn and accompanied by thoughtful scripts. Their cover logos and design were among the best in the field, and while they were not top-sellers, it is thought they were kept on because of the enjoyment they gave their creators. Left and below *Fightin' Marines* let us know the all-American sentiments that make life worth defending against the "commie rats". *Fightin' Marines* © 1951 St John Publishing Co.

Right D.C.'s *Strange Adventures* and E.C.'s *Weird Science-Fantasy*. Science fiction had been a staple of the early pulps but failed to really catch on in comics, even with TV tie-ins such as *Captain Video*. *Weird Science-Fantasy* © 1955 William M. Gaines. *Captain Video* © 1951 Fawcett Publications. *Strange Adventures* © 1950 D.C. Comics, Inc.

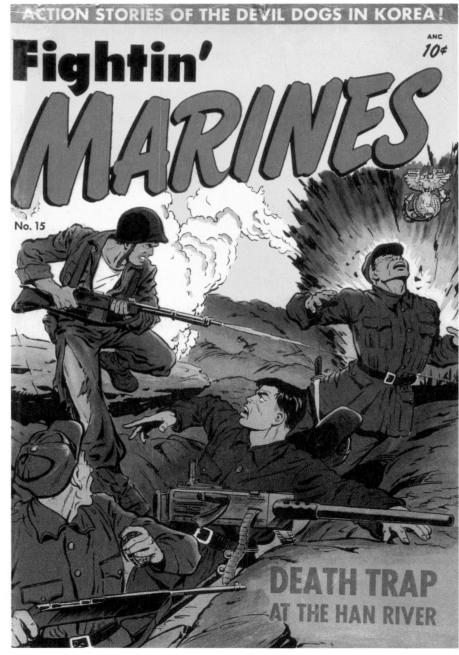

"THE TIME WHEN MEN COULD NOT WALK!"

One title that deserved longer exposure was Magazine Enterprise's Jet. Drawn by Bob Powell and starring Jet Powers, this excellent comic only lasted four issues before folding. Fawcett tried their luck with TV's Captain Video. The stories were good and the artwork, by George Evans, outstanding. Like Jet, Captain Video was dumped after five issues. Another TV hero was Tom Corbett, Space Cadet. Dell published Tom Corbett, which lasted longer than Flash Gordon, the latter beginning comic book life as reprinted newspaper material, notable for its exquisite Alex Raymond art. After two Alex Raymond issues, Dell boasted all new, original Flash Gordon stories and artwork, and it promptly died. Harvey released a single Flash Gordon newspaper reprint comic in their Harvey Hits series, but no more. No matter how they tried, science-fiction in the comics just didn't catch on.

Like the war comics, the very best of sci-fi comics came from E.C. These were *Weird Science* and *Weird Fantasy*. Beautifully and intelligently written and illustrated, both titles were the publisher's and editor's favorite comics. Yet again, they did not sell. E.C. tried everything, even adapting Ray Bradbury stories, but to no avail. "We at E.C. are proudest of our science fiction titles," was the oft-repeated message advertising the comics.

Speaking of Entertaining Comics, it is time to give the most brilliant, gifted and highly controversial comics of all time their turn. Put together by an incredible team of artists and writers who were the highest paid in the industry and were given complete freedom to interpret the story boards as they wished, E.C. will forever be remembered. Now read on..... Chapter Ten

HORROR WE, How's bayou?

with thanks to the Haunt of Fear and the Old Witch

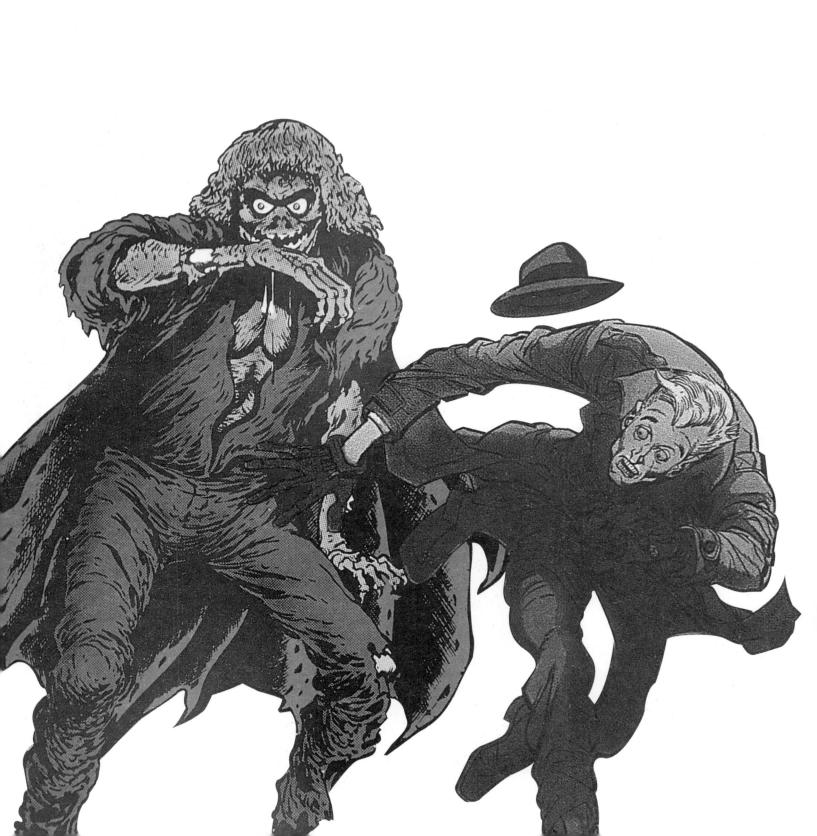

"WHAT I WANTED TO DO WAS STORY TELLING MUCH LIKE sex. In other words, a lot of foreplay and then coming to the climax," Al Feldstein chuckled. His description of the stories he wrote for E.C. comics was irreverent but entirely correct. Every story he ever wrote always had a twist in its tail, a punch ending. Not only was Feldstein a great artist, but his stories rank as the very best in the comics. And they are still being rediscovered through the excellent E.C. reprint series originated by Russ Cochran, published by Gemstone.

Feldstein was born in New York in October 1925, the son of a Russian immigrant father and first generation Polish mother. His father had a dental laboratory which went out of business in 1938, forcing 13-year-old Al to find an after-school job to help the family make ends meet. Al showed he had an artist's blood in his veins at quite an early age, and when he was 14 he enrolled in Manhattan's High School for Music and Art. While he was studying, Feldstein discovered the Iger-Eisner comic art shop. There he got a job as an after-school gopher, and eventually he was allowed to do backgrounds and inking, then graduated to drawing.

At this time, Feldstein wanted to be an art teacher, and studied at the Brooklyn College by day. At night he was taking art classes at the Art Students League. Then came the war and in 1943 Feldstein joined the Army Air Corps. His artistic talent was soon discovered and he spent his army time doing murals, painting signs, decorating pilot jackets, and other

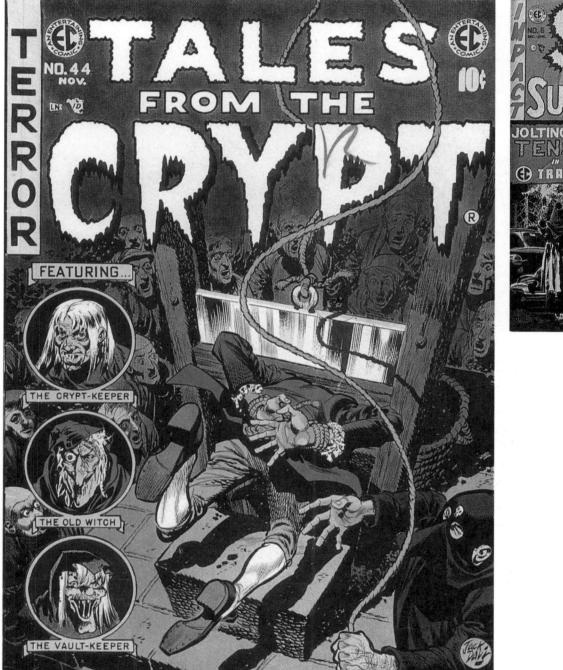

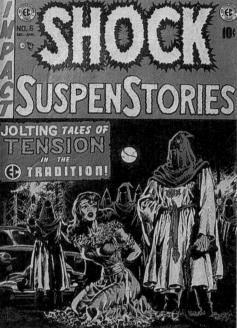

176

forms of artwork, beginning at the air base at Blytheville, Arkansas.

Discharged from the A.A.C. in 1945, Feldstein went back to the Iger shop (Eisner had long since gone). Soon he was working for a variety of Iger's clients, including Fox, Quality, and Fiction House. Iger paid his artists about \$75 a week, and according to Feldstein he was making "a bundle." He had some top talent working for him, people like Reed Crandall, Jack Kamen, and Al Feldstein. The artists would turn out two pages each a day, which Iger in turn sold to the varous publishers for \$30 each. Feldstein thought the income ratio heavily weighted in favor of Jerry Iger and decided he could do much better for himself if he went freelance. He left Iger, continued working for Fox, Fiction House and the rest on his own, and made much more money.

Feldstein did a lot of work for Fox during 1947 and 1948, illustrating stories in *Sunny, America's Sweetheart, Junior*, which became *Western Killers* from No. 17 on, *Meet Corliss Archer*, and *Aggie Mack*, published by Superior comics. Then he heard about Bill Gaines.

Gaines was quickly learning the comic book business with the help of Sol Cohen, who used to be Max Gaines's circulation manager, and Frank Lee, the business manager at Educational Comics. Both men watched over the flagging fortunes at E.C. while the young Gaines struggled to find a variety of comic that would sell. *Archie* and other teen comics were

and 1954 William M. Gaines. better for hit

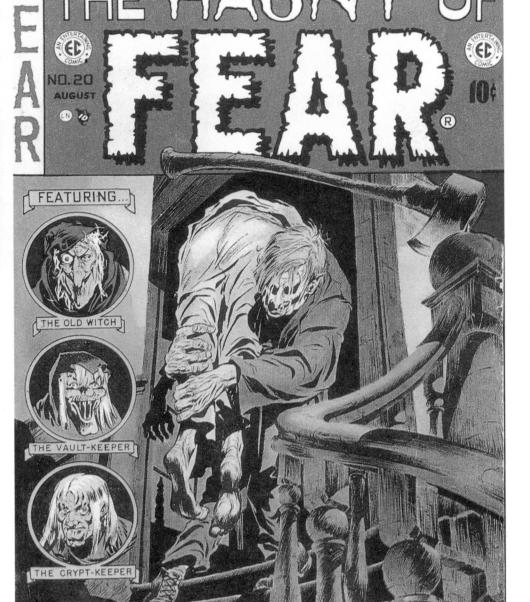

Some of Feldstein's crowning achievements, *The Haunt of Fear* (cover by Graham Ingels) and *Tales from the Crypt* (cover by Jack Davis) and *Shock SuspenStories* all of which he edited at E.C. under Bill Gaines. *The Haunt of Fear* © 1953, *Tales from the Crypt* © 1954, *Shock SuspenStories* © 1953 and 1954 William M. Gaines.

Web of Evil from Quality Publications and Uncanny Tales from Atlas – both inferior imitations of the E.C.-style horror comics. Web of Evil © 1954, Quality Comics Group. Uncanny Tales © 1954 Marvel Comics Group.

doing well, prompting Gaines to follow suit with his own teen comic. He needed an artist talented with women, and Cohen immediately thought of Feldstein, who was working at Fox. Cohen contacted Feldstein, who aranged a meeting with Gaines to show him his portfolio. Gaines was impressed enough to sign Feldstein up to do a title tentatively entitled *Going Steady with Peggy*.

Feldstein had only just completed the first story when Gaines called him into his office. With some reluctance, he told Feldstein *Going Steady with Peggy* was going to be a non-starter. Teen comics had died overnight – only the originals like *Archie* remained. In the five-year period after the war, tastes had changed. Superheroes were redundant, there were no Hitlers or Tojos to fight anymore, leaving only Superman, Batman, Superboy (Superman as a teenager), Captain Marvel and the Marvel Family to carry on protecting America. People had had their fill of war, hence the desire for fun characters on one hand, crime on the other. Teen comics had reached overkill proportions and crime would soon follow.

Gaines didn't want to lose Al Feldstein and was relieved when he said "Okay, tear up the contract. I'll work for you and help develop some more marketable titles." The result of that meeting was a complete turnaround for E.C., and the beginning of a strong friendship that would last many years. Their friendship would eventually take the comic book industry down a precipitous road and almost over the cliff, thanks in part to Dr. Frederic Wertham.

Dr. Wertham was nicknamed "Dr. Quarter" by his youthful patients at the Lafargue Clinic he opened in Harlem's slum district. It was the first psychiatric clinic ever to be housed in Harlem, and was

178

free to the poor in the area. All the outpatients were charged was one quarter per visit, hence Wertham's nickname. As he and his team investigated the generally ill-educated, sometimes illiterate and delinquent youngsters, Wertham noticed with growing alarm that his patients all read comic books.

Crime Does Not Pay became his bête noire. Wertham deplored, and with some justification, everything about Gleason's successful title. He wrote in his famous book, *Seduction of the Innocent*, that "One crime comic book announces on its cover that it is read by six million readers (*Crime Does Not Pay*). It is interesting that this is one of the worst comic books, a veritable primer for teaching Junior juvenile delinquency." He found many of his juvenile subjects, the majority of whom had committed felonies, read this comic; they were part of the "six million readers."

Much of Wertham's book went overboard in its assumption that all comic books were crime comic books. However, this was an accusation not always without foundation. Without a war to fight, the superheroes that were left took to fighting crime, and western comics invariably found the heroes dealing with cattle rustlers or gun fighters, who were criminals in a romantic setting.

Wertham's anxiety over some of the literature aimed at the nation's youth prompted *Crime Does Not Pay* publisher, Lev Gleason, to act. He and Charles Biro published a list of rules, aimed at their writers and artists. In *Crime Does Not Pay* and his new comic, *Crime and Punishment*, blood was not to be shown on somebody's face, hoodlums were not to show glee when killing somebody, and so on. It all looked very promising as far as Gleason and his distributor, I.S. Manheimer, were concerned. Not that

the comic book detractors would have been taken in by Gleason's and Biro's regulations; in the very issue of *Crime and Punishment* the list appeared, there were several violations of the supposed code.

On July 1, 1948, a dozen comic book publishers clubbed together to form the Association of Comics Magazine Publishers (A.C.M.P). The Board of Directors in 1951 was headed by Leverett S. Gleason (President), Harold A. Moore of Famous Funnies Inc. was Treasurer, Secretary was Orbit Publications' Ray Hermann (Orbit published *Wanted*, a famous crime comic), while Educational Comics' Bill Gaines, Irving Manheimer of Publishers Distributing Corp., and Frank Armer of Leader News Co., made up the rest. Henry E. Schultz was Executive Director of the Board. The president in 1948 was Phil Keenan, who was reported to have said that "we are on trial in the court of public opinion. Our defense is this code of minimal editorial standards designed to result in the production of comic magazines which are interesting, exciting, dramatic...and clean."

There was a six-point code which banned sadistic torture and bias against any religious or racial group. No female would be shown wearing anything less than a standard bathing suit, crime would not be shown as glamorous, authority – including the police, judges and government – would not be defined as stupid, and details of how crimes were executed would be forbidden. This set of standards

Below Like many others, Orbit Publications signed up to the Comics Code, yet their comics, which included *Wanted*, got even worse in many cases. *Wanted* © 1952, Orbit Publications.

Bloodstains MARKED the COIN of KILLERS! TE WE'RE PALS! REMEMBER? ONE FOR ALL ... AND ALL FOR ONE! YOU'RE THE LAST ALIVE, JOHNNY! SO I WON'T KEEP YOU APART FROM THE OTHERS N-NO! YOU'VE COME BACK FROM THE DEA... GHAAAAAA! EEEEEE! A WALKING DEAD MAN! HELP! **Out Of The MAUSOLEUM Of** WEIRD CRIMES MAKE WAY FOR-NY **E () () ()** () A TRUE-DETECTIVE story based upon **ACTUAL POLICE RECORDS**

was supposed to be adhered to by the comic publishers, who numbered 35 in all. Comic publishers who were members of A.C.M.P. would carry a certificate of membership on the covers of their comics, consisting of a five-pointed star emblazoned with the message "Conforms to the Comics Code," under a bar which read: "Authorized A.C.M.P"

Only a dozen publishers bothered to join. Some of the twelve were Gleason Publishing, Orbit Publications, Marvel/Atlas, Hillman Periodicals, Famous Funnies, Educational Comics, and Prize Group. The star and bar was initially quite noticeable on the comics, supposedly to give confidence to parents, but became almost illegible after a short time.

At first worried parents thought the industry was

cleaning up, and that kids would not come to any harm reading comics with the star and bar. Actually the opposite was true. After a while, many comics featuring the A.C.M.P. symbol got worse instead of better.

Not all publishers were as irresponsible. Dell published the best range of funny animal comics that were beautifully drawn and well written, Carl Barks and Walt Kelly being two of their finest artists. The Four Color series was especially good and highly imaginative. As far as Dell's adventure comics were concerned, they were clean and wholesome; *Roy Rogers*, *Gene Autry*, *Lassie*, *Tarzan*, and *Zorro* could all satisfy parents that Dell comics ranked alongside *Dr. Seuss* and *Golden Books* as good reading matter for their children. Consequently Dell

181

Below Dell's *Roy Rogers* was the epitome of the responsible and wholesome image the Comics Code was trying to foster.

comics outsold all other comics publishers combined almost two to one, a staggering amount.

National Comics Publications (D.C.) were aimed at a slightly higher age level, from eight to fourteen (Dell held the three to ten age group). Overall, National published a fine range of characters – Superman, Batman, the Green Lantern, and Flash were known and loved throughout the world. Fawcett Publications' comics were aimed at children between three and fourteen years, and consisted of Captain Marvel, Captain Marvel Jr., Captain Midnight and Tom Mix. Overall, Fawcett produced decent comics though there were the occasional lapses. The same could be said of Harvey Publications who published many childrens' comics like Joe Palooka, Humphrey, Little Audrey, and Black Cat. But by 1952 Harvey was publishing a range of comics that were in questionable taste.

Timely/Atlas/Marvel had a great mix of titles – westerns, funny animals, war, horror, crime, teen, and jungle – which appeared to have no age group. None fitted the very young, the likes of Sub-Mariner were probably aimed at eight years and older. Most were for the mid- to late teens and although there were several instances of questionable taste, the Marvel/Atlas comics were all pretty harmless.

Gilberton's *Classics Illustrated* were very good, especially the later issues. Early classics massacred the authors' books, but as time went on, more attention was paid to the adaptations of a writer's work

WEIRD TALES OF TERROR H OR R F C TERROR by the MASTER

Left Following E.C.'s lead Horrific tried their own sinister master of ceremonies called 'The Teller', a dead ringer for Vincent Price. Horrific © 1954 Comic Media.

Right Classic Comics which soon became Classics Illustrated, both abridged the literary greats to comic book form. They were viewed as inoffensive and even broadly educational in comparison to most other comics. Classic Comics and Classics Illustrated © 1944 and 1947 Gilberton Co.

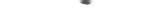

and the artwork improved. Classics were so popular across the globe that they were printed in 25 languages, and there were at least 250 original foreign editions not available in the U.S. England had fifteen of these, including the James Bond story, *Dr No. Classics Illustrated* had the largest European distribution of any American publication.

The controversial publishers that would eventually burst the comics bubble were small outfits like Story Publications, Comic Media (Allan Hardy Associates), Lev Gleason, Magazine Village, Fox and, to a lesser degree, Fiction House. All concentrated on feeding the reader a diet of sex, sadism, racism, and violence. But the publisher that turned a whole industry upside down was Bill Gaines's E.C. Bill Gaines and Al Feldstein got on together like a house on fire. They discovered they shared much in common such as the horror/suspense radio shows they listened to as youngsters. Their love for science fiction and horror remained with them into adulthood. Divorced, Gaines lived with his mother in Brooklyn, and Feldstein was having marital troubles at the time. They spoke about these things, their passion for the Brooklyn Dodgers, went out together and discussed comics. Feldstein began illustrating a romance comic called *Modern Love* but told Gaines the scripts were terrible. "I can do better than this," he complained. Gaines let him write and draw the comic. Other titles were *Internatonal Crime Patrol* that Gaines changed from *International Comics*,

183

then changed again to just *Crime Patrol* with issue No. 7. *Happy Houlihans* was altered to *Saddle Justice*, with a first E.C. appearance by Graham Ingels in issue No. 4. By the middle of 1948, Feldstein was working with both Graham Ingels and Johnny Craig, the first of the major E.C. artists to join the company.

Assessing the comic book market for what it was, Feldstein told Gaines it would be far better to begin a trend rather than imitate what was already on the market. It was about this time that comic artist, Sheldon Moldoff, who freelanced at E.C. between 1947 and early 1949, allegedly turned up at 225 Lafayette Street with an idea for a horror comic. Moldoff suggested a host called Dr. Death, who would act as an anchor man for the horror stories. Gaines took the idea but never contacted Moldoff, for, in all probability, Feldstein had already discussed the idea of a horror title with him. But Feldstein and Gaines were careful; they would test the water first. In issue No. 10 December 1949/January 1950 of *War Against Crime*, the infamous Vault Keeper made his debut in a Feldstein written and drawn horror tale titled "Buried Alive." And in *Crime Patrol* No.15, published the same month, Feldstein had another horror story, this one hosted by the Crypt Keeper, who eventually became the most famous horror anchor in the world.

As soon as the pair of comics hit the stands, Gaines and Feldstein knew they were on to someBelow The Keeper of the Vault, drawn by Johnny Craig. Feldstein and Gaines's groundbreaking horror strips anchored by the Crypt Keeper and the Vault Keeper first saw the light of day for E.C. in December 1949. *The Vault of Horror* © William M. Gaines.

thing good. Mail came to the offices clamoring for more. For the second, and last time, the two horror hosts appeared in the crime comics with tales of dread. *Crime Patrol* and *War Against Crime* folded, their names changed to *Vault of Horror* No. 12 and *Crypt of Terror* No. 17, both cover-dated April/May 1950. "Introducing a New Trend in magazines... Illustrated SuspenStories we dare you to read!" trumpeted the cover blurb of these and the next horror title, *Haunt of Fear* No. 15, May/June 1950 (a title that followed on from *Gunfighter*.) This third title in the terror trio had the only female host, the Old Witch.

Sol Cohen, Max Gaines's former circulation director who had stayed on at E.C. to guide young

Bill in the ways of the comics business, was none too impressed with the fiendish threesome, even though early sales returns showed the horror fare was right on target. It didn't matter to Sol; horror was not for him. He left E.C. to go to work with Avon Periodicals.

The Johnny Craig cover for *Crypt of Terror* shows an attractive woman walking fearfully through an alley, a cat searching through a garbage can, a cast-aside newspaper with the headline, "Werewolf Strikes Again," and creeping after the girl, the werewolf himself, all giving promise of what was to come. A man is stretched on the rack on the cover of *Vault of Horror*, and the unsavory Old Witch beckons the readers into her cave of hanging skeletons, evil demons, and ghouls in *Haunt of Fear*.

Below The Crypt Keeper and his terrifying tales, drawn by Jack Davis. *Tales from the Crypt* © 1953 William M. Gaines.

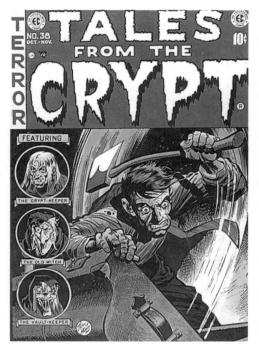

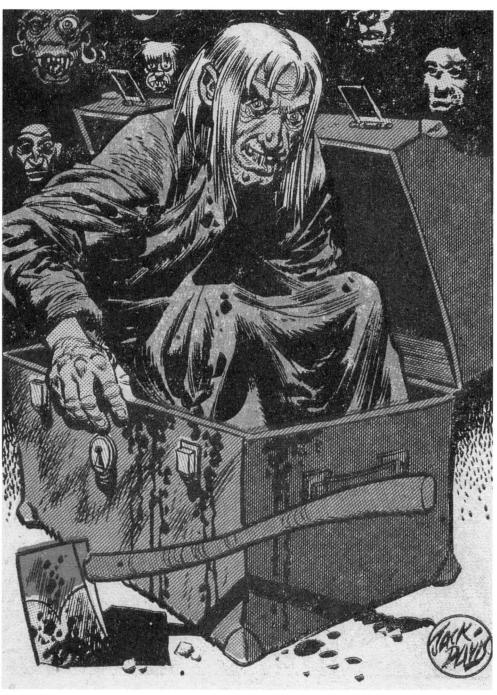

Here were the successors to the good old days of the *Inner Sanctum*, *Lights Out*, and other old radio shows filled with horror and suspense. The reformed E.C. was the new kid on the block with upstart ways and tales of gore.

Many think horror comics started with E.C., but nothing could be further from the truth. Avon Periodicals came out with a single issue of a comic called *Eerie* in January 1947, but the first continuous horror comic was *Adventures into the Unknown* which appeared in the fall of 1948. In fact Feldstein himself drew nine pages in the third issue of this comic, which subsequently became the longestrunning horror comic, with a life of 19 years. Always a fairly clean horror comic, *Adventures* *into the Unknown* and its later companion *Forbidden Worlds* were never cited for anything, thus their long runs.

The *Crypt of Terror* underwent a name change to *Tales from the Crypt* from issue No. 20 (October/November 1950), and issue No. 22 brought the traditional *Tales* cover logo. Soon the three GhouLunatics were hosting one story each in the three titles, each comic's chief host telling two. Thus, *Haunt of Fear* began with a tale entitled "The Witch's Cauldron" told by the Old Witch and always illustrated by "Ghastly" who was actually Graham Ingels. The next story would be either the "Vault of Horror" or "Crypt of Terror," followed by another tale by the Old Witch. All three of E.C.'s

Below The Haunt of Fear added the Old Witch to make a trio of ghoulishly irreverent narrators for E.C. horror comics. The Haunt of Fear © 1953 (left) and 1954 (below) William M. Gaines.

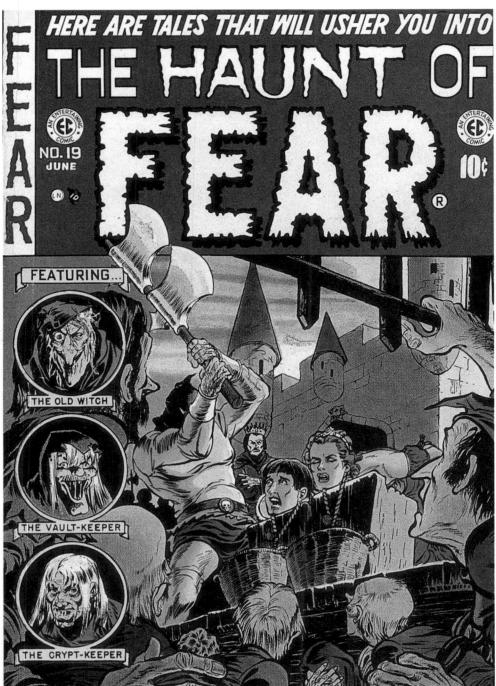

Below and left It was the mixture of sick humor, great storytelling and great artistry that made the E.C. titles such compelling reading just as much as the shocking horror. The artwork below, from *The Vault of Horror* No.34, shows sadistic, gurning kidnappers from the point of view of their victim. *The Vault of Horror* © 1953 William M. Gaines.

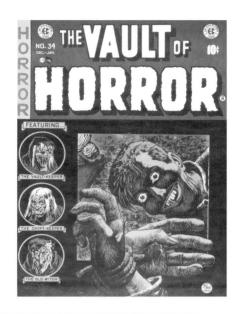

horror comics settled down into this formula once they became established.

Right from the beginning, E.C. intended to make the three hosts diabolically endearing, and blessed with nauseating charisma. They talked to the readers, called them "kiddies," were totally irreverent. The three mischief-makers dished out sickening, but amusing, puns - story titles such as "Bedtime Gory" and "Lover, Come Hack to Me!" are typical. A story opening from the Old Witch gives the general flavor: "Hee, hee! Well, hop into the haunt, hungry hidiots. This is the Old Witch, your shiverchef, stewing another scream-snack in her cruddy cauldron. I hope you haven't eaten already, because if you have...well, come closer to the cauldron just in case. I'd hate to have the floor messed up while I'm narrating my nauseating novelette. Besides...the old recipe needs a little flavoring! And now, read Emile's story in his own words. He calls it...SUCKER BAIT!"

Wanting to build up this camaraderie with the readers, and make a cult out of the Old Witch, the Vault Keeper and Crypt Keeper, Feldstein had photographs taken of artist Johnny Craig dressed up as the three characters in full wigs and costumes. The photos were offered for sale in the comics for a dime each...and sold out.

As anyone who read E.C.'s horror comics when they were youngsters will tell you, you never forgot them. Stories remained with readers 50 years on. This is partly due to Al Feldstein's superb writing skills; each seven-page yarn reads like a novelette. Feldstein's scripts were vastly superior to many short story writers', even better than some novels. This is why E.C. comics were so good, so memorable. Wallace Wood, Reed Crandall, George Evans,

Graham "Ghastly" Ingels, Jack Davis, Joe Orlando, Bernie Krigstein, Al Williamson, Al Feldstein, Harvey Kurtzman were among the artists who made E.C. the best horror/crime comics anywhere in the world. Each artist was an individual, and Gaines and Feldstein gave them free rein to interpret the scripts any way they wanted to in their art.

"Foul Play!" is a grisly tale about the most famous baseball game ever played: "It is midnight...the eve of opening day. Central City's bush-league ball park lies in darkness. There is a smell of freshly painted seats and rails and hotdog stands hanging in the cool night air. The championship pennant sags limply from the newwhitened flagpole in the outfield, lifting sadly now and then to flap in the soft breeze that sweeps in and across the silent deserted grandstands. But down on the green playing field, illuminated by the cold moonlight, are figures...figures in baseball uniforms...each in its position...waiting...waiting for the words...Play Ball!"

This particular baseball game is about as infamous as a baseball game can be. It appeared in *The Haunt* of *Fear* No. 19, the last story in the comic. It was illustrated by Jack Davis, one of the great artists who joined E.C. in 1951. "Foul Play" was used as a rallying cry, as an example of why comic books should be banned. It is a story that concerns two baseball teams playing against each other in the last days of the bush-league pennant race. The game is an end-ofseason playoff between Central City and Bayville.

Herbie Satten played for Central City. He wasn't a pleasant man on or off the field. But he wanted his team to win. Bayville's top man was Jerry Deegan, the league leader in hits and home runs. At one point in the game, Satten suddenly slipped, and slid into Left An original comic ad for the rapidly proliferating E.C. horror stable.

Below The morality tale "Foul Play!", one of the most notoriously gory of the E.C. strips, led to its artist, Jack Davis, being hounded by the anti-comic lobby for years. *The Haunt of Fear* © 1953 William M. Gaines.

Right and below The settled Tales from the Crypt format with the narrators in cameos down the left-hand side. Tales from the Crypt © 1953 William M. Gaines.

Deegan, his spiked boots catching Deegan's leg. A drop of blood trickled from the wound. The game had reached a tie. Bayville were confident Deegan would make the grade, as he always did. But Jerry, sitting in the dugout, waiting his turn, didn't look right: "I'm...I'm okay!" Jerry mumbled, "Just feel a little... dizzy..." Finally he made it to the batter's box, and Satten pitched to him. Deegan missed, Satten pumped another, then Deegan fell to the ground – dead.

Bayville's doctor was suspicious. He did a quick autopsy. "It...it wasn't his heart, boys! Jerry was poisoned. This is...murder!" The Bayville players put two and two together and realized that Satten was the culprit. In the words of the Crypt Keeper: "Yes, fiends. Herbie Satten had so wanted to win the pennant, not for Central City but for his own fat ego, that at the beginning of the ninth, while his team was at bat, he'd painted his spikes with fast acting poison...Herbie'd thought he'd gotten away with it. He'd pitched his team to victory and the pennant. He'd been declared a hero. Soon it would be the big leagues for him. Soon he'd be famous. He'd have a name. A name immortalized in the annals of baseball."

Satten received a letter claiming to be from a group of his most avid supporters. They wanted to place a special plaque honoring his achievements in baseball and asked Satten to meet them at the grounds at 11 p.m. to discuss the placement of the plaque. Naturally Herbie, puffed up with ego, went. Then he saw it was the Bayville team waiting for him. Only then did he realize...

In the gory climax of this tale, a ghoulish baseball game takes place in which the parts of Satten's dismembered body are creatively used as ball, bats,

chest protector and so on. It was this section that was decried by Wertham and others. Jack Davis regrets he ever drew the "Foul Play" story, which has become a millstone around his neck. Whenever neighbors find out he drew that story, they come around to badger him about it. The local newspaper, normally with nothing to write about, sees big headlines in Jack Davis. According to sources, Davis actually moved a couple of times to escape the press and public invading his privacy. Yet gruesome as it was, "Foul Play" was a highly moral tale about bad sportsmanship.

In October 1950, E.C.'s Crime appeared. It published depressing tales of dastardly crimes, love stories gone horribly wrong, faithless wives that want to murder their husbands or husbands who want to murder their wives. As for Shock SuspenStories, E.C.'s final horror/suspense title that debuted in February of 1952, that was a whole new ball game. It was a social comic that addressed the ills of society; the Ku Klux Klan and their evil bigotry, drug addiction, racism. Shock SuspenStories was a shocker, but brought to the world the evils we don't see, or rather, don't want to see.

Morals played an important part in all E.C. tales even though good did not always appear to triumph. An example of this was the E.C. classic, drawn with sinister realism by Reed Crandell for Shock Suspen-Stories No. 16. It is the story of the sheriff who raped a young girl, then framed a young stranger his

ISPENSTORIES

Below Crime SuspenStories, launched in October 1950, told twisted tales of violence, murder and punishment, while Shock SuspenStories, launched in February 1950, is straight horror-suspense.

Crime SuspenStories © 1954, Shock SuspenStories © 1952 William M. Gaines.

Bottom A panel from a rather sick E.C. tale of a cute little child who shoots her father and then frames her mother and her lover for the crime.

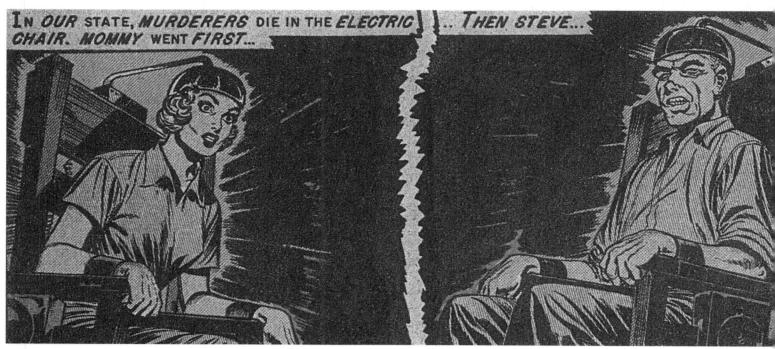

THE CLASSIC ERA OF AMERICAN COMICS

deputies picked up at the local diner. The deputies beat him up, but he continues to protest his innocence until the sheriff intervenes. Outside the jail a mob is howling for blood. The sheriff promises to protect the young man from the mob if he signs a confession. Eagerly the man signs, the sheriff goes out and faces the cretinous mob and waves the confession. The mob push him aside, crowds into the jail and beats the innocent, terrified young man to death. The sheriff doesn't hear the man's pleas, for he is driving the young girl home and telling her she did well not to say anything, and if she ever does he'll kill her, a typical Feldstein twist ending for an uncomfortable, sordid tale.

After a particularly horrible Shock SuspenStories

tale of Klu Klux Klan men thrashing a girl to death, witnessed by a young newspaper reporter, who in turn is shot to death, the final caption reads: "Yes...Safe! Safe behind their masks of prejudice, these hooded peddlars of racial, religious, and political hatred operate today! Mind you, there are shrewd and ruthless men such as those in our story! How long can we stay 'cool' and indfferent to this threat to our democratic way of life? It is time to unveil these usurpers of our constitutionally guaranteed freedoms!"

Of all the comics Gaines and Feldstein were responsible for, Weird Science and Weird Fantasy were their favorites. Both titles debuted as issues No. 12 and No. 13 respectively. They were cover-

Crime SuspenStories No. 22 the issue which finally got E.C. into hot water with the censorship lobby. Crime SuspenStories © 1954 William M. Gaines.

IN

Below A cover detail from

With the innocuously titled Men's Adventures, Atlas was producing weird and warped tales for teenage men too. Men's Adventures © 1953 Marvel Comics Group.

dated April/May 1950. Both titles were truly works of pure imagination, Al Feldstein's scripts so good that they should have been turned into a book of short stories. Tales like "Project...Survival," "The Two Century Journey," "The 10th at Noon," and "Not on the Menu," to name but a few, were thoughtful, yet believable tales of what space travel and the other planets might be like.

Science-fiction comics were generally not as popular as other genres. Well written and beautifully illustrated by the likes of Wood, Williamson, Orlando, and Kamen, *Weird Science* and *Weird Fantasy* were perhaps too intelligent for much of the comic-buying public. There were 22 issues of each title before they folded and combined to become *Weird Science-Fantasy*. Only seven issues were produced before there was a third title change to *Incredible Science Fiction*, which lasted a mere four issues.

E.C. had only twelve different comic titles ranging from horror and sci-fi to war and humor. They had two of the best war comics ever devised in the form of *Two Fisted Tales* and *Frontline Combat*. Both titles were down to Harvey Kurtzman, yet another genius to join the growing ranks of talent at 225 Lafayette Street.

Harvey Kurtzman was one of the greats in comics. He was born in Brooklyn, New York on October 3, 1924. His father died when Harvey was very young. His mother remarried and the family moved to the Bronx. Before the move his mother had enrolled him in art classes at the Pratt Institute and Brooklyn Museum. When he was nine, Kurtzman became fascinated with the Sunday newspapers' color comic sections. He said the Sunday funnies gave him the desire to draw comics. His art won several contests before he was enrolled in the High School of Music and Art in Manhattan. In 1939 he submitted a cartoon to *Tip Top Comics*' monthly "Cartoonist Club Contest." He was delighted to find he won a one dollar prize and, even better, his cartoon was printed. Kurtzman realized that cartooning was all he wanted to do. Graduating from high school in 1939, he received a scholarship to the Cooper Union Art School where he took classes in sculpture, lettering, and painting. Studying at night, Kurtzman worked at odd jobs during the day.

Louis Ferstadt, a Russian-born portrait painter, was looking for an assistant to help him with the comic book work he had taken on to help pay studio bills. He hired Kurtzman as inker on other cartoonists' work. By the time the government whisked him into military service, Kurtzman was writing and drawing stories for *Super Mystery* and *Four Favorites*. In the army Kurtzman was classified as a draftsman and worked on training materials for the Army Department of Information and Education. He also drew cartoons for *Yank*, *The Army Weekly*.

After his discharge from the army Kurtzman returned to New York and took examples of his work to show Stan Lee at Marvel Comics. Lee didn't need a regular comic feature but invited Kurtzman to do one-page fillers. He did a series of "Hey Look!" that featured lunatic characters who went through madcap adventures before the punchline at the end of the page. His "Hey Look!" cartoons appeared in *Joker Comics, Krazy Comics, Tessie the Typist*, and others.

In 1949, Harvey Kurtzman devised a medical facts cartoon to help people understand medicine. He decided to show his work to Educational Comics

not knowing Gaines had changed the title to Entertaining Comics. Harvey explained he wanted to do educational comics on medicine. Gaines and Feldstein said they were plotting a new line of comics and Kurtzman's ideas didn't fit in. But both men liked his art and eventually he was given work on *Weird Science*, *Weird Fantasy*, *Haunt of Fear, Crypt of Terror*, and *Vault of Horror*. He wasn't too keen on the horror comics, which he thought were in questionable taste, but quite enjoyed doing the sci-fi comics.

As was said earlier, Feldstein gave artists the freedom to interpret the scripts themselves, presenting them with story boards with script and panels already done. But Kurtzman had other ideas...he wanted to write his own scripts. Why not, he suggested, do he-men adventure comics for teenage males? Already Marvel/Atlas were producing *Men's Adventures* and *Man Comics*, both containing exciting stories of adventure and science fiction in sometimes exotic locations. Gaines followed suit with *Two Fisted Tales* and Kurtzman was the packager.

The first copy, cover-dated November/December 1950, was issue No. 18 and followed on from *Haunt* of *Fear. Two Fisted Tales* ran from Nos. 18 to 41. Apart from Atlas's *War Comics* (December 1950), there was little else on the market. When war comics finally became the rage, almost all were of the gung ho! variety. Not *Two-Fisted Tales*. Kurtzman made the comic as anti-war as possible. The stories, almost always written by himself, were brilliantly drawn by Jack Davis, John Severin, Bill Elder, Wally Wood, George Evans, Bernard Krigstein, and Harvey Kurtzman himself. All these artists drew as if possessed, Wally Wood certainly doing some of his best work for *Two-Fisted Tales* then later, *Frontline*

Combat. George Evans, already interested in aircraft, drew superb World War I stories, the Spads and Fokkers correct to the last detail.

Kurtzman was a hard taskmaster. Unlike Feldstein, who encouraged and gave his artists full rein, Kurtzman, according to his good friend, Bill Elder, held lengthy conferences with the artists, explaining how the story should be, panel by panel, detail for detail. Some of the artists were not keen on this approach, which they felt cramped their style – George Evans in particular. Whenever an opportunity arose, Evans would sneak in some small detail not called for by Kurtzman.

To ensure all the details were correct, Kurtzman spent long hours on each story. He went down in a submarine, was taken up in a Grumman amphibious airplane, went to the South Korean Embassy to check that his Korean language was correct in a balloon, delegated his assistant, Jerry Defuccio and colorist Marie Severin to photograph weapons of war, and check uniform details and flintlocks on rifles. Many of the stories were historical, taking place during Roman times, the Civil War, and the American-Indian Wars, and everything had to be researched and checked for absolute accuracy.

Frontline Combat made its first appearance with issue No. 1, cover-dated July/August 1951. It was another unforgettable war comic that showed the futility of armed conflict, as anti-war as *Two-Fisted Tales*. "At the time," Kurtzman once said in an interview, "it was fashionable to do war comics in terms of fantasy and glamor, which I thought was a terrible immorality. They made war a happy event where American supermen go around beating up bucktoothed yellow men...but the way war really is, you get killed suddenly for no reason." Nobody is a hero

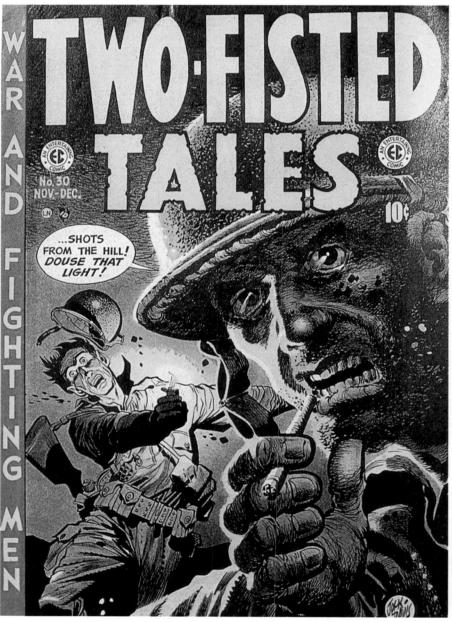

in Kurtzman's war comics, for he makes everybody equal on the battlefield. Sometimes the tales are savage and cruel, and Kurtzman shows there are no winners in war.

Examples of Kurtzman's anti-war fervor permeate every issue of E.C.'s pair of war comics. There is no warmongering, no romanticizing of war. What you are shown are weary men on either side trying to survive. Take "Bellyrobber," for instance, the story of a miserable mess sergeant who never smiles, who never has a kind word for his overworked cooks. One day he comes back to his mess tent only to find a tiny Korean orphan looking for food. "That little Schnooker! Stealin' my rations!" Bellyrobber says. "I'll get rid of him, sarge!" volunteers one of his cooks. But no, the grumpy Sergeant finds the little boy food and one of his cooks whispers "I'll be darned! Ol' Bellyrobber is smiling!"

The Sergeant nicknamed Bellyrobber adopts the little "Schnooker" as he calls him, feeds him, looks after him. He gets him clothes, even has a little army uniform made for him. One day, almost two months after the child turned up, Bellyrobber goes off in the food truck to "feed the boys in the field!" Everybody is happy; Bellyrobber, as one soldier remarks, has become human. Somebody warns that North Korean infiltrators are operating behind U.N. lines. At the field post, Bellyrobber tells his men to stay with the truck while he walks back to camp; he has rations coming in that day. As he nears his mess tent

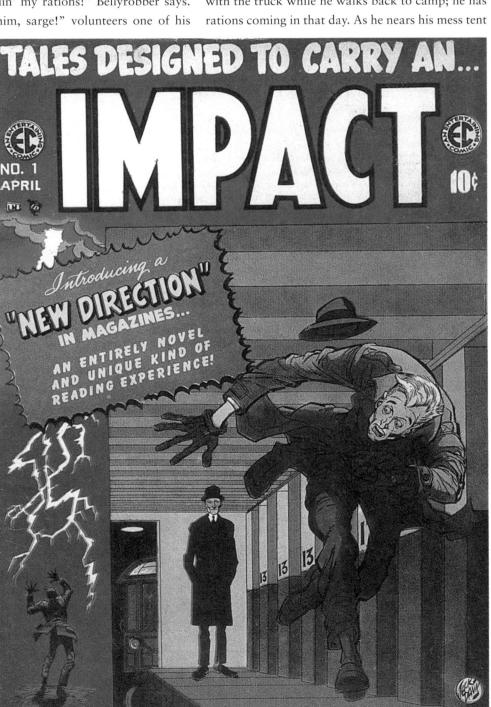

Bottom left *Two-Fisted Tales*, masterminded by artist Harvey Kurtzman, was the first ever anti-war war comic that showed battle for what it was – a game with no winners. *Two-Fisted Tales* © 1952 William M. Gaines.

Top left a panel from Master Race, the classic postholocaust story. Drawn by Berni Krigstein, it appeared in the first issue of E.C.'s *Impact* (right). *Impact* © 1955 William M. Gaines. 195

he notices people milling around. Then he hears shots. Unhitching his rifle he races toward the tent and sees two North Koreans with smoking guns in their hands – they have shot his cooks. He shoots down both men, but when a lieutenant and other men come rushing up Bellyrobber is in tears. He points to the floor where his little Schnooker lies, dead. Bellyrobber's humanity has disappeared; he returns to the hard, embittered person he was before.

Al Feldstein was editing and writing six comic books and had delegated *Crime SuspenStories* to Johnny Craig to edit. He was making more money than Harvey Kurtzman, who felt he was putting so much more into his war comics that he should have equal pay. He had a conference with Gaines, Feldstein, and Craig and discussed his ideas about a humor comic with a difference. It would be a lampoon-type comic whose trademark would be complete irreverence, a parody of all that is sacred. The comic would be called *Mad* and Kurtzman would edit it, with a pay rise. He was happy.

Mad No. 1 was cover-dated October/November 1952 and was an instant hit. It lampooned everybody, and everything that was an American institution. Nothing was safe from Kurtzman's satirical irreverence, even famous fictional characters. In issue No. 2. John Severin created a deftly drawn parody of Tarzan called "Melvin". Melvin and Jane are in their treehouse and Jane makes reference to a native tribe: "Melvin! When Ookaballakonga go on warpath...they take heads and shrinkum!" Jane cries. The sounds of wardrums are spread across three panels "BomtiDDiBomTiDDi..." "Listen, Melvin," whispers Jane. "Is wardrum of Ookaballakonga! Dis serious!" says Melvin thoughtfully. The next panel finds Jane holding a Chicago gangster-type tommygun and shouting: "We don't hafta take none o' that balony, Melv! Let's go out and blast 'em!" Melvin looks surprised, grabs the tommygun and cracks it over Jane's head. He has a superior look as he says "Ugh, Jane! You got firestick of many thunders! Melvin no like firestick! Bad white man invention! Melvin BREAK! Konk!"

Mad was a ten-cent comic book for the first 23 issues; from issue 24 it became a 25-cent magazine and has since become the most popular humor title published in the twentieth century. It is still available on newsstands all over the globe though the late Harvey Kurtzman – he died in February 1993 – had not been with the magazine since 1956. He was unceremoniously dumped by Gaines when he asked

for control of the magazine, and Al Feldstein took over, remaining with the magazine until 1984.

Clones of *Mad* began to appear all over the place. There was Cracked, Crazy, Nuts, and others. Gaines and Feldstein responded with their own clone called Panic, a similar comic book but edited by Al Feldstein. The first issue got E.C. into serious trouble with its Santa Claus parody based on a poem by C. Clarke Moore "The Night Before Christmas". Drawn by Bill Elder and considered in bad taste, it showed Santa's booted foot coming down the chimney and about to tread on one of those foul metal bear traps. An evil-looking boy watches, grinning from behind the fireplace. But it was the "Just Divorced" sign attached to the rear of Santa's Cadillac-style sleigh that made people really mad. Massachusett's Attorney General George Fingold moved swiftly to ban the sale of Panic across the state.

Apparently, Attorney Generals didn't have the legal power to prohibit the comic but Fingold stated his objections to the comic were meant to encourage retailers and distributors to pull the book off their shelves. This was enough; grateful retailers returned boxes of Panic to LaFayette Street. Gaines was furious. Acting through his attorney, Martin Scheiman, he wrote to the New York Times complaining that what Fingold had done was a "gross insult to the intelligence of the Massachusetts people." Scheiman stormed that "every reasoning adult knows that there isn't any Santa Claus." Then Gaines, through Lyle Stuart, his business manager, threatened to prohibit the sale of Picture Stories from the Bible from Massachusetts, only to discover that the comic hadn't been sold in the state since 1948.

Lyle Stuart, who had replaced Frank Lee as E.C.'s business manager and was a good friend of Gaines, suffered the indignity of being arrested by the N.Y.P.D. Encouraged by the Massachusetts scandal, New York's police, with obviously very few delinquent youngsters to chase, decided to pay a visit to 225 LaFayette Street. There, an officer picked up a copy of *Panic* No. 1, looked through it, and asked to see William Gaines. Stuart found Gaines in a desperate state, shaking uncontrollably and in danger of a possible seizure. Telling Gaines to stay in the washroom while he dealt with the problem, he returned to the officers and told them to arrest him because he was, after all, the company business manager.

Stuart was arrested for selling "disgusting" literature. But the story the cops objected to was not "The Night Before Christmas," rather it was the first, a

Below The controversial first issue of Al Feldstein's Panic.

Right Issue No. 22 of Harvey Kurtzman's Mad has fun at the expense of modern art. Mad © 1955 E.C. Publications.

chance to go to the judge's chambers to talk it over. Stuart said under no circumstances would he allow it. "You know, Bill, if you do this, I'm never going to speak to you again." Shortly after, Lyle Stuart and Panic © 1952 William M. Gaines. lawyer Martin Scheiman went to court. The judge asked the cop, obviously nervous, what was so offensive about the comic. The cop picked out one drawing from the Spillane spoof of a girl showing her legs. Looking hard at the policeman, the judge asked him if he had ever seen hosiery adverts on the

subway. After a few more questions the judge spoke directly to the officer and said, "I want you to deliver a message to the police attorney. Tell him that if he ever brings a flimsy case like this before me again, I'm going to arrest him." There were sighs of relief in the E.C. camp that night.

Although they had won, it didn't help E.C. one bit. The case had highlighted Gaines and his band in the worst possible way; they were pilloried in the press, and attacked by religious groups, women's institutes, and the Catholic Legions of Decency. Newsstands were even turning E.C. comics away. At the head of the pack, his message against comics illuminating the sky like a shining beacon, was Dr. Fredric Wertham.

Horror comics had become the fashion ever since E.C.'s excellent *Tales from the Crypt, Haunt of Fear,* and *Vault of Horror* came on to the scene in 1950. With the exception of a few publishers (Dell, Gilberton, Eastern Color, Famous Funnies Inc.), the others leapt onto this very profitable bandwagon with the utmost haste. Most were dreadful comics, stuffed with gore and nastiness. Over at beleaguered E.C., violence was rarely shown, mostly merely suggested in text and pictures. Terrific and imaginative stories set E.C. horror comics far and away above the rest.

Harvey had four horror titles: *Chamber of Chills, Black Cat, Witches Tales,* and *Tomb of Terror,* and they had very inviting cover designs. Occasionally, when the stories were drawn by Bob Powell, Howard Nostrand and Rudy Palais, Harvey's horror comics were lifted into the above-average class.

Fawcett relied on both Bob Powell and George Evans's art to give its titles above average marks. The best, and longest-running, were *This Magazine is Haunted*, and *Beware...Terror Tales*. These were accompanied by the less successful *Worlds of Fear*, and *Strange Stories from Another World*. Stories were well written and didn't rely on sensationalism and shock to make their point.

Most prolific was Atlas. This extraordinary company, the home of Captain America and Human Torch, was rarely original, relying on others to create the fads before leaping on board with an overkill policy with numerous titles in the same vein, including *Suspense*, *Adventures into Terror*, *Adventures into Weird Worlds*, *Astonishing*, *Journey into Mystery*, *Menace*, *Spellbound*, *Uncanny Tales*, *Mystery Tales*, *Mystic*, *Marvel Tales*, *Journey into Unknown Worlds*, and *Strange Tales*. Atlas horror consisted of five short tales per book, most of which

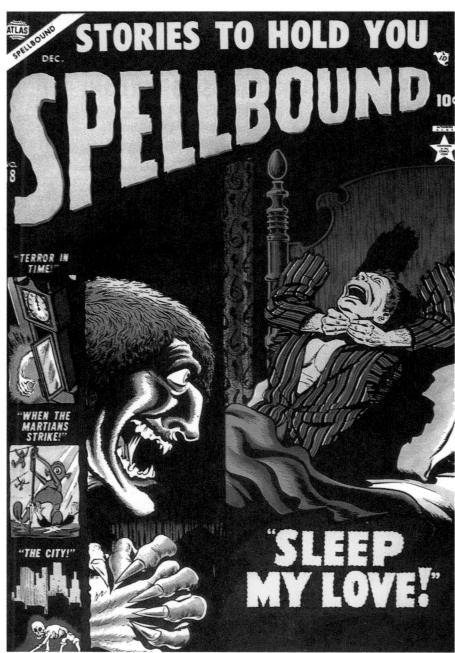

THE CLASSIC ERA OF AMERICAN COMICS

199

Harvey's four horror comics, Chamber of Chills, Witches Tales, Black Cat Mystery, and Tomb of Terror, and the Atlas range which included Spellbound all had strong covers, but the storylines were rarely up to E.C.'s inimitable standards. Chamber of Chills © 1952, Witches Tales © 1953, Black Cat Mystery © 1952. Tomb of Terror © 1953 Harvey Publications. Spellbound © 1953 Marvel Comics Group

EB.

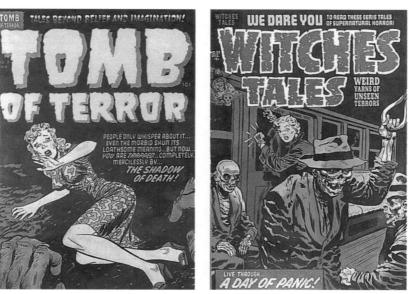

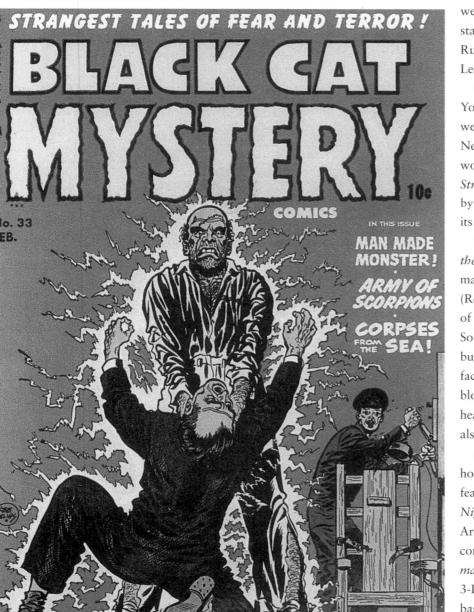

were fairly reasonable. Art was from the Atlas stable, standouts being Bill Everett, Joe Maneely, Russ Heath, Syd Shores, and Basil Wolverton. Stan Lee wrote many of the stories.

Canada's Superior Comics had offices in New York, but home was Toronto. Superior's horror titles were distributed across the U.S. by the American News Company and were considered among the worst of the genre. Mysteries Weird and Strange, Strange Mysteries, and Journey into Fear were used by Dr. Wertham as examples of "sexual sadism with its most morbid psychological refinements."

Standard had Adventures into Darkness. Out of the Shadows, and The Unseen. Stories and the majority of art were nothing to write home about (Reed Crandall and Alex Toth appeared in a couple of issues), and the comics relied on cheap thrills. So did Comic Media's Horrific and Weird Terror but Don Heck's gory close-up covers of gruesome faces, particularly the classic one of a man with bloodshot eyes and a bullet hole through his forehead, gave the titles some distinction. Rudy Palais also contributed with his sweaty, frenetic art.

St. John Publishing had a couple of thoughtful horror comics, one of them Weird Horrors which featured delightful Joe Kubert art in issues 8 and 9. Nightmare had been a Ziff-Davis book before Archer St. John took it over to add to his list of comics. Edgar Allan Poe adaptations were Nightmare's forte. St. John claimed it published the first 3-D comic, House of Terror, a one-shot possibly based upon Vincent Price's House of Wax Horror movie. And the 3-D effect really works!

Matt Baker did some good covers for St. John's Amazing Ghost Stories but this, like many comics from this publisher, only lasted three issues, though

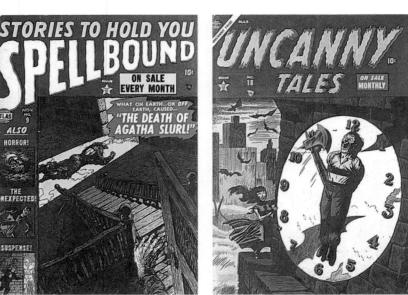

Strange Terrors managed seven. Another publisher is Haunted but had the gruesome "Thing" to worry the likes of Dr. Wertham. Gory Weird Mysteries from Gilmore certainly made Wertham choke on his cornflakes. Startling Terror Tales from Star stood out from the newsstands because of its L.B. Cole psychedelic covers, though the interior stories were

of better horror was Avon; apart from Eerie, which ran for 17 issues, almost all Avon's horror comics were one shot titles. Eerie was an excellent comic distinguished by Wally Wood and Joe Orlando art. Witchcraft ran for six issues and had Kubert and Hollingsworth art. Issue No. 4, with its cover showing people being boiled alive, is a standout. One quite good horror comic was Prize Group's

Black Magic. This comic was the result of the creative efforts of Joe Simon and Jack Kirby, who did many of the stories and much of the art for the first four years, after which Black Magic lost its momentum and became thoroughly boring. Dick Briefer's unusual art made their other horror comic, Frankenstein, particularly good. It began as a comedy comic but was changed to horror when it was seen that was the way everyone was headed.

Ace Magazines produced five horror titles, Baffling Mysteries, Challenge of the Unknown, Beyond, Web of Mystery, and Hand of Fate. None were awe-inspiring, except when Lou Cameron did the art. Some of his work was superb and if he was present, it lifted any Ace horror out of the doldrums.

Toby Press, Story Comics (its Mysterious Adventures was one of the very worst titles), Ajax/Farrell, American Comics Group (A.C.G.), Charlton, Star, Premier, Stanley P. Morse (which included Stanmore, Aragon and Gilmore), Ace, Fiction House, all published horror comics. Fiction House naturally had damsels in all sorts of distress in Ghost Comics while A.C.G.'s Adventures into Unknown Worlds and Forbidden Worlds were fairly innocuous, relying heavily on Ogden Whitney art. Charlton, an odd publisher with unpleasant rumors about some of its associates, took over Fawcett's This Magazine

mostly reprinted material from other publishers. In the beginning there was A.C.G. and E.C.; by 1954 there had been over 100 different horror comic titles with a total of 2400 issues published between 1950 and 1954. There was much disquiet from parents and responsible authority about the huge sales these comics engendered. By 1954 comic book circulation had reached a staggering 60 million a month. There were 40 different horror comics to choose from each month in 1954, accounting for a fair slice of the circulation figures. Although the majority of stories were about vampires and werewolves, many others bordered on thinly disguised sexual perversions. Take the tale in Ajax/Farrell's aptly named Strange Fantasy. A publisher has a heart attack, and while recuperating, receives an invitation to visit a health resort in Europe. He goes and is confronted by a whip-wielding woman in high heels and slinky evening gown, named Madam Satin. She forces him to undress and take a mud bath with the words, "I am the master here! You'll do as I say or feel the sting of the lash! Lie still on your back! Don't move until I tell you to!" More humiliation comes before the unfortunate publisher is buried alive in cement. This tale is an excellent example of what parents, police, and teachers were so worried about. Sado-masochism, sexual domination, perverted fantasy - it's all here in a comic book that any

Further titles from the Atlas horror stable - Mystery Tales, Marvel Tales, Mystic, Spellbound and Uncanny Tales. Beware Terror Tales was a Fawcett horror title. Mystery Tales © 1954, Marvel Tales © 1954, Mystic © 1954, Spellbound © 1953, Uncanny Tales © 1954 Marvel Comics Group. Beware *Terror Tales* © 1952 Fawcett Publications.

There was a witchhunt, and comics publishers

child could buy.

were being driven into a corner. Legislation was passed in numerous states banning the sale of horror and crime comics. Canada prohibited them outright and so did several European countries. Communities across America held comic book burnings. America in the early fifties had become a nation of investigation; Senator McCarthy mesmerized the whole country with his hysterical invective, his endless committees, and his ceaseless tirades against those who were not righter than right wing.

Then it happened. The comics industry was struck by a near-fatal blow. In the early spring of 1953 a book that was of atomic bomb proportions to the comics industry came out. It was a powerful and well written indictment against comics, and helped hasten the the end of an era.

Seduction of the Innocent had arrived.

"NOT DEAD

THE STRANGEST STORIES EVER TOLD!

"IT

HONTH

CAME FROM

NOWHERE!"

YSTIC THE MOST EERIE STORIES EVER TOLD!

IUE

Chapter Eleven

IT'S ALL OVER NOW

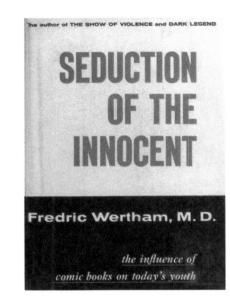

Left and below Seduction of the Innocent by Fredric Wertham, M.D. in both its American (left) and British editions (below).

Right E.C.s The Vault of Horror - just the kind of comic that would make parents' hair stand on end for different reasons to their childrens'. E.C. was one of the first to feel the newsstand boycott. The Vault of Horror © 1951 William M. Gaines.

the influence of "horror comics" on today's youth

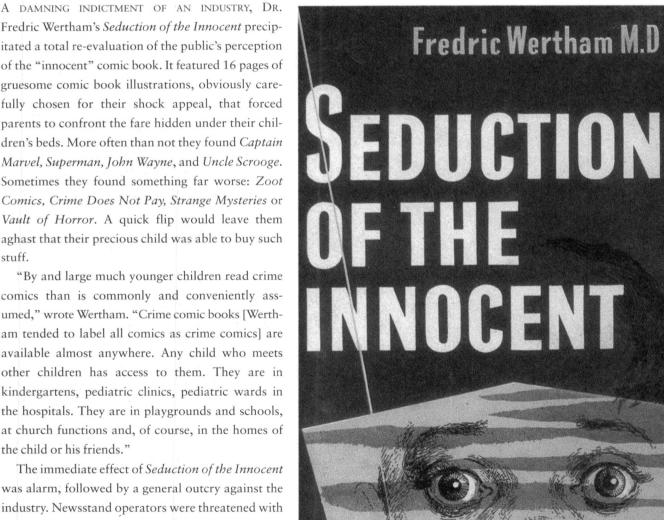

itated a total re-evaluation of the public's perception of the "innocent" comic book. It featured 16 pages of gruesome comic book illustrations, obviously carefully chosen for their shock appeal, that forced parents to confront the fare hidden under their children's beds. More often than not they found Captain Marvel, Superman, John Wayne, and Uncle Scrooge. Sometimes they found something far worse: Zoot Comics, Crime Does Not Pay, Strange Mysteries or Vault of Horror. A quick flip would leave them aghast that their precious child was able to buy such stuff.

"By and large much younger children read crime comics than is commonly and conveniently assumed," wrote Wertham. "Crime comic books [Wertham tended to label all comics as crime comics] are available almost anywhere. Any child who meets other children has access to them. They are in kindergartens, pediatric clinics, pediatric wards in the hospitals. They are in playgrounds and schools, at church functions and, of course, in the homes of the child or his friends."

The immediate effect of Seduction of the Innocent was alarm, followed by a general outcry against the industry. Newsstand operators were threatened with their lives in some areas if they didn't boycott horror, crime, and sex comics. Distributors could see the writing on the wall unless they stopped distributing the offending material. Over at E.C. they were beginning to feel the pinch as more and more unopened parcels of comics were returned.

Wertham's book certainly made many good points. There was no doubt that many of the comics sold were sick and filled with every imaginable nasti-

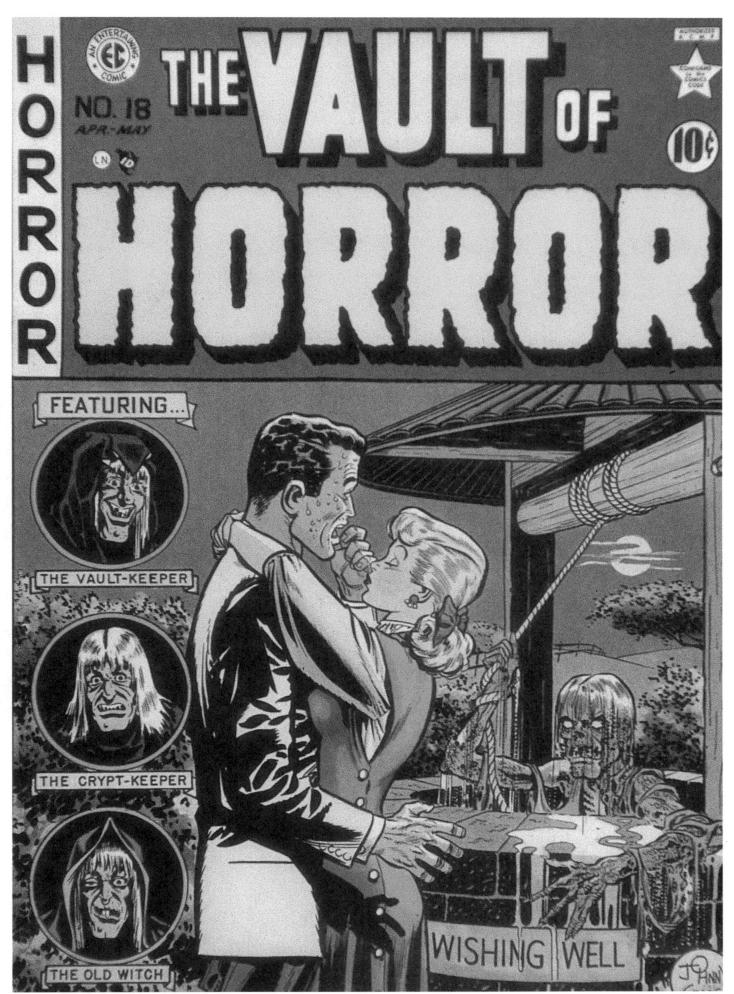

THE CLASSIC ERA OF AMERICAN COMICS

205

THE CLASSIC ERA OF AMERICAN COMICS

206

ness the writers could dig up to satisfy their masters. Yet certain comics heroes should not have been included or referred to in the terms Wertham used against them. Batman and his sidekick, Robin, were definitely abnormal as far as Wertham was concerned. In Chapter VII, titled "I Want to be a Sex Maniac," Wertham talks about adolescents going through periods of anxiety when they are not sure whether they are gay or not. "At an early age these boys become addicted to the homoerotically tinged type of comic book." Later he writes "Only someone ignorant of the fundamentals of psychiatry and of the psychopathology of sex can fail to realize a subtle atmosphere of homoerotism which pervades the adventures of the mature Batman and his young friend Robin. Male and female homoerotic overtones are present also in some science-fiction, jungle and other comic books."

This phobia about homosexuality continues with the following sequence: "Just as ordinary crime comic books contribute to the fixation of violent and hostile patterns by suggesting definite forms for their expression, so the Batman type of story helps to fixate homoerotic tendencies by suggesting the form of an adolescent-with-adult or Ganymede-Zeus type of love-relationship.

"Batman and Robin...go into action in their special uniforms. They constantly rescue each other from violent attacks by an unending number of enemies. The feeling is conveyed that we men must Swingers – Wertham singled out Batman and Robin's relationship as thinly veiled homosexual wish-fulfilment, that could easily lead adolescent boys astray. *Batman* © 1953 D.C. Comics, Inc.

THE CLASSIC ERA OF AMERICAN COMICS

207

stick together because there are so many villainous creatures who have to be exterminated...Sometimes Batman ends up in bed injured and young Robin is shown sitting next to him. At home they have an idyllic life. They are Bruce Wayne and 'Dick' Grayson. Bruce Wayne is described as a 'socialite' and the official relationship is that Dick is Bruce's ward. They live in sumptuous quarters, with beautiful flowers in large vases, and have a butler, Alfred. Batman is sometimes shown in a dressing gown. As they sit by the fireplace the young boy sometimes worries about his partner: 'Something's wrong with Bruce. He hasn't been himself these past few days.' It is like a wish dream of two homosexuals living together. Sometimes they are shown on a couch, Bruce reclining and Dick sitting next to him, jacket off, collar open, and his hand on his friend's arm.

"Robin is a handsome ephebic boy, usually shown in his uniform with bare legs. He is buoyant with energy and devoted to nothing on earth or in interplanetary space as much as to Bruce Wayne. He often stands with his legs spread, the genital region discreetly evident.

"In these stories there are practically no decent, attractive, successful women. A typical female character is the Catwoman, who is vicious and uses a whip. The atmosphere is homosexual and anti-feminine. If the girl is good looking she is undoubtedly the villainess. If she is after Bruce Wayne, she will have no chance against Dick."

I DOUBT IF WE'D FIND ANYBODY TO HIT! I'VE GOT A HUNCH THAT GOME-BODY WHO KNOWS OUR METH ODS TOO WELL IS HELPING THESE CROOKS!

Left "Make Way for Murder" – gruesome splash page artwork from Orbit's *Wanted*, issue No.50. *Wanted* © 1952 Orbit Publications.

Above The Senate committee hearing meant the writing was on the wall for the vault-keeper and his story-telling cronies at E.C. © William M. Gaines. Sounds pretty damning, doesn't it? But this is where his book falls apart, not with the sadistic comics but the superheroes. If Batman and Robin are gay, then Captain America and Bucky, the Blackhawks, Captain Video and Ranger, Human Torch and Toro, oh, and many other superheroes with youthful sidekicks, have to be gay as well. If only Wertham had looked closely at the evidence. The sidekicks were added to enable young readers to feel comfortable with someone their own age and identify with him.

An attempt was made in 1950 by Senator Estes Kefauver's Senate Crime Investigating Committee to look into the effects comics had on juvenile delinquency. Wertham offered his evidence for the committee to study. The investigation was badly organized and Kefauver gave comic books a clean bill of health. In New York the State Legislature presented a crime comic control bill which won the vote 141 to 4. Republican Governor Dewey vetoed the bill, claiming it was unconstitutional.

On 1 June 1953, a new Senate Subcommittee to Investigate Juvenile Delinquency was formed. The chairman was senator Robert C. Hendrickson of New Jersey, and other members of the subcommittee included senators Estes Kefauver of Tennessee and Thomas Hennings of Missouri. Knowing the hue and cry against comics, it was decided to review the problem one more time.

Whether it was a wise move or not, William Gaines decided he should attend the hearings with a prepared speech and he volunteered to answer any questions the committee might ask. Frederic Wertham also planned to attend; he was sure to win a lot of respect, especially since his book was out. Wertham was bound to be a star witness for the anti-comic movement, Gaines would be the reviled figure from the comic camp. In fact, most comic publishers had been hoping he would fall, taking his E.C. line with him. They felt it was mostly the E.C. comics that had caused the trouble.

Gaines was due to appear the day after Wertham had testified. Of course Wertham attacked the comic industry with all guns blazing. On April 21, 1954, he told the committee that the brutality found in horror and crime comics would cause "moral and ethical confusion" in children's undeveloped little minds. The comics also were a major contributing factor to juvenile delinquency which had been rising considerably since the war. Of the thousands of children he had studied, said Wertham, it would be the "normal" children who would suffer the most. The committee looked through examples of some of the worst comics Wertham and the committee had brought together.

Next day, Gaines appeared before the committee. They looked on unsympathetically as he read from his prepared statement, some of which is reproduced here:

"I am a comic magazine publisher. My group is known as E.C....Entertaining Comics. I am here as a voluntary witness. I asked for and was given this chance to be heard...

"My father was proud of the industry he helped found. He was bringing enjoyment to millions of people. The heritage he left, the vast comic book industry, employs thousands of writers, artists, engravers, printers. It has weaned hundreds of thousands of children from pictures to the printed word. It has stirred their imaginations, given them an outlet for their problems and frustrations...but most important, given them millions of hours of entertainment...

"I was the first publisher in these United States to

publish horror comics. I'm responsible! I started them! [Not entirely true. American Comics Group published the first continuous horror comic]...

"Some may not like them. That's a matter of personal taste. It would be just as difficult to explain the harmless thrill of a horror story to a Dr. Wertham as it would be to explain the sublimity of love to a frigid old maid...

"The comic magazine is one of the few remaining pleasures that a person can buy for a dime today...

"Our American children are, for the most part, normal children. They are bright children. But those who want to prohibit comic magazines seem to see instead dirty, twisted, sneaky, vicious, perverted little monsters who use the comics as blueprints for action...

"I do not believe that anything that has ever been written can make a child hostile, over-aggressive, or delinquent. The roots of such characteristics are much deeper."

Gaines-did his best, but his prepared statement was peppered with holes. It was repetitive and it didn't say very much that had not already been said by other comic book supporters. To say that reading never harmed anyone is not entirely true; the writings of Marx helped engineer a revolution and, although supposedly for good, the Bible has had its powerful say with millions upon millions of souls.

Gaines appeared to agree with Wertham that environment and social forces influence future behavior. Wertham believed comic books were a bad influence upon young minds but saw them as only part of a larger problem. He said in his summary at the end of *Seduction of the Innocent*, "People neglect the pre-violent manifestations of the trend toward violence. They forget what the philosopher Erwin Edman said: 'It does not take long for a society to become brutalized.' Comic books are not the disease, they are only a symptom. And they are far more significant as symptoms than as causes. They shed some light on the whole foundation of moral and social behavior. That, I begin to feel, was the most positive result of our studies. The same social forces that make crime comic books make other social evils, and the same social forces that keep crime comic books keep the other social evils the way they are."

After his prepared statement, Gaines spoke further to the committee. He argued that no one was forced to read horror stories, and that daily in newspapers children had easy access to true horror stories. To ban comics would be just one step away from banning newspapers, a first stage in the dubious process of censorship and the inevitable slide towards dictatorship.

Herbert Beaser then pressed Gaines on his contention that children cannot be hurt by anything that they see or read. When asked if there was any limit to what Gaines would put in a magazine, he replied that he would only be ruled by "the bounds of good taste." Gaines was heading into a trap. Senator Kefauver then held up issue No. 22 of Crime SuspenStories (May 1954), whose cover depicted a lurid illustration of a man with a bloody ax holding up a woman's severed head. "Do you think this is in good taste?" he asked. Gaines replied: "Yes, sir, I do, for the cover of a horror comic. A cover in bad taste, for example, might be defined as holding the head a little higher so that the neck could be seen dripping blood from it and moving the body over a little further so that the neck of the body could be seen to be bloody."

Above The damning cover of *Crime SuspenStories* (No. 22) that Senator Kefauver held up at the Senate Subcommittee investigating juvenile delinquency when Bill Gaines took the stand.

Crime SuspenStories © 1954 William M. Gaines.

Right This Fawcett one-off, like so many other comics, broke all the rules before you even got past the cover: glamorizing crime and violence with a thinly veiled pandering to bondage. On the Spot © 1948 Fawcett Publications.

In the aftermath of the Senate Subcommittee, the selfimposed comics industry censorship banned bloodshed, excessive gore, sadism and anything supernatural. Words such as "horror," "crime," and "terror" were banned outright. Uncanny Tales © 1953, Adventures into Terror © 1954 Marvel Comics Group.

It was all over. The Committee retired to discuss and make its decision. When it pronounced its findings it did not recommend legislation or federal intervention. The Committee said the publishers had a moral responsibility to clean up their act themselves. "The subcommittee feels that the publishers of children's comic books cannot discharge their responsibility to the Nation's youth by merely discontinuing the publication of a few individual titles. It can be fully discharged only as they seek and support ways and means of insuring that the industry's product permanently measures up to its standards of morality and decency which American parents have a right to expect." The committee concluded that it was up to the publishers to censor their own products to "standards of morality and decency." Otherwise, the Senate might do it for them.

"Bill wasn't ready for this," said Al Feldstein after the hearings. "He wasn't as sharp as he could have been. When they got into the issue of the ax and the severed head, Senator Kefauver really trapped him."

Hurriedly the comic book publishers met to discuss what to do. They formed the Comics Magazine Association of America which was headed by Judge Charles Murphy, a tough man who took his censorship role very seriously. A list of do's and don'ts were laid down to which the industry had to adhere. Words such as "horror," "crime," "terror," and "weird" were banned from the covers or in the text. All scenes of bloodshed, excessive gore, sadism, sex, gruesome crimes, ghouls, werewolves, vampires, walking dead, masochism and cannibalism, were banned. Early in 1955, the new code, marked by a stamp in the upper right-hand corner with the words "Approved by the Comics Code Authority," went into effect. The result was squeaky-clean, cen-

sored comics that were thoroughly boring.

There was nothing left. Gaines and Feldstein came up with a series of "New Direction" comics. Employing all the old artists, with Feldstein doing most of the scripts, the new comics were *Piracy*, *M.D., Extra, Psychoanalysis, Aces High*, and *Valor*. Even with the code now in operation, all the titles were beautifully done. Then Gaines and Feldstein came up with the idea of producing four horror/crime type magazines in black and white. They were *Crime Illustrated*, *Terror Illustrated*, *Confessions Illustrated*, and *Shock Illustrated*. Aimed at adults and were called "Adult Picto-Fiction".

An interesting sideline was the tale published in E.C.'s short-lived *Incredible Science-Fiction* magazine.

It was called "Judgement Day" and originally appeared in one of E.C.'s earlier sci-fi comics. The story concerns a small planet populated by blue robots and orange robots and a space galaxy investigator who is sent to see whether the robots have thrown off color prejudice and are therefore qualified to join the galactic empire, which has achieved racial harmony and equality. But the investigator decides they have not advanced enough to join; that there is still prejudice between the two colors. Returning to his ship, the investigator takes off his helmet to reveal he is black, his face covered with sweat.

"It can't be a black man," ordered Judge Murphy, according to Al Feldstein who recounted the tale. "But...but that's the whole point of the story!" E.C. replaced the banned horror and crime comics with titles such as *Piracy* – a sort of historical true crime and debauchery that got around the censorship rules. *Pirates* was a Gleason comic in the same mold. *Piracy* © 1954 (below) and 1955 (right) William M. Gaines. *Pirates Comics* © 1950 Magazine Enterprises.

protested Feldstein. "The black man has to go," said Murphy grimly. Feldstein was truly angry. "Listen," he yelled. "You've been making it impossible for us to put out anything at all because you guys want us out of business." He stormed out of the C.M.A.A. office and returned to LaFayette St., where he reported to Bill Gaines, who went mad. He called Murphy and shouted "This is ridiculous. I'm going to call a press conference on this. You have no grounds, no basis, to do this. I'll sue you."

AGAS OF THE SEA, SHIPS, PLUNDER AND.

"All right," Murphy said. "Just take off the beads of sweat." Feldstein and Gaines ran the story uncut.

No matter what E.C. tried to do, the company as a comic producer was finished. Even though the "New Direction" comics carried the C.M.A.A. code it wasn't enough to stop retailers and distributors returning them. And nobody wanted the Picto-Fiction titles either. They were a commercial failure and were dropped immediately after Christmas 1955. Gaines was so utterly sick of the C.M.A.A. that he killed all his comics. Only Mad remained. E.C.'s staff were laid off, including Feldstein. It was something Gaines hoped he would never have to do. Gaines fell out with Kurtzman, as we have already seen, and invited Feldstein back to edit Mad. He stayed until 1984 and, now retired, he and his wife live on a 250-acre ranch in Montana with 22 cats, several dogs, 13 horses and 10 llamas. Feldstein still takes commissions from collectors who want a painted copy of one of his original covers.

As for the wonderful artists employed by E.C., Jack Davis mostly does commercial work these days. Johnny Craig lives in Pennsylvania, and continues to work, mostly on commercial assignments. Jack Kamen still works, so does George Evans. Reed Crandell died some time ago, "Ghastly" Graham Ingels felt terrible guilt about his E.C. work and disappeared into Florida, cutting himself off from his comic book past. Initially, he even sent back the royalty checks that Gaines sent him. Apparently he became sufficiently reconciled with his past to do a few Old Witch oils for sale at auction. Ingels died in 1991.

Wally Wood continued to work in comics until he committed suicide in 1981, his life overshadowed by failing health and the impending threat of kidney dialysis. Joe Orlando worked on regularly for *Mad*, Marvel Comics, became an editor for D.C. and is now an Associate Publisher with the company. Al Williamson continues to work, so does Bill Elder. William Gaines died in 1992. A great innovator, Gaines was appreciated by all who knew him, as a man who was generous to others, loyal, and proud of his achievements in the world of comic book art.

By 1956 there were few comic publishers left. Only D.C., Dell, Gilberton, Atlas/Marvel, Harvey, A.C.G., and one or two others survived. As for Dr. Fredric Wertham, he continued with his work before retiring to his farm and to his wife. Wertham still felt there was much to be done to protect children, and was never happy with the results of the hearings.

An amazing, creative, and controversial era had come to a close, some 21 years after Maxwell Gaines, Harry Wildenberg, and George Janosik first decided to produce and sell a comic book. What they created became a part of American popular culture and gave birth to a new artform that has since become recognized as true art in Europe, and now in America.

1933 to 1955. A sometimes cold world made warm by the colorful fantasies children enjoyed in wickedly wonderful ten-cent comic books. Gone maybe, but never, ever forgotten.

Take care, Captain Marvel, wherever you are.

The Second World War and the Cold War era had been given a spark of warmth with comic book heroes like Captain Marvel. Gone but not forgotten. *Captain Marvel* © 1942, *Whiz Comics* © 1947 Fawcett Publications.

BIBLIOGRAPHY

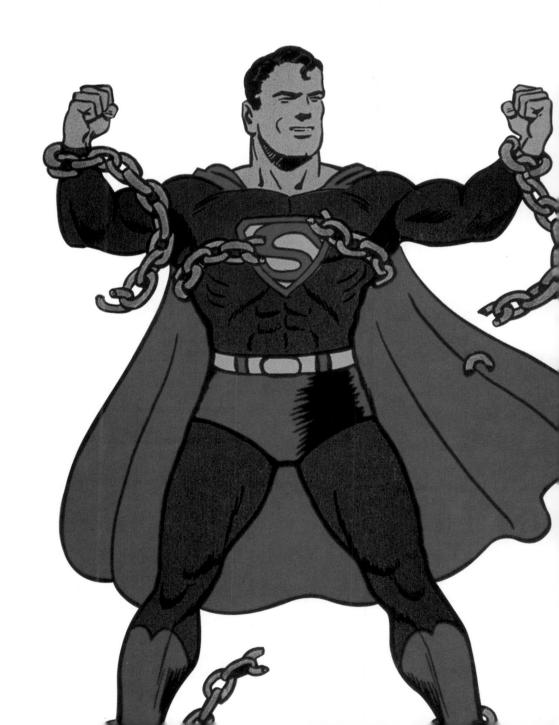

THE AMERICAN COMIC BOOK HAS BECOME A HIGHLY collectible item. Every week, somewhere in the United States, there is a comics convention where dealers gather to sell old comics. Collectors range from lawyers to pop stars, school teachers to taxi drivers. American comics are collected all over the world, for most countries reprinted them in their own language or, as in Australia and Britain during the forties and fifties, reprinted them with less pages and mostly in black and white. Today, American comics come direct from the U.S.

Many comic books have become tremendously valuable. Action Comics No. 1 will cost \$200,000 or more in mint condition, and there are supposed to be only four of those in that state. Unfortunately, many dealers are asking much more than a comic is really worth, but a good guide for collectors is the Overstreet Comic Book Price Guide. It lists all the gold and silver age comics ever published, along with Overstreet's prices for the various grades (Good, Fine, Nr. Mint). Dealers these days proudly boast how they sell a book for two, three, six times Guide. Try and avoid these dealers and stick to the ones who are fair in their pricing. Many collector markets have been ruined by overpricing and greed so let's not have this occur in the comic hobby.

Worthwhile comics such as E.C. titles, early superheroes, Disney comics, jungle comics, in fact any comic in the genre you might be interested in, are generally in the \$10-\$500 range. Decent original E.C.s can be purchased for around \$30 to \$100. Only the famous Gaines "File Copies" will fetch \$1500 up. It really is a matter of shopping around.

There are not that many magazines devoted to mainly Golden Age (loosely 1933 to 1955) and Silver Age comics (1955 to 1980). One is Gary Below *The Overstreet Comic Book Price Guide* is the bible of the comic collecting industry.

Below *Comic Book Marketplace* is great on classic era comics.

be Magazine for Golden Age and Silver Age Collectibles

Carter's *Comic Book Marketplace*. This magazine is informative, contains histories on particular comics and characters, and sometimes ferrets out stories never known before. It should be on sale at all major comic stores but isn't. To find out about the magazine, call Gary Carter, Liza or Amanda to help you. The address is Gemstone Publishing Inc., (West) PO Box 180900, Coronado, California 92178-0900 Tel. (619) 437-1996.

Try *Alter Ego* as well. Edited by Roy Thomas of Marvel fame, *Alter Ego* deals with Gold and Silver age history and interviews. The address is Too Morrows, 1812 Park Drive, Raleigh, North Carolina 27605 Tel (919) 833-8092.

NOTE: All details correct at time of going to press.

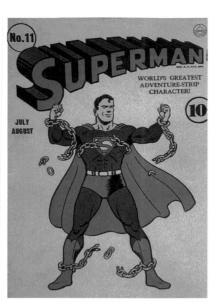

Superman and Star Spangled Comics from the D.C./National Comics stable. Superman © 1941, Star Spangled Comics © 1945 D.C. Comics, Inc.

To help collectors, here is a list of the major comic book publishers from 1933 to 1955:

EASTERN COLOR PUBLISHING INC. 1933–1955 Famous Funnies, Heroic Comics, Jingle Jangle

Comics and others.

DELL PUBLISHING COMPANY INC. 1933-1974

Mickey Mouse, Donald Duck, Walt Disney's Comics & Stories, Pogo the Possum, Raggedy Ann & Andy, Woody Woodpecker, Bugs Bunny, Looney Tunes and Merry Melodies, Fairy Tale Parade, Porky Pig, Sylvester the Cat, Santa Claus Funnies, Easter, Christmas with Mother Goose, Bambi, Brer Rabbit, Roy Rogers, King of the Royal Mounted, Gene Autry, Rex Allen, Tom Corbett – Space Cadet, Space Man, Range Rider, Tarzan, War Comics, Chip & Dale, Cisco Kid, Lone Ranger, Zorro, Andy Panda, Oswald the Rabbit, Little Lulu, Flash Gordon, Popeye, and many, many more.

NATIONAL COMICS PUBLICATIONS INC. (Now D.C. Comics Inc.) 1935– present

Superman, Superboy, Batman, Action Comics, Detective Comics, Star Spangled Comics, Flash Comics, World's Finest Comics, Real Screen Comics, The Adventures of Bob Hope, Leave it to Binky, Adventure Comics, Big Town, House of Mystery, Peter Porkchops, Our Army at War, Leading Comics, Sensation Comics, Wonder Woman, Comic Cavalcade, Mystery in Space, Strange Adventures, All Star Comics, Green Lantern Comics, More Fun Comics, New Fun Comics and many others.

222

A DAY IN THE LIFE OF CAPTAIN MARVEL JR.

FICTION HOUSE COMICS 1938–1954

Jungle Comics, Jumbo Comics, Planet Comics, Wings Comics, Waambi, Jungle Boy, Rangers Comics, Firehair Comics, Sheena, Jungle Queen, Kaänga, Ghost Comics and others.

FAWCETT PUBLICATIONS INC. 1939–1953

Captain Marvel Adventures, Captain Marvel Jr., Mary Marvel, Whiz Comics, Master Comics, Wow Comics, Bulletman, Spy Smasher, Minuteman, Tom Mix Western, Hopalong Cassidy, Don Winslow, Nyoka the Jungle Girl, Motion Picture Comics, Fawcett Movie Comics, Fawcett's Funny Animals, Rocky Lane Western, Western Hero, Captain Video, Beware...Terror Tales, Worlds of Fear, Down with Crime, Mike Barnett, Man Against Crime, This Magazine is Haunted, Hot Rod Comics, Battle Stories, Soldier Comics, and many others.

QUALITY COMICS. 1939-1956

Blackhawk, National Comics, Military Comics, Modern Comics, Doll Man, Plastic Man, Police Comics, Hit Comics, Web of Evil, Ken Shannon, T-Man and others.

FOX FEATURES SYNDICATE 1939–1951

Mystery Men Comics, Science Comics, Phantom Lady, Murder Incorporated, Famous Crimes, Women Outlaws, Rulah the Jungle Queen, All Top Comics, Cosmic the Cat, Corliss Archer, Western Killers, Jo-Jo, Dagar-Desert Hawk, Crimes by Women, Zoot Comics, Blue Beetle, The Flame, Wonderworld Comics and others.

Don Winslow and Captain Marvel Jr. – both Fawcett stalwarts. Don Winslow of the Navy © 1943, Captain Marvel Jr. © 1952 Fawcett Publications.

The Blonde Phantom came from Marvel comics, while Roy Rogers Comics and Zorro were part of Dell's lucrative movie tie-in program. The Blonde Phantom © 1949 D.C. Comics. Inc. Roy Rogers Comics © Roy Rogers. The Mask of Zorro © 1954 Walt Disney Co.

Right Jo-Jo and his shapely mate added a bit of jungle spice to Fox Features already sleazy list. Jo-Jo Comics © 1948 Fox Features Syndicate.

MARVEL/TIMELY/ATLAS COMICS. 1939-present

Sub-Mariner, Marvel Mystery Comics, Kid Komics, Young Allies, Human Torch, All Select Comics, Captain America, Wacky Duck, Ringo Kid, Two Gun Kid, Kid Colt, Apache Kid, Black Rider, Wild Western, Western Outlaws, Adventures into Terror, Adventures into Weird Worlds, Spellbound, Mystery Tales, Suspense, Menace, Men's Adventures, Man Comics, Battlefield, Battle Action, Battle, War, Battlefront, Battle Brady, Millie the Model, Venus, Blonde Phantom, Lorna, the Jungle Girl and many, many others.

LEV GLEASON COMICS INC. 1940–1956

Crime Does Not Pay, Silver Streak Comics, Crime and Punishment, Boy Comics, Daredevil, Desperado, Black Diamond Western and two or three other titles, mostly romance.

M.L.J./ARCHIE PUBLICATIONS 1940-present

Hangman, Pep Comics, Shield/Wizard, Zip Comics, Archie Comics, Jughead Comics, Wilbur Comics, Betty & Veronica and numerous others, all dealing with Archie.

HARVEY COMICS 1940-present

Joe Palooka, Dick Tracy, Humphrey Comics, Tomb of Terror, Chamber of Chills, Witches Tales, Black Cat, Warfront, Little Audrey and many more series and one shots.

GILBERTON PUBLICATIONS. 1941–1976 There were 167 Classics Illustrated produced in the U.S., several more in Britain and Europe.

10c

CONGO KINS

EAR

MASK OF

CONGO

HILLMAN PERIODICALS 1941–1953

Airfighters Comics, Airboy, Clue Comics, Real Clue Crime Stories, Crime Detective Comics, Frogmen, Western Fighters and many others.

PRIZE COMICS GROUP 1941–1958

Prize Comics, Black Magic, Justice Traps the Guilty, Young Romance, Frankenstein and many others.

ENTERTAINING COMICS (E.C.) 1942–1955

Land of the Lost, Picture Stories from the Bible, Picture Stories from American History, Animal Fables, Happy Houlihans, International Comics, Tiny Tot Comics, Moon Girl, Saddle Justice, Saddle Romances, Crime Patrol, War Against Crime, Tales from the Crypt, Haunt of Fear, Vault of Horror, Two Fisted Tales, Frontline Combat, Mad, Panic, Weird Fantasy, Weird Science, Crime SuspenStories, Shock SuspenStories, Piracy, Aces High, Valor, M.D., Psychoanalysis, Extra, very few others

MAGAZINE ENTERPRISES 1944–1955

Tim Holt Western, Bobby Benson's B-Bar-B Riders, Thun'da, Jungle King, Cave Girl, Ghost Rider, Guns of Fact and Fiction, Manhunt, American Air Forces, Straight Arrow, Durango Kid, Dream Book of Love, Undercover Girl, Strongman, White Indian, many other one shots and a few series.

AVON COMICS. 1946-1956

Strange Worlds, Space Mouse, Cow Puncher, Jesse James, Captain Steve Savage, Eerie, Slave Girl, and a large quantity of one shot titles like Attack on Planet Nars, Dead Who Walk, Out of this World, Geronimo, etc., etc.

There were many other publishers, many of which lasted a couple of months or maybe several years. But the number of comics to collect would be impossible to count, there are so many genres to deal with. Before we close down it might be worth mentioning something about restoration.

Susan Cicconi began to restore comic books that were very scarce or particularly hard to find in higher grades. Susan is a Sotheby's consultant on restoration and is an excellent restorer. Another wonderful and experienced restorer is Kelley Essoe, and her fees are considerably less than some of the others. Comic book restoration is especially needed at present. Older comics begin to fall apart and will die if they are not looked after properly. Therefore it is essential to reverse the trend to bring the precious book back to life. Kelley's phone number is (760) 325-5977. It is nonsense to grumble about a comic that has been restored...if restoration is good enough for the Sistine Chapel, then why not comics?

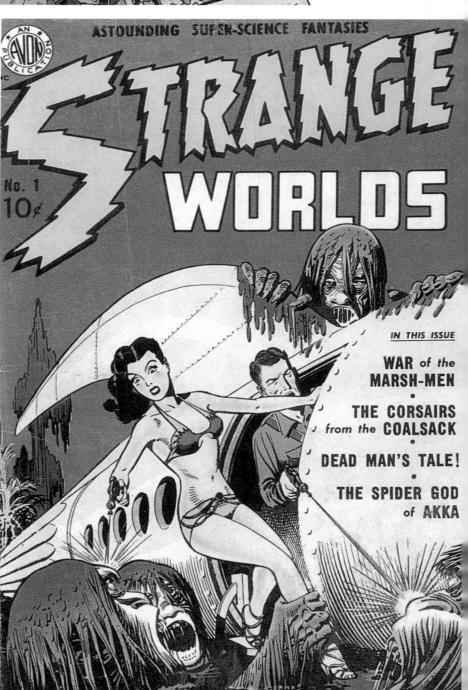

Left Alice in Wonderland – a *Classics Illustrated* from Gilberton Publications, the first *Jackpot* to feature Archie from M.L.J. and *Strange Worlds* from Avon. *Classics Illustrated* © 1948 Gilberton Co. *Jackpot Comics* © 1941 M.L.J. Magazines. *Strange Worlds* © 1950 Avon Periodicals.

Right and below National Comics featuring the Barker and his circus pals from the Quality stable. Police Action and Journey into Mystery from Atlas/Marvel. National Comics © 1947 Quality Comics Group. Police Action © 1954, Journey into Mystery © 1958 Marvel Comics Group.

INDEX

Ace Magazines 60, 169, 171, 200 Aces High 214 A.C.G. see American Comics Group A.C.M.P. see Association of Comics Magazine Publishers Action Comics vii, 28, 29, 30-1, 40, 41, 44, 46, 220 "Adult Picto-Fiction" 214-15 Adventure Comics 36, 46, 50 Adventures into Darkness 199 Adventures into Terror 198, 213 Adventures into the Unknown 186 Adventures into Unknown Worlds 200 Adventures into Weird Worlds 198 Aggie Mack 177 Airfighters 82 Ajax/Farrell 172, 200 Albert and Pogo Possum 116-17 "Albert Takes the Cake" 113-14 All American Comics 46, 50, 135 All American Western 135 All Select Comics 75 All Star Comics 50, 98 All Star Western 130 All Suprise Comics 118-19 All Top Comics 161 All True Crime 153 All Winners Comics 118 All-American Comics ix, 46, 50, 54, 98, 103, 154 Alter Ego 221 Amazing Detective Cases 25 Amazing Ghost Stories 199 Amazing Man Comics 39 Amazing Mystery Funnies 34, 39, 119 Amazing Spiderman 5, 6 Amazing Stories 22, 119 American Airforces 171 American Comics Group (A.C.G.) 121, 169, 200, 210, 216 American News Company 12, 199 Animal Comics 113-14, 116, 117, 118 Animated Movie Tunes 119 Anne 92, 94, 97, 165 Apache Kid 134, 135, 136 Arabian Nights 95 Archie 44, 125-7, 177-8 Archie Publications vii, 125, 126, 224 Archie's Pal Jughead 126 Arizona Kid 135 Armer, Frank 22, 24, 25, 180 Arnold, Everett M. 43-4, 63-4, 80, 96, 150 Arrow 39 Association of Comics Magazine Publishers (A.C.M.P.) 180-1 Astonishing 198 Atlas 5, 135-6, 166, 170-1, 172, 181, 182, 193, 198-9, 216, 224 Atom 50 Avon Comics 103, 136-7, 169-70, 185, 186, 200, 225, 226 Ayers, Dick 134 Baffling Mysteries 200 Baker, Matt 94, 95, 160, 161, 165, 199 Bambi 108 Barks, Carl 6, 106, 108-9, 110, 111, 112-13, 181 Barry, Dan 144 Batman 3, 27, 35, 36-9, 42, 50, 206-9 Battle 171 Battle Action 170 Battle Attack 171 Battle Brady 171 Battle Cry 171 Battle Front 170, 171-2 Battle Ground 170 Battle Report 172 Battle Stories 171

Battlefield 170

Beck, Charles Clarence 6, 51, 53-4, 55.56.57 "Bellyrobber" 195-6 Benton, Mike 100, 144 Bernhard, Arthur 47, 80, 82, 148 Best Comics 47 Best Western 135 Better Publications 47, 54, 59, 88, 121, 172 Betty & Veronica 126 Beware... Terror Tales 198, 201 Beyond 200 Big Shot Comics 60 Bill Boyd Western 132 Billy the Kid 137 Binder, Jack 80 Binder, Otto 79 Biro, Charlie vii, ix, 35, 82, 103, 140, 141-2, 144-5, 179, 180 Black Cat Mystery 198, 199 Black Diamond Western 137 Black Hood Comics 80 Black Magic 200 Black Mask 22 Black Phantom 134 Black Terror 59, 88, 89 Blaze Carson Comics 135 The Blonde Phantom 224 Blondie & Dagwood 124-5 Blue Beetle 43, 75, 153 Blue Bolt Comics 60, 76 Blue Ribbon Comics 44 Bob Colt 132-3 Bob Steele Western 132 Bobby Benson's B-Bar-B Riders 134 Boring, Wayne 44 Boy Comics 103, 140-1, 143 Boy Commandos 151 Brad Nelson 27 Bradbury, Ray 22 Brenda Starr Comics 101, 102 Brenner, George 44 Briefer, Dick 59, 200 Bringing Up Father vi, vii, 8, 13, 14 Bucky 77 Bugs Bunny 107, 109 Bulletgirl 58-9 Bulletman 58-9, 84, 85 Bumbazine 114, 116 Burgos, Carl 40, 41, 72, 73-4 Buscema, John 133 Buster Brown 14 Calling All Girls 88, 102 Cameron, Lou 200 Camilla 94 Campbell, Cliff 79 Capp, Al 20, 137 Captain America 67, 76-8, 151 Captain America Comics 76-7, 82, 103, 118 Captain Billy's Whiz-Bang 52, 53, 54 Captain Marvel 3, 47, 50-7, 59, 70-1, 84, 85, 86-7, 122, 216-17 Captain Marvel Adventures 51, 52-8, 58, 70-1, 83, 102, 216 Captain Marvel Jr. 58, 59, 83-6, 223 Captain Midnight 82, 83 Captain Nazi 83-4 Captain Terror 74 Captain Thunder 53, 54 Captain Video 173 Carlson, George 122-4 Carreno, Al 85 Carter, Gary 220-1 Catman Comics 60 Catwoman 37, 207 Celardo, John 165 Centaur Publications Inc. 34, 35, 39, 119, 132 Challenge of the Unknown 200 Chamber of Chills 198 Champion Comics 44 Charlton 166-7, 200 Chesler, Harry "A" vii, 34, 35, 40, 74,

82 85 Cicconi, Susan 226 Cinderella 107 Classics Comics 89, 95, 183 Classics Illustrated 5-6, 7, 35, 88-9, 182-3, 226 Claw 47, 80-2 The Clock 44, 60 Cochran, Russ 176 Cohen, Sol 177, 178, 185 Cole, Jack 6, 35, 43, 66, 78, 80, 148, 149,150 Cole, L.B. 200 Colombia Comics 60, 124 Combat Casey 171 Combat Kelly 171 Comedy Comics 119 Comet 78-9 Comic Book Marketplace 21-2, 82, 103,221 Comic Capers 119 Comic Cavalcade 98 Comic Favorites Inc. 44 Comic Magazine Company Inc. 20-1. 44.62.131-2 Comic Magazine Funny Pages 20 Comic Media 182, 183, 199 Comic Weekly vi *Comics* 14, 15, 106 Comics Code 4, 180-1, 213-14, 215 Comics Journal 53, 54 Comics Magazine 20, 21 Comics Magazine Association of America 213, 214 Comics Magazine Company 34 Comics on Parade 20 Compton, John 40 Confessions Illustrated 214 Coo Coo Comics 121 Cook, William 21, 34, 44 Cowboy Comics 34, 132 Coyne, Morris 44 Craig, Johnny 155, 184, 185, 187, 196, 215 Crandall, Reed 43, 187-8, 190, 215 Crash Comics 60 **Creston Publications 121** Crime 190 Crime Does Not Pay 141, 142-6, 161, 179 Crime Exposed 153, 154 Crime Illustrated 214 Crime Patrol 152, 155, 184, 185 Crime and Punishment 146-7, 179-80 Crime SuspenStories 153, 196, 210 "Crimebuster" story 103, 140-1 Crimefighters 153 Crimes by Women 155-6 Crossen, Ken 85 Crypt Keeper 184, 187, 189 Crypt of Terror 185, 186, 188, 193 Culture Corner 120-1 Cupples and Leon 13-14 Daigh, Ralph 52-3, 54, 55, 122 Daily Mirror 93 Dale Evans 135 Dan Dare 55 Daredevil 80-2, 143 Daring Mystery Comics 75 Dark Legend: A Study in Murder (Wertham) 156, 162 Davis, Jack 188, 190, 193, 215 Davis, James F. 122 D.C. Comics Inc. ix, 3, 17, 22-3, 26, 28-31, 35-42, 44, 46, 50, 51, 54, 62-3, 70, 86-7, 98-100, 103, 121, 122-3, 127, 130, 135, 151, 153, 172-3, 182, 206-7, 216, 222, 224 Dead-Eye Western 131 Delacorte, George T. 19, 106 Dell Publishing Company Inc. 2, 14, 16, 19, 51, 60-1, 87, 103, 106, 107-8, 109-10, 113, 114-18, 121, 122, 133, 136, 162-3, 173, 181-2, 216, 222

Des Moines Register-Tribune Syndicate 63-4 Desperado 137 Detective Comics 22, 23, 26-7, 28, 36, 38.46 Detective Comics Inc. 26, 34, 38-9, 44 Detective Dan 24-5 Detective Picture Stories 20, 24, 62 Detective Story Magazine 25 Dick Tracy vii, 18, 19, 36-7 Dirk, Rudolph 13 Ditko, Steve 5, 136 Doc. Savage 102 Doctor Occult 18, 21 Doll Man 43, 44, 62, 63 Don Winslow of the Navy 14, 131, 223 Donald Duck 106, 107, 109-10, 111-12 Donald Duck Finds Pirate Gold 109-10 Donald Duck Four Colors comic books 112 Donenfeld, Harry ix, 22, 24, 25-6, 27-8, 31, 36, 38, 41, 42, 44, 46, 47, 86, 102, 153-4, 168-9 Donenfeld, Irving 22, 24 Donny Press 22 Douglas, Steve 124 Dr. Fate 50 Dr. Mystic 21 Dr. Seuss 181 Dr. Sivana 56 D.S. Publishing Co. 152, 155 Duey 106, 110 Durango Kid 134 Dynamic Comics 74 Easter Bunny Parade 116 Eastern Color Printing Inc. 3, 10-11, 12, 14, 60, 106, 122, 124, 222 Educational Comics 154-5, 177, 181, 192-3 Eerie 186, 200 Eisner, Will ix, 36, 42, 44, 61-3, 64, 65-7,177 see also Eisner-Iger comic shop Eisner-Iger comic shop 36, 40, 42, 44, 45, 61, 62, 63, 64, 75, 92, 93, 94, 95, 176, 177 Elder, Bill 193, 194, 196, 216 Ellsworth, Whitney 18, 121-2 Entertaining Comics 4, 6, 120, 172, 173, 176, 177-8, 183-92, 193, 195, 196-8, 200, 204, 209, 214, 215-16, 220, 225 Essoe, Kelley 226 Evans, George 173, 187-8, 193, 194, 198,215 Everett, Bill 39, 40, 41, 60, 71, 72, 73, 136, 169, 199 Exciting Comics 59 Exposed 152, 155 Extra 214 Fago, Vince 122 Fairy Tale Parade 114-16 Famous Crimes 155-6 Famous Funnies 181 Famous Funnies: A Carnival of Comics 3, 11, 12, 14, 106 Fantastic Four 5 Fantom of the Fair 39 Fawcett Movie Comic 132 Fawcett Publications Inc. 51-9, 70-1, 82-7, 102, 103, 120-1, 122, 132-3, 136, 141, 157, 162-3, 165, 169, 170, 171, 173, 182, 198, 200, 201, 211, 216-17, 223 Fawcett, Roscoe 51, 52, 122 Fawcett, Wilford H, 51, 52 Fawcett, William H., Jr. 52 Fawcett's Funny Animals 122 Feature Comics 44, 62, 63 Feature Funnies 44 Feldstein, Al 160, 176-8, 183, 184-5, 186, 187, 188, 191-2, 193, 196, 213, 214-15 Fiction House Comics 4, 35, 36, 45, 46-